Max Beckmann and Paris

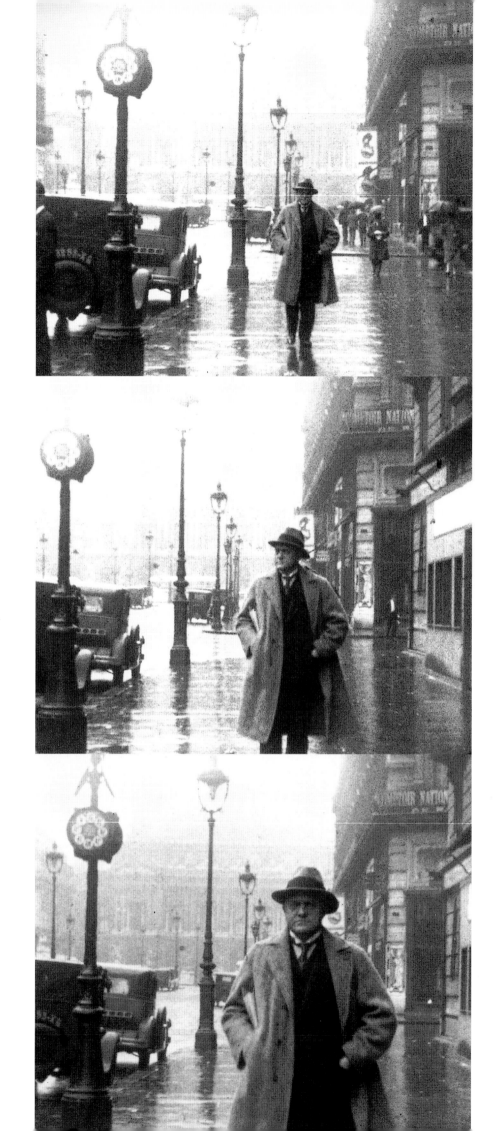

Max Beckmann and Paris

Matisse Picasso Braque Léger Rouault

Edited by

Tobia Bezzola and Cornelia Homburg

The Saint Louis Art Museum

Kunsthaus Zürich

TASCHEN

KÖLN LISBOA LONDON NEW YORK PARIS TOKYO

Cover
Max Beckmann, *Sunrise,* 1929, cat. 12

Back cover
Georges Braque, *Dressing Table in front of the Window,* cat. 68
Pablo Picasso, *Nude in a Red Armchair,* 1932, cat. 98
Henri Matisse, *Algerian Woman,* 1909, cat. 78
Georges Rouault, *The Loge,* 1940, cat. 109
Fernand Léger, *Still Life,* 1922, cat. 75

Back flap
Max Beckmann, *Resting Woman with Carnations,* 1940/42, cat. 43

Published on the occasion of the exhibition
Max Beckmann and Paris
Kunsthaus Zürich, September 25, 1998 – January 3, 1999
The Saint Louis Art Museum, February 6 – May 9, 1999

Exhibition and Catalogue: Tobia Bezzola, Zürich and Cornelia Homburg, St. Louis

Library of Congress Cataloging-in-Publication Data
Max Beckmann and Paris / edited by Tobia Bezzola and Cornelia Homburg
Essays by Tobia Bezzola, Fabrice Hergott, Cornelia Homburg, Carla Schulz-Hoffmann
Lexicon by Laurent Bruel, Barbara Stehlé-Akhtar, and others
p. cm.
Translated from the German
ISBN 0-89178-076-9
1. Beckmann, Max, 1884–1950 – catalogs. 2. Beckmann, Max 1884–1950 –
Criticism and interpretation I. Bezzola, Tobia. II. Homburg, Cornelia.
Library of Congress Number 98–060854

Edited by Mary Ann Steiner and Nicola von Velsen
Translations: Ishbel Flett, Brian Holmes, Laurie Stein; Beckmann in Paris: Stephen Reader, Heather Eastes, Janet Brümmer
Design: Matias Möller, Cologne and Rutger Fuchs, Amsterdam

Printed in Germany

English edition
ISBN 3-8228-7203-2

German edition
ISBN 3-8228-7609-7

Contents

Foreword

We celebrate the art of Max Beckmann again. It is good that we should do so, for each of our museums has a long history of presenting him as one of the most important artists of this century.

The Kunsthaus Zürich held its first major exhibition of Beckmann's art in 1930. Later, in 1955, Zürich commemorated the artist with a major retrospective. The Saint Louis Art Museum hosted its first exhibition of Beckmann's paintings in 1948. After Beckmann's great patron Morton D. May bequeathed his magnificent collection to the Museum, it celebrated the centenary of the artist's birth with a huge retrospective exhibition in 1984.

Our collaboration combines our historical interest with the artist's own ambitions to be recognized in the company of other international masters of the twentieth century. Seeing his art alongside masterpieces by Picasso, Matisse, Braque, Léger, Rouault, and Delaunay is an experience that is as instructive as it is beautiful. These stunning paintings, considered in equally stunning juxtapositions, confirm that the influences, stylistic tendencies, and recurrent subject matters are merely the vocabulary for an amazing cultural phenomenon.

We are so grateful to the lenders who have allowed us to include their works in this very special exhibition. We express particular thanks to Maja Beckmann, Mayen Beckmann and Michael Semler, who have been constantly supportive throughout. Our success rests on the generous loans of works of art from many individuals and institutions.

Tobia Bezzola, curator of exhibitions at the Kunsthaus Zürich, and Cornelia Homburg, curator of modern art at The Saint Louis Art Museum, organized this exhibition with admirable vision and execution. Their partnership has brought about an exhibition that is both breathtaking and thought-provoking. This book is the result of their careful scholarship and enthusiastic reconsideration of Beckmann's role in twentieth-century art. We are grateful to Carla Schulz-Hoffmann and Fabrice Hergott for their contributions to the catalogue. Taschen Verlag has worked with us to develop this catalogue and we are most appreciative of their helpful ideas and expertise. We thank Mary Ann Steiner for her assistance with the English edition.

Felix Baumann
Director, Kunsthaus Zürich

James D. Burke
Director, The Saint Louis Art Museum

Lenders

Our mutual thanks are extended to all the Museums and collectors who have made this exhibition possible:

Ahlers Collection
Baltimore, The Baltimore Museum of Art
Basel, Öffentliche Kunstsammlung Basel, Kunstmuseum
Bern, Kunstmuseum Bern
Fondation Beyeler, Riehen, Basel
Bremen, Kunsthalle Bremen
Cambridge, Fogg Art Museum & Busch–Reisinger Museum, Harvard University Art Museums
Chicago, The Art Institute of Chicago
Cologne, Museum Ludwig
Dortmund, Museum am Ostwall
Düsseldorf, Kunstsammlung Nordrhein-Westfalen
Duisburg, Wilhelm Lehmbruck Museum
Emden, Kunsthalle in Emden
Essen, Museum Folkwang
Richard L. Feigen, New York
Grenoble, Musée de Grenoble
Hamburg, Hamburger Kunsthalle
Hannover, Sprengel-Museum
Cola and Bernhard Heiden
Ursula and Stanley Johnson Family Collection
Kaiserslautern, Pfalzgalerie
London, Tate Gallery

Los Angeles, Los Angeles County Museum
Lugano-Castagnola, Fondazione Thyssen-Bornemisza
Madrid, Museo Nacional, Centro de Arte Reina Sofía
Munich, Bayerische Staatsgemäldesammlungen
Münster, Westfälisches Landesmuseum für Kunst und Kulturgeschichte
New York, The Metropolitan Museum of Art
New York, Museum of Modern Art
New York, Solomon R. Guggenheim Museum
Otterlo, Rijksmuseum Kröller-Müller
Paris, Fondation Georges Rouault
Paris, Musée d'art moderne de la Ville de Paris
Paris, Musée national d'art moderne, Centre Georges Pompidou
Emily Rauh Pulitzer, St. Louis
Solothurn, Kunstmuseum Solothurn
Stuttgart, Staatsgalerie Stuttgart
Villeneuve d'Asq, Musée d'Art Moderne du Nord
Washington, Hirshhorn Museum and Sculpture Garden, Smithsonian Institution
Wiesbaden, Museum Wiesbaden
Wuppertal, Von der Heydt-Museum

and all those lenders who preferred to be anonymous.

Acknowledgments

The realization of this exhibition has been possible only through the efforts, ideas, and support of very many people. We offer our gratitude to them all.

First of all we express our deep thanks to the Beckmann family: Maja Beckmann in Murnau, Mayen Beckmann and Michael Semler in Berlin have our heartfelt gratitude. Their early encouragement gave us the impetus to begin this project and their ongoing support has enriched its progress in many ways.

Stephan Lackner in Santa Barbara, Beckmann's good friend for many years and a contemporary witness to Beckmann's years in Paris, graciously aided our effort with such vivid and detailed answers to our questions that our understanding of this subject was greatly enhanced.

Fabrice Hergott, curator at the Musée national d'art moderne, Centre Georges Pompidou, in Paris, supported our efforts from the beginning with collegial cooperation, led us to important information and contacts; what we were afraid was impossible, he often made possible.

Laurent Bruel in Paris and Barbara Stehlé-Akhtar in New York carefully researched the original materials for us and established the groundwork for our understanding of Beckmann's Paris years. We are especially grateful for the care and thoroughness they devoted to these investigations.

We extend our special thanks to our colleagues for their help in preparing the exhibition and the catalogue. At the Kunsthaus Zürich Laurentia Leon has managed all the organizational matters of this project for several years; her careful attention left no detail overlooked. We thank Lynn DuBard and Michelle Komie for their research assistance on this project, and Susan Rowe and Manon Herzog for their help at so many levels. We appreciate the efforts of Jeanette Fausz in St. Louis and Gerda Kram in Zürich, who served as coordinators of the exhibition; Nick Ohlman, Romy Storrer and Diane Vandegrift for the arrangements of the loans; and Paul Haner and Paul Pfister for their conservation expertise.

We thank Volker Gebhardt and Nicola von Velsen of Benedikt Taschen Verlag for their energetic efforts in preparing the catalogue, and Mary Ann Steiner for overseeing the production of the English edition.

For their contributions to this project we especially wish to thank:
Stiftung Arsana, Douglas Baxter, Gérard Berrut, Ernst Beyeler, Yve-Alain Bois, Cécile
Brunner, Anja Bücherl, José Capa Eiriz, Pierre Chave, Rudy Chiappini, Guy-Patrice
D'Auberville, Matthew Drutt, John Elderfield, Christopher Eykyn, Jacques Faujour, Walter
Feilchenfeldt, Hilda François, Karin Frei, Klaus Gallwitz, Caroline Godfroy-Durand-Ruel,
Esther Grether, Tom Grischkowsky, Ay-Whang Hsia, Jutta Hülsewig-Johnen, Joachim Kaak,
Hans Kinkel, Christian Klemm, Annette Kruszynski, Claude Laugier, William S. Lieberman,
Guido Magnaguagno, Achim Moeller, Isabelle Monod-Fontaine, Ueli Müller, Peter Neumann,
Eva Orbanz, Claude Picasso, Bertrand Prevost, Christoph Pudelko, Hilde I. Randolph, Maria
Reinshagen, John Richardson, Elaine Rosenberg, Angela Rosengart, Isabelle Rouault, Bernd
Schultz, Reinhard Spieler, Laurie Stein, Jeremy Strick, Harald Szeemann, Daniel Varenne,
Germain Viatte, Ortrud Westheider, Paola von Wyss-Giacosa.

Tobia Bezzola, Cornelia Homburg
Zürich and Saint Louis, September 1998

24 Max Beckmann, *Rêve de Paris, Colette, Eiffel Tower*, 1931

Tobia Bezzola and Cornelia Homburg

Max Beckmann and Paris

"If only our paintings could be shown together …"
(Max Beckmann)

It is a fact all too rarely acknowledged that Max Beckmann, though an expressive painter, was not actually an expressionist. He had hardly anything to do with the various circles and groups known under that name in Germany, had no wish to be counted among them and even regarded their work with a critical eye. This tends to be ignored with remarkable regularity in our museums and galleries, where Beckmann is invariably presented alongside the artists of the *Brücke* or *Blaue Reiter.* His works are usually hung beside those of Kokoschka, Dix and Grosz.

This exhibition began with a rather naive question: why is it that no one seems to think of showing Beckmann alongside Matisse, Picasso, Braque or Rouault? Seen with fresh eyes, their proximity appears much more fitting. Once we realized how many sound historical reasons there were for considering Beckmann in the context of the Ecole de Paris, this project took its course.

In the mid-20s, Paris and the painting that emanated from there to capture the imagination of the world were the focus of Beckmann's interest. He visited Paris frequently. He met critics and dealers. He tried to find a foothold in the city that was the home of art and sought to bring his work into the international arena. In 1929, he settled in Paris, where his various endeavors to gain recognition culminated in a major exhibition at the Galerie de la Renaissance in 1931.

His involvement with the Paris art world is reflected in Beckmann's paintings of the late 20s and 30s. His creative rivalry with the artists there, especially Pablo Picasso, but also Henri Matisse, Fernand Léger, Georges Braque and Georges Rouault, led to certain similarities of artistic expression, evident at various levels: we find similarities in subject matter; similarities in technique, form and color; and similarities in atmosphere or mood.

Such affinities are not necessarily the result of direct influence. After all, Max Beckmann and his Paris contemporaries were shaped by the same precursors. Beckmann had visited Paris for the first time in 1903, at the age of nineteen. While he was there, he studied the nineteenth-century French modernists, just as Rouault, Matisse, Picasso, Braque and Léger had done only a few years before him.

In the late 20s, marked by his personal experience in the first world war and motivated by a number of factors, Beckmann turned his attention once again to the works of Eugène

Delacroix and Edouard Manet, Paul Cézanne, Vincent van Gogh and the lessons to be learned from them. This, together with the fact that he had chosen to live in Paris at the time, brought his work closer to that of his French colleagues in many different ways, as we think this exhibition clearly demonstrates. The catalogue presents, for the first time, the theoretical and factual basis of Beckmann's relationship to the French art of the day.

Showing Beckmann's major works from his Paris period alongside the masterpieces of his French colleagues sheds light on an aspect of his painterly temperament that has previously been neglected. Beckmann was not always brooding, gloomy, "German," harsh and apocalyptic. His œuvre is also informed by a serenely contented, upbeat and even sensual mood in which Beckmann produces some of the most superb examples of non-illusionist figurative painting our century has ever seen.

Max Beckmann had a distinctly competitive streak. He often wished to see his skills pitted against other artists, Picasso in particular. Today, there can be no question of staging such a competition or awarding laurels. Rather, in telling the story of Max Beckmann's Paris years, we have gained the far more satisfying result of creating an exhibition that presents a magnificent panorama of the masterworks of classical modernism, and puts a new slant on a fascinating chapter of European art history.

(Translation: Ishbel Flett)

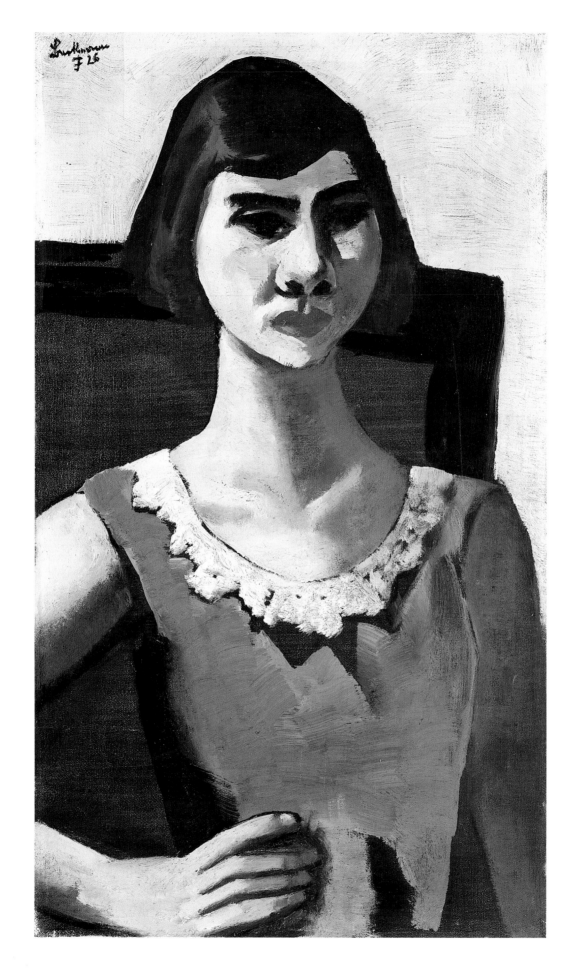

3 Max Beckmann, *Quappi in Blue*, 1926

Tobia Bezzola

Quappi in Blue

The Max Beckmann who returned from the first world war and from his experience as a para-
medic there was profoundly affected, deeply traumatized. His output in the years after the war
is grim and pessimistic. Rare instances of a humorous flavor soon taste bitter. His graphic work
dominates; it is a world in black and white. It is drawing which directs the paintings: their col-
oring is ashen, frightened. Here is someone who bites his tongue. He dares not sing.

Suddenly, in the mid-20s there is a change – the artist is barely recognizable, the painter
Beckmann returns, *en grande toilette.* Beckmann paints, and how he paints! Luminously color-
ful, sumptuous, sensual in salmon pink, exploding ultramarine, sprays of lemon yellow and
scarlet, with radiant oceans of turquoise, fields of juicy orange, and cypress green shadows.
A fortissimo of the most vehement chords played against a shimmering black background.

What had happened?

First we turn to the biographers. They may locate the circumstances of Beckmann's pri-
vate life to seek the source of this stylistic rejuvenation. Secondly, we know that every artist
develops stylistically in concert with the audience. The struggle for recognition, both in the
sense of social acceptance as an individual and in the sense of artistic acceptance of the
work, invariably plays a role. In Beckmann's case, however, we cannot avoid the question
of what it might mean for an artist in the 20s to want to be more than a "German" painter.
Finally, we look to the history of art which can enlighten us about the dialogue with precur-
sors and contemporaries, and place Beckmann's painting in its proper aesthetic context.

Accordingly, this investigation is organized in three parts. Each section of the following
essay bears a subtitle that addresses an aspect we consider central to understanding the
paintings in this exhibition.

appetito di belleza

"Little Quappi, what crazy tiger have you dragged into your old stall?"[1] Beckmann asked. Of
course, he provided the answer himself, indirectly in his paintings and directly in his writ-
ings. Beckmann was not just an artist who drew and painted. He was also a gifted writer.

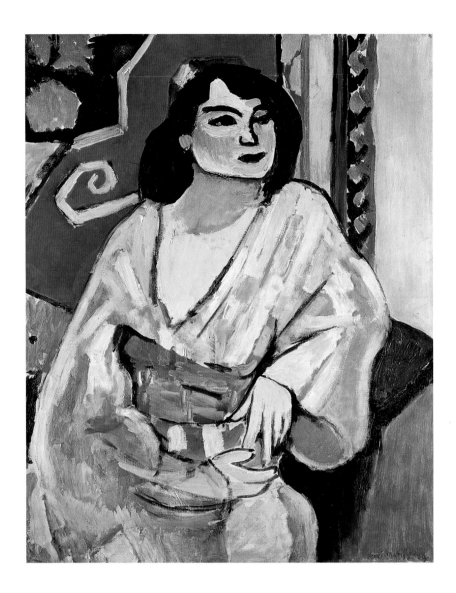

78 Henri Matisse, *Algerian Woman*, 1909

He wrote plays, kept a diary and penned innumerable letters in a distinctive and incisive style. A search for affinities between his writings and paintings proves highly rewarding. The love letters Beckmann wrote to his young bride, his second wife Mathilde Kaulbach, known as Quappi, reveal the craziness of the tiger more candidly than the works of art themselves.

The couple met in Vienna in early 1924 and were married a year and a half later. It was a love that released enormous energies in the older artist, lightening the pessimistic ground-swell of his *Weltanschauung*, liberating him and his art and preparing the ground for his mature work. He himself saw that perfectly clearly. In a letter to I. B. Neumann written just a few months after meeting Quappi, he summed up his artistic aims for the next few years. He would turn to portraits, still lifes and landscapes, he said, and to beautiful women, "*bathers and female nudes*." Beckmann turned away from the heavily laden symbolism of his "gothic" period and formulated instead a sensual and profane credo: "*A life of simply being.*

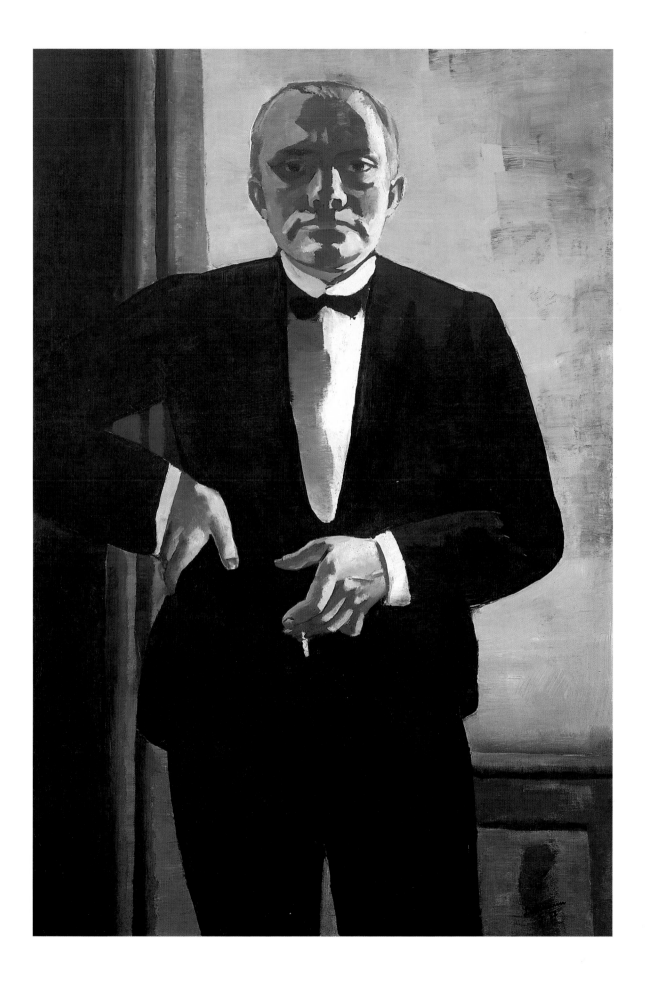

5 Max Beckmann, *Self-Portrait in Tuxedo*, 1927

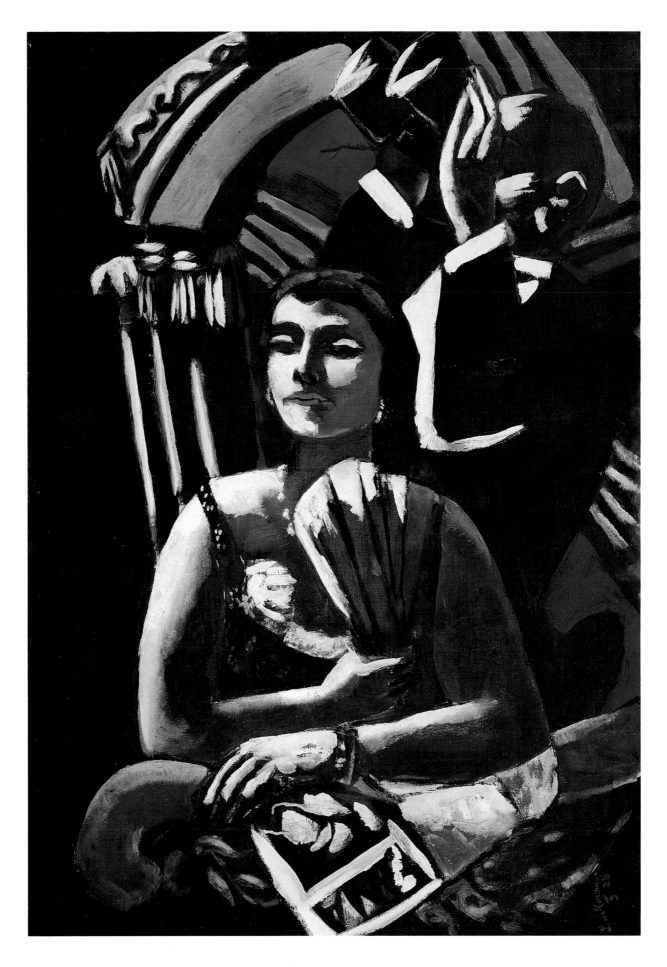

9 Max Beckmann, *The Loge*, 1928

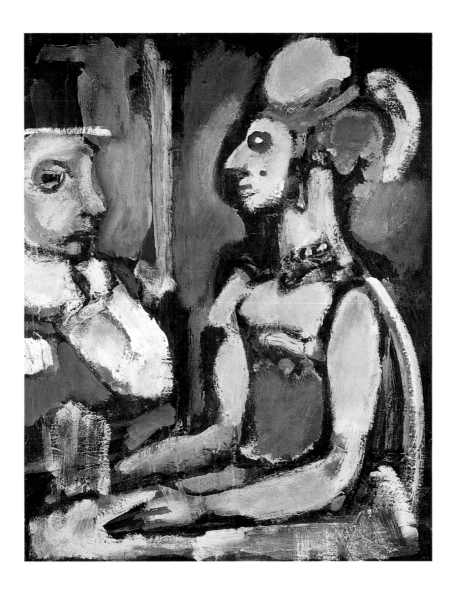

109 Georges Rouault, *The Loge,* 1940

Without thoughts or ideas. Fulfilled by the forms and colors of nature and from within myself. As beautiful as possible …"[2] Or, in the style of his letters to Quappi, "*Alongside the grand and pompous soundings of the soul, we can also be very very powdered, we Max Beckmann 'by the grace of God'.*"[3]

The artist also left his friend and agent Neumann in no doubt as to the reason for his *joie de vivre*, sensuality and levity. His formal syntax had, he claimed, "*become more serene and free, without losing any of its precision,*" adding that he was "*favored by certain auspicious moments in my life … to continue to strive towards utmost harmony.*"[4]

Everything smells like spring to him. And an incredible force of energy courses through this forty-year-old, a force he describes as having "*increased tenfold due to the considerably improved personal situation in which I now live, and I have more intensity and freshness than ever before in my life.*"[5] A little later, he also told Neumann what this meant for his career: "*My will is now free and condensed into further powers that I find almost uncanny. – My greatest works are yet to come!!!*"[6]

And come they did. With one fell swoop in the late 1920s, Beckmann produced the most beautiful pictures he had ever dared paint: *Aerialists* (cat. 11, p. 32), *Gypsy (Nude with Mirror)* (cat. 10, p. 75), *Large Still Life with Telescope* (Fig. 3, p. 159). The music stirs us to a new dance. We no longer hear strains of Brahms or Mahler. A breath of fresh air sweeps through the salon. The twentieth century is here. The spotlights are on. Beckmann swings lightly. Note the elegant and almost coquettish turn of the hip in his famous *Self-Portrait in Tuxedo* (cat. 5, p. 17). The tiger dances. His mood intensifies from moderato to andantino, culminating in the most exuberant allegretto. *"Looking forward so much to you on 2 January 1925, to dancing with you – so much. We'll do a lot of dancing and drinking ... Dein Tigretto."*[7]

Max Beckmann was a man with a complicated erotic temperament. His early diaries reveal a tormented Wilhelmine youth incapable of dealing with his desires, torn between cynical posturing, sentimentality, guilt, and self-recrimination. In his later years, he came to develop a complex world view in which the temptations of the senses, forsaking pure spirituality, take on a menacing role. Towards mid-life, that pressure disappears for more than a decade. Thanks to the magic of Mathilde Kaulbach, Beckmann and Eros come to terms. For a few, happy years, the insidious seductions of that terrible demon, great liar, deceiver, and bane of human fidelity lost their power. Beckmann discovered an innocent sensuality and was able to live out that sensuality without guilt. *"Black silk stockings black silk shoes white underwear your sweet mouth and your big cat eyes with beguiling pupils were very close to me. – Oh la la my sweetheart ..."*[8]

15 Max Beckmann, *Reclining Nude*, 1931

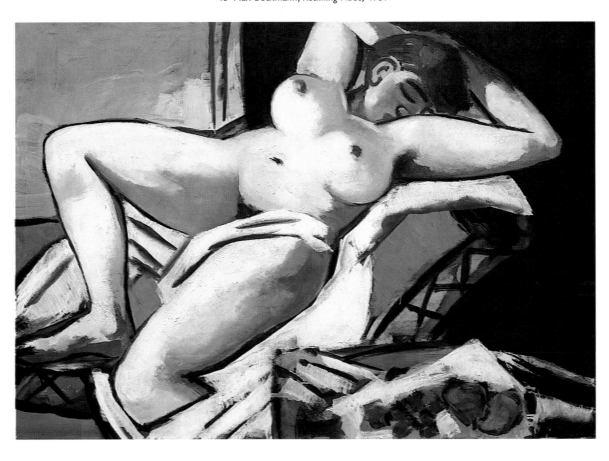

TOBIA BEZZOLA

22 Max Beckmann, *Portrait of Quappi on Pink and Violet*, 1931

That same *oh la la* hits us in his main works of the late 20s. Wide-eyed, thrilled at what is happening to him, Max Beckmann hurls his joy into his most powerful paintings.

"I have a terrible power of negation in me. You small sweet Cynthia have been chosen to transform that power completely into affirmation."[9] We owe some of the century's most beautiful paintings to the love between Max and Quappi Beckmann. Mathilde accepted her tiger just the way he was. She accepted his conditions, too. That meant no more riding, no more public performances as a musician, no children. Instead, she could have Pekinese dogs, fur coats and shoes from Paris, skiing at Saint Moritz and dinner at the Ritz, for a few years at least. Then came the years of exile, a cold apartment in a foggy city, and war. *"Watery liquid from ersatz stockcubes ... sometimes a few carrots ... a slice of rubbery bread ..."*[10] Max and Mathilde Beckmann, like René and Georgette Magritte, emerged from catastrophe with their lapdogs in hand, surprised to be there at all. Mathilde Kaulbach had become Quappi, promoter and protector. Without her, the old tiger could not have carried on. She accepted his total immersion in his work. Beckmann's last diary entry for 26 December 1950 reads:

> *"Snowing ... / worked all day / on the 'Head' / and on the 'Theatergarderobe'*
> *Q. was angry."*[11]

The World Champion

The competition for success and recognition leads again and again to a rivalry between artists. Each step the rival takes is observed with a suspicion that influences, even determines, the artist's creative choices. The fertile creative rivalry between Henri Matisse and Pablo Picasso is well documented. The significance of rivalry in the field of the intellect described by Karl Mannheim should not be underestimated in the field of art history.

As the most successful and famous German painter of his day, Beckmann was competing only in limited fashion with the artists in Paris for success and recognition. Yet he wanted more. He wanted international stature. The way there led via Paris, and the opponent he had to defeat in that arena was named Pablo Picasso.

His success in Germany and his relationship with Quappi gave Beckmann an incredible new drive. What Max Schmeling, the first German heavyweight world champion and the friend of his agent Flechtheim, had achieved, another Max could surely achieve too. Beckmann stepped into the ring as a challenger for the world championship title. He, too, had a manager, in the person of I. B. Neumann, with whom he discussed strategies and tactics, and considered allegiances: *"I certainly agree with you in regarding the Rosenberg-Flechtheim connection very critically."* Their common aim is constantly reiterated: *"Only in this way will we be able to bring our matter to international discussion and get out of this damned German provinciality."* He was not above tactical feints and opportunistic maneuvers: *"Until then we have to take a parallel course with this art because it has France – the realm of painting and the center of modern art – behind it in all its cosmopolitan snobbery."*[12]

This publication traces Beckmann's *stratégie parisienne* in detail now for the first time.[13] It will be apparent that the Paris strategy pursued by the German artist and the socialites who

TOBIA BEZZOLA

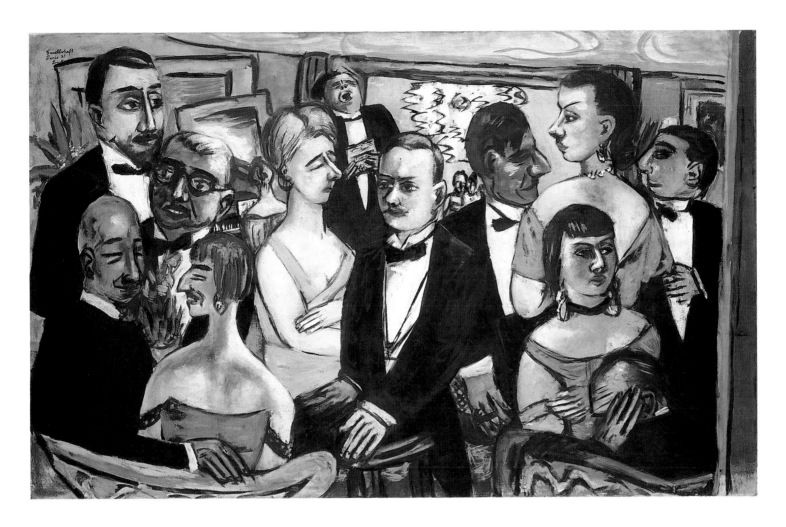

26 Max Beckmann, *Paris Society*, 1925/31/47

supported him was almost touchingly schoolboyish.[14] Already his timing was as bad as it
could be: just as Beckmann was lacing up his gloves, the international economic crisis sent
the art market reeling. The rise of new and aggressive forces in Germany hardly helped to
stimulate French interest (or international interest, for that matter) in German culture. What
was worse, the connections Beckmann had built up in Paris were the wrong ones. He had
failed to enlist the most important opinion-leaders on the art scene. Indeed, he hardly knew
who they were.

The struggle was doomed from the start. It would have been better for Max Beckmann in
1929 to have chosen the arena where, dazed and surprised, he would eventually achieve
international success: New York.

We, however, are more interested here in how much Beckmann's stylistic development
was dictated by his strategic calculations. That this should have played a role at all was some-
thing he never sought to conceal. Those with a naive view of the art world may be shocked
to find this out. After all, we prefer to believe that artists are answerable to none but their
own creative subjectivity. Yet Beckmann knew that he was going to have to paint "French" if
he was to break through on the Parisian and international art scene. That in itself caused him

no trouble. The French masters of the nineteenth century, Delacroix, Manet, Cézanne, on whose accomplishments his contemporaries had built, had been his mentors, too. What is more, he was confident enough as an artist not to fear that he might lose himself in an adapted idiom. So Max Beckmann set about gathering information. He went to Paris. He took a look around and he decided that what the stars of the day were doing, he could do too – only better.[15] He had no problems presenting himself a little more elegantly, either. When one is out to capture the heavyweight championship of the world, dressing the part is a small price to pay. He outlined his game plan to an astonished and skeptical I. B. Neumann, promising him a generous cut: "*With a part of my being, a certain amusing elegance … you can rule the world.*" Of course, compromise would be necessary: "*The stronger sensations are simply eliminated in favor of an amusing and ticklish dressmakers' taste.*" All in all, however, he felt he was more than a match for his rivals. What was for them the sole basis of success was for him only one of many trumps he held in an unbeatable hand: "*I said 'with a part of my being,' fully aware that these people [Braque and Picasso] do not take this from me, and that they also have it within themselves, but I also have the possibility for pretentious or witty elegance. However, I have not made that my main business, for in my case these merely constitute one department in a larger store of goods.*"[16]

This department of Beckmann's "store of goods" was subsequently taken to market in Paris. We present this for the first time in a historical analysis. What we find are champagne cocktails with a hint of cyanide, a Hollywood set of Paris where comedies are played out, but in a deeper shade of black. Beckmann was not making things easy for himself or the Parisians.

Les années folles

Although Max Beckmann, even by his own admission, was not a particularly nice person,[17] he was nevertheless capable of empathy. Our essays trace the feelings (and the expression of those sentiments) that Beckmann shared with the leading Parisian painters of the day. Apart from examining the art historical issues in the narrower sense, we wish to draw attention to the wider cultural context within which Beckmann produced his Paris works of the 1920s and 30s.

Quappi in Blue (cat. 3, p. 14) is the painting with which Beckmann stridently steps into a new stylistic phase in 1926. The technical and aesthetic achievements evident here for the first time were to form the basis for his painting for the rest of his life. And from what we have discussed earlier about the importance of Quappi in all aspects of his life, it is not surprising that it was a portrait of Mathilde Q. Beckmann that should mark such a breakthrough.

One has to pay attention to the title. Beckmann did not choose to call it a "portrait of Quappi in a blue dress" since that is not what he intended. What he was referring to was the blue underpainting from which he develops the portrait. In technical terms, he covers the picture plane with a strongly colored transparent paint that is so thin and transparent that the white-grounded canvas shows through it pale and grid-like and shimmers through from below like a kind of light reflector of the colors superimposed on it.[18] This process calls for

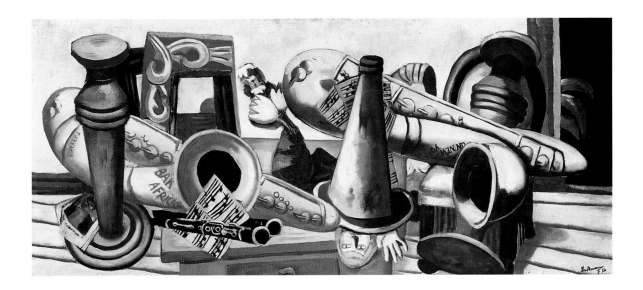

Fig. 2 Max Beckmann, *Large Still Life with Musical Instruments*, 1926

an extremely fast and highly concentrated manner of painting. Corrections are not possible. Each stroke of the brush must be just right the very first time. *"Never before had he succeeded so quickly in producing a portrait as this one,"* he told his beloved.[19]

Quappi in Blue would be a fine title for a jazz hit. *"I love jazz so much … that is sensible music. The things that can be done with it!,"* [20] Beckmann had already enthused in 1923. In exemplary fashion, he transposes the aesthetics of the jazz age into painting. The mood (blues) and the theme (Quappi) are prescribed, and from that everything else is improvised. The artistry lies in spontaneous improvisation rather than in the ability to reproduce precisely a given score (or a detailed preparatory drawing).

Paris was not only the European capital of the jazz he loved so much. The *années folles* of the interwar years were fertile soil for a nascent mass culture and emergent popular culture that incorporated the achievements of centuries-old tradition with mordant wit. His Paris period between 1926 and 1939 was a difficult time for Beckmann in terms of his career, yet the city offered a compensation in the intellectual climate in which his creative work flourished. Department stores evolved into avant-garde palaces, operetta was reborn in the form of the musical and ballet metamorphosed into *revue*. Film and photojournalism were booming, and the pace of life accelerated at breathtaking speed: racing cars, heroic aviators, athletic record-breakers and nonchalant overseas travel became the favored symbols of a frenzied age. In short, Paris was the center of the *vie moderne*, a world of chrome, bakelite and colored glass. The Paris in which Beckmann lived and worked was not only the center of western art, but also of fashion, advertising, architecture, literature and design. It was the Paris of the great Art Deco exhibition, the city of Josephine Baker and Jean Cocteau, of Colette and Coco Chanel, of Mistinguett and Maurice Chevalier, of Le Corbusier and Jean Renoir.

Max Beckmann was a painter and, consequently, a man who portrayed on canvas the things he saw. Even if he drew his themes from literature, the visual code in Beckmann's work was invariably nurtured by his direct visual impressions. When, for example, he wishes

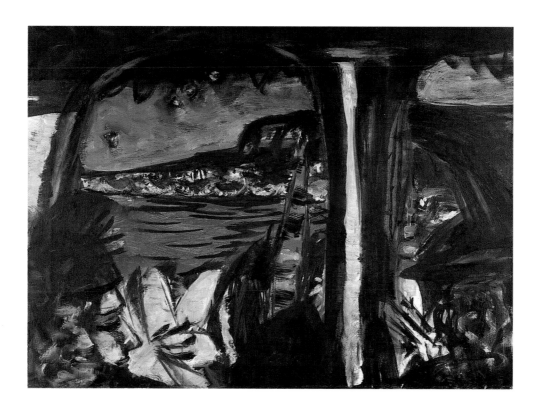

42 Max Beckmann, *Monte Carlo by Night Seen from a Touring Car*, 1942

to portray the Descent into Hades, he paints a Paris Métro sign (*Children of Twilight*, 1939, G 526). Small wonder that the Parisian aspect of his paintings goes far beyond the formal and iconographic affinities with Parisian painting. "*Manet, Manet, Manet ...,*"[21] the young Beckmann had cried out as an art student in Paris. Back in Paris a quarter of a century later, he himself was to become a painter of modern life. Elegant bars and hotels, lobster, oysters and his beloved champagne (nothing less than the rare Irroy would do), the sexy costumes of the showgirls at the Tabarin and Folies Bergères, his "*delight in women*"[22] in general, the fashionable views of the French Riviera, Quappi elegantly dressed in fur coats, stoles and her new Ferragamo shoes, *la fleche d'or*, the new *train de luxe* to Marseille, ice skating in the Bois de Boulogne, etc.

The footage that Max and Quappi shot with their Baby Pathé 9.5 mm camera in Paris and elsewhere in France has much of the charm of Jacques-Henri Lartigue's photographs. The couple with the canary-yellow Opel on the Champs-Elysées, Max in heroic pose on the beach at Bandol, Quappi in a new hat at the Longchamps race track, Beckmann strolling down the Avenue de l'Opéra. Paris was more than just a place of exile bravely borne for the sake of his career. It was a place to live well and have fun, a place to watch the world with eyes open wide.

With unflinching eyes Beckmann drew out of such "autopsies" the images for his canvases that may well be regarded as allegorical in the sense that Beckmann saw reality as nothing but a metaphorical spectacle. When he set up his easel on the Rue des Marronniers, it is as though Lartigue had set up his darkroom in a Faustian Auerbachs Keller. This German knight – crusading outside his homeland [23] – remains true to his expression and his tradition.

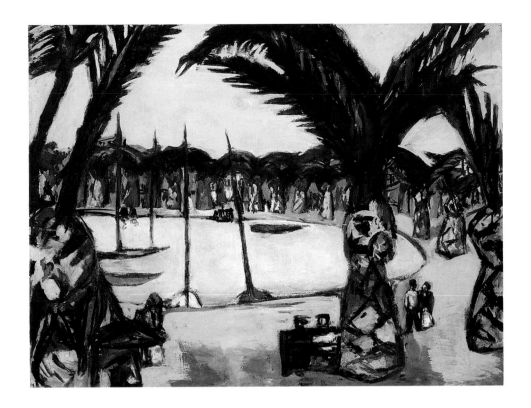

39 Max Beckmann, *Harbor by Bandol (Gray) and Palms*, 1939

Perhaps these waters have been fished too often. Perhaps this pool never contained that many possibilities to begin with. It may be that Beckmann's acquaintance with pleasure was not as complicated as he wanted us to believe. Neither the aggressive vitality of Picasso nor the more tempered *joie de vivre* of Matisse was entirely foreign to him. On a late winter evening in 1904, a slightly inebriated young Beckmann confided to his diary in the Closerie des Lilas just how little interest he really had in studying his Schopenhauer, in penetrating these "*dull, stupid mysteries.*" What he really wanted, he wrote, was "*to live. I swear it a thousand times. I want to.*"[24]

1 Letter to Mathilde Beckmann, Frankfurt, 29 December 1925. "Kleine Quappi, was hast Du für einen verrückten Tiger in deinen alten Stall geschleppt?" *Briefe*, vol. 2, no. 357.

2 Letter to I. B. Neumann, 9 August 1924. "Ein einfach daseiendes Leben. Ohne Gedanken oder Ideen. Erfüllt von Formen und Farben aus der Natur und aus mir selber. So schön wie möglich …" *Briefe*, vol. 1, no. 264.

3 Letter to Mathilde Kaulbach, 23 May 1924. "Neben den grossen und pomphaften Seelentönen können wir auch sehr sehr verpudert sein, wir Max Beckmann 'von Gottes Gnaden.'" *Briefe*, vol. 1, no. 280.

4 Letter to I. B. Neumann, 23 May 1925. "… heiterer und freier geworden ohne dabei an Präzision einzubüssen… begünstigt durch einige glückliche Lebensmomente … weiter nach äussersten Harmonien zu streben …" *Briefe*, vol. 1, no. 281.

5 Letter to I. B. Neumann, 20 August 1925. "… durch die erheblich günstigeren menschlichen Umstände in denen ich nun lebe verzehnfacht und ich bin von einer Intensität und Frische wie nie in meinem Leben." *Briefe*, vol. 1, no. 340.

6 Letter to I. B. Neumann, 26 August 1925. "Mein Wille ist jetzt ganz frei geworden und ballt sich zu weitern mir selbst fast unheimlichen Kräften zusammen. Meine Haupterke kommen jetzt erst!!!" *Briefe*, vol. 1, no. 344.

7 Letter to Mathilde Beckmann, Frankfurt, 29 December 1925. "Freue mich sehr sehr auf Dich am 2. Januar 1925 mit Dir zu tanzen. Sehr. Wir werden viel tanzen und trinken … Dein Tigretto." *Briefe*, vol. 2, no. 357.

8 Letter to Mathilde Beckmann, Frankfurt, 9 October 1925. "Schwarze Seidenstrümpfe schwarze seidene Schuhe weisse Wäsche Dein süsser Mund und Deine grossen Katzenaugen mit den verrückten Pupillen waren sehr in meiner Nähe. Oh la la mein Herzchen." *Briefe*, vol. 2, no. 352.

9 Letter to Mathilde Kaulbach, Frankfurt, 16 June 1925. "Ich habe eine furchtbare Kraft der Verneinung in mir. Diese Kraft in die Bejahung ganz umzusetzen bist Du kleine süsse Cynthia ausersehen." *Briefe*, vol. 1, no. 300.

10 Mathilde Q. Beckmann 1983, p. 36.

11 "Schneefall … / den ganzen Tag gearbeitet / auch noch am 'Kopf' / und 'Theatergarderobe' / Q. war böse" *Tagebücher 1940/50*, p. 400.

12 All the quotations in this paragraph are taken from an unpublished letter to I. B. Neumann, dated Frankfurt, 24 November 1928 (Estate of Max Beckmann). "Jedenfalls stimme ich Ihnen sehr zu wenn Sie die Verbindung Rosenberg-Flechtheim kritisch aufnehmen. … Nur dadurch wird es uns möglich sein unsere Sache erst einmal zur Weltdiskussion zu bringen und aus dem verdammten deutschen Provinzialismus heraus zu kommen. … Bis dahin müssen wir mit dieser Kunst parallel marschieren, denn sie hat Frankreich das Reich der Malerei und des Effort moderne in weltsnobistischer Weise hinter sich."

13 Cf. the article on the Strategie Parisienne in this publication, pp. 224–226.

14 As his contemporary Benno Reifenberg noted, quoted by Gallwitz 1984, p. 159.

15 In a letter to Mathilde Kaulbach, Paris, 28 July 1925.

16 All the quotations in this paragraph are taken from an unpublished letter to I. B. Neumann, dated Frankfurt, 2 June 1926 (Estate of Max Beckmann). "Mit einem Teil meines Wesens, einer gewissen amüsanten Eleganz …, regieren Sie die Welt. … Die stärkeren Sensationen sind einfach ausgeschieden zu Gunsten eines amüsanten und kitzlichen Schneidergeschmacks. … Ich sagte vorhin 'mit einem Teil meines Wesens' wohl bewusst, dass diese Leute [Braque und Picasso] das nicht von mir haben, sondern auch sich selbst, nur ist auch in mir die Möglichkeit zur geschmäcklerischen oder witzigen Eleganz. Auch ich habe kein Geschäft daraus gemacht, sondern sie bilden bei mir nur eine Abteilung in einem grösseren Warenlager …"

17 Included in Barbara Copeland Buenger 1997, p. 277.

18 Bruno Heimberg, in *Max Beckmann Retrospective*, (ex. cat.), St. Louis 1984/85, p. 135.

19 Mathilde Q. Beckmann in ex. cat. Karlsruhe 1963.

20 *Realität der Träume*, p. 102.

21 Letter to Caesar Kunwald, Berlin, 27 October 1904, in *Briefe*, vol. 1, no. 15.

22 See note 14.

23 Ibid.

24 Included in Buenger, Max Beckmann: *Self-Portrait in Words*, 1997, p. 67.

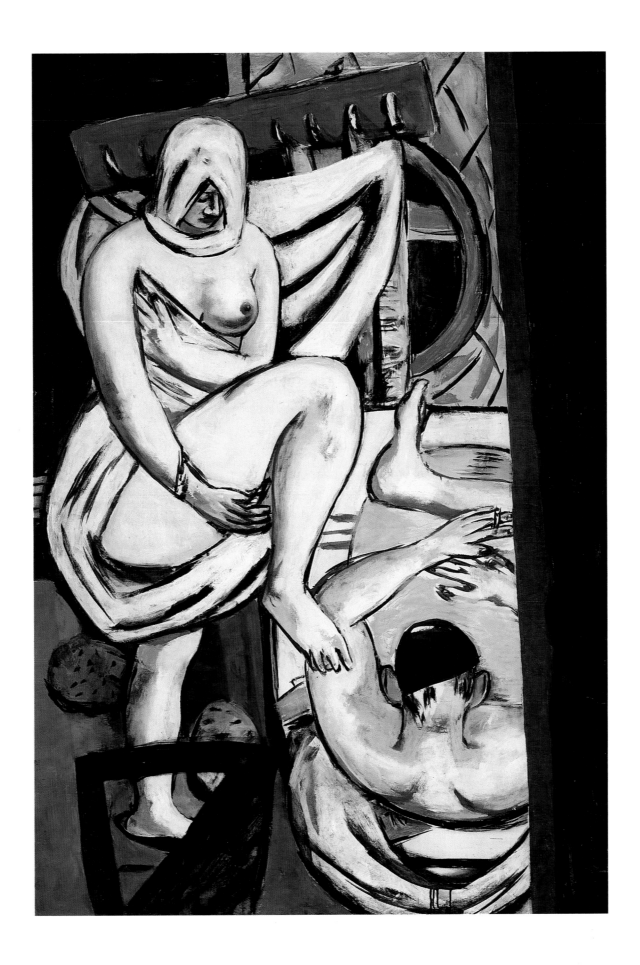

20 Max Beckmann, *The Bath*, 1930

30 Max Beckmann, *The Small Fish*, 1933

45 Max Beckmann, *Young Men by the Sea*, 1943

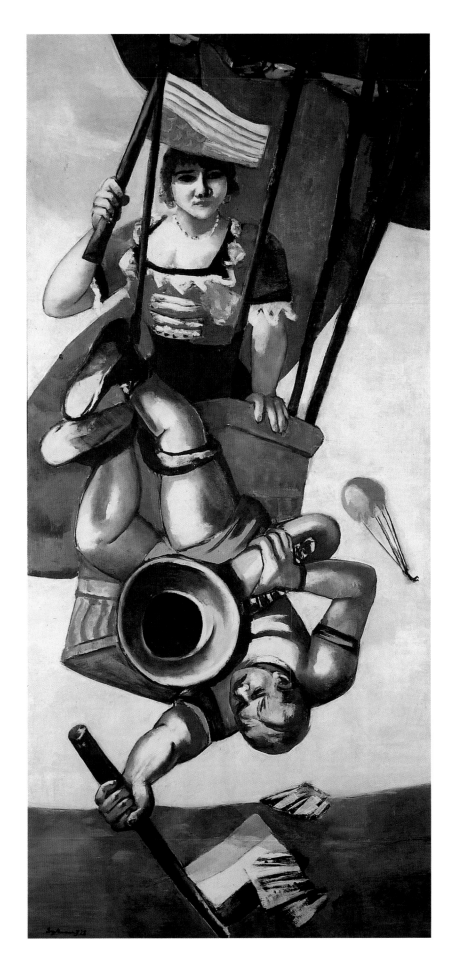

11 Max Beckmann, *Aerialists*, 1928

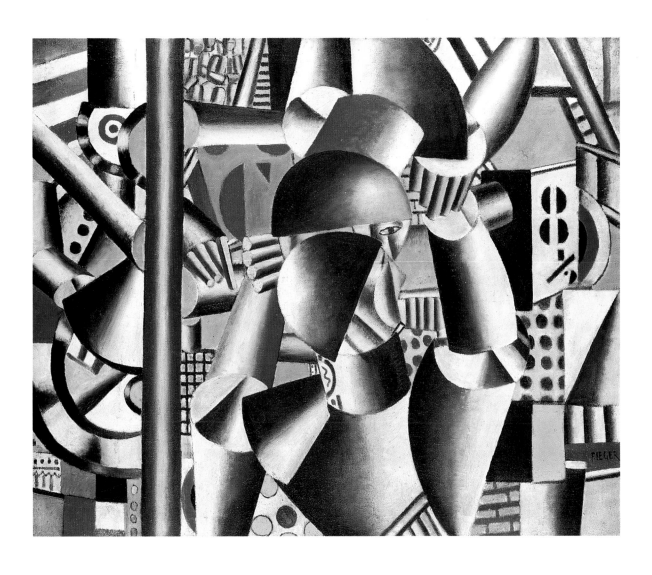

Fig. 5 Fernand Léger, *Acrobats at the Circus*, 1918

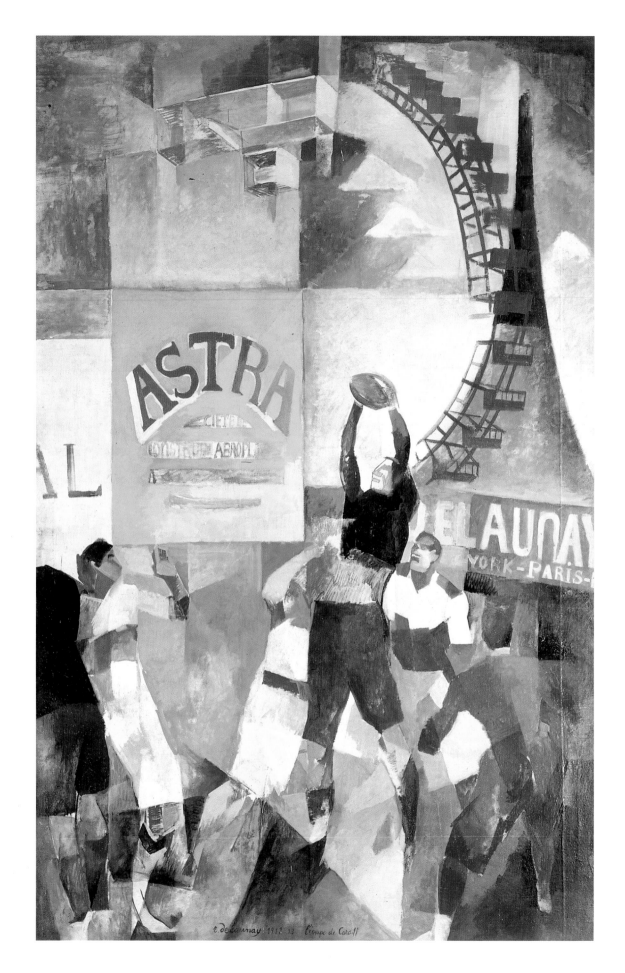

70 Robert Delaunay, *The Cardiff Team*, 1912/13

14 Max Beckmann, *Soccer Players*, 1929

89 Henri Matisse, *Still Life with Magnolia*, 1941

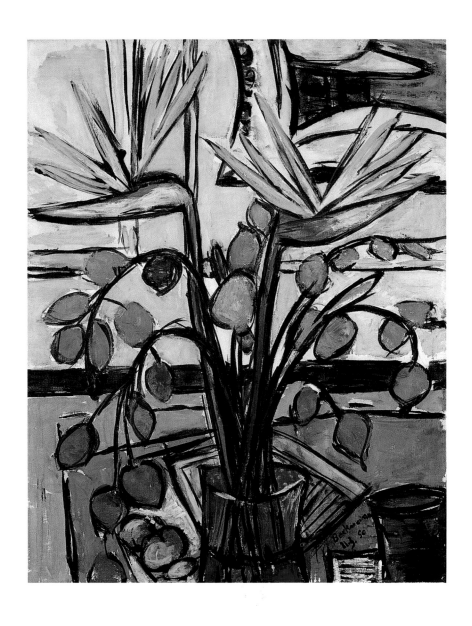

57 Max Beckmann, *Still Life with Birds of Paradise*, 1950

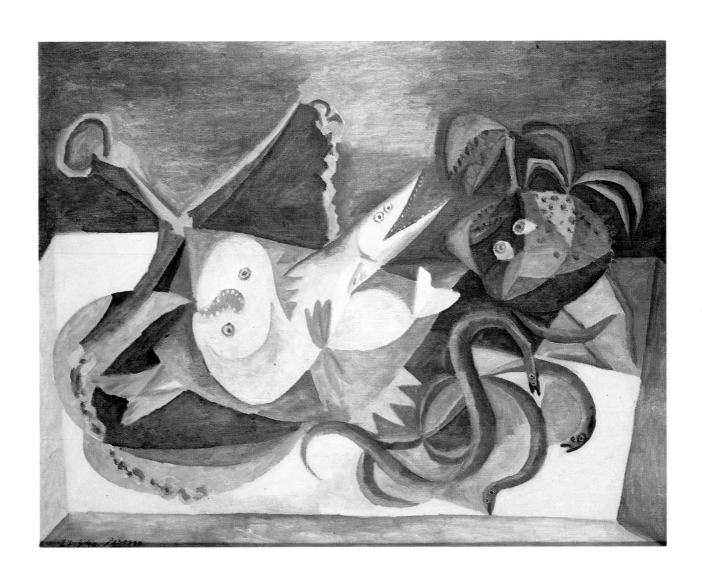

100 Pablo Picasso, *Still Life with Fish*, 1940

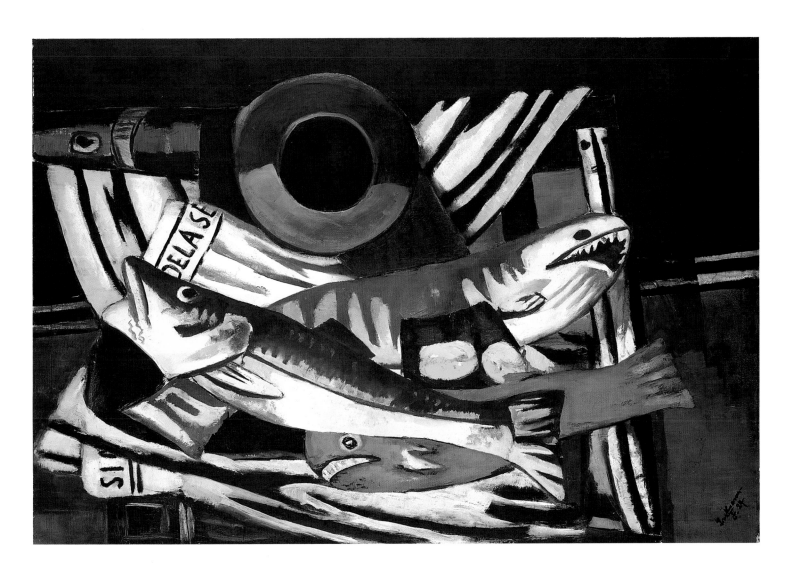

6 Max Beckmann, *Large Still Life with Fish*, 1927

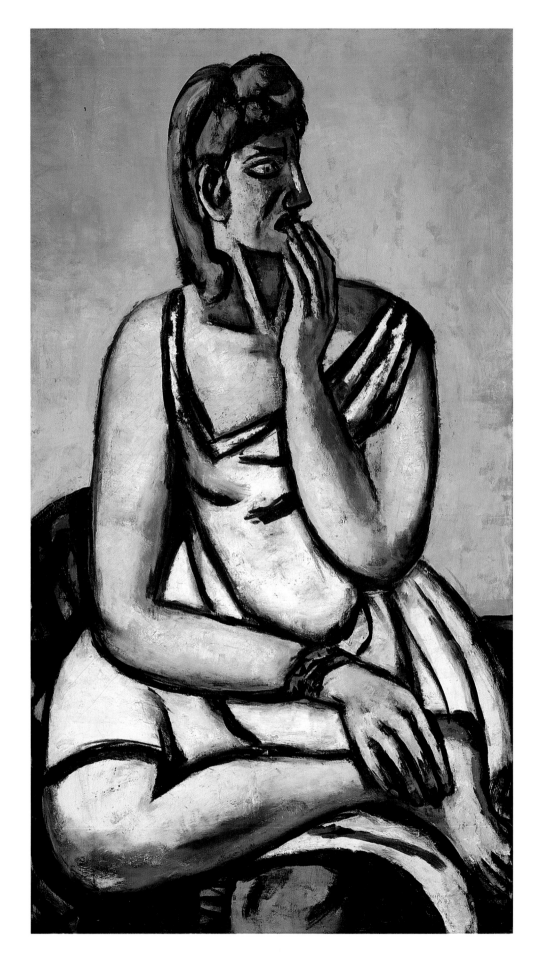

49 Max Beckmann, *The Frightened Woman*, 1947

Cornelia Homburg

Beckmann and Picasso

In his endeavor to become established on an international level, Max Beckmann was challenged considerably by the œuvre and renown of Pablo Picasso. Beckmann's reputation expanded and solidified in Germany during the 1920s, but an international presence on the scale of Picasso's remained elusive. As leading German dealers exhibited Picasso's art and influential German collectors acquired examples of his work, the international fame of the Spaniard and the enormous success of his dealers must have been a pointed incentive to Beckmann. He relentlessly pressured his own dealers to push for similar reception of his work abroad. Yet, it was specifically Beckmann's success in his native country and the fact that even during his lifetime he was regularly viewed as the "quintessential German" painter which contributed to the difficulties he encountered in his quest for international status.[1]

Beckmann, on the other hand, played a much less significant role for Picasso. It seems the two artists never met, not even during Beckmann's repeated and prolonged stays in Paris. While Picasso saw Beckmann's exhibition in Paris at the Galerie de la Renaissance and is known to have admired the German artist's work,[2] there is no indication that the Spaniard ever experienced the slightest sense of the artistic rivalry that motivated Beckmann.

Was Beckmann influenced by Picasso and, if so, is this influence demonstrated in his œuvre? Certainly. It seems that the influence was less rooted in Beckmann's artistic dependency on Picasso than it was channelled through the German's keen awareness of the success of the Spaniard and an urge to rise to the artistic challenge of his work. According to Stephan Lackner, Beckmann expressed the desire to see his paintings exhibited alongside those of Picasso: "If one could only once hang our pictures together so that the people could judge for themselves."[3]

Beckmann apparently studied Picasso's paintings carefully, and some of his works, including *The Frightened Woman* (cat. 49, p. 40), show undeniable stylistic relationships to compositions by Picasso. Critical analysis indicates, however, that many of the parallels between the works of the two artists derive more from shared approaches or interests than through a direct emulation. There are similarities in the ways that Beckmann's and Picasso's art reflected the world around them, the times they lived in, their modes of thinking, and especially the art they favored. Both looked to Cézanne and van Gogh, for example, as essential precursors of

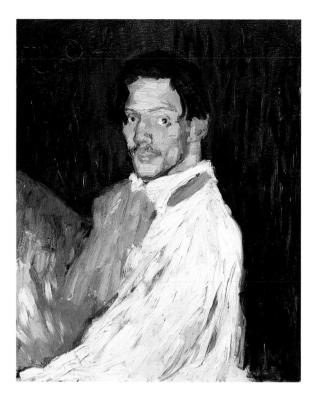

Fig. 9 Pablo Picasso, *Yo, Picasso*, 1901

their own endeavors. Further, their interests in particular themes or subjects followed parallel paths: Beckmann and Picasso were both fascinated by the circus and its performers, both artists regularly incorporated self-portraits into their compositions, and both possessed a distinct sense for dramatizing their own personae and for the projection of their creative qualities into their art.

Self-Portrait as Pose

Both Picasso and Beckmann were adept at positioning themselves advantageously to a potential audience. Each in his own way created works that fostered his image of himself as an artist. With his *Blue Self-Portrait* of 1901, for example, Picasso portrayed himself as the starving, self-sacrificing artist and dramatically emphasized the emaciated pallor of his face. In stark contrast to this is another self-portrait of the same year, *Yo, Picasso* (Fig. 9), which represents the artist as self-assured and direct, a characterization underlined by the strong, intensive palette and the bravura brushwork.[4]

Beckmann, too, presents himself in carefully selected poses in many of his self-portraits. He regularly portrayed himself as a man of the world, elegant, confident and socially successful. As early as 1907, while in Florence, he painted himself in a frontal pose, standing in a black suit with cigarette in hand. Twenty years later he created a self-portrait in which he repeated the same stance. In the later version, however, the impressionistic softness of the early work has disappeared in favor of a harsher, more confrontational presentation. Black and white coloration dominates the composition, the attitude borders on arrogance, and the

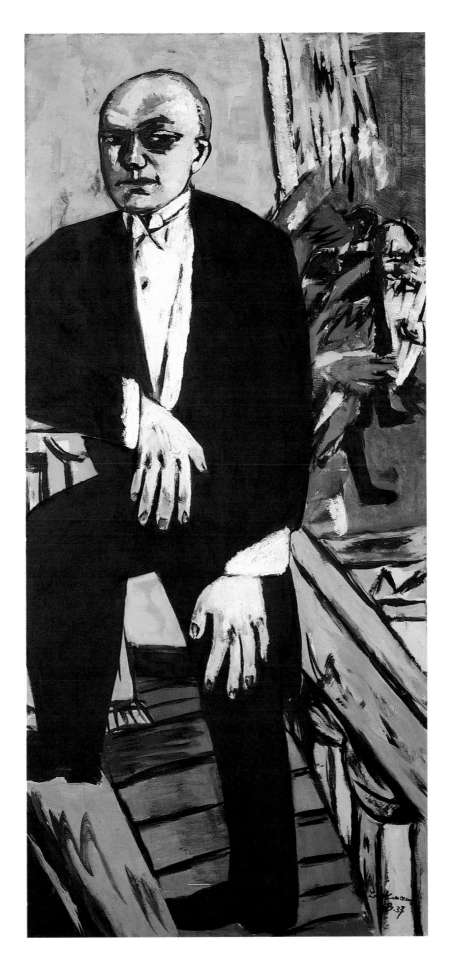

34 Max Beckmann, *Self-Portrait in Tails*, 1937

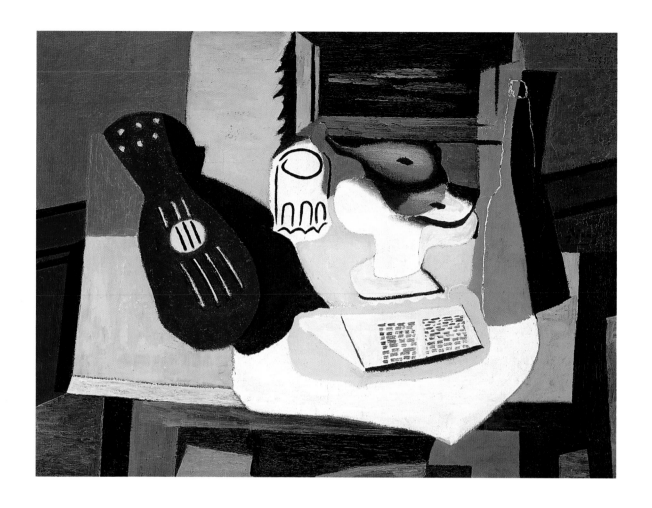

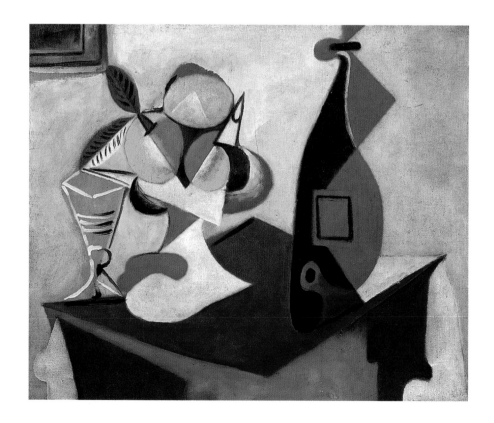

CORNELIA HOMBURG

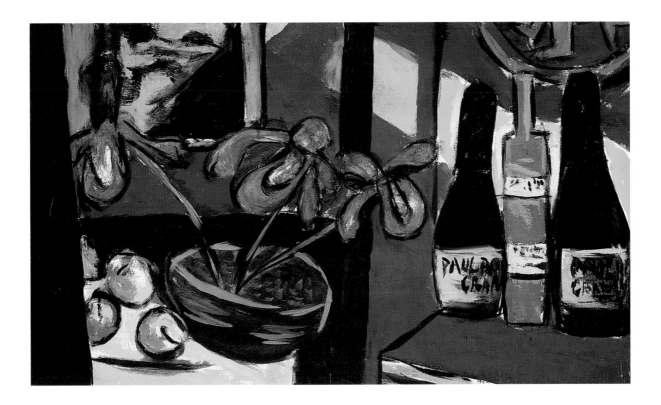

above: 31 Max Beckmann, *Still Life with Champagne Bottles and Orchids in Brown and Yellow*, 1934

top left: 94 Pablo Picasso, *Guitar, Glass and Fruit Bowl*, 1924

lower left: 99 Pablo Picasso, *Still Life with Lemon and Oranges*, 1936

facial expression is severe. Through these devices, Beckmann's deliberately constructed pose as a confident, successful artist preparing to enter international society is brought provocatively to the surface.[5]

The interest of both artists in studied poses is also evident in the genre of photographs. In Helga Fietz's photo of Beckmann in his Amsterdam studio in 1938, the viewer confronts the artist standing amidst his works. Almost all known photographs of Beckmann show him with earnest mien, a massive and imposing figure with the ever-present cigarette in hand. In the short private film footage shot by Beckmann with his wife Quappi, he also playfully assumed poses.[6] In 1915/16, Picasso did a series of photographs in which he placed himself in various guises. Dressed as an elegant gentleman or a humble worker, he is invariably positioned in front of his canvases in the studio, and his goal is always to define the role of the painter.[7]

By presenting themselves in such ways, both Beckmann and Picasso intended to establish their individual images as major artists and thereby engender greater success on the art market. Picasso was promoted early on by his dealer, D. H. Kahnweiler, who not only exclusively engineered the artist's career in France, but also established profitable connections with other galleries, especially in Germany. For example, the astute young dealers Thannhauser and Flechtheim became influential players in extending Picasso's fame beyond France.[8]

Correspondence from Beckmann to his dealer I. B. Neumann reveals the German artist's efforts to increase his value on the art market.[9] The letters show how the painter aspired to

above: 101 Pablo Picasso, *Still Life with Cherries,* 1943

top right: 102 Pablo Picasso, *Still Life with Lamp,* 1944

lower right: Fig. 8 Pablo Picasso, *Still Life with Candlestick,* 1937

create opportunities for exhibitions and sales not only through Neumann, but that he also maneuvered simultaneously for new contacts with other successful art dealers, above all in Paris.

Still Life

Not only are there similarities in strategies and modes of self-presentation between the artists, there are also opportunities for thematic comparisons between their work. Both painters created numerous still lifes. Beckmann and Picasso were tireless in their experimentation with new pictorial elements and inventive compositional arrangements. It seems as if both artists concentrated on still lifes whenever they were not engaged in projects for large-scale compositions or portraits. Frequently, the still lifes were exercises of a more private nature, although they sometimes developed into more ambitious works.

Both painters showed strong interest in a complex interlocking of pictorial elements within the compositional structure. In the still lifes, individual objects are not only placed in relation to each other, but also contribute to the definition of the surface and background planes of a work. Color serves to identify objects and also fulfills the key function of con-

CORNELIA HOMBURG

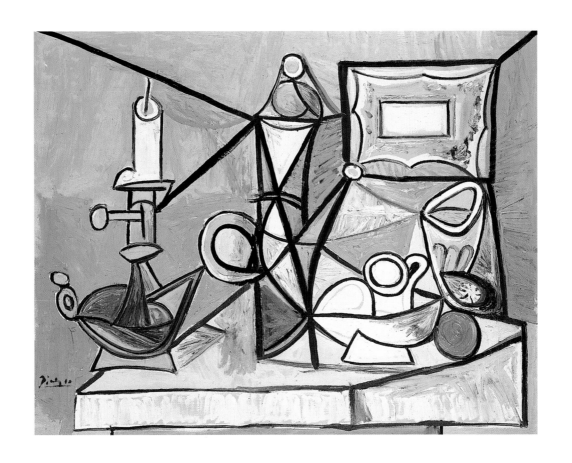

BECKMANN AND PICASSO

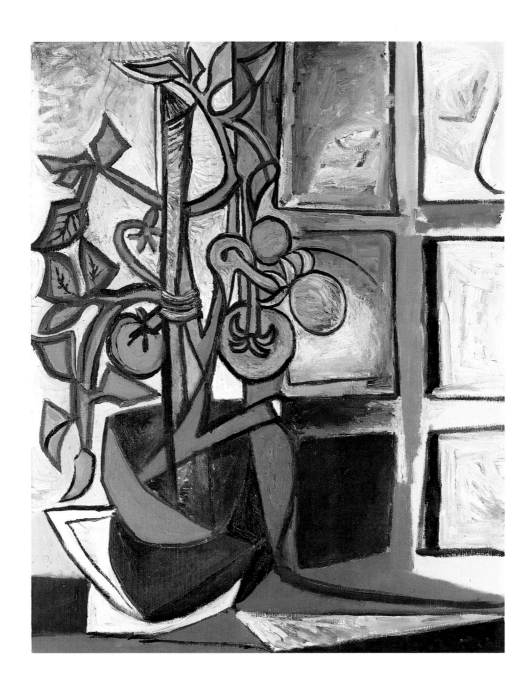

103 Pablo Picasso, *Tomato Plant*, 1944

CORNELIA HOMBURG

55 Max Beckmann, *Large Still Life, Blue Interior*, 1949

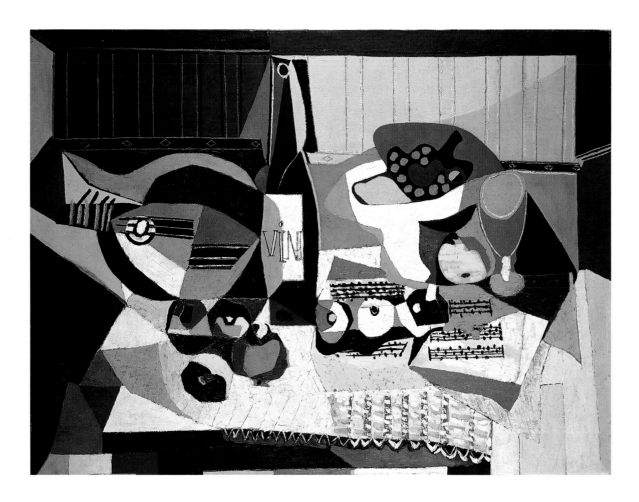

96 Pablo Picasso, *The Bottle of Wine*, 1925/26

necting the various elements of the composition into a whole. This is exemplified in works such as Beckmann's *Orchestra* (cat. 29, p. 128) or Picasso's *Guitar, Glass and Fruit Bowl* (cat. 94, p. 44). Both Beckmann and Picasso were – like other artists of their time – interested in a combination of objects and architectonic structure. Often, they translated this into pictorial terms by placing a still-life subject in close proximity to a window or a door. Their primary intention was to achieve an interweaving of structures, rather than to underscore any symbolic content of the motifs between the interior and exterior worlds. Beckmann's *Studio with Table and Glasses* (cat. 23, p. 120), or works such as Picasso's *Tomato Plant* (cat. 103, p. 48) and Beckmann's *Large Still Life, Blue Interior* (cat. 55, p. 49) emphasize geometric forms which are linked to traditional elements of still lifes.

A return to universal themes is evident, for example, in Beckmann's *Large Still Life with Fish* (cat. 6, p. 39), in which an image full of dynamic vigor and expressiveness is achieved through the color and forms of the powerful, curved bodies of the fishes. Beckmann, who in the best French tradition incorporated a newspaper into his composition, exhibited this painting prominently in his Paris exhibition of 1931. Picasso undoubtedly saw it during his visit to the show. In 1940, Picasso painted *Still Life with Fish* (cat. 100, p. 38), which was inspired by a memory of the market in Royan.[10] Despite the fact that Picasso's piece is less

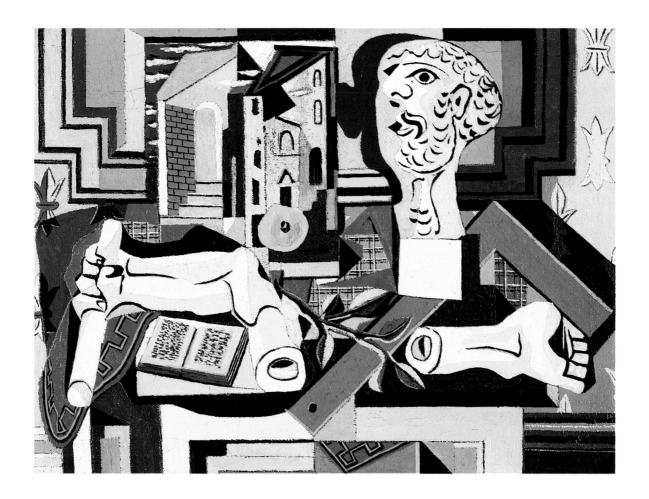

95 Pablo Picasso, *Studio with Plaster Head,* 1925

forceful than Beckmann's, the strong emphasis on compositional movement is comparable.
Even the gaping jaws of the sea creatures are similar in the two paintings. In both works,
fusion of the depicted objects with the background was attained through repetition of
coloration and formal language.

Both artists also produced still lifes as powerful, large-scale compositions. Picasso's *Studio
with Plaster Head* (cat. 95) or his *Mandolin with Guitar* exemplify firm interweaving of object
and space. These works can be juxtaposed with Beckmann's *Still Life with Cello and Bass*
(cat. 56, p. 96) or *Large Still Life with Musical Instruments* (Fig. 2, p. 25). Picasso's composi-
tions exhibit a higher degree of abstraction and a stronger stress on form, while Beckmann's
works have a more narrative quality, albeit without sacrificing unity for the sake of details.

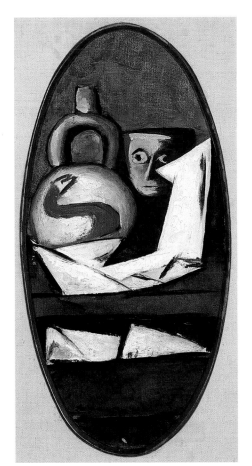

25 Max Beckmann, *Still Life with Mexican Figure*, 1931

Circus

Beckmann and Picasso were both fascinated by the circus, particularly by the performances of clowns and acrobats. Both enjoyed cabarets and music halls and had a penchant for costumes and masks. All aspects of the theatrical caught their imagination, both in their personal experience as well as in their artistic œuvre. This fascination is something they shared with a long line of precursors, for the portrayal of acrobats, clowns and fools has a long tradition.[11]

The Commedia dell'arte can be traced back to its origins in Italy in the sixteenth century. Its harlequin figure is the paradigmatic acrobat or clown. In the eighteenth century, French painters such as Antoine Watteau and Nicolas Lancret repeatedly painted figures and scenes from the Commedia dell'arte. It was also a popular source of motifs in the decorative arts, including the elegantly painted porcelain figures by Johann Joachim Kändler for the Meissen manufactory. While these early portrayals reflected the courtly settings of the rococo age, later artists, especially in the nineteenth century, were more interested in the social circumstance of these itinerant comedians. Honoré Daumier was one of the artists who depicted the harsh reality of everyday life for acrobats and entertainers: people constantly on the move, living on the margins of society, they carried their makeshift stages in the form of a carpet or a bench as they travelled from place to place. In the later nineteenth century, the situation of

CORNELIA HOMBURG

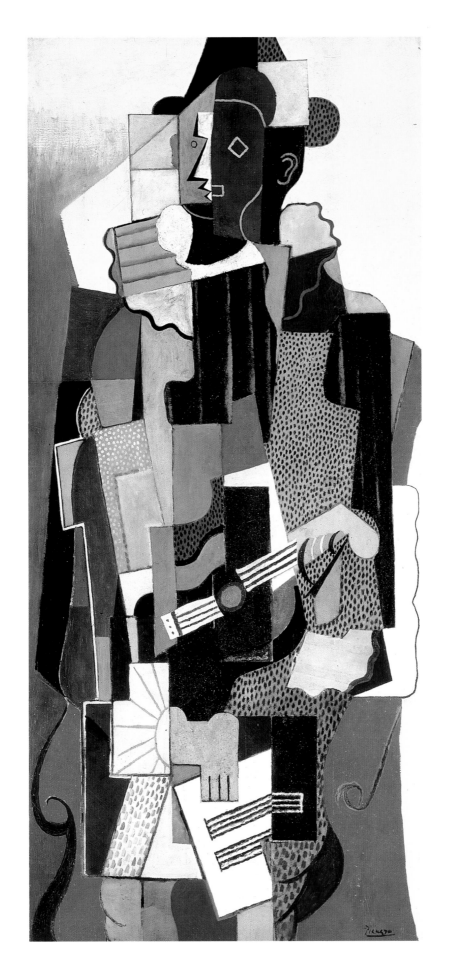

90 Pablo Picasso, *Harlequin*, 1918

these performers was often thematized in subjects of entertainment with social undertones. Artists such as Edgar Degas, Edouard Manet, or Georges Seurat were fascinated by this milieu, treating it in numerous drawings and paintings. Toulouse-Lautrec's many depictions of circus life are famous, and even Paul Cézanne painted a large harlequin in the late 1880s. In the early twentieth century, German expressionist artists were also drawn to the circus. Ernst Ludwig Kirchner painted a series based on circus themes, including the *Circus Rider* of 1914, which is in the Saint Louis Art Museum. In France, it was above all Rouault, an artist greatly admired by both Beckmann and Picasso, who turned again and again to the theme of the clown. Rouault generally depicted the clown as a tragic or melancholy figure (see cat. 104, p. 108; cat. 106, p. 109; cat. 107, p. 111).

The circus appealed enormously to Picasso. According to Fernande Olivier, Picasso enjoyed neither theater nor the symphony; only popular festivals and carnivals interested him in France.[12] The famous Cirque Médrano was one of his favorites and Picasso frequented it for many years, sometimes even several times in the course of a single week. Beckmann also liked to attend the circus, and he visited the Médrano when he was in Paris.

Although Beckmann adopted circus themes early in his artistic career, it was only after the first world war that acrobats and clowns became frequent elements in his work. Not only the circus, but also carnivals and *Fastnacht* provided sources of inspiration for him. He loved attending masked balls and masquerades, indulging gladly in the art of mask and disguise.

Neither Picasso nor Beckmann treated the figure of the performer or acrobat in terms of enjoyable entertainment. Nor were they interested in achieving a precise description of the figures. Instead, both artists approached such characters and their qualities in order to make a pictiorial commentary on the more complex aspects of human life and the social condition.

Picasso's early images of harlequins and acrobats reflect a life of hardship, fraught with hunger and privation. The emaciated bodies and suffering faces in the paintings of Picasso's Blue period present these people as tragic figures on the outskirts of society. Such an interpretation is further underlined by the fact that Picasso depicts the figures not only during their performances, but also in scenes from their daily lives. Beckmann, too, often employed circus figures to convey his reflections on political and social developments. The apparently entertaining and seemingly light-hearted world of the stage or circus provided him a vehicle for subtle commentary, layering a playful facade with incisive content.

The art historical literature on Beckmann has noted that the clowns and harlequins painted by Beckmann are related to similar figures in works from Picasso's Blue and Rose periods.[13] The *Portrait of N. M. Zeretelli* in harlequin costume, 1927 (cat.7, p. 55), is the most frequently cited example for such comparison. Apart from the similarity of motif, however, there is little basis for such interpretative or stylistic comparisons. The Saltimbanques, from Picasso's Blue and Rose periods, are mostly figures that convey an impression of weakness and vulnerability; their thin bodies expose an acrobatic suppleness but they also reveal the precariousness of their survival. These portrayals by Picasso are strongly contrasted with Beckmann's powerful portraits of a Zeretelli or a Columbine (cat. 59, p. 57).

On the other hand, Beckmann's representations of circus figures from the mid-20s can certainly be compared with Picasso's harlequins and masked musicians from 1917/18

7 Max Beckmann, *Portrait of N.M. Zeretelli*, 1927

BECKMANN AND PICASSO

41 Max Beckmann, *Acrobat on the Trapeze*, 1940

CORNELIA HOMBURG

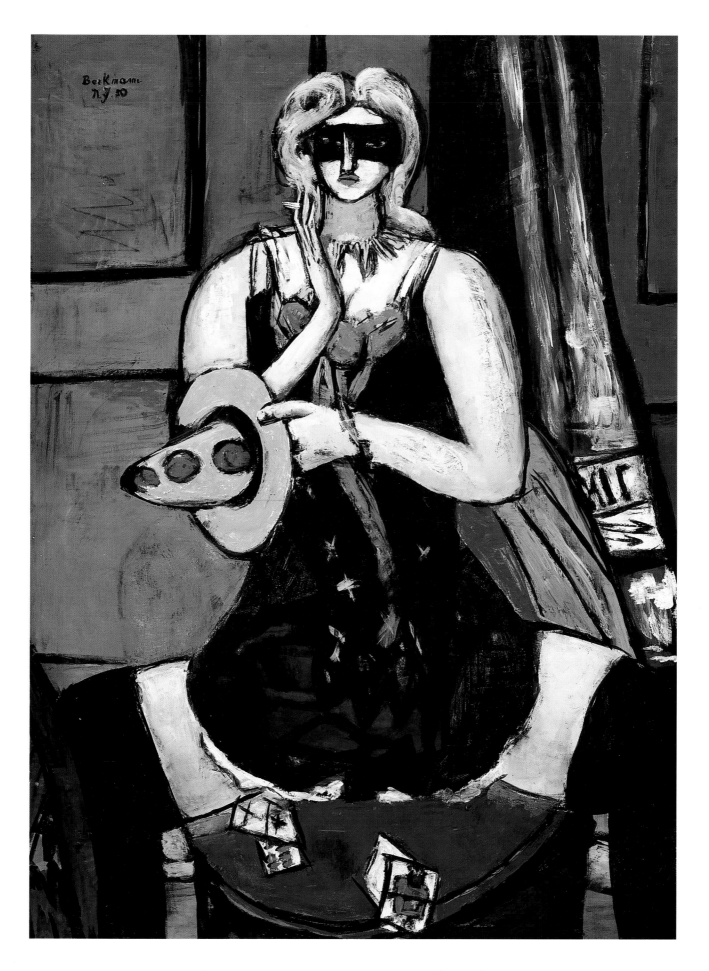

59 Max Beckmann, *Carnival Mask, Green, Violet and Pink (Columbine)*, 1950

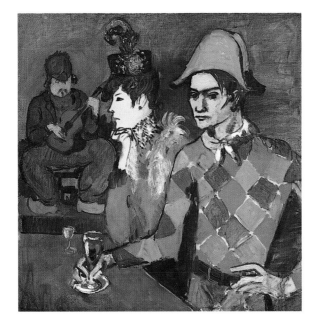

Fig. 10 Pablo Picasso, *At the Lapin Agile,* 1905

onwards[14]. This is apparent, for example, in a comparison of Beckmann's *Zeretelli* with Picasso's *Harlequin* of 1918. (cat. 90, p. 53). Though the works differ stylistically, there are remarkable similarities in pose and approach. In both compositions, the palette is restricted to black, white, and only two additional prominent colors: in the case of Beckmann's *Zeretelli* these are blue and mauve; for Picasso's *Harlequin* they are blue and red. Both figures sit with an air of confidence and composure as actors confronting the spectator. Beckmann may have seen Picasso's painting in the collection of the German industrialist Gottlieb Friedrich Reber. Reber, a major collector, possessed a number of important works by Picasso, Braque, and other French artists, but had his portrait painted by Beckmann.

Zeretelli is a powerfully expressive example of Beckmann's artistic rivalry with Picasso. The cubist style for which Picasso was becoming famous made little impression on Beckmann. While the sharp-edged angularity of *Zeretelli* is vaguely reminiscent of the formal language of Cubism, the portrait is a clear and distinctive reply to Picasso's harlequins. Beckmann takes up the theme important to both painters, yet treats it in an independent manner that avoids stylistic dependence.

Representation of the Self

There is a notable tendency in the œuvre of both artists to employ the figure of an actor or performer in order to portray personal situations on canvas or paper. Theodore Reff has shown that many of Picasso's early circus scenes actually contain portraits of the artist himself, often in the guise of harlequin.[15] Thus Picasso could convey individual aspects within the painting or outline his own position.[16] In so doing, he sought to define his identity as an artist; he could take himself beyond the framework of the everyday and align himself with the role of the outsider which he considered to be the lot shared by artists and performers.[17]

Picasso took on the guise of harlequin for the first time in *At the Lapin Agile* of 1905 (Fig. 10, p. 58). He sits at a bar with a woman who stares ahead with an expression of boredom on her face. The typical nature of the bar scene is underlined by the caricature of a musician in the background. The subject matter and attitude of the protagonists can be traced to similar examples in the art of Degas and Toulouse-Lautrec. Picasso deliberately places his work within a specific tradition while simultaneously portraying himself as creator and participant in the scene. The colorful shirt of the harlequin, with its recognizable diamond-shaped geometric patterning, identifies the painter; simultaneously he is an actor in the drama he creates, yet remains set apart by his own attitude.

A later example is the *Harlequin with Violin*, 1918 (Cleveland Museum of Art). The figure holds a musical score bearing the words "si tu veux." Here, too, Picasso has taken on the role of harlequin. The text, "if you want," is probably a reference to his forthcoming marriage to the Russian dancer Olga Kokhlova. In this respect, the painting symbolizes the change in Picasso's personal situation, bringing with it a more stable and traditional lifestyle, made possible in part by his increasing fame and improved financial circumstances.[18]

This projection of the self into the guise of another character can also be found in Beckmann's work. He often used disguises in paintings which are clearly self-portraits. One example is the 1921 *Self-Portrait as Clown* (Fig. 1), which shows the artist dressed in harlequin collar surrounded by various carnival props such as a trumpet and a mask. The meditative mood of the picture suggests that the artist saw himself not so much as a participant in the tumult of the carnival but as a distanced, self-contained observer.[19]

Beckmann took on the persona of a king in a number of compositions. One important example is *The King* (cat. 36, p. 110). Beckmann reworked an early version, painted in 1933, completing it finally in 1937. The composition presents the artist in the figure of a king, sitting with feet planted squarely and leaning on a sword. His young wife Mathilde von Kaulbach, known as Quappi, can be recognized on the left side of the composition, and there is a veiled female figure in the background. The painting has been convincingly interpreted as a reaction to the impending threat of National Socialism in Germany.[20]

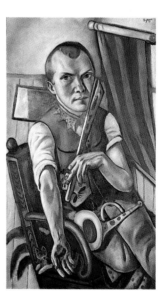

Fig. 1 Max Beckmann, *Self-Portrait as Clown*, 1921

Reff has pointed out that Picasso may well have known the play *König Harlekin* (King Harlequin) by Rudolph Lothar. It was performed in Paris in 1902/03 and published in French in 1903. In the play, Harlequin calls out, "Who am I? Sometimes I believe I am a King – so exalted do I feel. Sometimes I think I am a miserable beggar, an outcast. ... Life is not what we have been, or what we are, but what we feel. My life is a search after the forms that express my feelings – it is pouring my soul daily into new moulds – it is being daily a different man. That is my life – that is my art. I am a creator."[21] Reff has argued that Picasso's understanding and use of the harlequin figure is reflected in this ambivalent relationship to reality and illusion. On the one hand, it indicates the ambivalence in life itself, while on the other hand, it points to the position of art, which needs reality in order to create illusion.

Beckmann may also have known this play since it was published in Germany around 1900. His use of the harlequin image as well as the king figure (who appears more like an actor than a real ruler) suggests that Beckmann held an attitude similar to that of Picasso. The artist takes on the persona of an actor playing the clown or ruler, and as such confronts the problems of life with feelings of exaltation or despair, depending on the situation. In the end, he has his fate only so far in hand that he is able to act on the stage of life. Beckmann's *King*, which the painter completed during a period of political turmoil, is derived from and exemplifies this context. Another example, Beckmann's *Actors* triptych (Fogg Art Museum, Cambridge, G 604), is also a powerful adaptation of the theme of the king. The identification of the harlequin with creative qualities in Lothar's play also supports Beckmann's self-definition as an artist.

Painter and Model

Kirk Varnedoe has shown that Picasso projected himself into many of his paintings and frequently worked his emotions and associations into the painted figures.[22] In addition to harlequins and acrobats, he portrayed himself in compositions on the theme of painter

18 Max Beckmann, *Small Female Nude (Pink and Brown)*, 1930

97 Pablo Picasso, *Reclining Woman*, 1932

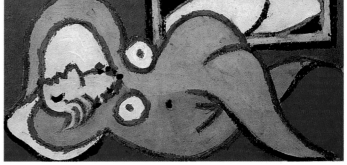

28 Max Beckmann, *Siesta*, 1924/31

and model. The physiognomy is rarely recognizable, yet his understanding of his personal position *vis à vis* his models, who were often the women he loved, is an integral aspect of the content of the paintings. The relationships between object and subject, between model and painter – who is also observer and creator of the image – is evident in these compositions.

In *Siesta* (cat. 28), Beckmann positions himself at the feet of a reclining semi-nude female. The title of the painting suggests the hour of rest during the hottest time of day, as the outside air seems to flow into the room through the open window, or perhaps it indicates the calm repose that follows tempestuous lovemaking. Musical instruments and scores may be references to Beckmann's future wife, Quappi, a trained singer with a fine voice who loved to sing. In this respect, the painting suggests the intimate relationship of the painter to Quappi, to whom it is dedicated.

The placement of the figures within the compositional space and the relationship between man and woman in *Siesta* have parallels in Picasso's portrayals of painter and model, where the female image is not only the model, but also counterpart and muse. While Picasso may have had more varied and complicated relationships with women than Beckmann, both artists turned to women equally as models and as sources of inspiration and support for their work. This is also reflected in the many portraits that both artists painted of their respective lovers. These range from cabaret and music hall scenes in which Beckmann integrated his wife Quappi as model (cat. 33, p. 144) to ambitious interpretations of works by Delacroix in which Picasso included his mistresses.

A series of compositions in which the artists presented women in contemplative introspection deserve special attention. They show that Beckmann was especially challenged by Picasso's classical phase. Indeed, Beckmann's *Portrait of Minna Beckmann-Tube* of 1924 (cat. 1, p. 62) can be read as a reply to Picasso's *Portrait of Olga* (Fig. 7, p. 63).

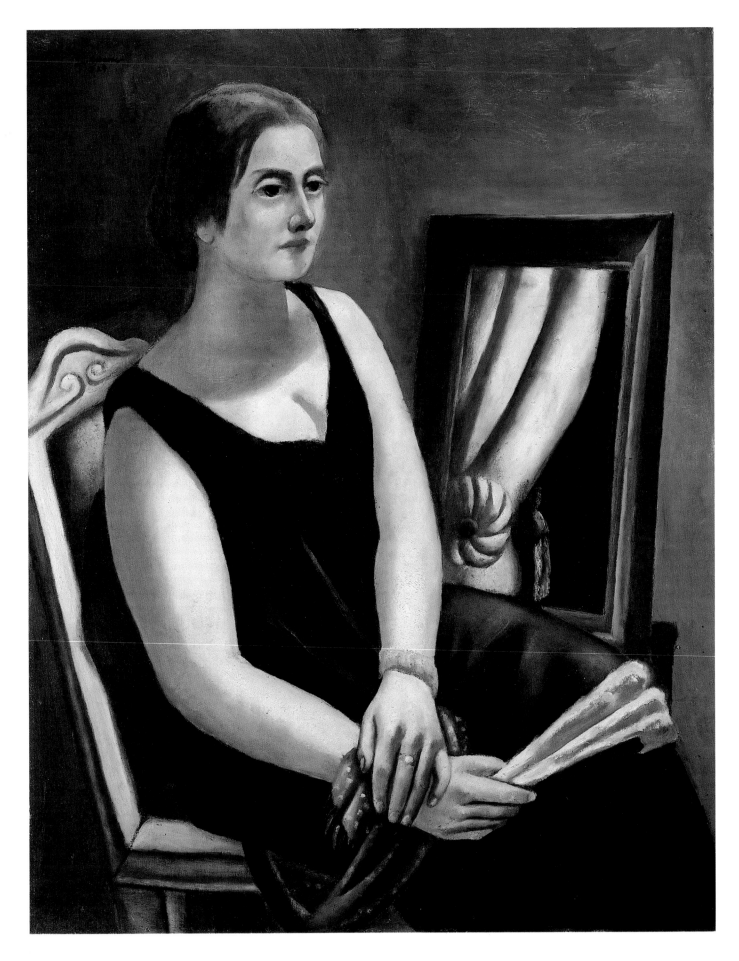

1 Max Beckmann, *Portrait of Minna Beckmann-Tube*, 1924

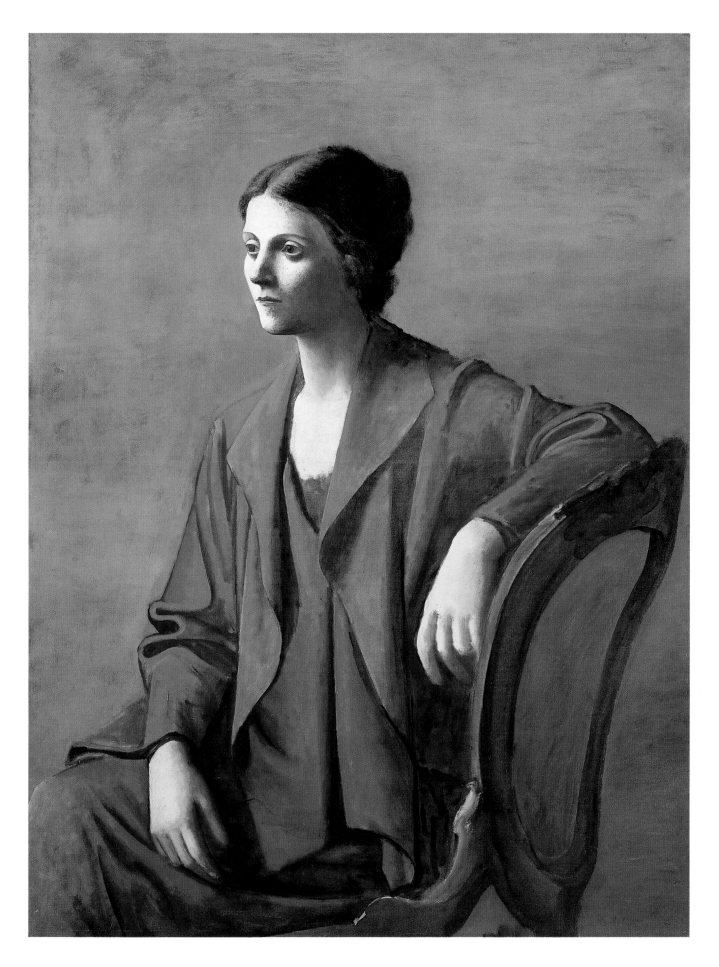

Fig. 7 Pablo Picasso, *Portrait of Olga*, 1923

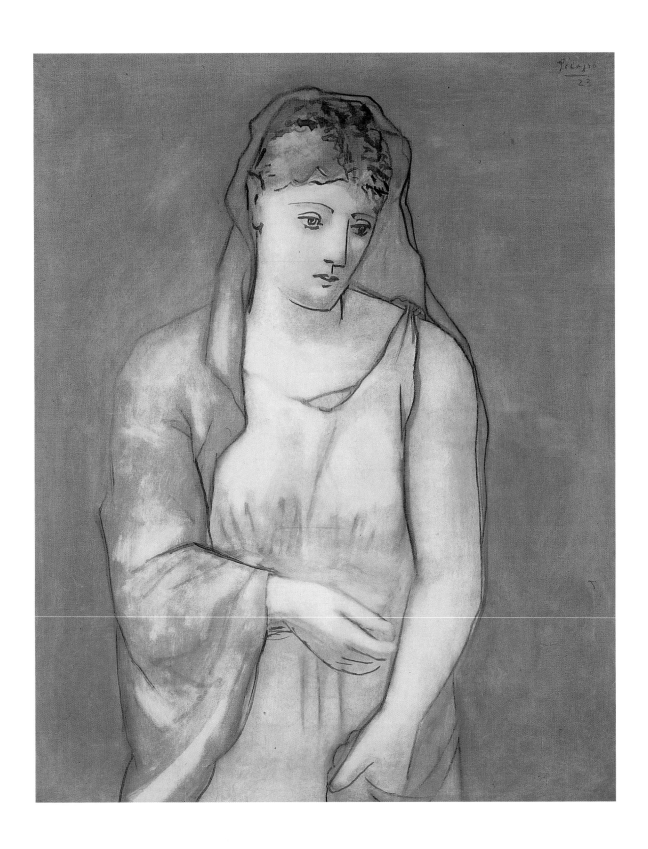

93 Pablo Picasso, *Woman with Blue Veil*, 1923

CORNELIA HOMBURG

21 Max Beckmann, *Portrait of Minna Beckmann-Tube*, 1930

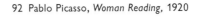
92 Pablo Picasso, *Woman Reading*, 1920

It is interesting that Beckmann chose to paint his first wife Minna when he wanted to create a counterpart to Picasso's impressive portraits. In 1930, long after he was married to his second wife, Beckmann again painted a large portrait of Minna. In this work, he chose an introverted, contemplative attitude in which the figure pauses while reading a French journal and is lost in thought. (cat. 21, p. 65). Picasso's monumental painting, *The Reader,* lends itself to comparison here (cat. 91, p. 67). Although Beckmann's work is more colorful than Picasso's version, which is dominated by gray tones, both painters similarly emphasize an introverted and thoughtful attitude in the female figures.

Beckmann's paintings of Quappi are often distinguished by brighter colors which can be traced to Matisse's palette. They demonstrate the elegance and *joie de vivre* that the artist so loved in his young wife. Comparable to these representations of Minna and Quappi as two differentiated female types are the contrasting approaches used by Picasso in his paintings of Olga and Dora Maar.[23]

In summary, how can we characterize the relationship between Beckmann and Picasso?

Picasso's œuvre and his fame posed a special challenge which, from the mid-20s, the German artist was able to meet with inventiveness and self-assurance. Beckmann considered his own art a worthy alternative to Picasso's achievements. When, towards the end of his life, his *Departure* triptych was installed across from Picasso's *Guernica* at the Museum of Modern Art in New York, it may well have affirmed for Beckmann the appropriate comparison of both artists' work. It provided the German painter with a sense of having finally arrived at a satisfying conclusion to his rivalry with Picasso.

(Translation: Ishbel Flett)

CORNELIA HOMBURG

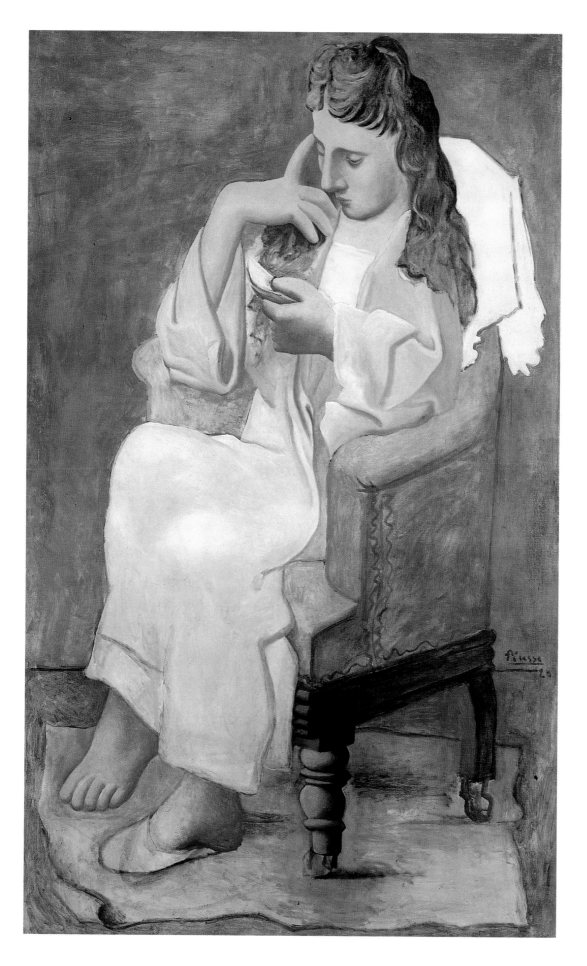

91 Pablo Picasso, *The Reader*, 1920

1 Michael Schwarz has correctly noted that the political climate following the first world war was hardly helpful either. The author cites a number of influential critics who saw Beckmann as a typically German painter. See Birgit and Michael V. Schwarz, *Dix und Beckmann, Stil als Option und Schicksal*, Mainz 1996, p. 24.

2 A visit with Vollard is recorded, during which he is said to have commented, "il est très fort."

3 Stephan Lackner, *Max Beckmann: Memories of a Friendship*, Coral Gables 1969, p. 71.

4 For a comparison of both paintings, see, for example, Kirk Varnedoe, "Picasso's Self-Portraits," in *Picasso and Portraiture: Representation and Transformation*, edited by William Rubin, New York 1996, pp. 124 ff.

5 This portrait is often seen in connection with Beckmann's essay, *Die Rolle des Künstlers im Staat* (The Role of the Artist in the State). See, for example, *Max Beckmann Retrospective*, St. Louis 1984, cat. no. 53, p. 39.

6 These films have only recently come to light.

7 Varnedoe (see note 4). For further information on Picasso's photography, see, Anne Baldassari, *Le Miroir noir: Picasso, sources photographiques 1900–1928*, Paris 1997.

8 John Richardson, *A Life of Picasso*, Vol. 2, 1907–17, New York 1996, chapter 20.

9 For further information on I. B. Neumann, see "Beckmann in Paris A to Z" in this publication, pp. 224f.

10 See Jean Sutherland Boggs, *Picasso & Things* (ex. cat.), The Cleveland Museum of Art, Cleveland 1992.

11 For a survey, see E. A. Carmean, Jr., *Picasso: The Saltimbanques*, Washington, D. C. 1980, pp. 57–58.

12 Fernande Olivier, *Picasso and His Friends*, London 1933, p. 126.

13 *Max Beckmann Retrospective*, (ex. cat.), St. Louis 1984 p. 238; and Karin V. Maur, *Max Beckmann: Meisterwerke 1907–1950* (ex. cat.), Staatsgalerie Stuttgart 1994, p. 94.

14 See the brief reference in *Max Beckmann Retrospective*, (ex. cat.), St. Louis 1984, p. 238.

15 Theodore Reff, "Harlequins, Saltimbanques, Clowns and Fools" *Artforum* 10 (October 1971): 30–43; see also, Reff, "Picasso's Three Musicians: Maskers, Artists & Friends," in *Art in America* 68 (December 1980): 124–142.

16 See, for example, the watercolor *Meditation*, 1904, Museum of Modern Art, in which Picasso portrays himself observing a sleeping woman. This watercolor refers to his connection to Fernande Olivier.

17 Reff, *Artforum* (see note 15), p. 36.

18 Carmean, (see note 11), pp. 18 ff.

19 See also, Friedhelm W. Fischer, *Max Beckmann*, London 1972, pp. 29 ff.

20 Fischer, (see note 19), p. 132 ff., and *Max Beckmann Retrospective*, (ex. cat.), St. Louis 1984, p. 264.

21 Rudolph Lothar, *König Harlekin*, Leipzig and Berlin 1900, translated in Reff, *Artforum* (see note 15), p. 40.

22 Varnedoe, (see note 4).

23 See Rubin, *Picasso and Portraiture*, (see note 4).

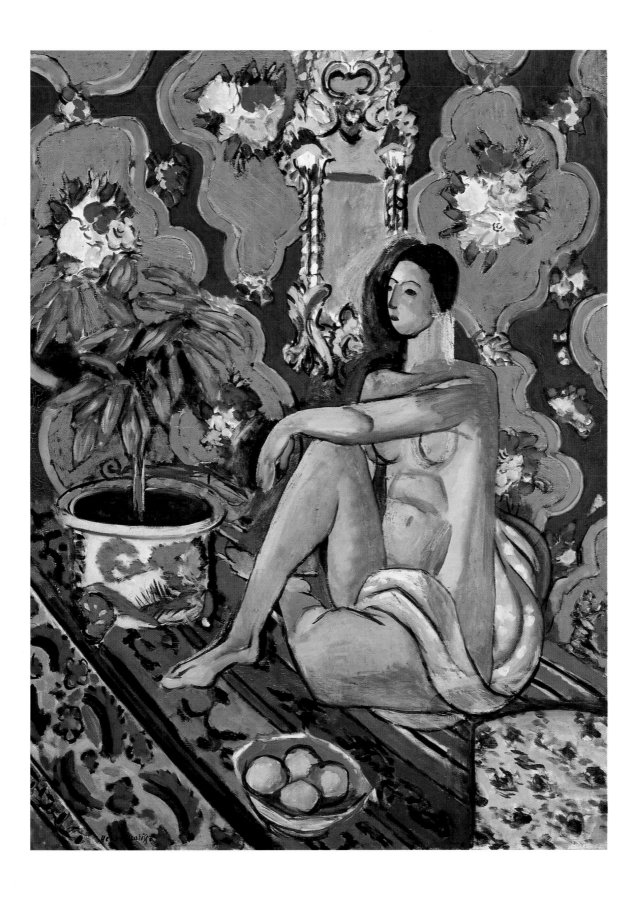

84 Henri Matisse, *Decorative Figure on an Ornamental Background*, 1925/26

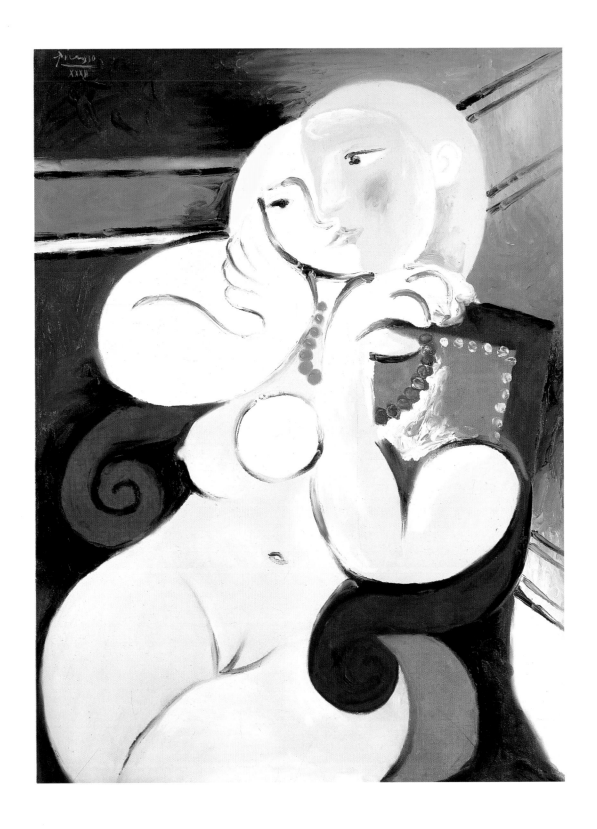

98 Pablo Picasso, *Nude in a Red Armchair*, 1932

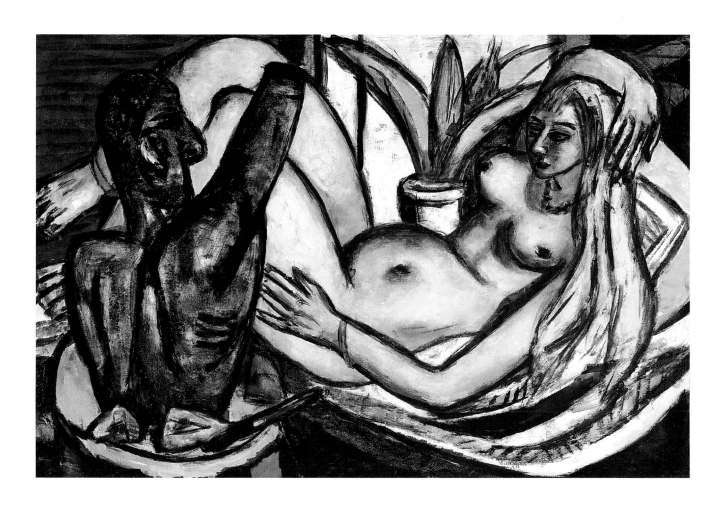

47 Max Beckmann, *Studio (Olympia)*, 1946

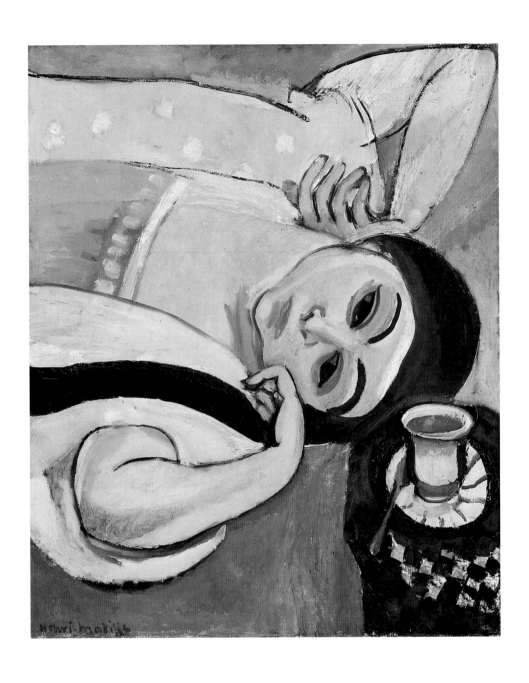

80 Henri Matisse, *Laurette with Coffee Cup*, 1917

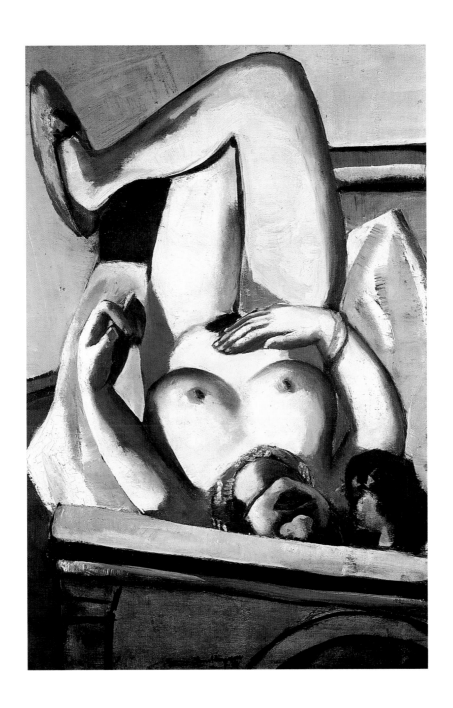

4 Max Beckmann, *Female Nude with Dog*, 1927

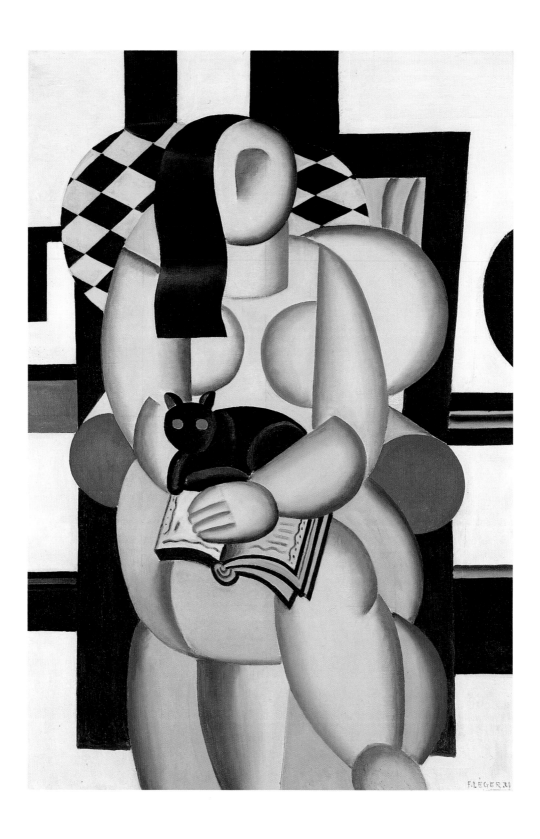

74 Fernand Léger, *Woman with a Cat*, 1921

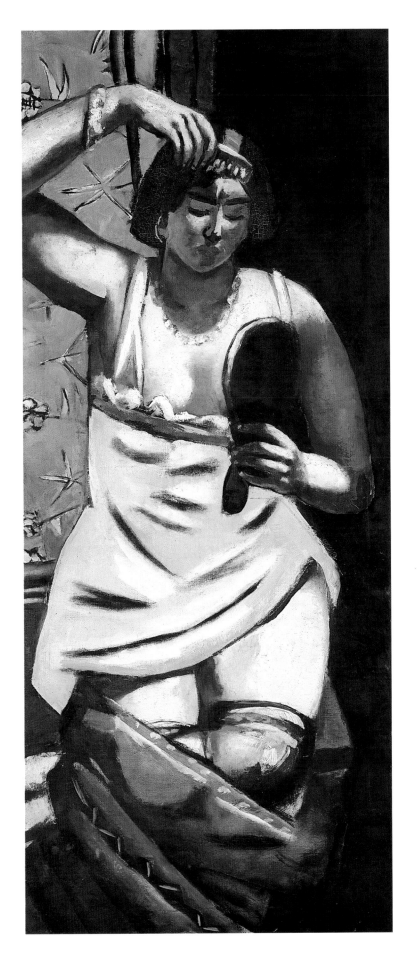

10 Max Beckmann, *Gypsy (Nude with Mirror)*, 1928

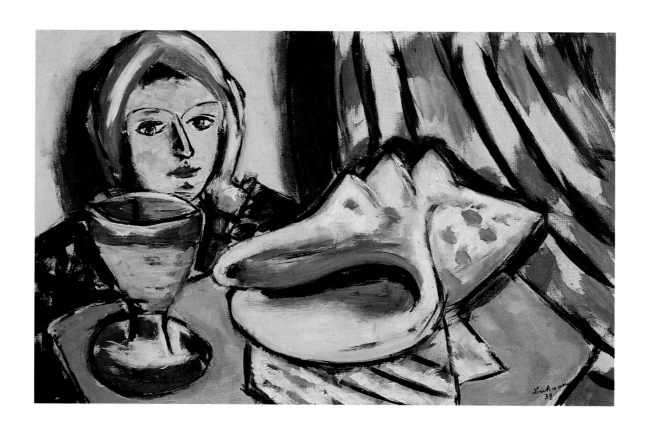

40 Max Beckmann, *Woman with Large Shell and Wine Glass,* 1939

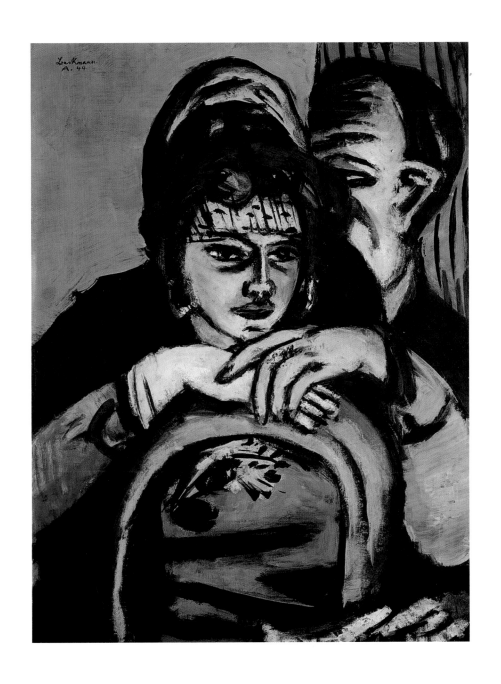

46 Max Beckmann, *Loge II*, 1944

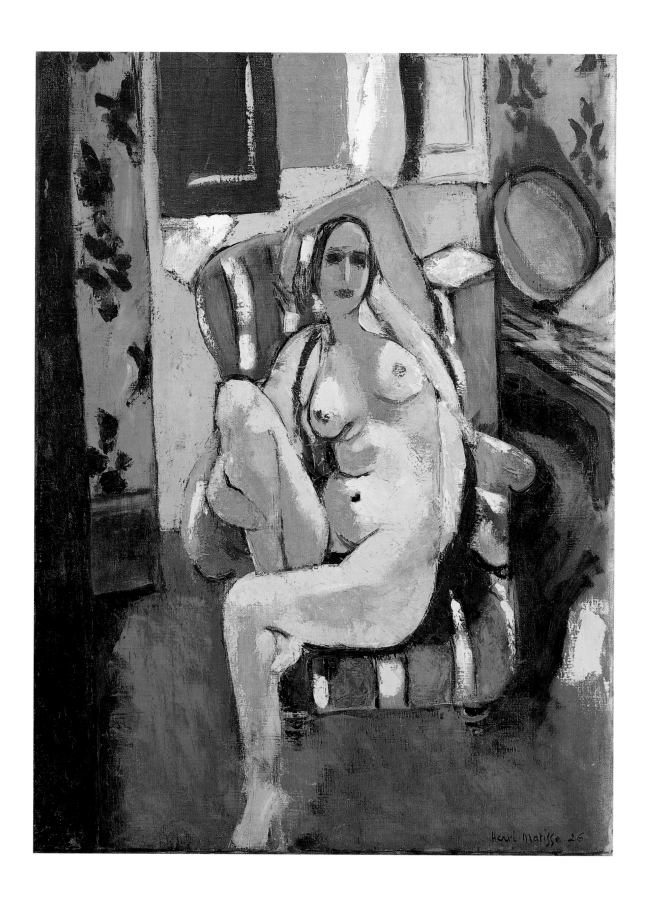

85 Henri Matisse, *Odalisque with Tambourine*, 1926

Carla Schulz-Hoffmann

Beckmann, Matisse and Léger

"My paintings are a kind of medicine through inurement and delight. They really are somewhat heroic. They are not a sedative but a tonic. You should not use my art like an easy chair, but like a breath of fresh air."[1]
(Max Beckmann)

In May 1950, the year of his death, Max Beckmann painted his *Woman with Mandolin in Yellow and Red* (cat. 58, p. 81). It is a masterly synthesis of pure, sensual painting and expressive intensity that superbly sums up his stance on the central tenets of the French avant-garde. Matisse and Léger represent the two extremes of the artistic range that informed Beckmann's response to contemporary art. The compositional harmony of Matisse's late period and Léger's distinctive cubist bodies are both echoed in a visual syntax that, for all that, loses nothing of its own inimitable identity. This simultaneous sense of proximity and distance becomes particularly evident when we consider two thematically and structurally comparable works, Matisse's *Odalisque with Red Trousers* (cat. 82, p. 82), and Léger's *The Red Bodice* (cat. 76, p. 83). Each of these vibrantly colored horizontal compositions centers on a reclining semi-nude woman. The figure dominates the situation in all three paintings and determines the composition in a predominantly planar setting. In terms of atmosphere and mood, however, the three works are very different indeed.

Beckmann's "Leda"[2] is charged with sensual presence and controlled tension in equal measure, Matisse's Odalisque is thoroughly relaxed and self-assured, while Léger's reclining women exude an air of cool detachment in spite of the undeniable physicality of their presence. These are the tendencies inherent in Fauvism and Cubism, honed to perfection in the œuvres of Matisse and Léger, that Beckmann applied under very different premises. There is something almost casual in the way he takes up Léger's variation on the cubist formal syntax. It serves as a useful vehicle by which to enhance and sharpen his definition of pictorial space, without ever becoming an issue in itself. Consider, for instance, the formal discrepancy between the powerfully voluminous body forms and the planarity of the setting, or the visual impact of broad swathes of contrasting colors accentuated by black outlines. Such general structural characteristics probably made Léger's works so interesting to Beckmann and can be found in the latter's work as well (compare, for example, cat. 32, p. 95). Léger is one of many modernist innovators whose works Beckmann repeatedly saw at galleries and exhibitions, and whose stylistic vocabulary he used whenever it suited his own purposes, without necessarily occupying himself with it in the long term.

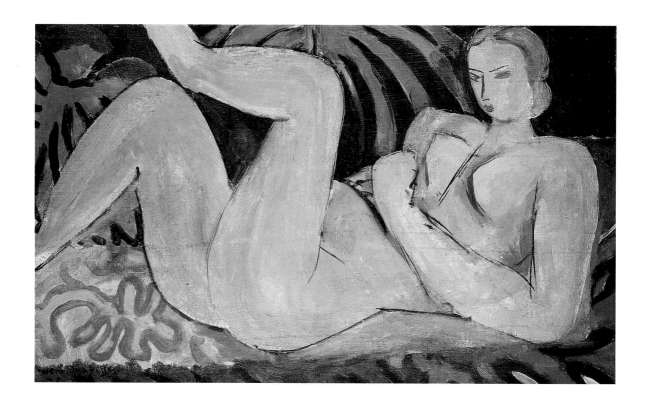

88 Henri Matisse, *Reclining Nude*, 1936

This interest in Léger's work as a means of clarifying certain questions of form contrasts starkly with Beckmann's considerably more complex appreciation of Matisse, whose work touches upon a fundamental problem in Beckmann's œuvre. The apparent lightness of being and arcadian serenity in the work of Matisse could hardly be further removed from the earthy complexity of Beckmann's pictorial world. Matisse embodies an unattainable otherness, a sense of yearning, a serene and otherworldly inner harmony that needs no *raison d'être* and ventures no explanation: it quite simply exists.

This thesis is confirmed at least indirectly by Beckmann's theoretical approach to modernism, although in his later years, as a mature artist, he does not indulge in direct comment on, let alone critique of, contemporary art.

In the polemical attacks launched by the ambitious and still relatively unknown Beckmann against the French avant-garde, Matisse came under fire more than most. With all the arrogant hubris of his immaturity, Beckmann damned Matisse mercilessly and mindlessly, at the risk of being branded a dyed-in-the-wool reactionary. It all began in 1911 with the ill-starred German Artists' Protest against a perceived excess of French art in German collections, a vitriolic attack initiated by the reactionary minds grouped around the Worpswede artist Carl Vinnen, and nurtured by the political climate of the Kaiserreich.[3] That same year, Franz Marc responded with an anthology of statements by leading artists, including Beckmann, though this does not mean that he had been persuaded to see the modern movement in a more favorable light. Indeed, on the contrary, Beckmann's statement was based on the

CARLA SCHULZ-HOFFMANN

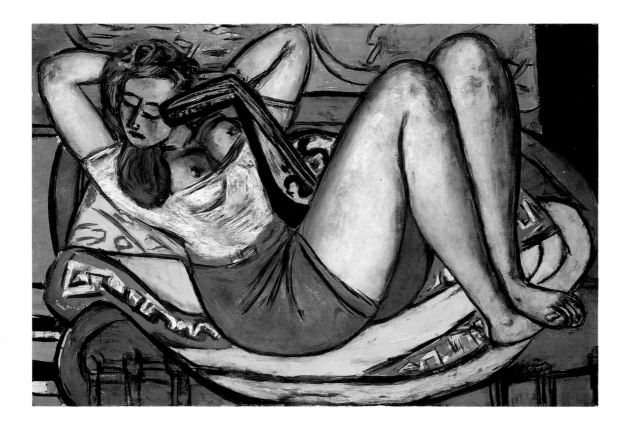

58 Max Beckmann, *Woman with Mandolin in Yellow and Red,* 1950

allegation that the young French artists were qualitatively too insignificant to be taken seriously in the first place. "I myself have always taken every opportunity to speak out against the overvaluation of such intelligent but derivative talents as Matisse, Othon Friesz, Puy, etc.; but it would never occur to me to mount a solemn protest against them, since I do not consider it very important if a number of untalented persons imitate Bastien-Lepage or Böcklin ..."[4] In order to understand this rather odd reaction that aligned Beckmann with a school of thought to which he did not actually subscribe, let us recapitulate briefly.

"A painted or drawn hand, a grinning or weeping face, that is my confession of faith; if I have felt anything at all about life it can be found there."[5] This seemingly laconic statement, formulated by Beckmann in his "Creative Credo," sums up a many-faceted œuvre – often seen as difficult and hermetic – that has always attracted astonished admiration and detailed attempts at interpretation. However, it would be as wrong to deduce from this that Beckmann regarded a simple imitation of nature as the highest aim of art as it would to attribute to him a false sense of modesty. What he summarizes here as his credo contains his interpretation of a pictorial reality that far surpasses visible reality, with all the exacting demands on art that entails. In the same text, Beckmann specifies what he means. Though the words he chooses are very much in the spirit of the time, the underlying message was to remain valid: "I believe that essentially I love painting so much because it forces me to be objective. There is nothing I hate more than sentimentality. The stronger my determination grows to grasp the unutterable things of this world, the deeper and more powerful the

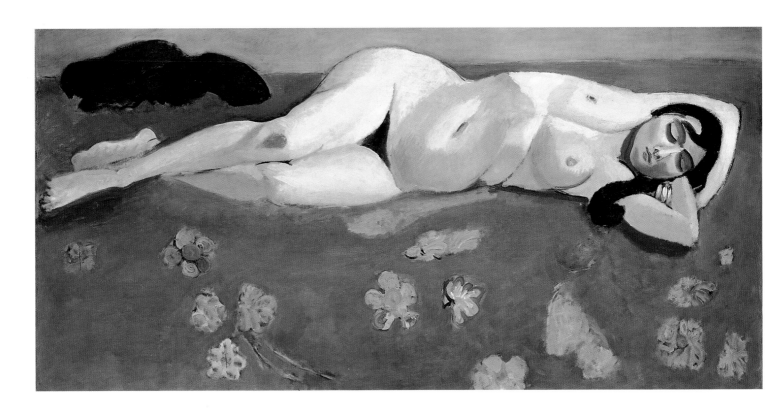

79 Henri Matisse, *Sleeping Nude on a Red Background*, c. 1916

82 Henri Matisse, *Odalisque with Red Trousers*, 1921

emotion burning inside me about our existence, the tighter I keep my mouth shut and the harder I try to capture the terrible, thrilling monster of life's vitality and to confine it, to beat it down and to strangle it with crystal-clear, razor-sharp lines and planes."[6] In that statement, he outlines an entire spectrum of diverse attitudes that describe not only Beckmann himself but also sketch an almost classical image of the artist as such. On the one hand, there is an awareness of the existential dependence on the lowly spheres of everyday reality that holds the average mortal inextricably in its grasp. On the other hand there is the hope that these constraints can be overcome through artistic work. It is precisely this hope that is seminal to the notion of the artist's special role as a figure capable of endowing things with meaning – that notion which would shape so many aspects of modernism and which Beckmann and his œuvre so clearly represent. The fate and the myth of the artist converge in the firm belief that the artist has a crucial role to play in an era of disintegrating ethical values.

All his life, Beckmann preached the immutability of artistic law. It was a conviction that excluded him from the prevailing aims of the avant-garde, linking him instead to the classical tradition that he adopted for his own era and sought to uphold: "... new people, ... that's the only thing that is new. The laws of art are eternal and immutable, like the moral law within us."[7] Such a view almost ineluctably demands a concentrated effort that is possible only within the framework of an ordered lifestyle. At the same time it defines the points of reference for an artist secure in his role and certain of his duties, who does not act on the basis of an "anti"-stance, but who sees himself as the legitimate heir of a great artistic tradition that has to be renewed for his own era.[8]

76 Fernand Léger, *The Red Bodice,* 1922

Against this backdrop, Max Beckmann – a supposed "outsider" according to any of the prevailing categories, who initially dismissed the avant-garde achievements of his era as "decorative wares" and later officially ignored them even though he measured himself against them – can be seen as one link in a closely forged chain whose individual components bear witness to the validity of a realistic concept of art on the basis of the respective era. Shortly before the end of the first world war, Beckmann wrote, "I certainly hope we are finished with much of the past. Finished with the mindless imitation of visible reality; finished with feeble, archaistic, and empty decoration, and finished with that false, sentimental, and swooning mysticism! I hope we will achieve a transcendental objectivity out of a deep love for nature and mankind. The sort of thing you can see in the art of Mälesskircher, Grünewald, Brueghel, Cézanne, and van Gogh."[9]

This statement clearly stakes out the boundaries of Beckmann's artistic concept in terms of its objectives and priorities, and he leaves us in no doubt as to its singular position. The question it begs is whether he is thereby propagating a conservatism that precludes all formal and stylistic experimentation and innovation. Certainly, he rejects all developments in the direction of abstract art and any tendency to call painting as such into question. Apart from his well-documented controversy with Franz Marc[10] and his repeated denigration of some of the more celebrated artists such as Picasso, Gauguin and Matisse, mainly in the years before his own artistic breakthrough, there is little to indicate that he occupied himself with the various avant-garde movements of the day. Indeed, there is much to suggest that Beckmann showed little interest in the details of their work and goals. Much of their activity seemed to him to be mere sham. "It is ludicrous, in any case, to talk so much about cubism or structural ideas. As if there were not a structural idea embodied in every good painting, old and new – including, if you like, those calculated to achieve cubist effects. Great art lies

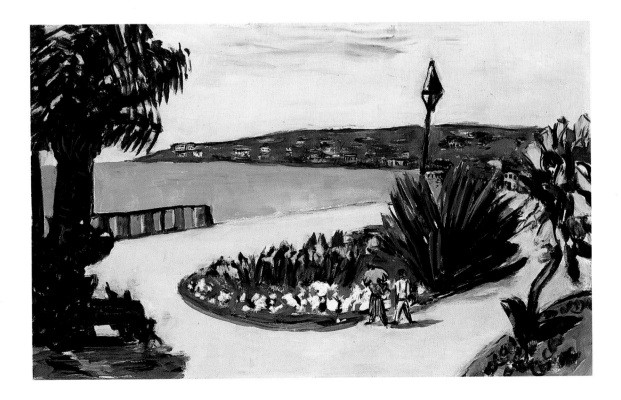

38 Max Beckmann, *Small Italian Landscape*, 1938

84

CARLA SCHULZ-HOFFMANN

in concealing these – in a sense – basic compositional ideas in such a way that the composition looks completely natural, and at the same time rhythmical and balanced: constructed in the best sense of the word."[11]

The artists he attacked would hardly have quibbled with these statements. Yet there was, in the first third of the twentieth century, a clear tendency towards theoretical elucidation and the practical exploration of formal problems that contradicted Beckmann's view of art and, in his view, therefore degraded each picture into a decorative object. "Not until the combined forces of pure and applied art have spent another ten years churning out their framed Gauguin wallpapers, Matisse fabrics, Picasso chessboards, and Siberian-Bavarian folk-icon posters will they realize, perhaps, that genuinely *new personalitie*s do exist – but that these have never, alas, been all that modern or contemporary."[12]

However, the very artists he mentioned here were soon acknowledged to be classics and clearly the upholders of a tradition that set the standards for Beckmann himself as well. Beckmann actually revised his own one-sided polemicism as early as 1914 in the periodical *Kunst und Künstler* and tried to make his position clearer by admitting to the existence of two more or less equally valid art forms: "One, which at this moment is in the ascendancy again, is a flat and stylized decorative art. The other is an art with deep spatial effects ... The former wants the whole effect on the surface and is consequently abstract and decorative, while the latter wants to get as close to life as possible using spatial and sculptural qualities ... As for myself, I paint and try to develop my style exclusively in terms of deep space, something that in contrast to superficially decorative art penetrates as far as possible into the very core of nature and the spirit of things."[13]

Though Beckmann quite unequivocally outlines his position and clearly verbalizes a subjective weighting, he expresses himself less dogmatically than before. It would not be

37 Max Beckmann, *Park Bagatelle in Paris*, 1938

entirely wrong to surmise that this shift may have come in response to Wilhelm Worringer's groundbreaking study *Abstraktion und Einfühlung* (Abstraction and Empathy),[14] which was so keenly discussed in Germany that it soon came to be regarded as an indispensable cornerstone of art theory. Worringer's lucid anti-thesis mitigated even Beckmann's overly narrow view of the boundaries between figurative and non-figurative art and offered a possibility for approaching new developments. "Just as the empathetic drive as a prerequisite for aesthetic experience finds fulfillment in the beauty of the organic, so too does the drive for abstraction find its beauty in the life-negating inorganic, in the crystalline, generally speaking, in all abstract laws and necessity."[15] This astute and subtle distinction avoids one-sided value judgment in a way that Beckmann could hardly afford to ignore, especially as an artist eager to make his mark in the international arena.

Beckmann was acutely aware of the fact that the "international" art world geared its standards to the work of the French modernists. In this respect, if he ceased to rail against the heroes of the French avant-garde, it was as much a tactical consideration as an indication that his youthful stubbornness was giving way to a more mature attitude that allowed him to view his contemporaries without the blinders of prejudice.

In many of Beckmann's works we can find obvious formal and coloristic affinities with both Léger (compare cat. 75, p. 105) and Matisse (compare cat. 85, p. 78; cat. 86, p. 101; cat. 88, p. 80). Yet in the late twenties especially, Beckmann produced paintings whose mood seems to echo the arcadian pictorial world of Matisse – not as tangible reality, but as distant

81 Henri Matisse, *Large Landscape, Mont Alban*, 1918

CARLA SCHULZ-HOFFMANN

promise. In Beckmann's *Sunrise* of 1929 (cat. 12, p. 104) that ambivalence is clearly evident in the almost sterile beauty of an unreal situation. Here, the rising sun is found in a small hand mirror, rather than above the sea. In the picture itself, a mere image of real life, the sense of the unreal and the unattainable is further heightened by the mirror motif. Even the structure of the composition contributes to making the sunrise over the endless sea seem like an unfulfillable promise. The dark wooden barrier that closes off the picture from the viewer also seems to protect the illuminated objects in it from that same viewer's grasp. This is especially significant with regard to the telescope pointed skywards: its aperture – and any insights it might reveal to the spectator – are hidden behind wooden slats.

The combination of signs recalls a particularly forceful passage in Jean Paul's novel *Titan*, which Beckmann may even have had in mind in creating this motif. The young hero of the novel, Albano, visits an observatory, where he finds "the old, lonely, thin, eternally calculating astronomer, with neither wife nor offspring, ever friendly and natural as a child ... Yet from under those sparse eyebrows his aged eye peered out, sparkling, towards the sky, and his heart and tongue leapt when he spoke of that highest earthly point, the clear sky above the black, deep earth – of the unnavigable cosmic ocean that has no shore, in which the spirit, seeking in vain to fly over, sinks exhausted, and whose ebb and flow laps at the throne of infinity – and of the hope of the starry sky after death, through which your earthly disc will not cut as now, forming instead a vault around itself with neither beginning nor end."[16]

What Matisse presents as self-evident pictorial reality, utter relaxation and self-containment becomes, in the work of Beckmann, the reflection of some distant future whose identity must necessarily remain unknown. In his *Letters to a Woman Painter*,[17] Beckmann again described the fundamental problem of existential dependencies and obligations that underpin this attitude, making it impossible for him to portray the kind of natural harmony posited by Matisse. And the one addressed, with only a fictional reality, thus becomes an existential counterpole, who, like himself, is vested neither with redemption nor freedom, his alter ego nevertheless remaining intangible for him in reality.

"And on you go, walking in dreams like myself. But through this we must also persevere, my friend. You dream of my own self in you, you mirror of my soul ..."[18]

This utopian vision of a distant and uncertain future countered by the antithetical structure of Beckmann's pictorial world is already present as artistic reality in the works of Matisse. Where Beckmann calls everything into question, Matisse creates self-contained units that demand no response. Whereas Beckmann chooses "not a sedative, but a tonic. Not an easy chair, but ... a breath of fresh air,"[19] what Matisse dreams of is "an art of balance, of purity and serenity, devoid of troubling or depressing subject matter."[20]

Who will decide how the priorities should be set? Clearly, two such very different artistic approaches are bound to present mutual problems of comprehension. Indeed, the reception of both artists was fraught with difficulty. In Germany, there was a tendency to dismiss a casually balanced and harmonious art as cheap decoration lacking intellectual depth, while in France the emphasis on content and symbolically laden painting that Beckmann presented fell on similarly stony ground.

This situation is also reflected in the less than favorable comments made by Carl Einstein in his review of both artists' work.[21] In his inimitably caustic style, he declares the vitality

72 Fernand Léger, *The Staircase*, 1950

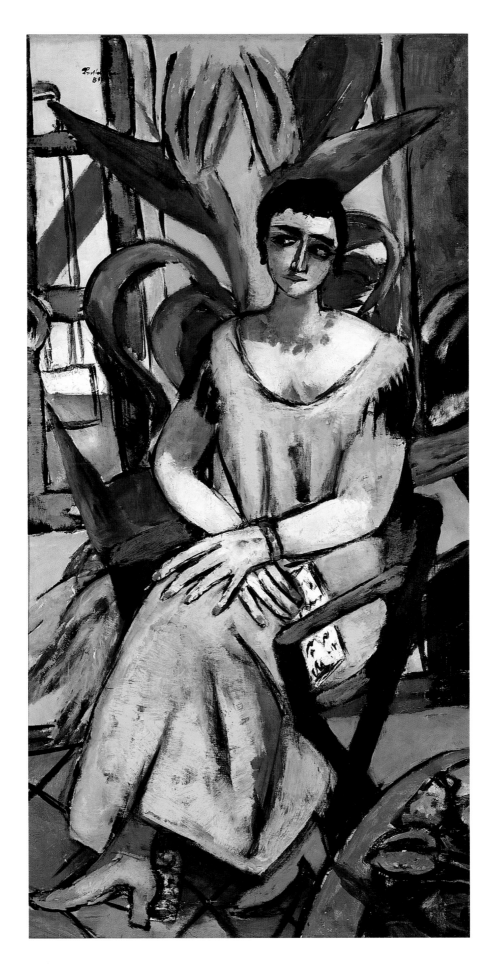

35 Max Beckmann, *Portrait with Birds of Paradise*, 1937

BECKMANN, MATISSE AND LÉGER

50 Max Beckmann, *Still Life with Large Green Fruits,* 1947

and exuberance of Matisse to be "nothing but ornament. The eye glides smoothly with nothing to stimulate in it any sense of spatial density."[22] From this Einstein concludes that "Matisse has rediscovered the ancient Latin, thoroughly positivistic approach … Now he is content merely to harmonize what he has found, with the emphasis on technical perfection … Yet another case of trying to regain paradise by honing the skills of a craft."[23] His words betray his discomfort in contemplating an art that allows and even encourages the individual to indulge in sheer aesthetic pleasure. He does not, however, see Beckmann in these terms; rather, he ranks him instead among those painters "who seek to achieve something more significant than a coloristic-schematic equation."[24] But even so, "this great undertaking tragically reveals the still unresolved struggle of a man whose intellect may well be greater than the painstakingly painted result."[25] While Einstein criticizes Matisse for what he sees as reprehensible hedonism in the guise of perfection, he is all too aware of the perceived discrepancy between Beckmann's aims and his achievements. Nevertheless, Einstein expressly acknowledges Beckmann's attempt to remedy this discrepancy by closely studying the Paris art scene and the international avant-garde as a whole in his endeavors to overcome provinciality and "painting as a test of conscience."[26] To the French, such an attitude was largely incomprehensible. So incomprehensible, in fact, that the problem on both sides is succinctly rendered in a single contemporary remark: "The shock of Beckmann is like a punch in the stomach."[27]

(Translation: Ishbel Flett)

CARLA SCHULZ-HOFFMANN

Fig. 6 Henri Matisse, *Still Life with Oranges*, 1912/13

1 Max Beckmann, cited verbatim by Stephan Lackner in his memoirs, from the period between 1934 and 1939, in Stephan Lackner, *Memories of a Friendship*, Coral Gables 1969, p. 31.

2 Beckmann mentions this painting several times in his diary entries between 31 January and 20 May 1950 as "Leda." See Max Beckmann, *Tagebücher 1940–1950*, Munich 1979, pp. 329 ff.

3 Carl Vinnen (ed.), *Ein Protest deutscher Künstler, Mit einer Einleitung von Carl Vinnen*, Jena 1911.

4 Max Beckmann, from his "Response to 'In Battle for Art: The Answer to the Protest of German Artists.'" Included in Buenger, *Max Beckmann: Self-Portrait in Words*, 1997, p. 112.

5 Max Beckmann, "Creative Credo," 1918. Originally published in Kasimir Edschmid (ed.) *Schöpferische Konfession XII, Tribune der Kunst und Zeit*, Berlin, 1920. The present translation is taken from V. H. Miesel (ed.) *Voices of German Expressionism*, New Jersey, 1970, p. 108.

6 Ibid., pp. 107–108.

7 "[…] neue Persönlichkeiten, […] das einzig Neue, was es gibt. Die Gesetze der Kunst sind ewig und unveränderlich, wie das moralische Gesetz in uns." Max Beckmann, Gedanken über zeitgemässe und unzeitgemässe Kunst, in *Pan II*, 17, Cassirer, Berlin 1911–12, pp. 499–502.

8 See in particular Hans Belting, *Max Beckmann: Tradition as a Problem in Modern Art*, New York 1989.

9 Max Beckmann, "Creative Credo" (see note 5).

10 The point of departure was Franz Marc's essay "Die neue Malerei" in *Pan II*, 16, Cassirer, Berlin 1911–12, pp. 468–471. Max Beckmann's response "Gedanken über zeitgemässe und unzeitgemässe Kunst" in *Pan II*, 17, op. cit., pp. 499–502. Franz Marc's reply to Beckmann, "Anti-Beckmann" in *Pan II*, 19, op. cit., pp. 555 f.

11 Max Beckmann, from his "Thoughts on Timely and Untimely Art" included in Buenger, p. 116 (see note 4).

12 Ibid., p. 117. "Siberian-Bavarian posters" is clearly a reference to Kandinsky and Marc and the artists of the Blaue Reiter group.

13 Max Beckmann in response to a questionnaire entitled "Das neue Programm" in the periodical *Kunst und Künstler*, translated in Buenger, pp. 131–132 (see note 4).

14 Wilhelm Worringer, *Abstraktion und Einfühlung, Ein Beitrag zur Stilpsychologie*, Munich 1908, reprinted 1959, 1981.

15 "Wie der Einfühlungsdrang als Voraussetzung des ästhetischen Erlebens seine Befriedigung in der Schönheit des Organischen findet, so findet der Abstraktionsdrang seine Schönheit im lebensverneinenden Anorganischen, im Kristallinischen, allgemein gesprochen, in aller abstrakten Gesetzmäßigkeit und Notwendigkeit." *Max Beckmann, Die Realität der Träume in den Bildern, Schriften und Gespräche 1911 bis 1950*, edited and with a foreword by Rudolf Pillep, Munich and Zurich 1990, p. 36.

16 "[...] den alten, einsamen, mageren, ewig rechnenden, weib- und kinderlosen Sternwärtel immer freundlich und unbefangen wie ein Kind. [...] Aber funkelnd blickte das alte Auge unter den sparsamen Augenbrauen in den Himmel, und poetisch erhob sich ihm Herz und Zunge, wenn er von der höchsten irdischen Stelle, dem lichten Hummel über der schwarzen, tiefen, Erde, sprach – von dem unüberwindlichen Weltmeer ohne Ufer, worin der Geist, der vergeblich überfliegen will, ermüdet sinke und dessen Ebbe und Flut nur der Unendliche sehe unten an seinem Throne – und von der Hoffnung auf den Sternenhimmel nach dem Tode, den dann Deine Erdscheibe wie jetzt durchschneide, sondern der sich um sich selber ohne Anfang und Ende wölbe."

Jean Paul, *Titan: A Romance,* translated by Charles T. Brooks. New York, 1877.

17 The letters were written by Beckmann in January 1948 for presentation as a lecture and were delivered in English by his wife Quappi at Stephens College in Columbia, Missouri, on 3 February. Reprinted in Peter Selz, *Max Beckmann*, New York 1964, p. 133.

18 Ibid.

19 See note 1.

20 Henri Matisse, *Notes d'un peintre,* in *La Grande Revue,* LII, 24, 25, December 1908, pp. 731–45. The present translation is taken from Jack D. Flam (ed.), *Matisse on Art*, Oxford 1973, p. 38.

21 Carl Einstein, *Die Kunst des 20. Jahrhunderts*, edited and commentated by Uwe Flechner and Thomas W. Gaethgeus in: Carl Einstein, *Werke*, vol. 5, Berlin 1996.

22 Ibid., p. 64.

23 Ibid., p. 70.

24 Ibid., p. 228.

25 Ibid., p. 231.

26 Ibid.

27 Paul Fierens, "Trois peintres, trois peintures, Chronique Artistique," *Nouvelles Littéraires,* Paris, 1931.

2 Max Beckmann, *Lido*, 1924

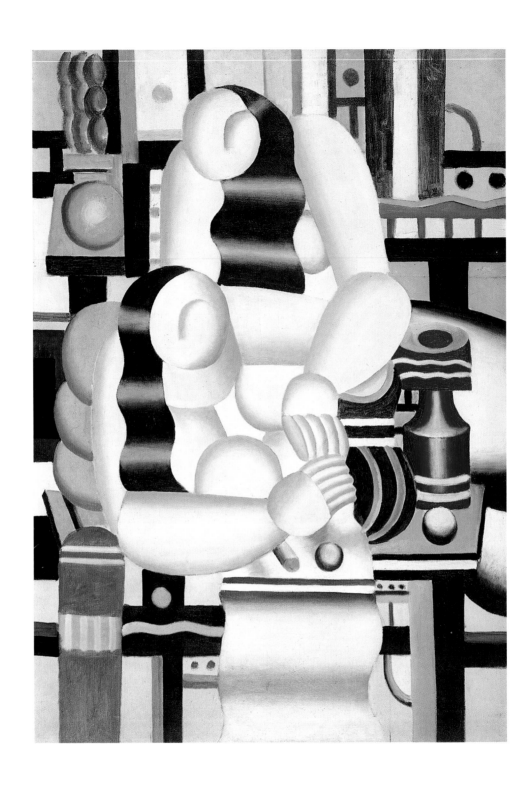

73 Fernand Léger, *The Lunch*, 1921

32 Max Beckmann, *The Three Sisters (Four Women Bathing)*, 1935

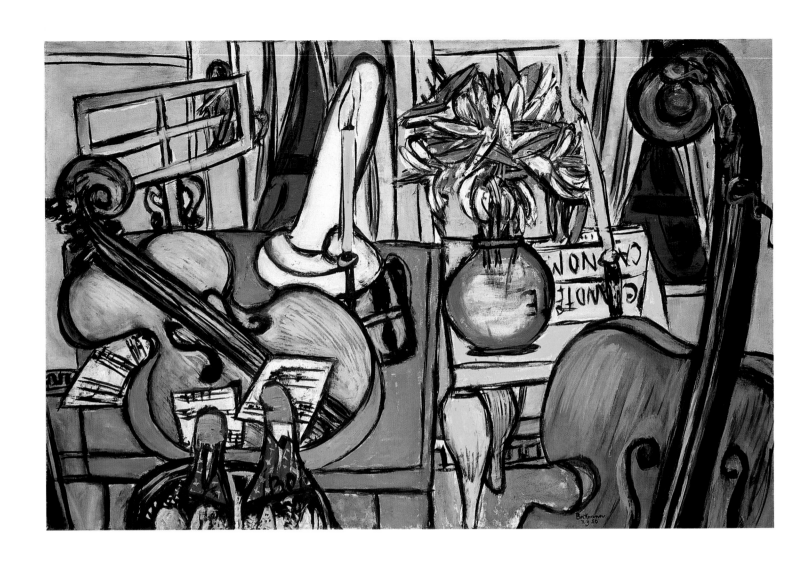

56 Max Beckmann, *Still Life with Cello and Bass*, 1950

87 Henri Matisse, *Still Life with Green Sideboard*, 1928

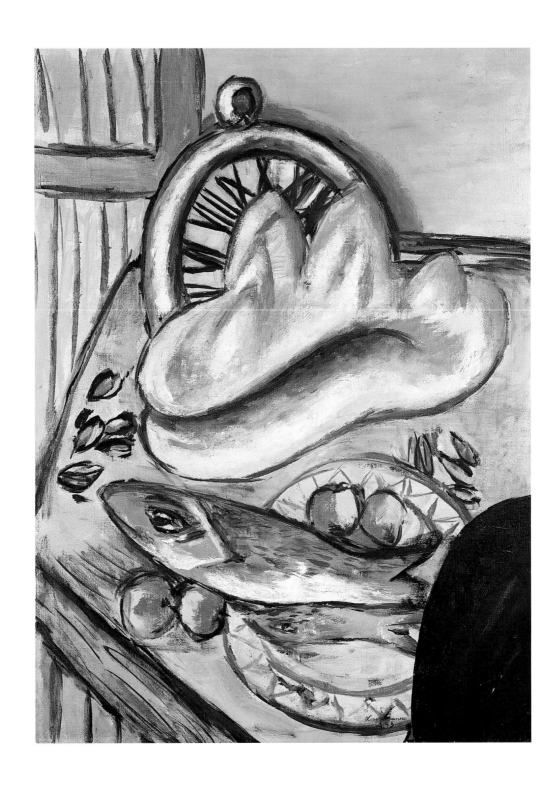

44 Max Beckmann, *Still Life with Fish and Shell*, 1942

19 Max Beckmann, *Artists by the Sea,* 1930

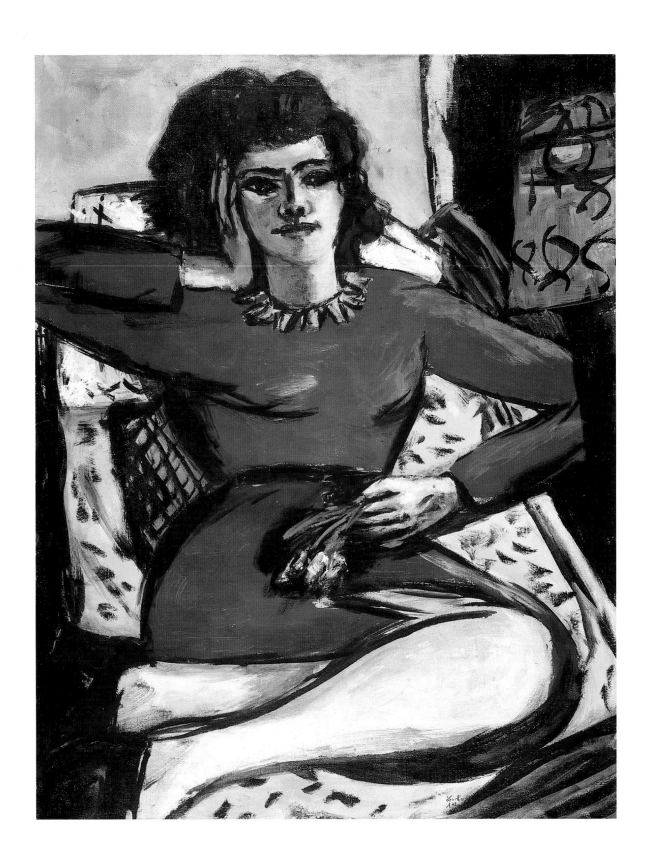

43 Max Beckmann, *Resting Woman with Carnations*, 1940/42

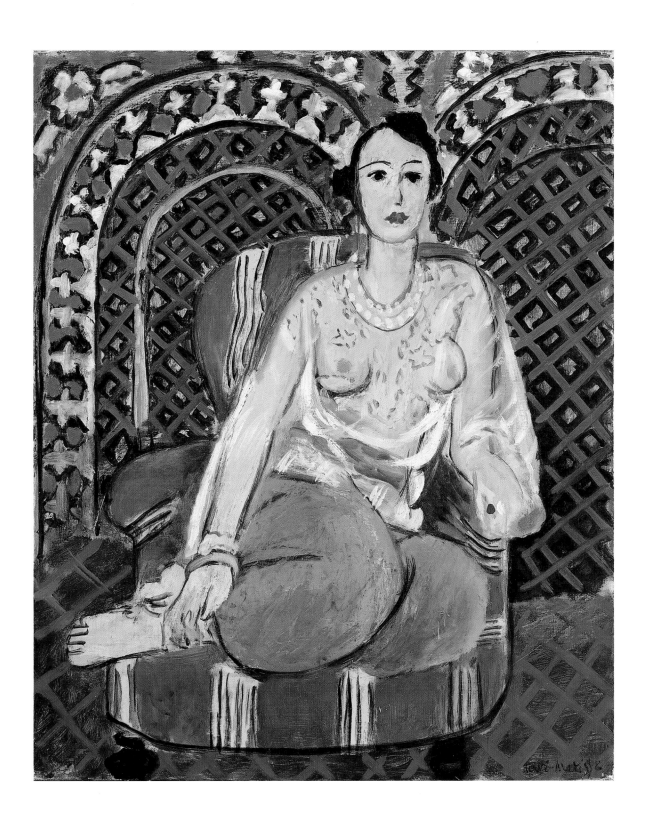

86 Henri Matisse, *Odalisque*, 1926

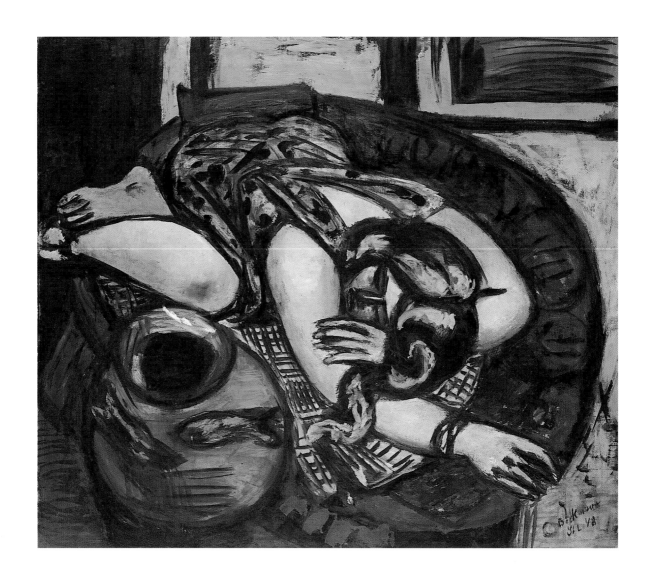

53 Max Beckmann, *Sleeping Woman with Fish Bowl*, 1948

83 Henri Matisse, *Woman Before a Fish Bowl*, 1921/23

12 Max Beckmann, *Sunrise*, 1929

75 Fernand Léger, *Still Life*, 1922

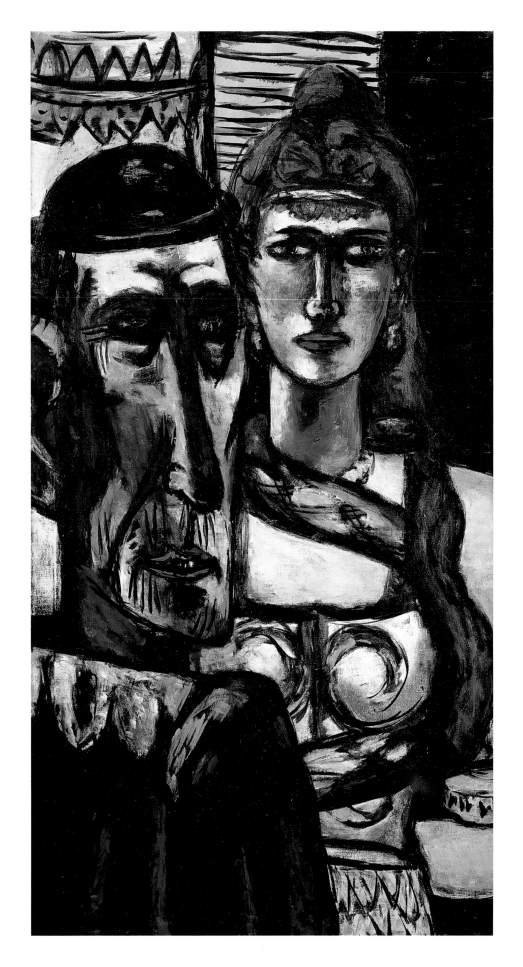

51 Max Beckmann, *Artistes*, 1948

Fabrice Hergott

With Rouault and Braque
On the Inner Paths of Painting

"I am not a revolutionary painter, I'm not seeking exaltation, fervor is enough for me."
(Notebook of Georges Braque, 1917–1947)

During the entire period from the end of the first world war to the outbreak of the second, Max Beckmann lived in close contact with the most successful examples of the "new painting" that was developing at the time in Paris. Gifted with a sure eye and a deep conviction as to his role as a painter, he was quite curious about what was going on around him. He visited the galleries (the museums did not yet exhibit the painters of the new school) and left with many ideas which he almost immediately formalized in his canvases. The reassuring recognition of numerous convergences of vision must have mingled with the irritation of having to face virulent competition. In the course of his frequent stays in Paris, he did not cease to seek out the physical presence of these paintings, obviously preferring the originals to the reproductions that could be seen in the handful of art journals circulating at the time in Germany. This quest for a personal and exclusive confrontation with unique objects – and thereby, for an affirmation of his deeply held elitist sentiments – was proof of a courageous attitude on his part. His courage was particularly impressive in that Beckmann never spoke French well enough to talk seriously with the painters and to give his technical observations a social or even friendly cast. Indeed, he was never able to penetrate the circles within which the painters worked. He remained on the fringes: too German to find favor in the eyes of a man like Jean Cocteau, who was primarily concerned with dumbfounding his audience with his flashes of wit; too steeped in French art not to become impatient with even the most Francophile of his companions on their way through Paris. And what would he have said to painters such as Rouault or Braque if he had actually met them?

Like him, they only lived for their work, but, unlike him, they no longer even made the effort of putting on the evening clothes into which a painter like Pierre-Auguste Renoir would have hastily slipped upon his return from the motif, some fifty years before. In the twenties Braque and Rouault lived in almost total isolation, seeing very few people and, unlike Beckmann, making no attempt to engage in the most vibrant spirit of their time. The French painters now preferred their tight circles of friends to the exchanges of the salons, which had grown superficial. Beckmann, with the social attitude of a bourgeois artist, issuing from the tradition of the great court painters of the German nineteenth century, found no equivalent in France of a tradition whose last reflection had been Manet. Picasso was the only one who still

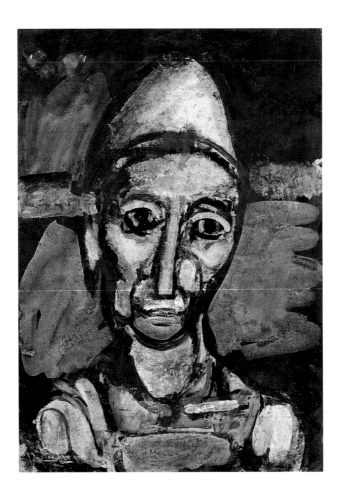

106 Georges Rouault, *The Old Clown*, 1917–20

frequented certain salons, but he deliberately avoided having any painters around him. If he knew Beckmann's work, he granted it only that sincere, condescending and posthumous admiration that the living grant to the dead, like an autograph. What Beckmann might have thought of these painters never reached their ears, and would have been of scant concern to them. It was less from scorn than indifference, that eminently Parisian trait which has always been the essence of social relations in the French capital.

It is quite likely that Braque had seen Beckmann's painting at the Jeu de Paume, in the Musée des Ecoles Etrangères, but what could he have recognized in it, he who feasted his eyes on Italian, indeed, Etruscan painting, and who imagined himself breathing the same air as Corot? Isabelle Rouault, the painter's daughter, and also his secretary since the 1930s, never even heard Beckmann's name, neither from her father nor from his friends, the painters, writers, and critics. For all these artists, the period of combat, where in the company of friends they sought confrontation with the works of their contemporaries, dated from before 1914, whereas for Beckmann, in the throes of his strategies for the conquest of the Parisian market, that period of confrontation was still current in his work, both in the studio and in the galleries with which he collaborated. Unlike Beckmann, the French painters did not feel the need to look for what they lacked beyond their national borders. The war

FABRICE HERGOTT

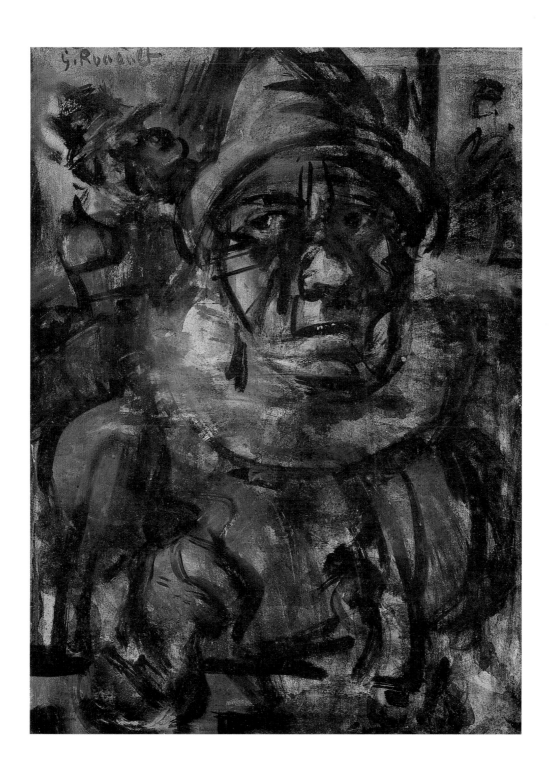

104 Georges Rouault, *Head of a Tragic Clown*, 1904

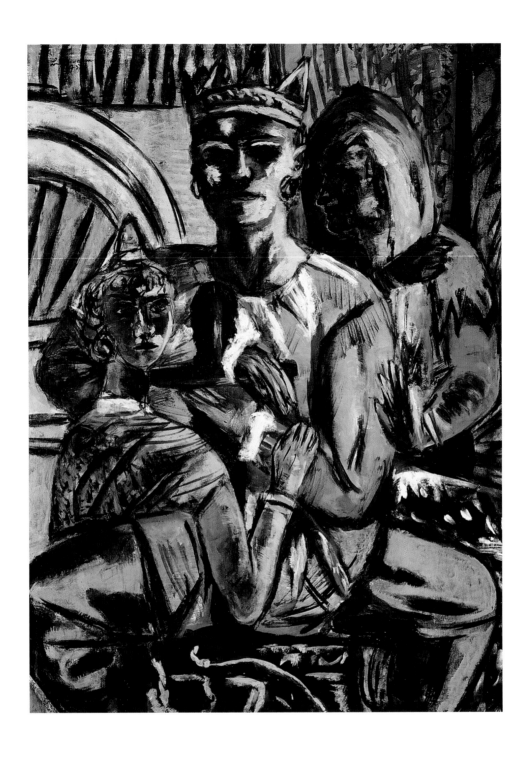

36 Max Beckmann, *The King*, 1933/37

FABRICE HERGOTT

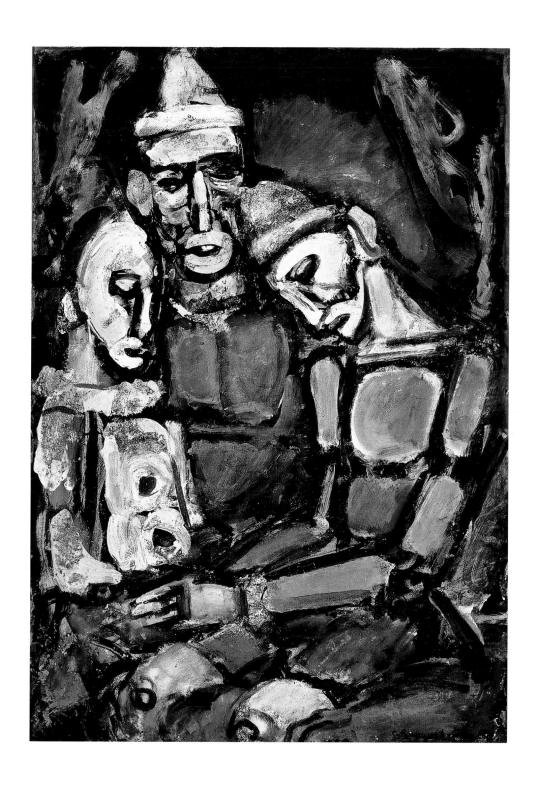

107 Georges Rouault, *Three Clowns*, 1917–20

WITH ROUAULT AND BRAQUE

and their work had allowed them to bear and accept the solitude of the studio, the isolation of a mental life built up from its own discoveries. They worked with what they had learned since childhood, and lived with the commercial and moral spirit of Impressionism, which consistently demanded further audacity and greater clarity.

Before the war, Beckmann had painted large canvases on the themes of current disasters such as the sinking of the Titanic or the earthquake of Messina, the two great pre-1914 events which he had been able to drape in the lyricism of the *Raft of the Medusa* or the *Massacre of Chios.* They displayed Beckmann's predisposition to pay particular attention to his time, his will to follow his epoch in the belief that contemporary events were worthy of being painted. In this he had the ambition of a Géricault or a Delacroix, an ambition that had faded in France with Realism and then Impressionism, both of which preferred small events – a burial or a card game – to great catastrophes.

Beckmann arrived in Paris with a painterly vision that did not exactly match the production of the painters he would admire. His interest in them was all the more laudable; and if one considers the solitude in which he lived, his capacity to open up to other modes of work and thought is exceptional in the history of art. He would adapt very quickly, understanding like Schwitters that the life of little objects, the space in which he found himself, the faces of the people and the entire appearance of things had assimilated the unprecedented effects of the cataclysm that now brought them all together: the world war that had just come to a close. Having seen the war's effects more directly in Germany, he understood how the little events – a still life, the portrait of a woman – shared inwardly in this disaster. The impact of World War I had been glimpsed by Cubism and taken full in the face by Dada; Beckmann had participated in all that, but he wanted to give it a particular form, for which he saw no equivalent outside French painting. Without ever being

FABRICE HERGOTT

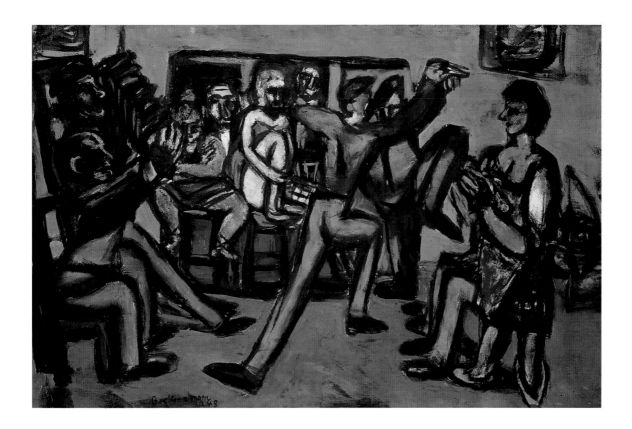

48 Max Beckmann, *Soldiers' Bar,* 1946

nationalistic, he was linked as an individual to the history of his country. In Germany, the defeat made the collapse of European culture more concretely felt, whereas in France the illusion of victory lent the war the aspect of a passing drama for which one need not feel responsible.

The French painters did not have the same awareness of the war. Braque had been wounded and didn't even speak of it. Rouault was older; he was conscious of the tragedy, and sought to give his feeling form in a cycle of engravings entitled *War and Misery,* which would only be seen by the public after 1945. Beckmann sought a way of blocking the resentment he might have felt. He found it in the attitude that he imposed upon himself. His strong awareness of himself (the self-pride that resurfaces in painters like Baselitz and Lüpertz) stemmed from his personal experience of the war and of the defeat. Perhaps what he sought was a style of painting that could reflect this dandy's posture: perfectly poised, maintaining his allure, completely cool amidst the flames.

Rouault, aggressive before the war, had calmed; Braque and Picasso had been frightened by their own audacity. They had begun to think that in painting, a certain mildness could be no less effective. Rouault no longer painted prostitutes or bloodthirsty judges, but bathers like Cézanne's, and Christs whose faces he consulted like an oracle even while giving them form. No longer did he rebel before the suffering he witnessed: it went far beyond the brothels and the courts, he accepted the pain he imagined and tried to give it shape with his painting. To do so he plunged into a legendary and artificial past, inspired by his reading

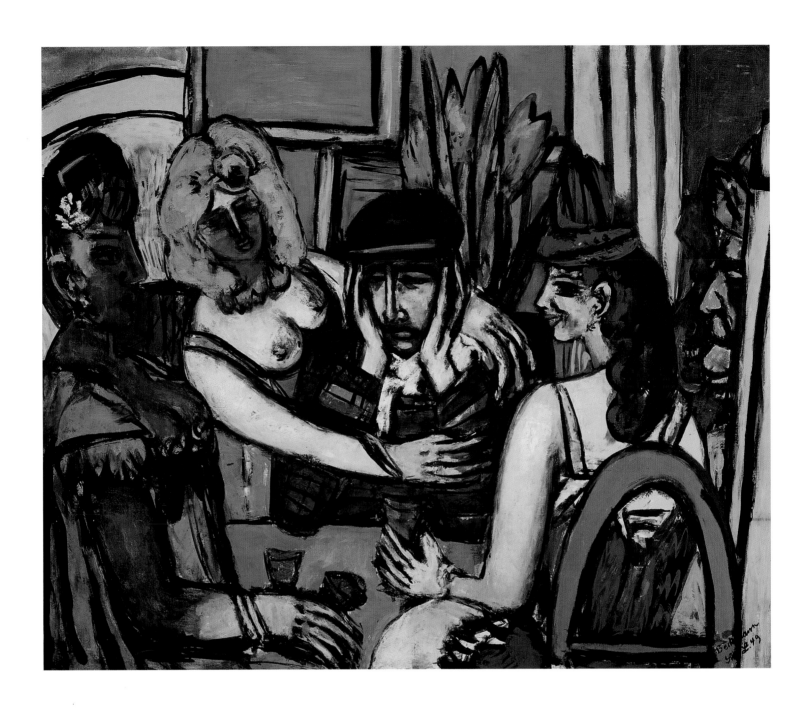

54 Max Beckmann, *The Prodigal Son*, 1949

FABRICE HERGOTT

105 Georges Rouault, *The Fugitives (The Exodus)*, 1911

of the Bible and his visits to the Louvre, in the quest to uncover a continuity between the reality in which he lived and the reality which had always existed.

Returning from the war, Braque had given classical form to Cubism, painting apples realistically against background assemblages of Cubist forms. He understood that Rouault's "legendary" world was untimely. Rouault engraved Baudelaire's portrait with the same reflections that Rembrandt must have had when painting Old Testament figures; he stood aloof from the time he lived in. Beckmann quickened its spirit with a timely gaze. His *Paris Society* (cat. 26, p. 23) was the 1930s version of Manet's *Ball at the Tuileries*. He could paint the world of his day with all the majesty of classical painting, and lend a definitive structure to a troubled epoch. He confided his fundamental project to Neumann: "To make apparent reality into absolute ideality (in a philosophical sense). To have been made conscious of it." (letter, 2 June 1926). Such a clear display of the desire to be conscious of everything is a hallmark of the dandy: the will to bring one's attention to every detail of one's own person and, by extension, to every detail of one's actions. That way of thinking was totally foreign to Rouault, whose deep religious belief had convinced him that such lucidity concerning oneself was unattainable.

Beckmann had assimilated all those things as well, along with the strategic battle for the conquest of the French market that he sought to wage with Neumann's aid. Through a form of modesty unknown in France, he preferred to speak of money and strategy and thus to leave an open field for his strictly artistic decisions and intentions. There was something schizophrenic about his behavior and he put that schizophrenia into his painting, oscillating from his ego to the objects whose multiplicity of faces he perceived like an echo of his own personality. He lived in a double world, split between a keen awareness of reality and an equally sharp consciousness of himself; he brought the two together in the self-portraits. Like Braque, he had been at the front and had seen death. Braque had undergone surgery on his skull; Beckmann experienced a deep psychological crisis. The experience of the war showed him the modern individual's isolation amidst other men, each living as though in a jungle nourished by his own anxiety. He could have made this the subject of his painting, like Grosz or Dix, with a mix of discouragement and nihilism that marked the immediate post-war period, but for him this was not enough. A very elevated sense of his objectives in art, a singular vision very close to a painterly mystique, pushed him to go to Paris and rejoin the painters that Cassirer, Flechtheim and others were beginning to show in Germany, before the effects of the 1929 crash and Hitler dissuaded them.

Beckmann's interest in Rouault came from the fact that the French painter was the only one not to have abandoned the signification of the subject. For Rouault the themes have a meaning. They answer an inner vision. They are less a realistic representation than a way of forcing reality. Prostitutes and judges are not represented as they are, but as Rouault sees them. He paints the fright that these subjects produce, always taking the least enviable position. He puts himself in the place of the prostitute observing herself with lassitude and fear in the mirror, or on the side of the accused who sees the judge as a modern incarnation of the ogre that haunted his childhood nightmares. All these representations are oriented. They imply that the painter does not simply play the role of a photographer in the face of social reality, but that he is an actor in this reality, an actor in the full sense of the word. Indeed, Rouault plays out what he portrays, sincerely feeling his model's emotions. This faculty of sympathy is transmitted to him by the painting, whose plastic qualities – the placement of a blue, the transparency of a face – act directly on his sensibility. The painter is at once actor and spectator of his painting. He plays all the roles. Here Beckmann could not help but recognize his own method. His correspondence bears witness to his complete identification with the themes he paints; the ego is omnipresent as an element of the space, just as in Rouault's work. As an artist he could be no more than an element of the superior entity he was painting.

Rouault was a lonely artist who worked in his studio and saw very few people. From his youth he had kept up a small circle of solid friendships which constituted the basis of his relationships. Unlike Beckmann he did not seek any new encounters and lived in the memory of the handful of great personalities whom he had met and admired. Degas, Renoir, Gustave Moreau, the writers Léon Bloy and Huysmans: these figures peopled an inner world, deeply impregnated with a Christian spirituality more personalized than it may at first seem. He frequented neither Picasso nor Braque, nor even less Léger. They all felt like foreigners in their art, except for Cézanne, whom Rouault considered "our common father," the shared

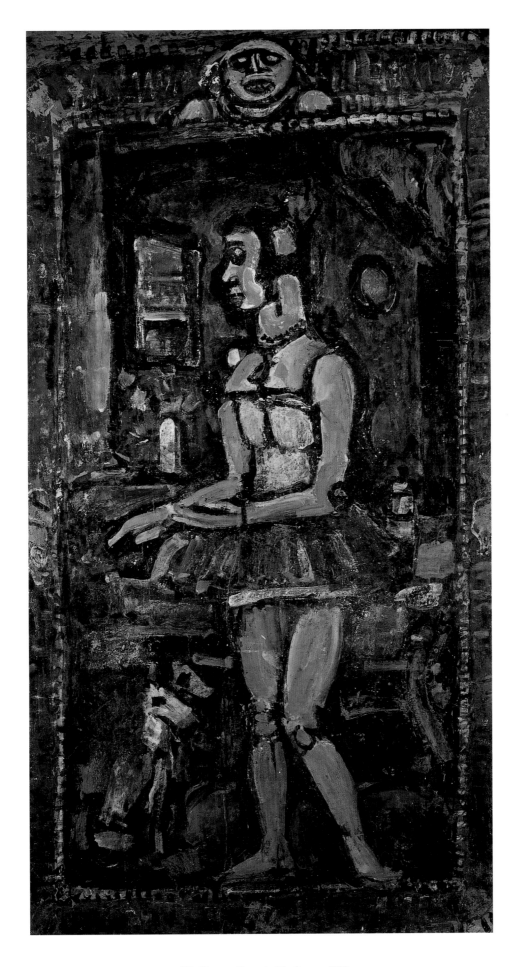

108 Georges Rouault, *The Dancer*, 1932

trunk of twentieth-century artists. He liked Matisse, whom he had met in Moreau's studio at the Ecole des Beaux-Arts; he had a profound sense of his friend's art, going beyond the notions of the pleasure of life, that superficial category into which Matisse was being fitted and which, in the twenties, had begun to bring him fame. In truth, this gaze on a past peopled simultaneously by Baudelaire, Ingres, Rembrandt and Degas was part of Rouault's gaze on things themselves. He was conscious, with his craftsman's modesty, of having approached and frequented exceptional personalities, and he aimed to be worthy of them. This labor of introspection formed part of Rouault's process. He painted himself ever deeper into the inner feeling of that which he had perceived in his encounters and in his readings.

Naturally given to an almost spiritual vision of his painting, Rouault developed a keen sense for his pictorial material. He painted on sheets of paper which he gradually covered with fine layers of pigment. In the course of realization these increasingly heavy sheets were glued onto canvas or, when they became very thick, onto wooden panels. Thus there occurred a veritable ascension of painting, which became more and more transparent and rose from the "ground" of the bare surface. This elevation is to be taken in its Christian sense. It makes the painting into a conceptual space for the progressive approach to that which is above. Rouault's painting is created in a veritable fervor, an ideal quest for a goal, where the materials, the line and the color act together in a common concern for harmony, but whose final aim is a more-than-human image, situated half-way between himself and what Rouault conceived as God. He painted fervently, seeking to give each stroke of paint a significant place in the picture. A red, a yellow, a black were not merely colors but a form, whose every detail possessed a function not only organic but spiritual. These considerations are delicate to state, to the extent that Rouault avoided any speculative approach to his painting. He held the conviction that the important things need not be emphasized, and that an explanation only reduced the meaning or the feeling he sought to express. The material profundity of color is the principle of his painting. His pictorial leitmotif was "form, harmony and color," seemingly the precepts of Matisse, but in fact the heritage of their common master, Gustave Moreau.

Beckmann, with a more speculative turn of mind, had great knowledge of different religions. He knew that the basis of religion was to permeate even the slightest act with a direction which remained always constant, man towards God. For him, God was space. It was an ingenious formulation which allowed him to integrate all the religions, while remaining modestly aloof from any sentimentality. His still lifes, no less than his large compositions, are expressions of this feeling, melded of personal experience and the sensation of the abyss. His lucidity towards himself, painting himself as he saw himself (and therefore as he was), evokes a will to bring out details for their own sake. Thus he came to mistrust the great themes: war, death, the apocalypse as he had painted them before 1917 were the oversized cloaks of an overly narrow way of thinking. Following Braque's example, he seemed to confine himself within the little things to bring out the echo of the great ones, the clap of distant thunder, a storm which has just passed but which gives the sunny landscape of his painting a more intense and durable tonality. The color effects borrowed from Braque allow this simultaneous contradiction of intent. The black dinner jacket stands out against a light gray ground, the face is in half-shadow even when the artist portrays himself head-on, with all his accustomed frankness.

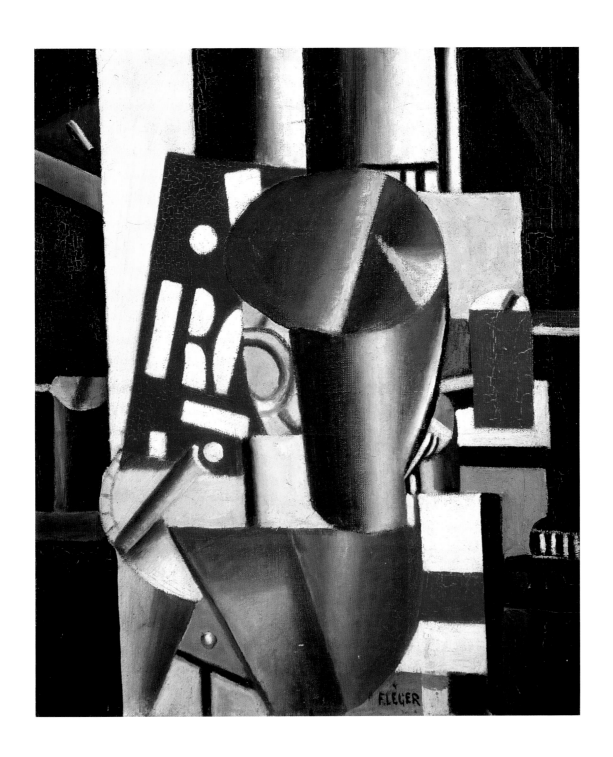

71 Fernand Léger, *The Typographer*, 1919

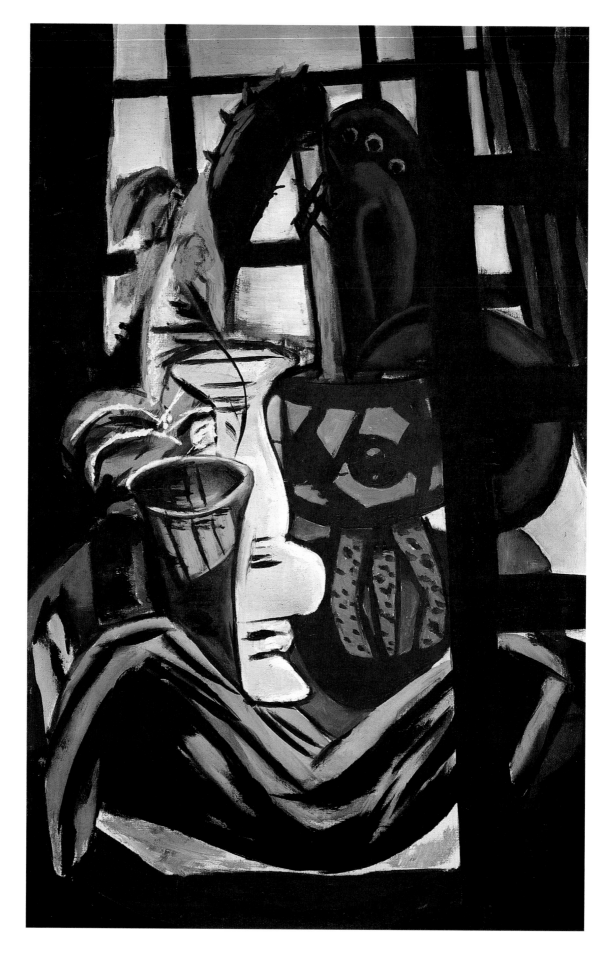

23 Max Beckmann, *Studio with Table and Glasses*, 1931

FABRICE HERGOTT

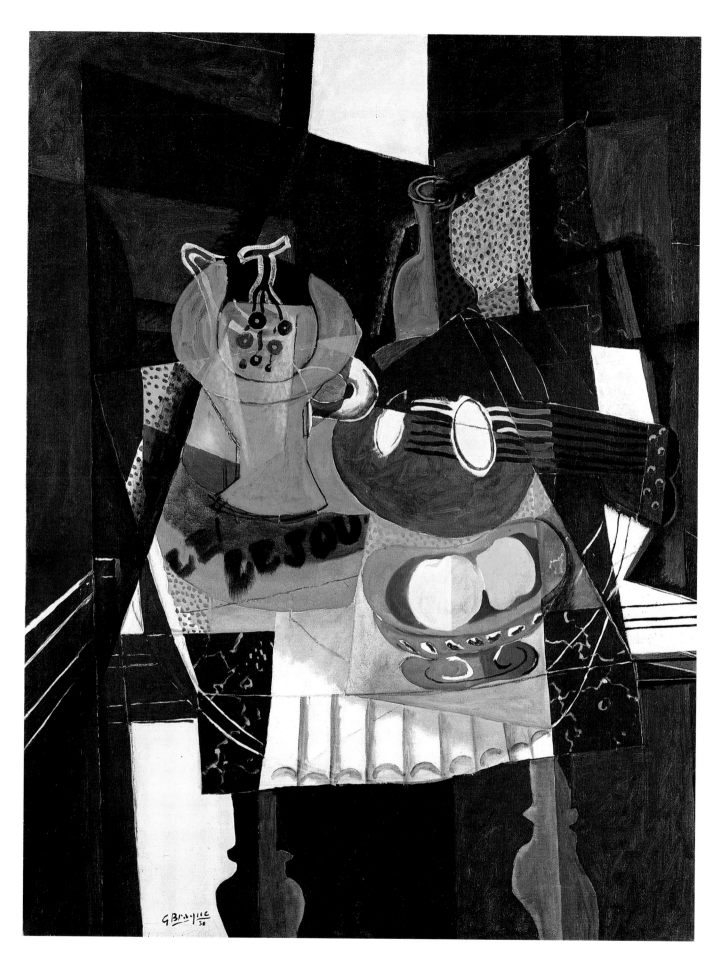

66 Georges Braque, *Still Life with Fruit Bowl, Bottle and Mandolin*, 1930

WITH ROUAULT AND BRAQUE

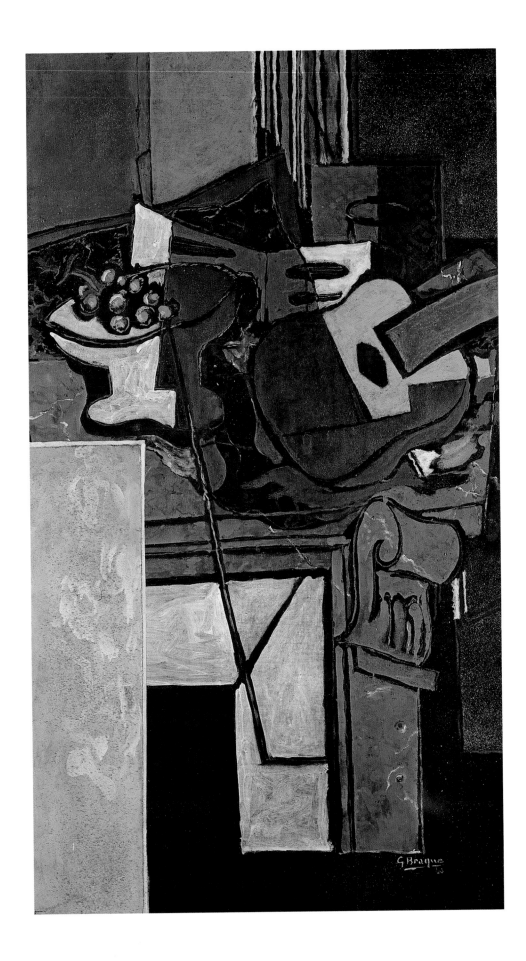

65 Georges Braque, *The Fireplace*, 1923

FABRICE HERGOTT

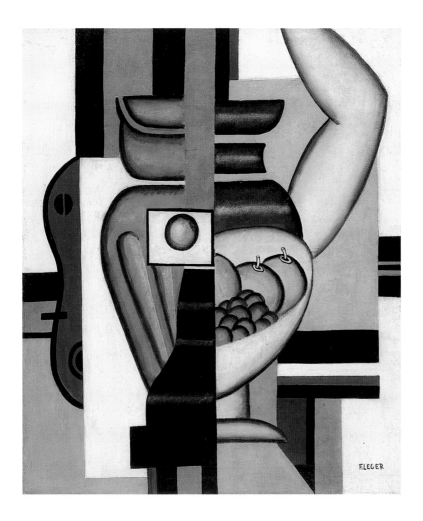

77 Fernand Léger, *Still Life with Arm,* 1927

The scorn or esteem which painters bear each other can be telling. These sentiments allow us to visualize their way of seeing, and consequently, to better understand their way of painting. That Beckmann considered Rouault with great attention, that he went so far as to admire his paintings, his technique, is obviously quite eloquent testimony of his capacity to consider painting beyond the commonly recognized appearances. Who would think of associating Beckmann and Rouault, and what could one find in common between them? They are two symmetrical figures. The German painter's social dynamism is radically opposed to the simplicity and voluntary solitude of the Frenchman. Beckmann's avowed ambitions seem to find their negative image in Rouault's almost Franciscan modesty. And their working processes include spectacular differences. Beckmann, who worked a great deal, never ceased in his letters to sing the praises of the pieces he had just finished. He calculated the effect they would produce on his admirers in advance, and counted on each painting as a blow against the resistance to his œuvre. He claimed to be conscious of the stages he was going through, and fantasized aloud of what a recently finished painting would bring him.

Rouault worked ceaselessly but withheld his paintings in his studio. He sincerely hesitated over their quality, to the point where he only very slowly finished what he had started

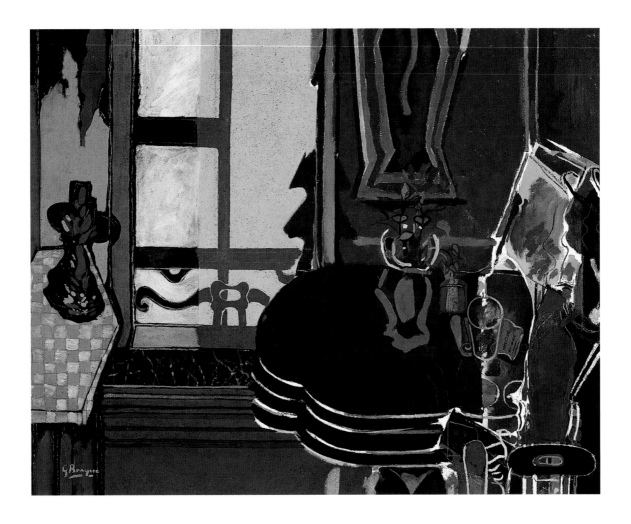

69 Georges Braque, *The Salon*, 1944

to paint. Many works begun around 1910 were only finished thirty or forty years later. He never ceased remodelling them, sometimes adding hundreds of layers of shadow to an arm. He worked through constant addition of color, which was supposed to allow him to attain the ideal harmony he sought, but whose material effect was to considerably thicken the pictorial surface of his paintings. If the works of the forties and fifties are so thick, it is simply because he worked on them longer. An idealist, he worked outside time. Though he sincerely believed he could respect a deadline, the idea he formed of his œuvre went beyond all material contingencies. This was the origin of the tension which gradually set in between him and Vollard, despite the dealer's openness of mind.

Rouault exhibited little and had a difficult time letting go of his paintings. Beckmann could only rarely have seen them. Vollard, whose gallery Beckmann dreamed of entering, maintained a relationship with Rouault that seems extraordinary to us today, but it was linked to the extraordinary personalities of the two people involved. In 1917 Vollard, the dealer of Cézanne, Renoir and Picasso, had bought Rouault's studio and ensured himself the exclusive contract of the rights to all the paintings that came out of it. Happy to be able to escape any worry for himself and his family, Rouault accepted this arrangement, to the

FABRICE HERGOTT

point of working on the top floor of Vollard's domicile on Rue de Martignac. No doubt he viewed the Faustian simplicity of this pact as a contemporary form of the relationship between medieval artists and their commissioners. Rouault saw Vollard every day on his way to his studio. He was there from the early hours of the morning until nightfall. This discipline which he imposed upon himself had no other end than the achievement of a certain perfection in his painting. It imposed a framework which would allow him to bring his paintings to their plenitude, with the practiced eye of the great art dealer as it measure.

The Rouaults that Beckmann saw must have principally been those of the early period of the Prostitutes and the Judges, along with a few paintings of the twenties. We can surmise that he was struck by some of Rouault's procedures, like the floorboards where the vanishing point of the perspective is raised high in the composition, making the ground an overbearing plastic element, crushing the model. More generally, the way Rouault sets up his motifs in the space seems to have greatly interested Beckmann. Certain of his paintings take up almost literally the hieratic construction that Rouault used from 1910 on, though Beckmann lends them a less idealistic subject. It is as though he replaced the poses of the timeless bathers or the sacred figures of the Bible with the faces and dress of his friends. There is also the way the subject is isolated in the frame, leaving little breathing space around it, and above all, the energy with which it solicits the collaboration of all the pictorial elements down to the least detail, in order to integrate the figure into a coherent pictorial whole. Beckmann obliges his subject to render up what it contains by enlarging that content to all the elements of the canvas. In Rouault's work, each stroke of color converges in the deep meaning of his painting; and this scrupulous economy of relations between subject and form is what drew Beckmann to the French painter. He must have admired that "sweet sentiment of religious gravity" which he had already seen in the work of Henri Rousseau (according to William Rubin, at least).

And it is in this sense that Beckmann's approach is particularly original. His status as a foreigner made him into a kind of archaeologist of modernity, transforming it on-site into canvases where his own culture, his personal world and the world building up around him all mingled. Today, through his paintings, we can see rather clearly what he saw, what left its mark on him and what he reworked in the laboratory of his pictorial thinking. The chemistry remains mysterious, because it is intimate, rarely formulated, perhaps impossible to formulate in his texts. The modern painting which stemmed from Cézanne and Cubism was a painting which radically modified the apprehension of space. Space became more immediately perceptible, invading the gaze in waves. To that, Beckmann sought to add a content that came from his personal experience of life, marked by the war. It is curious that his self-portraits (*Self-Portrait with Cigarette Against a Yellow Ground*, 1923, G 221; *Self-Portrait in Tuxedo*, 1927, cat. 5, p. 17), bear a direct relation to Rouault's 1925 self-portrait, entitled *The Apprentice Worker*. The same intensity of the gaze on the self is constitutive of both, but one affirms a consciousness of self-importance, while the other is not only derisive of the painter's appearance (Rouault paints himself with an old clown's hat, as he had already appeared in a photograph) but also of his craft. While Max Beckmann makes his social activity as a painter into an occasion to display himself with an aplomb whose only equivalent is to be found in the painters most confident of their social position from Dürer to Rubens or Velàzquez, Rouault, much to the opposite, portrays himself with great humility:

27 Max Beckmann, *View at Night onto the Rue des Marronniers*, 1931

FABRICE HERGOTT

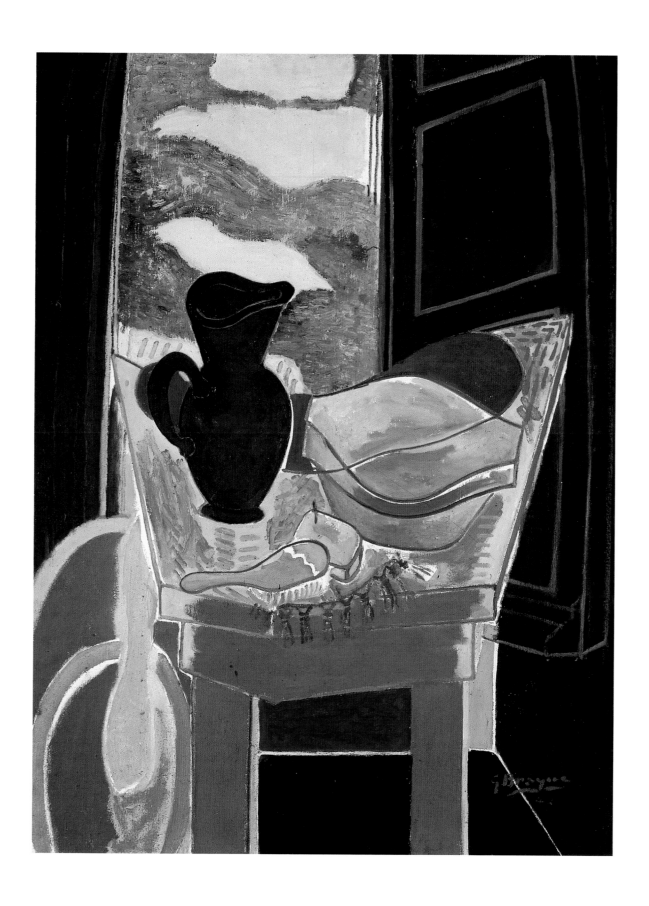

68 Georges Braque, *Dressing Table in front of the Window*, 1942

29 Max Beckmann, *Orchestra,* 1932

"I am like a child in the face of my art, very modest when thinking of my great ancestors
and even more modest when thinking of my own efforts" (letter to Ambroise Vollard,
14 October 1920). He lends the frontal pose the ambiguous significance of an artist portraying
himself with the obvious signs of lucidity, but a bitter lucidity, with a critical and subversive
twist of derision. Just as he claimed that his painting "left no one his glittering robes, be he
king or emperor" (letter to Edouard Schuré, circa 1905), so Rouault knew that the artist too
is a king: his double, subterranean face – as a clown destined to amuse his public and as a
craftsman forced to meet the demands of his materials – must also be shown. This attitude,
resting on a Christian conception of the individual where spiritual values are hidden beneath
material appearances, would have kept him from conceiving that an artist might portray
himself in evening clothes.

But one must bring certain nuances to this moral opposition between Beckmann's self-
portraits and the rare self-portraits of Rouault. Rouault is an artist who cannot help returning

FABRICE HERGOTT

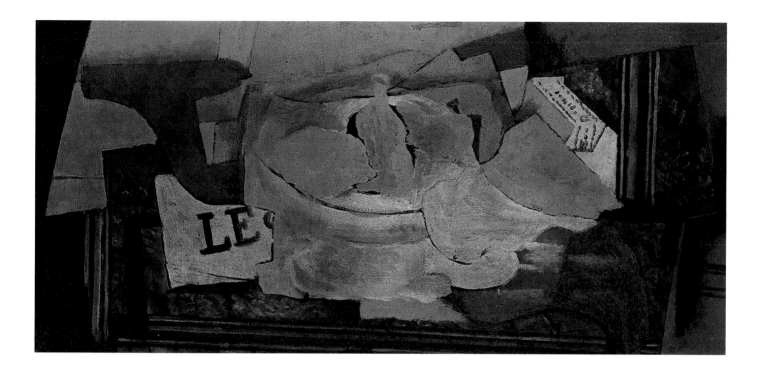

64 Georges Braque, *Fruit Bowl and Tobacco Pouch,* 1920

to himself and to his own image; his modesty does not escape becoming a kind of vanity in reverse, a declarative, even showy humility. This attitude refers back to the rediscovery of Watteau by the Romantics, spurring on the fusion between the artist and his painting. The fusion of the painted role and the model is intimate. One feels, and sees in the time spent on the painting, that the painter, the clown and the man are one and the same. In Beckmann's work, the man exists at the mercy of his successive roles. Though he often portrays himself and never hides his lack of modesty, to the point of making it the very backbone of his pictorial and strategic program, he nonetheless painted himself as a clown as early as 1921. At that time, he probably did not imagine that the clown portraits done by Rouault before his self-portrait were in fact autobiographical. He had no doubt seen Rouault's works of the period 1905–1910, showing circus actors in the full swing of their role, at that moment when they let yield to an anxious, panicked expression. Beckmann portrays himself as more relaxed, sometimes in the company of his family. The family is painted like the wings of a world stage. He insists on the ever-present element of social interplay, he thrusts the artificial, exaggerated, "clownlike" character of social conventions into the foreground. He shows not only that he gives into them, that he respects them, but also that he knows how derisive they are. Perhaps this is a more sincere humility, revealing a submission to the conventions, the impossibility of extricating oneself. He simply shows their artificiality, like papier-maché, enlarging to the scale of the portrait what Friedrich had earlier done for the landscape. The clown is one of the two or three costumes that the artist would wear throughout his entire

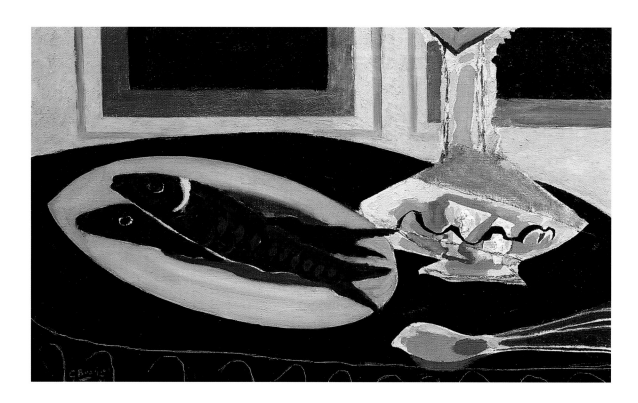

67 Georges Braque, *Carafe and Fish,* 1941

career as his own model, but these costumes, except perhaps for the dinner jacket, give the impression that they are disguises superimposed on the personality of the German painter. Nowhere does one find in Beckmann exactly what one finds in Rouault. His borrowings are seemingly dialectical, as though they had been discussed, rearranged, in light of his thought and intuitions.

The saying of Braque, which Paulhan quotes in his book on the painter, "today the artist is required not so much to represent a thing as to live it," could, at first reading, be applied to the chameleon Beckmann, the twentieth-century painter who engaged in the most theatrical experience of his social position as a painter. But should Braque's phrase be read in that way? One can also understand it not as a denunciation of his dissipated colleagues, concerned more with "living" than working, but as a high ambition, that of no longer making the painting something exterior to the artist's intimacy. Beckmann saw in Braque exactly those qualities for which Picasso reproached him: "He organizes surfaces." A reproach matching those of almost equal cruelty which Beckmann could address to Picasso himself, as he visited the Parisian galleries after the war: "Cézanne's legacy has been moved into workshops of Paris dressmakers," he commented to Neumann. A very strong image which helps one measure everything that separates Beckmann from contemporary French painting. He found the importance of content above all in the work of Rouault. Beckmann and Rouault are the two painters most difficult to integrate into a modernist conception of twenti-

FABRICE HERGOTT

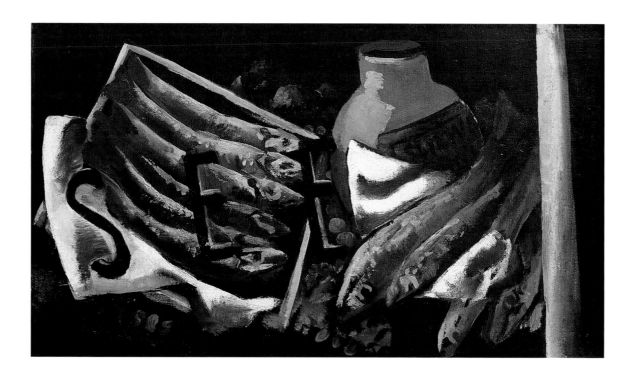

8 Max Beckmann, *Smoked Herring*, 1928

eth-century art history (founded on the rejection of the subject). Braque would offer Beck-
mann the conviction of the importance of space, and perhaps the whole aspect of a painterly
laboratory experimenting with the plastic possibilities of the technical means, as in Braque's
loudly proclaimed will to push "the alliance of volume and color" as far as possible – a
phrase which could have been spoken by Beckmann himself.

 It is possible that the German painter's interest in French art allowed him to struggle
against his natural penchant for the spectacular, his sense of the subject and the symbol.
Conscious of his limits that were cast into full relief in his strategic projects with Neumann,
Beckmann sought through his contact with the painting of certain French masters to gain
access to all that he could not attain himself. In France, the incomprehension from which his
work had always suffered stems from the superficial gaze on his painting. He manipulated the
subjects to the point of violence, cutting and gluing them in total opposition to the simplicity
and naturalness that French art proclaimed. "Make much with little" has been the watchword
of French painting since Impressionism. And one finds such an economy of means in the
movements that followed Impressionism, and not only in single canvases. Is Cubism not a
way of conveying the feeling of an object through a manipulation of the surface, where color
plays only a very slim role? Was Fauvism not an almost irrational effusion of color, with no
concern for line or form? Beckmann, who like Brecht was always keenly aware of the histori-
cal density of his time, seems through his contact with French painting to have tried to sim-
plify his in-depth vision of things. Braque, Rouault and Beckmann were convinced that their

paintings only revealed themselves slowly, through a gradual assimilation of the plastic elements and of the subject. As Braque said, "I find it necessary to work slowly; the person who looks at the canvas retraces the same path as the artist, and as the path counts more than the thing, people are most interested by the itinerary." That assertion could be applied unchanged to the narrative character of Beckmann's painting, which proceeds by the addition of heterogeneous elements. And one must count not only objects of different origins, but also distinct spaces which are gathered together on the canvas. Each painting, even the still lifes, tells a story that is always somehow funny or droll, where humor is often closely intermingled with a more dramatic sentiment of space, as though in each painting one crossed the different periods of a lifetime, with the same feelings as one moves through the hours of a day.

After the great stylistic turning-point of *The Night* (1918–1919, G 200) Beckmann's painting became an art of memory more than of representation. His stays in Paris and his voluntary confrontation with certain painters who were then working in the city allowed him both to deepen his own point of view (the conviction which he had elaborated along parallel lines) and to add nuances to something which he perceived as too formulaic. No doubt one must read his strategic correspondence with Neumann with the same attention that one gives to aesthetic manifestos. His desire to be present in Paris must also be understood as a search for the source of the particular presence of the painting being made there. The abandonment of the great spectacular themes for extremely sensitive subjects seen through the little things, the humble aspects of reality or of memory, also had a powerful effect on his painting. It is fascinating to see the depth at which this contact took place. As though he had succeeded in seeing through the apparent superficiality of French painting, to grasp its inner meaning. Beckmann's curiosity– or more precisely, acuity – must not have been far from that of the American painters in the forties, seeking their own path through Matisse or Picasso. At least as much as Pollock or Newman, Beckmann was touched by the forms and colors as well as a certain spirit of the subject, a particular notion of European painting linked to the use of materials and the variations of space. And his attention went above all to that economy of means whereby certain canvases were able to give depth to the simplest subjects, a depth which stems both from the composition and from the substance and its material history. Beckmann's visits to Paris encouraged him to paint friends' faces or a few fruits laid out on a table with as much poignancy as he would give to a shipwreck or a natural disaster, and with as much grandeur as though the subject were sacred, yet without taking away any of the fruits' savor, nor any of the substance of his friendships.

(Translation from the French: Brian Holmes)

FABRICE HERGOTT

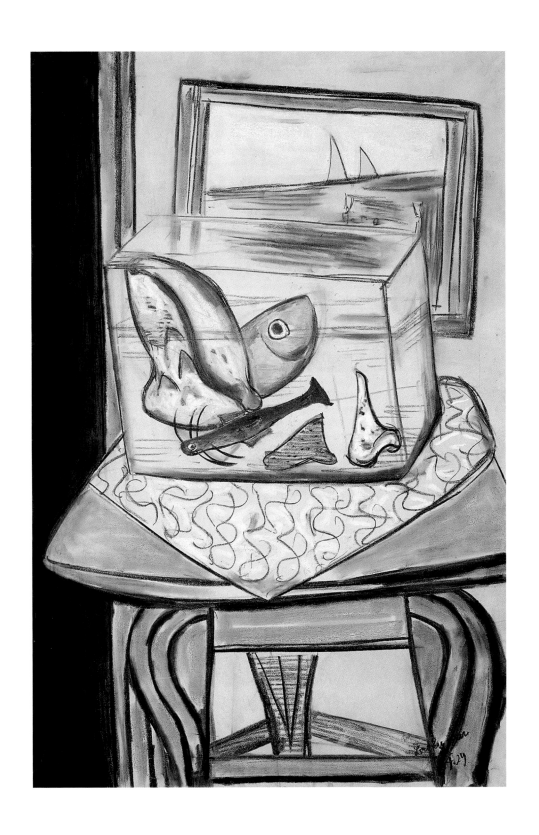

60 Max Beckmann, *Aquarium*, 1929

133

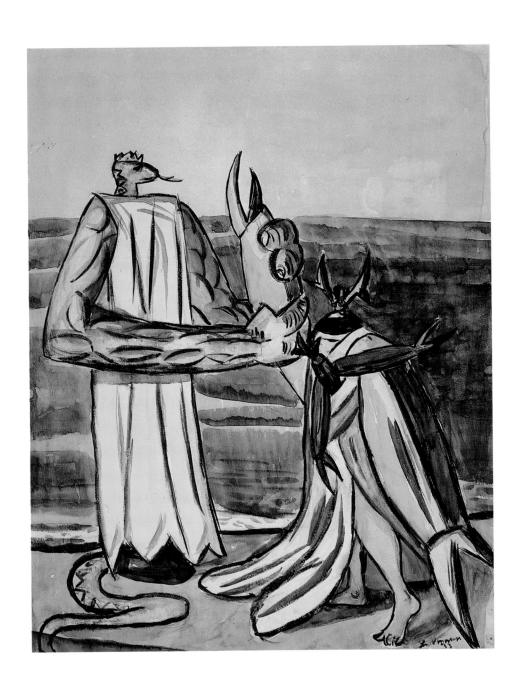

61 Max Beckmann, *The Snake King and the Stagbeetle Queen*, 1933

63 Max Beckmann, *Early Men*, 1946/48/49

Fig. 4 Max Beckmann, *Place de la Concorde by Day,* 1939

Sport in der Kunst.

Rugby von Max Beckmann.

Der Querschnitt, Mai 1930

Berliner Börsen Kurier Juni 30

Neue Baseler Zeitung Juni 30

Sommerausstellungen der Galerie Flechtheim.
Im Juli: Werke von Renoir aus dem Besitz seiner Söhne, Bilder von Matisse, Munch, Rouault, Derain und Hofer, Bronzen von Maillol, Kolbe und Sintenis, Zeichnungen von Degas, Renois, Rodin und Seurat. — Den Mittelpunkt der Ausstellung im August werden Picasso und Klee bilden. Das Graphische Kabinett in München zeigt im Juli neue Bilder von Beckmann, während sein gesamtes Oeuvre im August in der Kunsthalle in Basel ausgestellt wird.

Münchner Telegram-Zeitung V.30

Sammlung Hirschland, New York

Max Beckmann

Max Beckmann im Graphischen Kabinett

Im „Graphischen Kabinett", Briennerstraße der Zeitung Günther Franke, wurde gestern mittag eine große Ausstellung von Werken Max Beckmanns, die vor allem ein Dutzend Bilder seiner jüngsten, Pariser, Periode enthält, in Gegenwart des Kultusministers Dr. Goldenberger, des Ministerialdirektors Hendschel und zahlreicher

Augsb. Postzeitung Juli 1930

behalten wissen möchte — die dekorative Kunst möge sich [...]

(Die umfangreichen Spalten der Zeitungsartikel sind hier nicht vollständig lesbar.)

Frankf. Zeitung Juli 30

Kunstchronik München.

Im August wird in Basel und in Zürich das Lebenswerk Max Beckmanns zur Debatte gestellt werden. [...]

Germania, Berlin Juli 30

Heidelberger Tageblatt VII.30

Freiburger Zeitung, Juli 30

Semaine à Paris III-31

Galerie de la Renaissance.
— Une importante exposition de Max Beckmann va permettre à Paris de connaître ce peintre allemand, ailleurs déjà si apprécié et qui, en 1930, recueillit le prix de l'Institut Carnegie à Pittsburgh.

Œuvre forte que celle-ci, large par l'équilibre qui règne sur ces masses simples aux couleurs sonores, large aussi par le style vigoureux et grave de son dessin.

Max Beckmann, hardiment construit les plus volontaires et expressifs de ses tableaux, avec une riche, robuste couleur qui ne craint pas de s'affirmer, car dans son intensité telle qu'elle s'est imposée à l'artiste, celui-ci veut à son tour nous en communiquer toute la puissance expressive. **Yvonne Mareschal.**

Le Figaro Paris III-31

A la *Renaissance*, exposition débordante d'un peintre allemand qui paraît appelée à faire quelque page. C'est véhément, massif, truculent, et — on est bien forcé d'appliquer le terme, — colossal. Imaginez quelque chose comme un Picasso germanique (mais c'est Picasso qui a commencé) ou en, s'il m'était permis de parler musique, un Hindemith déchaîné. Évidemment cet art est expressif d'une race, mais point de la nôtre. La commune mesure nous manque, et l'on conçoit pourtant que la peinture convienne à un public avide de sensations fortes. Certaines synthèses outrées, outrancières, nous font reculer de trois pas. C'est un relatif physique tout au moins. Mais après avoir parcouru ces toboggans de l'art, restons la nation française, sobre, et si c'est possible spirituelle.

En somme, historiquement et logiquement c'est la suite de Boëcklin à Corinth et de Corinth à Beckmann.

Arsène Alexandre.

Journal des Débats Paris III-31

Max Beckmann (Renaissance) : Encore un allemand et encore « une force ». Une force brutale et contre laquelle il se peut que le sentiment français réagisse pour commencer. Cherchons ici précisément ce qui manque parfois à nos maîtres subtils, distingués, nuancés : grandeur, la monumentalité des formes, la nudité du fond, une espèce de vulgarité épique. L'art de Beckmann nous apporte autre chose que des accords de valeurs, des équilibres de motifs : une recréation du monde par un plasticien qui s'empare de la réalité et qui, sans esprit de système, la transfigure en quelque chose de plus concret qu'elle-même, de plus vrai que le vrai, de plus impressionnant que l'impression.

Léon-Zack (Jacques Bonjean) : Le dessin, simple soit-il, peut faire mieux que délimiter les contours, les plans, les volumes ; la couleur acquérir une autre vie que celle des rapports... Et s'il vous faut du mystère, en voici, puisque voici l'homme. *Ecce homo*. Voici un peintre pour qui l'âme existe. Une émotion, secrète et mélancolique, pénètre la matière, le contenu de cet art justifie son apparence et sa lumière est tout intérieure. Les figures de Léon-Zack baignent dans une atmosphère spirituelle, poétique. Elles sont belles par elles-mêmes et par tout ce qu'elles suggèrent d'inarticulé. Émanation du sentiment, cette peinture a quelque chose à nous dire, quelque chose d'important, d'essentiel... et qui semble aujourd'hui d'une surprenante nouveauté.

Die Kunstauktion Berlin IV-31

Deutsche Kunst in New York

Im Museum of Modern Art in New York folgte auf die große Daumier-Ausstellung Mitte März die Eröffnung der durch den Direktor des Museums, Mr. Alfred H. Barr, zusammengestellten Ausstellung moderner deutscher Kunst. Hier werden zum ersten Mal in New York Hauptwerke der Malerei und Plastik von folgenden Künstlern zumeist aus deutschem Museums- und Privatbesitz ausgestellt: Barlach, Baumeister, Beckmann, Belling, Dix, Feininger, Grosz, Heckel, Hofer, E. L. Kirchner, Klee, Kokoschka, Kolbe, Lehmbruck, Macke, Marc, G. Marx, Paula Modersohn, O. Müller, Nolde, Pechstein, Schlemmer, Schmidt-Rottluff, Schrimpf u. a.

I. von Saxe. Redaktion: Dr. R...

« L'Europe nouvelle » Paris VI-31

les peintures mêmes.

La Bibliothèque Nationale a fait le grand effort d'extraire de ses collections les peintures, sculptures, estampes, meubles, médailles, tapisseries évoquant ce que fut notre empire colonial pendant quatre siècles et rien n'est plus vivant peut-être que les ouvrages qui, selon les mots de Julien Cain, nous paraissent aujourd'hui pleins de fantaisie alors qu'ils se croyaient exacts et fidèles.

Aux expositions gothico-bouddhiques et indo-helléniques, André Malraux fait succéder (Galerie de la N. R. F.) l'art des nomades de l'Asie centrale.

Il est incontestable que le sens de la matière manque à beaucoup d'artistes allemands ; ils sont plus intelligents que peintres : d'où la plupart de nos désaccords. Ils sont plus graves aussi que nous ; de leurs dessins ou de leurs tableaux monte souvent l'aveu d'une souffrance acceptée, exaltée, comme si elle ne trouvait de satisfaction qu'en elle-même, une tension qui parfois fait peur. Cet héroïsme inguérissable, ce besoin métaphysique qui continuent à s'affirmer, et parfois grâce aux moyens les plus redoutables, dans la peinture allemande, imposent le respect, je dirais même l'admiration si l'admiration française n'était faite bien plus d'élan que d'effort volontaire. Le prestige de Bekmann est, dit-on, considérable. Ses admirateurs l'appellent le Cézanne allemand. Il les a domptés par une main de fer. Jamais on ne disciplina plus âprement les apparences. L'éloquence funèbre de ces vastes morceaux où, souvent, le noir domine, l'exaltation de la forme jusqu'au paroxysme, l'amour du colossal imposent au spectateur des coups répétés. J'imagine que, là encore, nos réactions sont assez différentes de celles de nos voisins et que cette grandeur-là, nous manquons d'instruments pour la mesurer.

Avec Kokoschka l'intimité s'établit plus facilement. S'il fallait comparer le lyrisme de Kokoschka à celui d'un peintre français, c'est le nom de Rouault qu'on prononcerait. Les récentes toiles exposées chez Georges Petit attestent une mise en œuvre plus parfaite encore des richesses que nous avions signalées ici même, à propos des portraits.

Daily Mail Paris VI-31

Mr. Dunn-Gardner.

At Bernheim Jeune's, a very talented British painter, Mr. Dunn-Gardner, shows about forty works full of variety and pleasing features. He deals successfully with landscapes and figures, the latter appearing to attract him the most. Among his best efforts are his portraits of Marchioness Vitelleschi, the Countess of Scarborough and Lady Serena James. Works by a German painter, Max Beckmann, who was born at Leipzig in 1884, are being shown at the Renaissance, 11, Rue Royale, for a month. His figures, landscapes and still-life reveal an art which owes nothing to southern schools. This forms the principal subject of interest to the observer.

That excellent marine painter Arsène

« L'Homme libre » Paris III-31

...tion de la convention de 1921.

LES EXPOSITIONS

Le 16 mars aura lieu à la Galerie de la Renaissance, rue Royale le vernissage de l'exposition Max Beckmann, un des peintres les plus originaux de l'Allemagne moderne. Ses expositions à Berlin, à New-York et à Zurich ont déjà affirmé sa maîtrise, nul doute que l'élite parisienne ne lui apporte une nouvelle consécration. — **LAZARILLE.**

« Figaro » Paris VI-31

LA VIE ARTISTIQUE

EXPOSITIONS

Après la peinture à coups de massue de M. Max Beckmann (c'était de lui qu'il s'agissait dans mon dernier article, mais son nom ne venant qu'à la fin, cela avait l'air d'une charade) après donc la peinture écrasante de M. Beckmann à la Renaissance, voici chez Petit la peinture à coups de torchons de M. Kokoschka. On me dit : « C'est un peintre ». Tant pis. Pour cela non plus je n'ai aucun goût, et je crois qu'il en sera de même pour tout public un peu raffiné. Ce parti pris de laideur et de vulgarité dans les grosses têtes sans l'amertume savoureuse d'un James Ensor, ces paysages qui se tiennent tout de travers — non, non et non ! Nous en avons assez de tout cela. Que nous importe ce qu'on dit être de « qualités de couleur » ? On obtient toujours des effets de couleur avec un barbouillage au hasard. Mais continuez à nous montrer ces choses qui ne sont ni conçues, ni faites, ni à faire. Une réaction n'en sera que plus proche, et l'on sait que la réaction que nous attendons n'aura rien d'académique. Le reste pour le moment n'est que danses de sauvages sur un champ de bataille — où on ne se bat plus.

« Le Soir » Paris III-31

UN ARTISTE ALLEMAND

De l'art et de la discussion

Après quelques expositions qui ne nous donnèrent pas de notions très précises sur les tendances artistiques de nos voisins, voici plusieurs manifestations bien davantage capables de nous renseigner.

Oskar Kokoschka, Autrichien, Galerie Georges Petit ; Max Beckmann, Allemand, Galerie de la Renaissance, sont des révélations. Nous n'oisions plus guère en attendre. Trop de grandes déceptions avaient remplacé de vastes espoirs.

Max Beckmann n'a nullement le lyrisme fougueux d'Oskar Kokoschka. En ses œuvres, on ne trouve pas le ruissellement de tons bousculant toutes les formes des toiles d'Oskar Kokoschka. Une mathématique plus grave préside à l'organisation de l'œuvre de Max Beckmann. Il en résulte une certaine froideur d'abord. Elle s'atténue d'une richesse volontairement sombre qui ne se révèle qu'après une sorte de sondage dans l'œuvre examinée.

Cet art ne correspond pas à notre tempérament. Nous avons besoin d'un certain effort pour l'admettre. Mais nous nous apercevons vivement, en contemplant d'autres expositions de peintres plus proches de nous par la palette, la technique, une sensibilité plus intime, que seulement où la discussion est possible, l'art se trouve réellement.

Je n'irais pas jusqu'à dire, selon Waldemar George, que :

— Si l'art de Max Beckmann est actuel, s'il dépasse les limites d'une école nationale, c'est qu'il marque une étape importante dans l'Europe d'après guerre, c'est qu'il annonce peut-être sa prochaine rédemption.

J'ignore si Max Beckmann sera le Rédempteur — fût-ce de l'Art — mais je puis au moins continuer à croire, avec son apport, qu'une œuvre, pour amener quelque chose de neuf à une époque, doit fatalement exciter autour d'elle d'âpres tournois.

Rien n'est plus terrible pour l'art que le calme plat, l'horizon bleu et rose comme le coucher de soleil d'une carte postale en couleurs. **Fanny CLAR.**

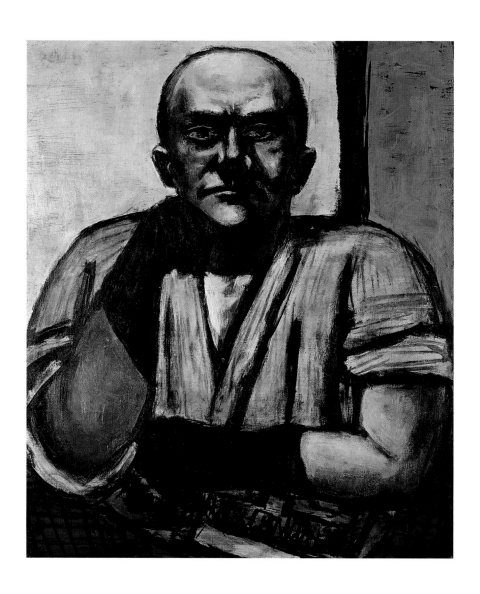

52 Max Beckmann, *Self-Portrait with Dark Blue Gloves*, 1948

Tobia Bezzola

"German Follies"

Critical Response to Beckmann's Exhibition in Paris

Each work of art contains within it the potential of its impact on those who view it and, even in that single instance, the reception of the artist's œuvre as a whole. Before we look at the response to Beckmann's major Paris exhibition, therefore, let us consider what it was that Beckmann was actually showing at the Galerie de la Renaissance. After all, the Paris public did not see all of Beckmann's œuvre in 1931, but only a selection of works strategically chosen by the artist and his closest confidantes. It is possible to reconstruct the exhibition because the photographer Marc Vaux not only took three pictures of the exhibition space, but also photographed all the paintings kept in the Galerie's storeroom which were not included in the exhibition. Beckmann had many more paintings in Paris than could have been shown. The exhibition catalogue also gives insight into the original concept, for it includes paintings that were not shown in the end. Finally, a sketch by Mathilde Q. Beckmann allows us to reconstruct the definitive arrangement of the paintings and flesh out the summary list of works in the catalogue. These three documents not only lead us to certain conclusions, but also direct us to some questions. Clearly, the show was originally planned as a small retrospective. At least two paintings produced before the first world war were intended to indicate Beckmann's artistic background. Of the seven other pictures listed in the catalogue but not actually shown, all but one were created in the first half of the 1920s. In the end, only four paintings from this period were exhibited.

The exhibition focused on works from the five previous years, some coming almost straight from the easel, as it were. What is more, certain stylistic factors (*Portrait of Quappi on Pink and Violet*, cat. 22, p. 21; *Still Life with Mexican Figure*, cat. 25, p. 52) or certain iconographic factors (*Rêve de Paris, Colette, Eiffel Tower*, cat. 24, p. 10) suggest that they were actually painted with a Paris public in mind. Yet selections were also made within the scope of his most recent work: Landscapes and cityscapes (12) and still lifes or interiors (12) predominate, with portraits or double portraits (7) and nudes (2) making up the rest. Beckmann presented his Paris public with only four complex, multi-figural compositions. In so doing, he avoided appearing too German, too difficult or symbolically overladen. This may explain why such works as *Carnival, Paris* (Munich, Staatsgalerie Moderner Kunst, G 322) or *The Bath* (cat. 20, p. 29) were not included, but it does make clear why less "difficult" paintings such as his magnificent *Portrait of Minna Beckmann-Tube* (cat. 21, p. 65) or *Studio with Table and Glasses* (cat. 23, p. 120) were also

omitted, even though they were in Paris at the time. Perhaps Beckmann hoped that the smaller pictures might be more appealing to collectors?

Paris and the French Response

In considering how Beckmann's work was received in Paris and in France in general,[1] we have to distinguish between the reactions of unprepared journalists and the more serious texts published by sympathetic (and commissioned) writers responding to the exhibition. For years, Beckmann had endeavored to win over the authoritative voices among the Paris art critics. In the end, it was Philippe Soupault and Waldemar George who published lengthy commentaries to mark the occasion of the exhibition. Of the four essays published, one by George appeared in the exhibition catalogue of the Galerie de la Renaissance, and one by Soupault in the gallery's own magazine *Revue de la Renaissance*. George published another of his texts in the magazine *FORMES*, of which he himself was editor. Only one lengthy article by Waldemar George was actually published in the "independent" *Revue Mondiale*. The most important and prestigious art publication, *Cahiers d'Art*, remained silent. Beckmann had sought in vain to capture the interest of its editor, Christian Zervos.

An excellent monographic study of Philippe Soupault's essay on Beckmann is available.[2] For Soupault, it was a casually penned text, written as a favor for his friend, the dealer Marie-Paule Pomaret. Soupault's essay summarizes the known facts, focuses on Beckmann's painterly temperament (in contrast to the contemporary belief that the Germans were graphic artists rather than painters) and takes precautions to ward off the chauvinism of the French public. Soupault knew the art scene enough to realize that Beckmann was not going to be well received in Paris. For that reason, he made a half-hearted attempt to avert prejudice, insisting Beckmann was not the philistine that the notoriously snobbish Paris art scene considered Germans in general to be. Soupault also noted how close Beckmann's paintings came to those of the city's more famous names. His conclusion could not have been more flattering:

> The French painters and those who form the Ecole de Paris can learn much from this honest and powerful work.

The three texts by Waldemar George on Beckmann must be regarded even more certainly as political pamphlets. According to the maxim of a *retour à l'ordre*, Paris in the 1920s witnessed a call for what might be described as "aesthetic reparations" from German art. In short, there was a widespread wish to see French culture cleansed of detrimental, and especially German, influence. Beckmann was aware of this. For this reason, he had made it a central premise of his *stratégie Parisienne* to present himself as a European rather than as a German artist. Behind the florid verbosity of his writing, Waldemar George's texts did little more than reinforce this same idea, as the titles themselves suggest. One essay is titled "Beckmann l'Européen", while the catalogue text is called "Beckmann et le problème de l'art Européen."

The daily press, however, proved less friendly than his two "official" critics. By 1931, the political climate had begun to take on nationalistic overtones in France as well as in Ger-

TOBIA BEZZOLA

62 Max Beckmann, *The Rape of Europa*, 1933

many. How Beckmann was judged in Paris tended to depend on just how conciliatory or otherwise one felt towards Germany. The very fact that two "German" painters were being exhibited in Paris at the same time – Max Beckmann at the Galerie de la Renaissance and Oskar Kokoschka at the Galerie Georges Petit – provoked reactions that ranged from aversion to outright hate among the extreme right. Visions of an artistic *Anschluss* – powered by Jewish art dealers – were conjured up. In a direct comparison of the two painters by Jacques Baschet in the *Illustration*[3] of March 1931, Beckmann fared even worse than his Austrian colleague:

> A German at the Galerie de la Renaissance, Monsieur Max Beckmann, and an Austrian at
> Georges Petit, Monsieur Kokoschka, are masters of deformation. Whereas the former, with all his
> accumulated errors, is still indulging in the kind of infantilism that our repentant Fauves have
> long since renounced, the latter has an undeniable sense of color. At the same time, one must
> admit that reality is of no importance or that any manner of liberty may be taken with it. We do
> not believe that these two foreign and allegedly important elements can enrich our art in any way.[4]

Whenever nationalism, anti-Semitism and anti-Modernism met, the judgment was devastating. Camille Mauclair gave vent to his fury in two articles, the first in the *Ami du Peuple*:[5]

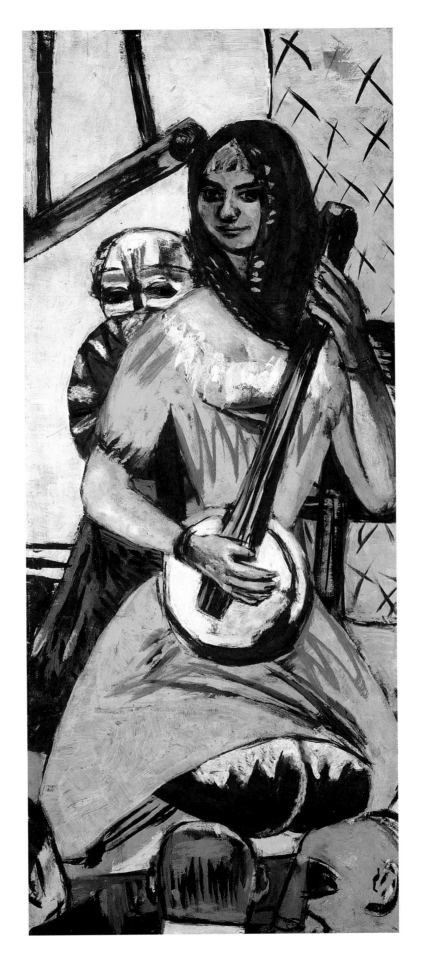

33 Max Beckmann, *Varieté (Quappi)*, 1934/37

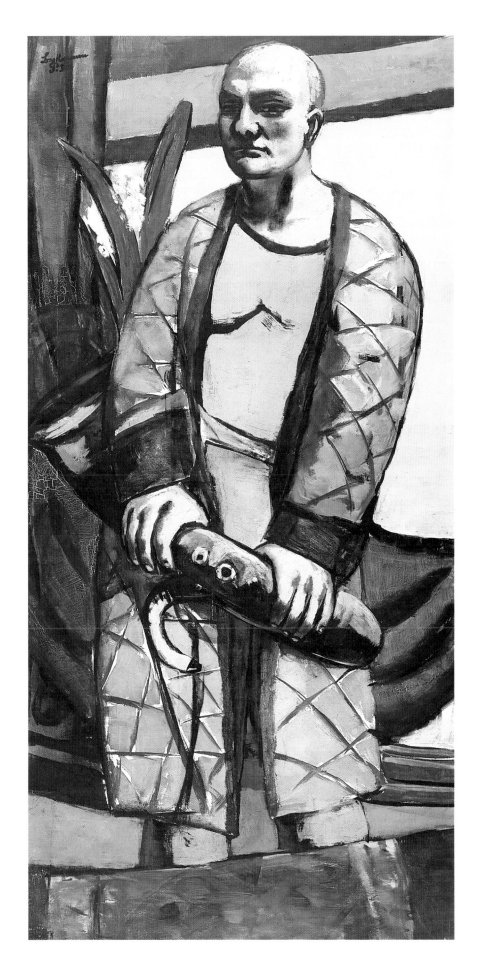

17 Max Beckmann, *Self-Portrait with Saxophone*, 1930

The unfortunate idea of abandoning subject matter and imagination has led to a confusion of the means and the end, deifying "pure painting." The result is now there for all to see: an inhuman art, as icy and boring as the mentality of "pure intellectuals:" an art that threatens to decline into geometry and mechanics (Picasso, Braque, Léger, Miró) or monstrosity, in a hatred of human normality, as we can see in the dreadful mess of this Beckmann exhibition that one has recently had the audacity to impose upon us like a sort of Anschluss between Parisian and Berlin traffickers.[6]

In March 1931 Mauclair published yet another tirade against the Teutonic smear-artists and traitors who sought to infiltrate French art. The article entitled "Ébats Germaniques" (Germanic follies) appeared in the extreme right-wing *Eclaireur de Nice*, railing against the "*productions du sieur Max Beckmann, de Leipzig:*"

These are ridiculous little fairground gingerbread mannekins, cranky, ignominiously comical, rendered in blotches of color that would shame the lowliest house-decorator.[7]

He even went so far as to slander Waldemar George, the Polish-born critic, as "*a foreigner who has spent years in Paris without even managing to master the language.*"[8] Worst of all was the fact that the French state should actually purchase such works; Beckmann's *Forest Landscape with Woodcutter* acquired by the Musée du Jeu de Paume being

… a kind of half-burnt straw supposed to represent a forest, in a style that would not even find a buyer on the fleamarket.[9]

Art criticism could fall no lower. From then on, it could only become more intelligent and subtle. The political and cultural sensitivity of the exhibition, which unleashed a minor scandal in Germany, also shed a poor light on the powers of judgment of Beckmann's critics. Their criticism was aimed first and foremost at "the German painter" rather than at an individual talent. The cultural and political setting of the exhibition came under fire:

Beckmann's reputation is said to be considerable in Westphalia. His admirers call him "the German Cézanne." He has tamed them with an iron fist. The Europäischer Kulturbund reveals to us this new god.[10]

The author, Claude Roger-Marx (*Trois peintres allemands à Paris: Grosz – Beckmann – Kokoschka, Le Bravo*, April 1931), goes on to dismiss this provincial talent with all the blasé arrogance of a dyed-in-the-wool Parisian critic:

Never have outward appearances been disciplined more fiercely. The grim eloquence of these large works in which black often predominates, the exaltation of form to the point of paroxysm, harsh rings around the eyes, full color tones, flat, cruel, systematic brutality, a love of the colossal – whether it is a fish, a magnum, a figure – repeatedly insult the specta-

tor. I can well imagine that our response is not that of our neighbors: we simply do not possess the instruments by which to measure such dimensions.[11]

Other interpreters such as the critic for the *Journal des Débats*[12] were willing to admit that the foreign element, "the brute force from which French sentiment recoils," could well enrich the somewhat anemic Ecole de Paris:

> Let us look here for what is sometimes missing in the work of our subtle, distinguished and nuanced masters: grandeur, monumentality of form, ruggedness of tone, a kind of epic vulgarity. Beckmann's art brings us something other than harmonious values and balanced motifs; a recreation of the world by a plastic artist who takes charge of reality and, without forcing it into a system, transfigures it into something more tangible than itself, more true than truth, more impressive than the impression.[13]

Fanny Clar, writing in *Le Soir*[14] ("Un artiste allemand. De l'art et de la discussion"), expressed her hope that the sheer vehemence with which Beckmann's work was dismissed might point towards a positive effect in the long term:

> This art does not correspond to our temperament. It takes a certain effort to admit it. Yet we keenly sense, when we consider the exhibitions of other artists closer to us in terms of their color, their technique and their sensibilities, that art can only really be found where debate is possible. I do not know whether Max Beckmann will be the Redeemer – albeit of Art alone – but I do have reason to believe, as his work shows, that an œuvre that seeks to contribute something new to an era must inevitably trigger bitter conflict.[15]

Louis Leon-Martin, in *Paris-Soir*,[16] expressed a similarly humanistic view:

> At first glance, Max Beckmann seems specifically German, which, in my view, is a merit. … Max Beckmann presents himself with all his faults and qualities … with a candor for which he is to be praised. … Waldemar George, who has written the foreword to the catalogue, describes Max Beckmann as a German painter and a European painter. Why? German painter and humanist painter, yes. In art there is neither a Germany, nor a France, there are people, and that is all that counts.[17]

The reviews that make direct comparisons between Beckmann and the stars of the Ecole de Paris are particularly interesting since, after all, he had gone to Paris to pit his skills against Pablo Picasso. In *Figaro*[18] Arsène Alexandre made the long-awaited comparison, albeit not quite as Beckmann might have hoped:

> It is vehement, massive, earthy and – no other term will do – colossal. … Imagine something like a Germanic Picasso (though it was Picasso who paved the way) or, if I may venture into the world of music, a raging Hindemith unbound. This art is clearly the expression of a race that is not our own. We possess no common yardstick, yet we realize that his art appeals to an audience hungry for sensation. Certain exaggerated and outrageous synthe-

ses make us take three steps backwards. This is, at most, a physical effect. After our ride on this toboggan of art, let us remain the gray, sombre nation, if possible, the spiritual nation.[19]

Yet even though the author does not admit Beckmann to the Parnassus of Parisian art, he does at least give him the honor of ranking him within the German tradition:

All in all, both historically and logically, there is a sequence that runs from Boecklin to Corinth and from Corinth to Beckmann.[20]

While Beckmann's affinities to his French contemporaries were often noted, they tended to be interpreted as emulation. The *Comoedia*[21] magazine's critic, for instance, admonished Beckmann for his profound debt to Matisse, Picasso and Cubism:

Although the foreword advises us in pedantic tones that this artist "owes nothing to the Ecole de Paris," we cannot but notice that a certain view of Notre-Dame would have been impossible had M. Beckmann been unfamiliar with Henri Matisse's studies. The Fish is the pretext for a painting in which at least one of the figures owes much to Picasso. If we take the analysis still further and seek the origins of various details, we will come up with other names. M. Max Beckmann, with his original temperament, which is the essential aspect, may not be quite so far removed from our Cubists as one might have us believe. Though the rhythms he creates are, on the whole, devoid of subtlety, they are nevertheless solid and robust, and possess an essentially cerebral equilibrium.[22]

Paul Fierens, on the other hand, writing in the *Chronique artistique* of *Nouvelles Littéraires*, underlines Beckmann's individuality as a positive trait. In spite of certain affinities with the Ecole de Paris, the substantial differences cannot be overlooked:

After Picasso's guitar, this saxophone has a truly visceral impact. One can hardly resist the orders, the commands uttered by the raw and guttural voice of this artist convinced of his power over things, the interpretation of which – in all their harshness, bold simplicity, eloquent exaggeration – bears the seal of greatness. A Frenchman, perhaps offended by this art, recognizes in it nothing of the things he admires in Matisse, Derain, Braque or even Rouault. … The shock of Beckmann is like a punch in the stomach. But it is undoubtedly a friendly nudge, a kind of challenge.[23]

Another critic reacted very sensitively to what he saw as a particularly clever strategy of Beckmann's in his portrait of the famous Parisian actress, Valentine Tessier (cat. 16, p. 151). The *Carnet de la Semaine*[24] did not see in it a homage to the Paris audience, sensing instead base caricature and the stench of treason:

Beckmann's painting does not lack lustre or luminosity. But it is neither modulated nor regulated. His palette is one of garish virulence in which everything looks the same. It is a thoroughly aggressive style: wooden figures, no sense of rhythm. The words cadence,

charm, grace have no meaning for this artist. He simplifies and schematizes landscapes and humans alike with the same harshness. … One of his pictures bears the title Portrait of Valentine Tessier. On approaching it, I think of the grace of this sinuous actress. Yet M. Beckmann has transformed this exquisite creature into a lifeless mannekin dressed in a gown of metallic blue, with bovine eyes, heavy arms, and the rough hands of a milkmaid. Caricature and treason. In short, this M. Beckmann … is a kind of Fernand Léger from the banks of the Spree.[25]

Inept Art Policy and the German Response

There was little response to Beckmann's Paris exhibition in the German press. There would have been still less had the exhibition not triggered a debate about Germany's art policy in general. Yet even those articles that did not actually address what Beckmann himself described bemusedly as the "*Beckmann-cravalle*"[26] tended to focus on how a modern German master would be regarded in Paris, that bastion of modern masters.

First of all, the opening of the exhibition was reported. Beckmann had planned his entrance on the scene with care. Most of his local supporters, including Lilly von Schnitzler and Käthe von Porada, were friends from Frankfurt. The first report, written by Benno Reifenberg, was published in the *Frankfurter Zeitung* and announced, hardly surprisingly, a resounding success.

> The opening itself was a highlight of the Parisian art world's season. The French Minister of Education and Arts, M. Mario Roustan, was there in person, as was Herr von Hoesch, the German Ambassador to Paris, and an astonishing number of Parisian art lovers and interested parties who regarded the paintings attentively and with undoubted respect. … The hanging of the exhibition is exemplary, with the paintings displayed in an astonishingly harmonious sequence, creating a wonderfully rich and mysterious world.[27]

Reifenberg closed with the announcement of a forthcoming detailed review of the exhibition in which he claimed he would "discuss at length the reception among the French public." The review duly appeared in the *Frankfurter Zeitung* on 1 April 1931. Based on a highly selective collection of quotes, it created an overall positive impression. Reifenberg underlined the French state's purchase of the *Forest Landscape with Woodcutter*:

> … The purchase of Beckmann's Woodcutter (painted in 1927) by the French state is remarkable in that it marks the first acquisition of a German painting by the Luxembourg Museum in decades. … More important still than such external considerations is, however, the question of the impact in France …[28]

Reifenberg also pointed out the allegedly great public success and an impact on young Parisian artists, which he deduced from seeing a young visitor copying a painting into his sketchpad.

An article in the *Münchner Neuesten Nachrichten* of January 1931 indicates that even before the exhibition opened, the German critics were already worried about the effects of confronting the French public with Beckmann's "German" art. Their fears were often expressed with no knowledge of how Beckmann's art had actually developed over the past few years or just what he intended to show in Paris.

> It will be interesting to see how the Parisian public reacts to the distinctly Germanic-Nordic
> essence of this painting, whose author … influenced by the works of Grünewald and Hol-
> bein (master of the Dominican altarpiece in the Städel Museum in Frankfurt) and who may
> be described as the modern upholder of the spirit of German late Gothic.[29]

A report in the *Berliner Tagblatt* (March 1931) emphasized once again the political impor-tance of the event, as manifested by the state purchase.[30] The exhibition was seen as mark-ing "a new date in postwar Franco-German artistic relations." Here, too, it is the acceptance of German art that is the focal point, and the reporter expresses more hopes than analyses:

> The impression one had at the Beckmann opening was that the artistic personality of Beck-
> mann, however foreign, does have a chance of making a mark in Paris. The willingness of
> the French to open their minds to the spiritual and intellectual movements of "Europe"
> may well play a role in this respect.[31]

There are more skeptical voices. Writing in the *Weltkunst* of March 1931, Fritz Neugass reports a "strange and alienating feeling at seeing the works of this painter in Paris," given that "Beckmann's almost demonic obsession" did not always strike the author as particular-ly pleasant. What is more, Neugass was one of the few critics to address one of the most crucial aspects, namely that Beckmann in Paris was showing himself quite consciously from his French side. Neugass was concerned about this strategy, and one can read between the lines an accusation that the artist is disguising his true self, a claim that cannot be entirely denied:

> Everywhere in his most recent works, all of them created in Paris, one finds him addressing
> the problems of the Ecole de Paris. In his little green still life of 1929 we can sense some-
> thing of Braque and his Portrait of Mme Tessier of 1930 has something of Picasso's female
> figures. His *Self-Portrait with Saxophone*, another recent work, does have that strong inner
> tension that is so distinctive of Beckmann's early works. In Paris, Beckmann will not easily
> find favor, for his painting is too heavy and too problematic and his palette is not subtle
> enough.[32]

It is part of the rhetoric of polemics to weave a straw doll before our very eyes, only to send it up in flames. Here, it is Beckmann's alleged national representational role that serves this purpose. Years before the exhibition, the German press had noted his international ambi-tions. From this, it was deduced that Max Beckmann alone had to represent "German art" to the rest of the world. Therein lies a certain irony, given that Beckmann had always been

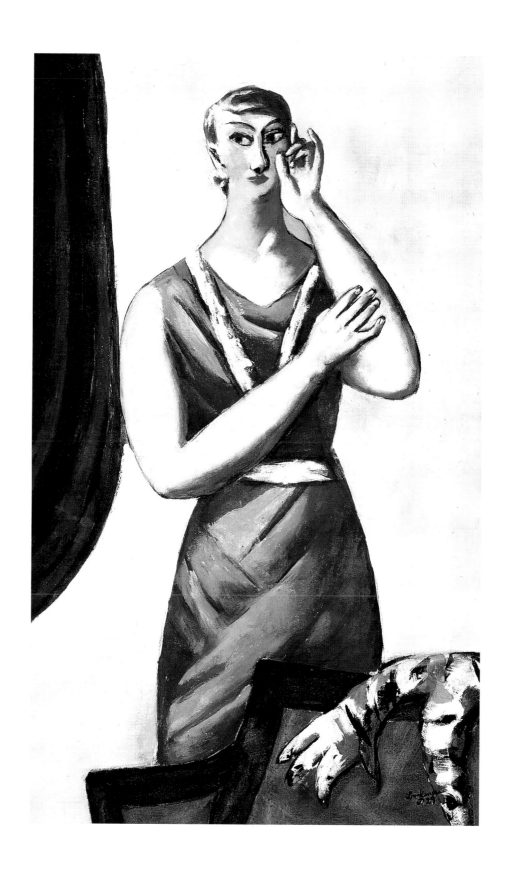

16 Max Beckmann, *Portrait of Valentine Tessier*, 1930

careful to avoid being seen as a "German artist" in Paris. In Germany, no one had noted that strategy, with the result that all the articles on the exhibition are concerned primarily with the question of whether and how this supposed representational claim might be legitimized.

Beckmann is praised as the most outstanding representative of German art. He has become an international name. Pampered by critics, wooed by dealers, valued as "business" by collectors. Yet a look at his overall œuvre indicates that foreign countries may well be interested in supporting an original and strong German talent, but not in supporting the representative of a typically solid and earthy German art and mindset. This exhibition shows neither the direction nor the value of German art.[33]

Things came to a head on 2 April 1931. Hans F. Secker, former director of the Wallraff-Richartz Museum in Cologne, and later an art dealer, published a vehement attack on Max Beckmann and his Paris exhibition in the *Kölnische Zeitung* under the title "Ungeschickte Kunstpolitik" (Inept Art Policy).[34] Secker compared the Paris exhibition with the fatal goal scored against itself by the German soccer team in a recent match against France, adding:

Any German who wishes to be a patriot in the best sense of the word must hope that this exhibition will be quietly ignored ... and that it will soon be forgotten.[35]

Beckmann's agent Alfred Flechtheim countered Secker's article with one of his own in the *Frankfurter Zeitung* of 9 April, under the title "Ungeschickte Kunstpolitik oder Max Beckmann und die Kartoffelbrater" (Inept Art Policy or Max Beckmann and the Potato-Fryers). Basically, he accused Secker of purely mercantile interests. This art dealer posing as a critic, he claimed, would probably have preferred to see the artists he himself represented being exhibited in Paris. Secker replied immediately in the *Kölnische Zeitung* with an article headed "Herr Flechtheim als Schutzengel" (Herr Flechtheim as Guardian Angel), in which he sought to show up Flechtheim's defence of Max Beckmann as pure sales propaganda.

So brief but venomous an exchange may be dismissed as nothing but a skirmish between jealous art dealers. Yet there are two points worth noting. One is the fact that Secker was by no means an enemy of modernism nor was he a propagator of some Aryan ideal of "purity" in art. He proposes Kirchner as an alternative to Beckmann, for instance, and he also praises the Kokoschka exhibition at the Galerie Georges Petit. Whether Secker really was pursuing a German art policy that sought to tell the French what France was meant to understand and appreciate is a moot point. In disqualifying Beckmann with such vehemence, however, he was in fact speaking a few bitter truths that the painter would have to face up to in coming years:

The fact that none other than this controversial painter should be shown in Paris in a major exhibition was a deeply regrettable error in an art policy that ought to take into account the mindset of other countries in such cases. Nothing is or remains more alien to the French than Beckmann's harsh, tormented, insistent and distorted means of expression.[36]

The Paris public's indifference confirmed Secker's views. (Similar in content, if more tempered in tone, was Günter Metken's reaction to the retrospective exhibition of Beckmann's work at the Musée national d'art moderne almost four decades later).[37]

Soon, others entered the fray. Although Paul Westheim put himself at a distance from certain admirers who "make a cult of this Beckmann-mania," he felt he had to complain about "the way the German artist is combated" (in *Berliner Börsenzeitung*). Georg Swarzenski, director of the Städel Museum in Frankfurt, whose support for Beckmann was considerable and who purchased a number of Beckmann's works for his museum, made a case for reason to prevail in the *Frankfurter Zeitung*.

[Secker's] claim that he acts in the interest of German art and German art policy cannot go unchallenged. After all, Beckmann's art is regarded in Germany at least, and to some degree abroad as well, as serious and significant. The attack on Beckmann and his Paris exhibition is therefore damaging to Beckmann's art and German art or, rather, an attempt to damage it.[38]

Even Wilhelm Uhde, doyen of German art criticism, gave his essay the title "Der Streit um die Pariser Beckmann-Ausstellung" (The Quarrel about the Paris Beckmann Exhibition)[39]. His essay, however, is interesting for a different reason. Uhde, who was anything but a fan of Beckmann's work, must be given credit for being the only one to look really closely at the paintings. What is more, he actually revised his opinion of Max Beckmann at the Paris exhibition:

I did not go to the Beckmann exhibition in a festive mood ... My view of Beckmann was less than favorable. I had in mind an exhibition I had seen in Frankfurt several years ago: strained, large-scale pictures trying hard to be Faustian, but looking more like a mere cramp in the leg that had transferred to the brain. ... Then I went up to the paintings, moved in close to each one, so close that they hardly had any illustrative effect any more. And suddenly I saw something entirely different: hands, wonderfully painted, set against a harmony of black, gray and dark red (Portrait of an Argentinian). Time and time again these hands, remarkably well done, then the ample, rich baroque of that large nude. Two ladies at the window, with that noble movement of the hand that is universal and common to all good painters of all times. And then, in my personal opinion the most beautiful painting of all, a woman with her arm raised and holding a small mirror in her hand. It could be hung anywhere in Paris alongside some very good paintings, and it would assert itself. It is all cumulative, the last paintings are the best; the influence of French finesse is making its mark. The man is strong enough to bear it.[40]

Among the German critics, Uhde was the only one to have known the Paris art scene so well over such a long period. His commentary on the art policy of Beckmann and his friends summed up their problems succinctly. His opinion on the allegedly sophisticated cultural policy orchestration of the exhibition was more than confirmed by the course of events:

One should avoid inaugurating such exhibitions in a manner practiced in Paris only in the case of great Frenchmen no longer living or South American painters of kitsch who are still alive. That is to say, with ambassador, government officials, a so-called "state purchase" and such like. In this case, the machinery was further oiled by the involvement of the Europäischer Kulturbund, a bevy of friends, preliminary teas and dinners. When Picasso has an opening, there are a few people gathered contemplatively before his paintings. Henri Matisse recently had an exhibition of sculptures at a small gallery on the Left Bank, without the slightest ado. If such modest behavior is considered the thing to do among the most famous Parisian artists, then unknown foreigners who have not been extended a special invitation to exhibit should not be introduced right from the start with all the pomp and circumstance of an assured triumph.[41]

The art historical quarrel that raged so heatedly in Germany was regarded by Uhde with utter sang-froid. He knew that Beckmann would not be a sensational success in Paris, but he also knew that it did not matter very much:

From my statement it is clear that I consider an exhibition of Beckmann's work in Paris to be both good and useful. The fact that it met with little favor and had such a cool reception – we should not be misled by a handful of polite press reports – is no reason to think otherwise. If three or four serious and important supporters can be found, then that counts for a lot. Beckmann's works should continue to be shown here, and I am sure that one day, in accordance with their value, they will be appreciated and will receive the ranking they deserve.[42]

Uhde's prophecy has yet to be fulfilled. Although the situation may have improved somewhat since 1968, a glance at the titles of the articles published on the occasion of the Beckmann retrospective exhibition at the Musée national d'art moderne shows that Beckmann got away quite lightly in 1931. Paris, in the tumult of the student revolts of 1968, saw in him only a "second-rate expressionist," "a vital monster," "a terrifying narcissist," "a gloomy view" and, *plus ça change*, "an unknown German."[43]

(Translation: Ishbel Flett)

1 The basis of this brief synopsis was a "scrapbook" kept by Mathilde Q. Beckmann. The scrapbook was a large album in which she kept all the press reports on her husband. Today, it is part of the Beckmann estate, and we wish to thank the Beckmann family most sincerely for allowing us to study and use this unique source. Because Mathilde Beckmann's interest was not primarily historical or philological, she did not always give precise details of the publications for the individual articles. This lack of information is also reflected in some aspects of our report. A search for the original sources would have involved a great deal of time and energy that we felt would be more usefully employed on other aspects. No doubt this research will soon be carried out. In the meantime, it should be borne in mind that the matter itself is more important here than these notes.
I wish to thank the following persons: Laurent Bruel for collecting information on the Paris press of the 1930s, Paola von Wyss-Giacosa for assisting with the documentation and, in particular, Laurentia Leon for translating the quotations into German.

2 See Birgit and Michael V. Schwarz, *Dix und Beckmann. Stil als Option und Schicksal*, Mainz 1996.

3 *L'Illustration* was regarded as a quality newspaper of international standing during the interwar years. A right-wing publication, it was nevertheless against the extreme-right Front populaire, especially under the influence of Robert de Beauplan.

13 Max Beckmann, *Portrait of Gottlieb Friedrich Reber*, 1929

4 "Un Allemand à la Galerie de la Renaissance, M. Max Beckmann, un Autrichien chez Georges Petit, M. Kokoschka, sont les maîtres de la déformation. Mais, tandis que chez le premier nous en somme à l'enfantillage avec toutes les erreurs accumulées, déjà reniées par nos fauves repentis, il y a chez le second un sens indiscutable de la couleur. Encore faut-il admettre que la réalité ne compte pas ou qu'on peut prendre avec elles toutes les libertés. Nous ne croyons pas que ces deux éléments étranger et d'importance, nous dit-on, apportent quelque richesse à notre art."

5 *L'Ami du peuple* was founded in 1928 by Francois Coty, then the proprietor of *Figaro*. Right-wing and demagogical, the newspaper put out a populist call for "the support of honest people against the evil forces of politics, the secret power of money and business, the intrigues of evil and the stupidity of the administration."

6 "La funeste idée de l'abandon du sujet et de l'imagination a conduit à prendre le moyen pour le but en déifiant 'la peinture pure'. Résultat final, actuellement trop visible à tous: un art inhumain, aussi glacial et ennuyeux que la mentalité des 'purs intellectuels': un art dévoyé soit vers une géométrie et une mécanique (Picasso, Braque, Léger, Miro), soit vers des monstres, en haine de toute normalité des êtres, comme on le voit dans l'épouvantable cafouillis de cette exposition Beckmann qu'on a eu récemment le toupet de nous infliger, par une sorte d'Anschluss entre trafiquants parisiens et berlinois." *L'Ami du peuple*, March 1931.

7 "Ce sont d'inénarrables bonhommes de la foire au pain d'épices biscornus, ignoblement cocasses, revêtus de placages de couleur que désavouerait le moindre badigeonneur du murailles."

8 "Un métèque qui, ornant Paris depuis de longues années, n'a pu encore apprendre le français."

9 "Une espèce de margotin semi-brulé représentant censément une foret, du genre qui ne trouve même pas acquéreur au marché aux puces."

10 "Le prestige de Beckmann en Westphalie est parait-il, considérable. Ses admirateur l'appellent 'le Cézanne allemand'. Il les a domptés par une main de fer. L'Europäischer Kulturbund nous révèle ce nouveaux dieu."

11 "Jamais on ne disciplinera plus âprement le apparences. L'éloquence funèbre de ces vastes morceaux où souvent, le noir domine, l'exaltation de la forme jusqu'au paroxysme, des cernes durs, des tons entier, plats, cruels, une brutalité systématique, l'amour du colossal – qu'il s'agisse d'un poisson, d'un magnum, d'une figure – imposent aux spectateurs des coups répétés. J'imagine que, là encore, nos réactions sont assez différentes de celles de nos voisins et que cette grandeur-là, nous manquons d'instruments pour la mesurer."

12 *Le Journal des Débats* was a quality middle-of-the-road publication, a major daily newspaper of the leading classes, increasingly in competition with *Le Temps*. On home affairs, the paper was distinctly right-wing, especially under the influence of economic interests; in foreign affairs, where Germany was concerned, it closely reflected the opinions current in French diplomatic circles.

13 "Cherchons ici précisément ce qui manque parfois à nos maîtres subtils, distingués, nuancés: la grandeur, la monumentalité des formes, la crudité du ton, une espèce de vulgarité épique. L'art de Beckmann nous apporte autre chose que des accords de valeur, des équilibres de motifs: une recréation du monde par un plasticien qui s'empare de la réalité et qui, sans esprit de système, la transfigure en quelque chose de plus concret qu'elle-même, de plus vrai que le vrai, de plus impressionnant que l'impression." *Le Journal des Débats*, March 1931.

14 *Le Soir* had been a business newspaper since the end of the nineteenth century. During the interwar years, it was right-wing.

15 "Cet art ne correspond pas à notre tempérament. Nous avons besoin d'un certain effort pour l'admettre. Mais nous nous apercevons vivement, en contemplant d'autres expositions de peintres plus proches de nous par la palette, la technique, une sensibilité plus intime, que seulement où la discussion est possible, l'art se trouve réellement. ... J'ignore Max Beckmann sera le Rédempteur – fût-ce de l'art – mais je puis au moins continuer à croire, avec son apport, qu'une œuvre, pour amener quelque chose de neuf à une époque, doit fatalement exciter autour d'elle d'après tournois."

16 *Paris-Soir* was a leading populist newspaper after it was taken over by Jean Prouvost in 1930. Founded in 1923 by Eugène Merle as a "daily financial paper" and then as a left-wing publication, it represented a moderate political line from 1925 onwards. Under Prouvost it avoided precise statements on home affairs.

17 "Dès l'abord Max Beckmann apparaît spécifiquement allemand; ce qui, d'ailleurs, est à mes yeux un mérite. ... Max Beckmann se présente avec des défauts et des qualités qui sont bien à lui et se place de la sorte sur un plan de franchise dont il faut le féliciter. ... Waldemar George, qui a Préfacé le catalogue, appelle Max Beckmann: peintre allemand et peintre européen. Pourquoi? Peintre allemand et peintre humain: oui. En art il n'y a ni Allemagne, ni France, ni Europe; il y a des hommes et cela seul compte."

18 *Le Figaro* was headed by Francois Coty from 1922 onwards. After that the newspaper had been right-wing and even favored Mussolini. Since 1934 it pursued a moderate line, adopted a classical conservative stance and put itself at a distance from the extreme-right fascists.

19 "C'est véhément, massif, truculent, et – on est bien forcé d'appliquer le terme, – colossal. ... Imaginez quelque chose comme un Picasso germanique (mais c'est Picasso qui a commencé) ou bien, s'il m'était permis de parler musique, un Hindemith déchaîné. Evidemment cet art est expressive d'une race, mais point de la notre. La commune mesure nous manque, et l'on conçoit pourtant que cette peinture convienne à un public avide de sensations fortes. Certaines synthèses outrées, outran-

cières, nous font reculer de trois pas. C'est un résultat physique tout au moins. Mais après avoir parcouru ces toboggans de l'art, restons la nation grise, sombre, et si c'est possible spirituelle."

20 "En somme, historiquement et logiquement c'est la suite de Boecklin à Corinth et de Corinth à Beckmann."

21 *Comoedia* never regained the position it had enjoyed before the first world war: mainly focused on the world of the stage and, increasing the cinema, it remained apart from the great literary movements of the day.

22 "Bien que la préface nous avertisse doctoralement que cet artiste 'ne doit rien à l'école de Paris' force est de constater que certaine vue de Nôtre-Dame ne serait point telle si les recherches d'Henri Matisse étaient inconnues de M. Beckmann. Le Poisson est prétexte à un tableau où sont des personnages dont l'un, au moins, doit beaucoup à Picasso. Et si l'on voulait pousser cette analyse, rechercher les sources plus ou moins lointaines de divers détails, d'autres noms seraient à prononcer. M. Max Beckmann, avec un tempérament original, ce qui d'ailleurs est l'essentiel, n'est peut-être pas aussi loin de nos cubistes qu'on voudrait nous faire croire. Mais si les rythmes qu'il établit sont dans leur ensemble peut subtils, ils n'en restent pas moins solides et robustes, dans un équilibre essentiellement cérébral."

23 "Après la guitare de Picasso, ce saxophone qui vous saisit aux entrailles. On ne résiste point aux ordres, aux commande-ments lancés d'une voix gutturale, rauque, par cet artiste convaincu de son pouvoir sur les choses et dont toute interprétation – avec des duretés, des simplifications hardies, des amplifications éloquent – porte le sceau de la grandeur. Un Français, que cet art scandalise peut-être, n'y reconnaît rien de ce qu'il admire chez Matisse, Dèrain, Braque et même Rouault. … On reçoit le choc de Beckmann comme un punch dans l'estomac. Bourrade amicale sans doute, qui ressemble à un défi."

24 The *Carnet de la Semaine* did not represent any political party and pub-lished all manner of opin-ions. It was founded and run by Henri Fabre, founder of the Journal du peuple, a newspaper asso-ciated with the Commu-nist Party.

25 "La peinture de Beckmann n'est pas dépourvue d'éclat, de luminosité. Mais cela n'est ni modulé, ni réglé. Un coloris d'une virulence flamboyante, mais où tout est égal. Un style résolument agressif; des personnages en bois; aucun sens du rythme. Le mot cadence, charme, sou-plesse, sont dénués de sens pour cet auteur qui simplifie, schématise avec dureté le site comme l'être humain. … Une toile s'in-titule: Portrait de Valen-tine Tessier. Je m'en approche, songeant à la grâce de cette sinueuse comédienne. Or?? M. Beckmann a mué ce mod-èle exquis en un man-nequin inerte chargé d'une robe de métal bleu, qui a des yeux bovins, des gros bras et des mains épaisses de vachère. Caricature et trahison. Pour me résumer, ce M. Beckmann

… est une manière de Fer-nand Léger des bords de la Spree."

26 "Haben Sie die lächerliche Seekesche Flechtheim Beckman[n] cravalle in den Zeitungen gelesen. Trotzdem ist Bing ernster als je bei Unser[er] Sache. (Have you read the ridicu-lous Secker-Flechtheim Beckman(n.) cravalle in the newspapers. Neverthe-less Bing is behind us more earnestly than ever.) From the collected letters of Max Beckmann: *Briefe*, vol. 2 no. 562.

27 "Der Akt der Vernissage gestaltete sich zu einem Ereignis dieser Saison des Pariser Kunstlebens: der französische Minister für Unterricht und schöne Künste, Herr Mario Rous-tan war persönlich erschienen, von deutscher Seite Herr von Hoesch, der Botschafter in Paris, mit ihnen eine erstaunliche Anzahl Pariser Kunstfreunde und Kunstinteressierter, die mit Aufmerksamkeit und zweifellosem Respekt die Bilder betrachteten. … Die Ausstellung ist exemplar-isch gut gehängt: die Tafeln folgen einander in erstaunlicher Harmonie und weiten sich zu einer wunderbar reichen und geheimnisvollen Welt."

28 "… Der Ankauf der 'Holzfäller' von Beckmann (gemalt 1927) durch den französischen Staat ist insofern bemerkenswert, als damit zum ersten Mal seit Jahrzehnten ein deutsches Bild in das Lux-embourg-Museum einziehen wird. … Aber wichtiger noch als derar-tige äußere Wirkungen wäre es, festzustellen, wie die innere Effekte sind."

29 "Es wird interessant sein, zu beobachten, wie das Pariser Kunstpublikum auf das ausgesprochen

deutsch-nordische Wesen dieser Malerei reagieren wird, deren Schöpfer … wohl am meisten vom Beispiel Grünewalds und des alten Holbein (des Meisters des Dominikaner-Altars im Frankfurter Städel) berührt, in nicht geringem Maß als der moderne Fortsetzer des Geistes deutscher Spät-gotik bezeichnet werden darf."

30 See article on *Forest Land-scape with Woodcutter* and *The Small Fish.*

31 "… der Eindruck, den man bei der Beckmann-Vernissage hatte, war doch der, das die künstlerische Persönlichkeit Beckmanns trotz ihrer Fremdartigkeit auch in Paris Chancen hat, sich durchzusetzen. Die größere Bereitwilligkeit der Franzosen, sich den geistigen Strömungen 'Europas' zu öffnen, mag dabei eine Rolle spielen."

32 "Allenthalben findet man in seinen letzten Werken, die alle in Paris ent-standen sind, eine Berührung mit den Proble-men der 'Ecole de Paris.' In dem kleinen grünen Stilleben von 1929 spürt man etwas von Braque, und das Portrait der Mme Tessier von 1930 ist nicht ganz unberührt von dem Typus der Frauengestalten Picassos. Sein *Selbstbildnis als Saxophonspieler* aus dem letzten Jahre hat jedoch wieder die starke innere Spannung, die besonders den Beckmannschen Werken der frühen Jahre eigen ist. In Paris wird Beckmann nur schwerlich Sympathie finden, da seine Malerei zu schwer und zu problematisch und seine Palette nicht subtil genug ist."

33 "Man preist Beckmann als den hervorragendsten, repräsentativsten Vertreter der deutschen Kunst. Er

ist international geworden. Verwöhnt von der Kritik, vom Kunsthandel umworben, von den Sammlern als 'Geschäft' gewertet. Überblickt man aber diese Gesamtschau seines Schaffens, so muß man feststellen, daß das Ausland sich wohl für ein originelles und starkes deutsches Talent einsetzt, aber nicht für den repräsentativsten und typisch bodenständigen Vertreter deutscher Kunst und Gesinnung. Es ist weder Richtung noch Wert der deutschen Kunst mit dieser Ausstellung gekennzeichnet." Johannes Reichelt writing in the newspaper *Neue Preussische Kreuz-Zeitung*, Berlin, November 1930.

34 For further information on the Secker controversy, see Susanne Rother, *Max Beckmann – der Maler im Urteil seiner Zeitgenossen 1917–1933*, Cologne 1985.

35 "Jeder Deutsche, der im besten Sinn Patriot sein will, muß dieser Ausstellung wünschen, daß sie … still und unbesucht bleiben möge … und daß sie recht bald in Vergessenheit gerate."

36 "Daß man nun in Paris mit großem Aufwand ausgerechnet diesen umstrittenen Maler als Vertreter deutscher Kultur ausstellte, das war ein tief bedauerlicher Fehler unserer Kunstpolitik, die in solchen Fällen Rücksicht auf die Denkweise des Auslands zu nehmen hat. Nichts aber ist und bleibt den Franzosen in höherem Masse wesensfremd als diese harte, gequälte, aufdringliche und verzerrte Ausdrucksweise Beckmanns."

37 See note 43.

38 "Es muß widersprochen werden, wenn er [Secker] behauptet, daß sein Vorgehen im Interesse der deutschen Kunst und der deutschen Kunstpolitik liege. Denn tatsächlich wird Beckmanns Kunst zum mindesten in Deutschland aber teilweise auch im Ausland, als eine ganz ernsthafte und wesentliche Erscheinung im Rahmen der heutigen deutschen Kunst angesehen. Deshalb bedeutet der Angriff gegen Beckmann und seine Pariser Ausstellung – ganz unabhängig von den Motiven und eventuellen Wirkungen – eine Schädigung der Kunst Beckmanns und der deutschen Kunst, oder richtiger: den versuch ihrer Schädigung."

39 *Das Tagebuch*, 12, 1931, pp. 745–48.

40 "Ich bin zu der Beckmann-Ausstellung nicht wie zu einem Fest gegangen. … Mein Urteil über Beckmann war nicht günstig. Ich dachte an eine Ausstellung vor vielen Jahren in Frankfurt; das waren verkrampfte, gerne große Bilder, die faustisch sein wollten, aber doch nur wie ein ins Gehirn gestiegener Wadenkrampf wirkten. … Dann aber näherte ich mich den Bildern, schritt an jedes ganz dicht heran, so dicht, daß das illustrative kaum noch Wirkung hatte. Und sah plötzlich etwas ganz anderes: Hände, wunderbar gemalt, vorgelagert einer Harmonie von Schwarz, Grau und dunklem Rot (Portrait eines Argentiniers). Immer wieder Hände, bemerkenswert gut gestaltet. Dann der große Akt, üppig reiche Barockkunst. Zwei Damen am Fenster, mit welch nobler Handbewegung, die international und allen guten Malern aller Zeit gemeinsam ist. Und dann, für meinen Geschmack das schönste Bild, eine Frau mit erhobenem Arm, die mit der Hand einen kleinen Spiegel hält. Das könnte man überall in Paris neben ganz gute Bilder hängen, und es würde sich halten. Das alles ist aufsteigend, die letzten Bilder sind die besten; der veredelnde französische Einfluß macht sich geltend." (see note 39).

41 "Man vermeide, dergleichen Ausstellungen so zu eröffnen, wie man es in Paris sonst nur tut, wenn es sich um große französische Tote oder um südamerikanische lebendige Kitschmaler handelt. Das heißt mit Botschafter, Unterstaatssekretären, einem sogenannten 'Ankauf durch den Staat' und dergleichen. In diesem Fall war der Apparat verstärkt durch den Europäischen Kulturbund, einen Freundeschor, vorangehende Tees und Diners. Wenn Picasso eine Vernissage hat, so sind ein paar andächtige Leute von den Bildern vereint. Henri Matisse hatte kürzlich eine Ausstellung seiner Skulpturen in einer kleinen Galerie des linken Ufers, ohne die geringste Aufmachung. Wenn so bescheidenes Benehmen der berühmtesten pariser Künstler als gute Sitte gilt, sollte man hier unbekannte Ausländer, die auszustellen nicht besonders eingeladen wurden, auch nicht von vornherein als Triumphatoren prunkhaft und siegesgewiß einführen." (see note 39).

42 "Aus meiner Stellungnahme ergibt sich wie von selbst, daß ich eine Ausstellung des Werkes von Beckmann in Paris für gut und nützlich halte. Daß sie wenig Teilnahme fand und kühl beurteilt wurde – man lasse sich nicht durch eine Handvoll höflicher Pressestimmen irremachen – ist kein Grund dagegen. Sind drei oder vier ernsthafte und wichtige Anhänger gefunden, so wiegt das schwer. Man sollte weiter hier Bilder Beckmann zeigen, und ich bin sicher, daß sie eines Tages, ihrem Wert entsprechend, geschätzt werden und den Rang erhalten werden, den sie verdienen." (see note 39).

43 "un petit-maitre de l'espressionisme," un monstre de vitalité, "un narcisse inquiétant," un regard sombre, "un allemand inconnu." See the following articles published in various German daily newspapers: Werner Spies, "Barrieren der Verständigung, Französische Stimmen zur Max Beckmann-Ausstellung," published in *Frankfurter Allgemeine Zeitung* on 14 October 1968 and Günter Metken, "Das verpasste Rendezvous." Zur Beckmann-Ausstellung in Paris, published in *Der Tagesspiegel, Unabhängige Berliner Morgenzeitung*, on 26 October 1968 (the same article was also published in *Frankfurter Rundschau* on 22 October 1968 and *Stuttgarter Zeitung* on 25 October 1968 under the title "Ein unbekannter Deutscher. Zur Beckmann-Ausstellung im Musée National d'Art moderne").

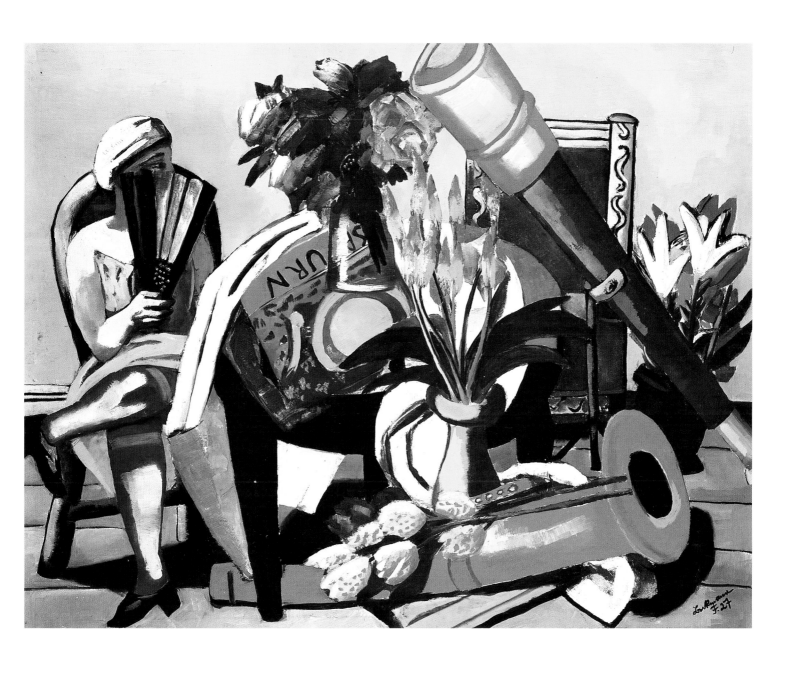

Fig.3 Max Beckmann, *Large Still Life with Telescope*, 1927

Beckmann in Paris

with contributions by

Tobia Bezzola

Laurent Bruel

Ursula Harter

Cornelia Homburg

Barbara Stehlé-Akhtar

A Chronology

23 September
Max Beckmann arrives in Paris. He stays only long enough to make preparations for his forthcoming studies and rents a studio in the Rue Notre-Dame-des-Champs.

From early October – first December
Beckmann attends courses at the Colarossi and Julian private academies of art. Frequents cafes and cabarets. It is not known whether he visited the first Salon d'Automne.

15 December
Beckmann travels to Amsterdam to see Minna Tube.

1904

2 January
Returns to Paris.

2 February
Beckmann and Edvard Munch both spend the evening at the Closerie des Lilas, but do not actually meet each other.
Visits the Salon des Indépendants

Late March – 14 April
Beckmann's first sojourn in Paris is nearing an end.
He returns to Berlin via Chalon sur Saone and Geneva.

1906

22 September – 14 (?) October
Max Beckmann and Minna Beckmann-Tube spend their honeymoon in Paris at the Rue Lalo.

1908

Third visit to Paris.

1909

1 October – 8 November
Beckmann attends the Salon d'Automne.

1925

27 – 31 July
Meets I. B. Neumann at the Hotel California.

23 July
Visits the exhibition of *25 peintres contemporains* at the Galerie Druet, which includes works by Bonnard, Rouault, Picasso and Matisse.

31 July
Beckmann visits Versailles. Dinner at the Ritz Hotel with his future sister-in-law Hedda and her first husband, the sculptor Toni Stadler. A student of Maillol, he had married the sister of Mathilde Kaulbach that year. The couple lived in Paris from 1925 to 1927.

1926

Käthe von Porada moves to Paris.

March
Beckmann takes part in an exhibition of prints at the Galerie Billiet, Rue La Boétie no. 30 in the 8th arrondissement.

11 – 15 August
Beckmann and I. B. Neumann meet in Paris. Beckman stays at the Hotel Foyot.

13 August
Travels to Dieppe.

15 August
Leaves Paris.

1927

The names Waldemar George and Philippe Soupault crop up for the first time in Beckmann's correspondence.

5 – 14 January
Takes part in the *Multi-National* exhibition at the Galerie Bernheim-Jeune.

10 – 12 October
Stays at the Hotel Scribe in Paris.

5 November – 18 December
Beckmann is represented at the Salon d'Automne.

1928

9 – 14 September
Beckmann sees Minna Tube again in Paris.
They meet at the Hotel Claridge.

1929

10 June – 8 July
Takes part in the *Exposition des peintres graveurs allemands contemporains* at the Bibliothèque National in Paris.

10 – 14 July
Beckmann stays at the Hotel Foyot, where he makes preparations for moving to Paris. He finds a studio on Boulevard Brune and an apartment in the Rue d'Artois, both of which he uses from September onwards.

Between 15 and 20 September
Paris becomes Beckmann's main domicile.

8 November
Beckmann, his wife and Käthe von Porada attend the première of *Amphitryon 38* at the Comédie des Champs-Elysées with Valentine Tessier in the leading role.

1930

Beckmann and his wife move to the Rue des Marronniers.

15 January – 8 February
Takes part in an exhibition of portraits at the Galerie Mettler.

27 March
Beckmann travels to the French Riviera for a few days.

18 June – 15 November
Beckmann travels to Frankfurt am Main and Ohlstadt, Germany, and to Badgastein in Austria.

16 November
Returns to Paris.

1931

Travels to Germany and Switzerland: Frankfurt am Main, Munich, St Moritz, Frankfurt am Main.

29 January
Returns to Paris.

8 February
Günther Franke visits Beckmann in Paris.

Late March
Visits Frankfurt am Main.

1 April
Returns to Paris.

16 March – 25 April
One-man show at the Galerie de la Renaissance.

April
Travels to the French Riviera. Visits Julius Meier-Graefe at La Ciotat.

1 – 5 May
Visits Frankfurt am Main.

5 May
Returns to Paris.

May
An exhibition project at the Galerie Bignou fails to materialize. Beckmann's works are shown at the Galerie Bing & Cie. instead.

25 May
The French state purchases Beckmann's 1927 painting *Forest Landscape with Woodcutter* (G 273) for the Musée du Jeu de Paume.

Early June – 20 June
Visits Frankfurt am Main.

2 June – early July
Brief visit to Paris. Beckmann spends the summer in Germany.

17 – 22 November
Stays in Paris.

1932

At the beginning of the year, Beckmann meets the German art historian Erhard Göpel in Paris.
At the end of the year, the economic crisis forces him to give up his Paris apartment and studio.

20 May – 10 June
One-man show at the Galerie Bing & Cie., attended by Beckmann personally.

7 July
Frankfurt am Main. Beckmann spends most of the summer in Germany.

First week of August
Stays in Paris

9 August
Travels to Frankfurt am Main

16 – 18 December
Returns to Paris

23 December – 8 January 1933
Paris. Beckmann finally gives up his studio.

1933

Stephan Lackner, whom Beckmann had met in Berlin, moves to Paris

15 October
The French state purchases *The Small Fish* (1933, G 373) for the Musée du Jeu de Paume.

1934

25 June – early July
In Paris, Beckmann meets Wilhelm Uhde. He also meets Heinrich Simon, in exile in Paris. Endeavors to make new contacts in the Paris art world, especially Bing, through Käthe von Porada. Beckmann and his wife consider leaving Germany for good to settle in Paris or Amsterdam.

1936

26 October
Rendezvous with Stephan Lackner in Paris.
Beckmann plans to emigrate, either to Holland, France or the United States.

1937

With their chances of being able to stay in Paris fading, Beckmann and his wife rent an apartment in Amsterdam.
During the course of this year (or possibly not until 1938) Beckmann is introduced to Walter Benjamin by Stephan Lackner at Lackner's Paris home.
Beckmann works on illustrations for Stephan Lackner's play *Man Is Not a Domesticated Animal*.

16 – 28 September
In Paris Beckmann meets with Rudolf von Simolin and Stephan Lackner. He shows Lackner photos of his latest works. Stephan Lackner purchases a number of works, including the *Temptation* triptych (1936–37, G 439).

30 October
Paris

2 November
Amsterdam

1938

11 February
Private exhibition of Stephan Lackner's collection at his home in the Rue Gaston-de-Saint-Paul.

24 – 29 March
Paris

August
Travels to the French Riviera with Stephan Lackner.

October
Beckmann and his wife rent an apartment in the Rue Massenet, where they stay until May 1939. Still no decision has been made on where to emigrate.

4 November
The antifascist exhibition *Freier Kün-stlerbund 38* opens in Paris. Although Beckmann does not officially belong to the group, one of his paintings is shown at the exhibition along with works by artists such as Spiro, Wolheim, Lohmar, Klee and Kirchner. There is no catalogue. It was probably Stephan Lackner who enabled him to take part.

1939

17 February
The Berlin author and playwright Mario Spiro, whose portrait Beckmann painted in 1906 (G 60), visits Beckmann in the Rue Massenet and asks him to contact I. B. Neumann in connection with this painting.

April
Travels to the French Riviera.

26 April
Beckmann and his wife are granted foreign residents' permits for France. They give their address as Rue Lepic.

28 April – 15 May
Dates of a scheduled Beckmann exhibition at the Galerie Alfred Poyet. Official permission for the exhibition is not granted, so it is held privately by Poyet instead.

22 May
Beckmann and his wife arrive in Amsterdam, where they spend the war years.

June
Käthe von Porada mounts a Beckmann exhibition at her home in Rue de la Pompe.

December
The works by Beckmann held at the Galerie Poyet are moved to the attic of a house in Rue d'Anjou.

1945

December
Waldemar George organizes the Expressionist exhibition at a Paris gallery. Beckmann is represented together with Marcel Gromaire, Chagall and Rouault. Andre-Pieyre de Mandiargues visits the exhibition.

1947

2 February
Beckmann applies for a visa for France.

25 March
Moves from Amsterdam to Paris.

25 – 27 March
Paris, Hotel Edouard VII.

27 March – 18 April
Travels to South of France and Riviera

18 – 22 April
Last visit to Paris. He and his wife Quappi stay at Hotel d'Arcade together with Stephan and Margaret Lackner and their baby.

21 April
Beckmann and Stephan Lackner collect the paintings hidden at Rue d'Anjou.

22 April
Beckmann brings the paintings to Amsterdam. Emigrates to the United States.
Beckmann does not return to France.

Laurent Bruel and Barbara Stehlé-Akhtar
(Translation: Ishbel Flett)

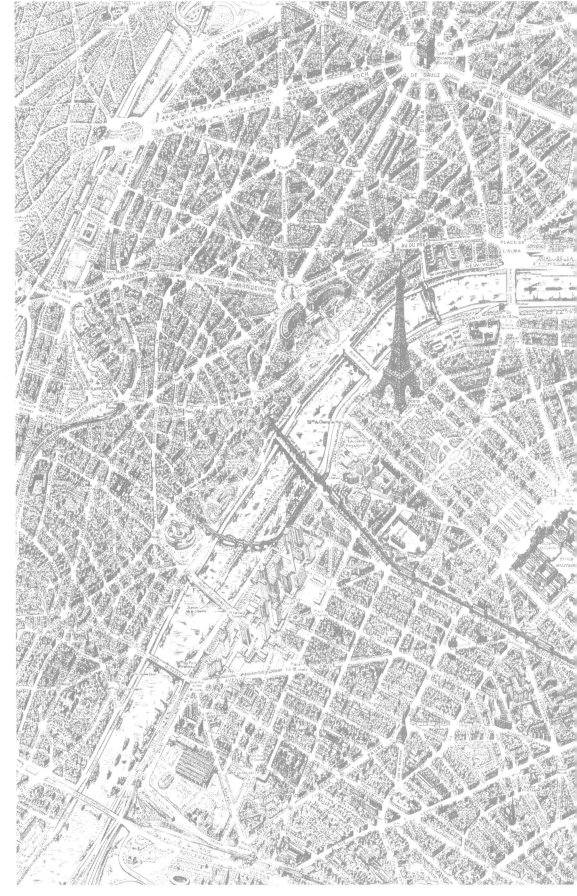

Beckmann in Paris A to Z

left: Académie Julian, Paris, c. 1910.

below: Opening in the Galerie de la
Renaissance; left to right:
Leopold von Hoesch, German Ambas-
sador in Paris; Mario Roustan, French
Minister of Culture with his wife and
daughter; far right Marie-Paule
Pomaret.

Académie Julian and
Académie Colarossi

During his first sojourn in Paris, from
September 1903 to March 1904, Beck-
mann regularly spent time at the stu-
dios of the Julian and Colarossi inde-
pendent art academies. Both offered
lessons which were based primarily on
the great Ecole des Beaux-Arts,
although they implemented neither its
rules nor its selection criteria. There-
fore, painters and sculptors with very
different expectations and from very
different social backgrounds were
gathered in the various studios to
work from life under supervision for a
humble fee. From 1904, the Académie
Julian was open all day until 7 p.m.,
and it was possible to work in the
Académie Colarossi in the evenings
from 8–10 p.m. as well. Both art acad-
emies are still in existence today. In
1957 the Académie Colarossi was
renamed Académie Charpentier; the
Académie Julian kept its original
name.

In 1886, with the support of the
Académie des Beaux-Arts, Rodolphe
Julian opened his first school of fine
arts in the Passage des Panoramas on
the right bank of the Seine. Due to its
great success, an additional school was
added on the Rue du Dragon in St.
Germain-des-Prés in 1890. There
Beckmann also worked, with several
of his compatriots, including Lovis
Corinth, Ernst Barlach, Paula Moder-
sohn-Becker and Käthe Kollwitz. The
academy also has records of Matisse

having studied there in 1890, as well
as Nabis artists Denis, Vuillard and
Bonnard, and later also Marcel
Duchamp and Fernand Léger.[1] In
1903, during the period when Beck-
mann was one of their students, the
Académie Julian enjoyed the great
honor of having seven of its students
nominated for the Rome Prize.[2]

Beckmann, however, had a prefer-
ence for the Académie Colarossi, 10,
rue de la Grande Chaumière. It was
situated nearby, was not considered
trendy and gave challenging lessons.
This academy originated from the
Académie Suisse, founded in 1815 on
the quai des Orfèvres, and its students
included Delacroix, Monet, Pissarro
and Cézanne. In 1870 it was taken
over by Colarossi, a former model,
and then moved into new rooms in
Montparnasse.[3] Thus, in 1903 Beck-
mann was able to walk from his studio
at 86, rue Notre-Dame des Champs to
the art academy in just a few minutes.

The young artist advised his friend
Caesar Kunwald: "You could work
here at the Colarosie [sic]. Not a lot,
start with 2–3 hours a day."[4] Later he
told him: "I would strongly advise you
not to go to Julien [sic] but rather to
Colarosie, as it must be particularly
unpleasant for you to work together
with people who behave like naughty
school children, making the most
intolerable noise and accomplishing
little work. At Colarosi [sic] you can at
least work in peace, as there are
women studying there who often work
better than the others. I can speak
personally for Julien [sic] as I have

often visited people there and I was
immediately embarrassed by
the childish behavior there."[5]

1 Briefe, Vol. 1, note p. 398.
2 Martine Herold, 1968 – Julian a cent ans,
 archives of the Académie Julian.
3 Information from Elisabeth Nicole, Académie
 Charpentier.
4 Briefe, Vol. 1, letter 9 to Caesar Kunwald,
 Paris 1 February 1904.
5 Briefe, Vol. 1, letter 12 to Caesar Kunwald,
 17 April 1904.

Ambassade
d'Allemagne

In the files of the German Embassy
in Paris there is little information to
be found about the 1931 Beckmann
exhibition in the Galerie de la Renais-
sance. There is no correspondence to
or from Beckmann on file, nor are
there any records of registration or
passports from the Paris Embassy
from that time in existence. Neither
the Foreign Office nor the German
Embassy were involved in the organi-
zation of Beckmann's exhibition.
Ambassador Hoesch was, however,
present as one of the guests of honor
at the opening ceremonies. Legation
counsellor Kühn sent two reports
about the exhibition's reception from

Apaches and Apache Dance in contemporary representations, c. 1915.

Max Beckmann, *Apache Dance*, 1938 (G 495).

Paris to the Foreign Office in Berlin (on 27 March and 17 April 1931). His tone was neutral and he expressed no personal opinions about the somewhat indifferent attitude of the press, and enclosed five newspaper clippings (*Figaro*, 17 March; *Beaux-Arts*, April 1931; *Journal des Débats*, April 1931; *Revue Mondiale*, 1 April; *Le Petit Parisien*, 2 April).

On 3 April 1931, Hans F. Secker sought the support of the embassy for his campaign against the Beckmann exhibition in Paris. He sent his controversial article from the *Kölnische Zeitung* (2 April 1931) on the supposed "unjudicious art policies" to Ambassador Hoesch, whom he had known for some time.[1] On 18 April, legation counsellor Kühn sent Secker a very detailed reply. He expressed his thanks for the letter, but mentioned that the ambassador should leave the evaluation of art to the art experts. Kühn then went on to correct Secker's claim that the Beckmann exhibition was one of the first major exhibitions of German art in Paris after World War I. He lists "collections" of Fritz Rhein, Willi Geiger, Ernst Oppler, Hedwig Woermann, Dietz Edzard, Renée Sintenis; a "small collection of modern German art" at the Galerie Bonjean; an exhibition of the Berlin Secession in the Salon d'Automne in 1927 as well as the exhibition of modern German graphics, organized under the supervision of Curt Glaser in the Bibliothèque Nationale in June/July 1929 (Exposition des Peintres Graveurs Allemands Contempo-

rains). Hans Secker sent a reply to legation counsellor Kühn on 20 April 1931, expressing his thanks for the information, and enclosed Alfred Flechtheim's response to his attack (*Frankfurter Zeitung*, 9 April 1931) as well as his own reply. The second letter from Secker was not answered by the Paris Embassy.

Generally speaking, existing information leads us to believe that the German Embassy in Paris was indifferent to Max Beckmann's efforts to make a name for himself in Paris. There is a painting by Beckmann which was done after a reception at the German Embassy in Paris (*Paris Society*, G 346, no. 26). German ambassador Leopold Hoesch can be seen in the foreground on the right side of the painting, holding his head in his hands. Apart from this reception and the ambassador's visit to the opening, the artist received no further support. There are no signs that there were outright hostilities or an otherwise malevolent attitude on the part of either the ambassador or the Foreign Office. TB

This text was based on information and documents which Dr. Grupp from the Foreign Office in Bonn was kind enough to make available to us. We would like to thank him sincerely for his contribution.

1 Cf. "German Follies", p. 141 ff.

Apaches

During the 1920s, "style voyou" came into vogue in Paris. People pretended to be hoodlums or, as Jean Cocteau would have said, they "bought their clothes at Schiaparelli to look like Al Capone or Mae West." But the ideal of a true ruffian was the "apache," an expression created by the press. These were young, loosely organized gangs of delinquents from the so-called "zone," the ghettos behind the old fortifications outside the city. They did not have regular jobs and their income came from stolen goods and prostitution. They spoke "apache," acted "apache," recognized things or people as belonging to the "apaches," and addressed each other with "apache." The men wore battered peaked caps, short belted jackets, wide-cut trousers, brightly colored scarves, pointed boots decorated with gold studs, and sported tattoos and pomaded their hair. On Friday or Saturday evenings the "apaches" swarmed into the city center from their suburbs of Belleville, Ménilmontant or from Montmartre and made a spectacle of themselves at fairs and popular dance revues. They danced polkas, the mazurka or waltzes to accordion music with their girlfriends, swinging and swaying about wildly, according to personal style or talent. Genuine "apaches" could be identified by their characteristic dancing style. Soon the phenomenon was taken up by the rest of society and the "Apache Dance" was born. The Balajo,

at 9, rue de Lappe in the Bastille workers' quarter, was the stronghold of such chaotic dancing orgies, which usually ended in huge fights. Beckmann was not able to completely withdraw from the "apache" scene and in 1928 he told Rudolf von Simolin: "What a pity you weren't in Paris with us. You would certainly have got a laugh out of the rue de Lape!"[1] From then on he had a soft spot for the dance, be it in its traditional folklore form or as adapted to the ballrooms of high society. The painting *Apache Dance* (1938, G 495) shows a dancing "apache" couple in the midst of exclusive and elegant society people. It is possible that the pictorial source for an archaic erotic ritual as a disruptive factor in a world of well-ordered etiquette can be traced back to an evening in the rue de Lappe, or perhaps Beckmann was inspired by the chorus of a Paris cabaret, which often reflected Paris customs and traditions. LB

1 Briefe, Vol. 2, letter 478 to Rudolf von Simolin, Frankfurt 17 October 1928.

Beckmann's library

That which was left of Beckmann's library now belongs to his estate. The number of art books in the library is relatively small; literature and philosophy books dominated by far.[1] The following is a list of books, catalogues and journals on French modern art in the broad sense, from Manet to Picasso. In addition there are essays on the Old Masters (e.g., Uccello, Bosch, Rembrandt) and also the Nordic moderns (e.g., Munch, von Marées, Nolde). Max Beckmann made no notes on the individual books when they came into his possession, so the only reference point has been provided by the individual publication dates.

On Manet, Cézanne, Rousseau, van Gogh, Gauguin, Rouault, Chagall and Picasso, there are monographic articles. It is probable that the volume on Juan Gris ended up in the library more or less accidentally as a gift from Alfred Flechtheim. Braque, Léger and Matisse are only present as part of collected works.

Julius Meier-Graefe, *Die Entwicklungsgeschichte der Modernen Kunst in drei Bänden*, Vol. 1, Munich 1914.

A. Efross and J. Tugendhold, *Die Kunst Marc Chagalls*, Potsdam 1921.

Ambroise Vollard, *Paul Cézanne*, Munich 1921.

Die Neue Rundschau, 34. Jahrgang der Freien Bühne, 5th issue, May 1923; 2nd special issue on Germany, including Julius Meier-Graefe, *Unsere Kunst nach dem Krieg*.

Jacques-Emile Blanche, *Manet*, Paris 1924.

Carl Einstein, *Die Kunst des XX. Jahrhunderts*, Berlin 1926 (numerous illustrations, incl. works by Matisse, Derain, Vlaminck, Modigliani, Kisling, Rousseau, Rouault, Utrillo, Picasso, Braque, Léger, Gris, Ozenfant, Delaunay, Kokoschka, Klee, Chagall, Beckmann [6 plates]).

André Level, *Picasso*, Paris 1928.

Daniel Henry [Kahnweiler], *Juan Gris*, Leipzig and Berlin 1929 (with dedication: "Fröhliche Weihnachten/Flechtheim").

Georges Rouault, *Munich Exhibition 1930*, J. B. Neumann and G. Franke, New York/Munich, text by

Will Grohmann, Germ. and Eng., 33 b/w illustrations, paintings and lithographs (two copies).

Roman Cogniat, *Georges Rouault*, Illustré de 32 reproductions en héliogravure, Paris 1930 (worn copy with paint smudges).

Renoir und Lebende Meister, ex. cat. Galerie Alfred Flechtheim, Berlin 1930 (Picasso, Rouault, Matisse, Léger, Laurencin, Gris, Derain, Braque, Beckmann [*The Argentinian*]).

FORMES, March 1931, No. XIII, Paris/New York, Edition française, containing, among others: Waldemar George, Beckmann l'Européen.

FORMES, April 1931, No. XIV, Paris/New York, Edition française, containing, among others: Waldemar George, Les 50 ans de Picasso; André Beucler, Sur le Précubisme de Picasso (with numerous illustrations).

Vom Abbild zum Sinnbild, Ausstellung von Meisterwerken Moderner Malerei im Städelschen Kunstinstitut, ex. cat. Städel, Frankfurt 1931.

Exposition Picasso, Documentation réunie par Charles Vrancken, Galerie Georges Petit, 16.6.–30.7.1932 (total of 227 exhibits, pink and blue periods, cubism, classicism, 1920s, latest works).

Cahiers d'Art, 7th year of issue, 1932, Nos. 3–5, Exposition Picasso aux Galeries Georges Petit. Articles on the big Picasso exhibition in German, French and English, numerous illustrations (very worn copy).

Omnibus, Almanach auf das Jahr 1932, Galerie Flechtheim, Berlin and Düsseldorf, incl. illustrated section "Lebende Kunst in amerikanischem Besitz" with illustrations from works by, among others, Beckmann, Léger, Picasso.

Paul Gauguin, *Noa Noa*, with eight plates, Bruno Cassirer, Berlin 1934.

Vincent van Gogh, Sa vie et son œuvre, Exposition Internationale de 1937, Groupe I, Classe III, Catalogue édité par L'Amour de l'Art, Editions Denoel, Paris 1937.

Pablo Picasso, Forty Years of His Art, ex. cat. MoMA, New York/Art Institute, Chicago 1939.

Jean Cassou, *Picasso*, Paris 1940 (many illustrations, some in color).

Pierre Courthion, *Henri Rousseau, Le Douanier*, Genf 1944.

James Thrall Soby, *Georges Rouault, Paintings and Prints*, ex. cat. MoMA, New York 1945.

James Johnson Sweeney, *Marc Chagall*, ex. cat. MoMA, New York/Art Institute, Chicago 1946.

L. Goldscheider, W. Uhde, *Vincent van Gogh*, Oxford/London 1947.

Juan Larrea and Alfred H. Barr Jr., *Picasso Guernica*, New York 1947.

1 Cf. Peter Beckmann 1992

Beckmann's letters

"The letters, considered less for publication than the diaries, show Max Beckmann as a person more clearly than other sources."[1] Beckmann's literary talents flow from the letters, and his private worries and artistic ambitions can only be reconstructed with the help of the excellently edited correspondence. This is especially true of his time in Paris. A particularly sensational discovery for us has been an unpublished bundle of letters from Beckmann to I. B. Neumann, which provide a detailed exposé of a Stratégie Parisienne more determinedly pursued than was hitherto supposed. We are very thankful to the Beckmann family for their permission to make use of these.

For the transcription of quotes from the published letters, we have relied on the book edition, which reflects the free flow and the unique spelling used by Beckmann. The orthography of the unpublished letters was adapted accordingly.

1 Uwe M. Schneede, postscript in *Briefe*, Vol. 1, p. 504.

Letter to I. B. Neumann, 2 June 1926.

Frankfurt am Main, 6/2/1926

Indeed, my dear and very admired Impresario Friend Manager and Mr. Neumann, we will do it. – If you have enough blood, energy, self-discipline, cleverness, love and cool calculation. – The chairs in Paris have weak occupants. – I was just recently there. – In me you have a formidable weapon. – It depends if you will be able to use it like this. The difficulties are enormous. That is completely clear to me. The German painter does not exist yet. – … but the most essential work which you still can achieve is the creation of the German painter Max Beckmann. That too, is completely clear to me.

…

It is really a shame, that you do not have even a small shop in Paris. That is where we must attack. Not only once, but continually. You can make money in New York. That is a lot and I hang all my hope on that. – But, to literally steer public, this unfortunately still needs to be done from Paris. – This bastion is securely locked and without exception effortlessly and cheaply occupied by Rosenberg, Flechtheim, Picasso, Braque. – With a fantastic foolishness the taste and the philosophy of the art of the whole world is still being directed from there. – With a part of my being, a certain amusing elegance which you can still push through with a shot of chic Parisian bluff, you can rule the world. In the world, dear Mr. Neumann, we do not want to fool ourselves. – The stronger sensations are simply eliminated in favor of an amusing and ticklish dressmaker´s taste. – I said "with a part of my being" fully aware that these people [Braque and Picasso] do not take this from me, and that they also have it within themselves, but I also have the possibility for pretentious or witty elegance. However, I have not made that my main business, for in my case these merely constitute one department in a larger store of goods. Cézanne´s legacy has been moved into the workshops of Paris´s dressmaker´s (Picasso, Braque). Whoever has these shops, now [has] installed Greek statues of the gods in order to conceal the inner wretchedness. – That is Paris 1926. That is the situation. – A man like you, who possesses the capability for potentially impossible things, could do a lot in this neglected, kingless kingdom. If you manage to really make a profit, even if only a small one, then you can later rule the world from Paris, as Vollard did 20 years ago.

Frankfurt am Main, 12/15/1926

Paris is crying out for us. The French are completely exhausted, there is nothing left except for the little taste from Braque. We are coming now with the new ´object´ – not New Objectivity. That is also already bankrupt. – What we make is truly new and the appropriate supplement to the nascent architecture into which the objectless painting has gone astray.

Frankfurt am Main, 12/15/1926

There is currently a large French exhibition here with Braque and Picasso as focal points. – This has unintentionally proved to be a complete triumph for my painting. It was very strange. If you now would really intervene in Europe, we will soon be successful.

Frankfurt am Main, 12/15/1926

What we want is a new luxury of the emotions again, no longer arabesques or patched together spatial elements rather the most complex painting with clear perspectives and unmistakable solid objects in a new completely unreal ideal state. My paintings will always appear as if they were cut out of the wall. They actually should be set into the wall or at the very least framed by a thin surround like the example which I am sending to you around the white mandolin. My paintings are transportable pieces of wall, that work with modern architecture but are not only pieces of decoration, rather without abandoning the sense of ornamentation they provide the portion of the individualistic world which determines the artwork. Radium-filled power complexes, for strengthening and refreshing the viewer.

Frankfurt am Main, 6/18/1927

As I have already told you, I will spend the second half of the winter in Paris and prepare everything for you. We have then not only the clique around Uhde, Waldemar George, Supault (sic), Dreyfuss Nacivet in favor of us, but also the whole large circle of Prince Rohan, and with this a good proportion of the aesthetic circle Faubourg St. Germain. In effect, all of Paris.

Paris, 10/10/1927

If we are not capable of erecting a new closed world – into which the rhythm of the machines and automobiles does not go astray, in which one can be different, in which there is rest and exchange with the outer world, then we can hang ourselves. What the world needs is quiet, a collection of silence – a different way than the cars, the machines, in cubism à la Osenberg the automobile has crept in and has murdered the artist. – Now they can no longer get rid of this state and paradise has disappeared. That is also the reason for the unconscious estrangement of people from art. No reasonable person wants to climb out of the mad rush of cars into the poster prisms of Cubism. Especially here, the world must be different, the intensity of modernity must lay deeper in another collected power.

This occurred to me as I walked through Paris today.

Frankfurt am Main, 11/24/1928

It is good that you now also want to work more closely with Flechtheim. – I do not actually know if it will work but it appears to me that becoming a world power in the future is only possible with Rosenberg in Paris, Franke in Munich, Flechtheim in Berlin and you in New York. If, for example, you manage to get the large Picasso exhibition which is coming up now at Tannhäuser in Feburary (in Berlin together with Flechtheim) to go from Berlin to New York then following afterwards with a large Beckmann exhibition next winter, in between Renoir, whom Flechtheim now represents exclusively with Rosenberg, maybe even Maioll [sic] about whom Flechtheim currently is doing a major exhibition together with graf Kessler, then perhaps also Klee and possibly Hofer, then Braque and your Weber, then you would have presented the entire compendium of world painting and should be able to make a great impression in New York. You understand however that these are only excursions [of thought] of a painter which you can test for their accuracy in art dealer terms.

Paris, 3/1/1930

… our chances are excellent, the big fuss over Picasso is falling flat.

Paris, 12/4/1930

My energetic and clear behavior in relation to the Rosenberg clique is just beginning to bear fruit. – It is a difficult path that we are taking. But it is the only one possible!! Only through these means do we make friends here and that will have repercussions again in America. The Rosenberg clique shivers with fear about the first true push, which threatens their entire structure. Because it is hollow. – And we will triumph, if we energetically hold together and consciously make ourselves succeed, quietly and doggedly.

Paris, 4/20/1931

Here we have achieved all that we could. The Woodcutter painting is being sold to Luxenburg [sic]. – Very serious success with the press and as provisional repository "Bing" a most charming and likable person, who so long as you yourself are not doing anything here, will represent our interests very well. … By the way Bing also told me today that he is friends with Demotte. Moreover, he organized the first Ro[u]ault exhibitions here – despite Vollard – and still has several very fine ones too. Besides, he

also has Bombois and Vivin, who are both quite good and whom you can incorporate to great benefit. – You know that if I say such a thing, it is so.

… I have now gotten my feet very firmly planted on the ground here and you must take advantage of that commercially now!!!! That is more important than if you go into the American wilderness. – They will only buy after I have really taken off from here!!! and that is now the case!!!

Paris, 3/17/1939

I have already been here in this charming little city since October of last year. … Here in Paris a large group of people are interested in me and I think it not out of the question that I can gain some influence. Although everything takes time and naturally above all international peace. Well, the most important thing is in any case, that one lives and continues to bring this spooky world to reality in a painting in as intensive a manner as possible. The single true reality that there is. – To be more real than life is probably the farthest extreme that a man can reach and I am exercising this stimulating profession daily.

(Translation: Laurie Stein)

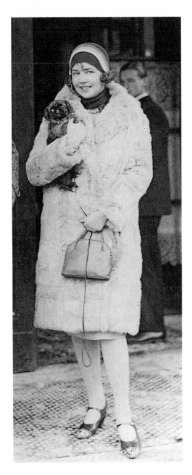

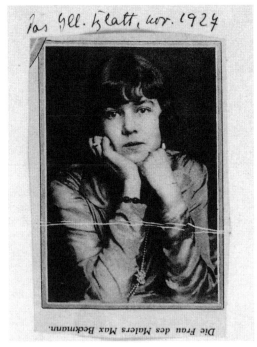

"The wife of the painter
Max Beckmann,"
Detail from Quappi's Scrapbook.

below: Quappi, Paris c. 1930, film still.

Pas Ill. Blatt, nov. 1924

Die Frau des Malers Max Beckmann.

Mathilde (Quappi) Beckmann-Kaulbach (1904–1986)

Mathilde Kaulbach, the youngest daughter of the artist Friedrich August von Kaulbach, first studied violin under the supervision of her mother, concert violinist Frida Schytte. She then studied singing in Munich and in Vienna. There she made friends with Marie-Louise von Motesiczky, in whose parents' house she first met Max Beckmann in the spring of 1924. One and a half years later, on 1 September 1925, the wedding took place in Munich, after Beckmann had divorced his first wife, Minna Beckmann-Tube.

Modern views may make it difficult for us to understand the devotion with which Quappi (the nickname comes from a distortion of "Kaulbach" to "Kaulquappe") sacrificed her own artistic ambitions and dedicated her life unconditionally to Max Beckmann and his work. This was the most important factor in Beckmann's artistic rebirth in the 1920s. His marriage gave him the strength and the courage to fight for international recognition in Paris.

Beckmann's love letters to Quappi create an island of charm, tenderness and carefree feelings within the overall body of his correspondence. Pretty, elegant, cultivated and lively, she was for Beckmann at once an inspiring young lover and an abruptly cheerful note in his gloomy life's philosophy. Born the daughter of an artist, she was able to adjust to life on the fringe of bourgeois conventions. In the difficult years of exile and the wearisome period while getting a fresh start in the USA, Quappi – as Beckmann's diaries document – became an even more loyal and patient partner, assistant and translator. With her bright and well-balanced nature she was able to soothe Beckmann's notorious pessimism and frequent periods of depression. After her husband's death,

Mathilde Q. Beckmann continued to manage his estate prudently over three decades. Beckmann painted almost twenty portraits of Quappi, and in addition to these her features grace many figurative pictures. TB

Minna Beckmann-Tube (1881–1964)

Minna Tube was born to bourgeois Prussian parents. She decided very early on to become an artist. In the fall/winter semester of 1902/03 at the Weimar art school she met Max Beckmann, a fellow student two-and-a half years her junior. The two young students fell in love and began a turbulent relationship, which did not end until Beckmann's death in 1950. In 1903 Minna refused to accompany Max Beckmann to Paris, which caused him to break off the relationship. However, one year later he returned repentantly to Minna in Berlin and on 21 September 1906 they married. In 1908 their son Peter was born. When Beckmann insisted that his wife give up her career as a painter, Minna took singing lessons. In 1915 she gave her first performance, and over the next ten years she enjoyed a remarkable career. From 1918 to 1925 she performed at the opera in Graz, where

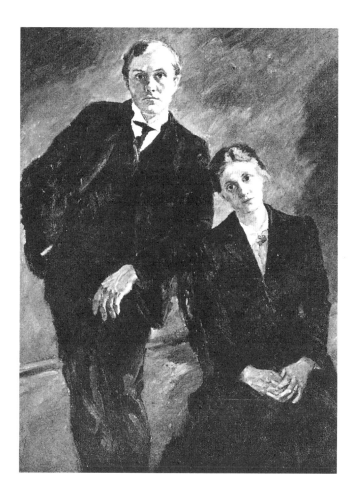

Max Beckmann, *Double Portrait of Max Beckmann and Minna Beckmann-Tube,* 1909, (G 109).

Walter Benjamin, 1938, Photo by Gisèle Freund.

she was primarily celebrated as a Wagnerian singer. When Max Beckmann divorced her in 1925, it seemed as if Minna had lost her voice completely. From then on she gave up her career as a singer. From 1927 to 1945 she lived in Hermsdorf, in the house that Beckmann had built and where she had lived together with him from 1907 to the start of World War I. In 1945 she fled to her son Peter in the Bavarian town of Gauting, where she lived until her death.[1]

In many ways, Minna embodied the antithesis of Mathilde Q. Beckmann. Not only was she older than Max, she was also a match for him in every respect and was not prone to accept his moodiness without a word. Due to her dynamic energy and austere decisiveness, Beckmann sometimes appeared to be the weaker partner in the relationship. He depended on Minna's advice and judgment. He made an effort, even after the divorce, to maintain a friendship with her. When one reads his letters from the last years of his life, it is evident that everything he wrote about really substantial topics was usually addressed to Minna Tube. Even during his Paris career, Max Beckmann attempted to involve Minna. In 1928 he made a supreme attempt to persuade her to visit him in Paris. He could hardly wait to show her his new hunting grounds and his new works and to reestablish their relationship on a new basis as friends.[2] In the second week of September Max and Minna met at the Hotel Claridge. This shared time in Paris in 1930 appears as an imposing echo in the last portrait that Beckmann painted of Minna Tube.[3] TB

1 On Minna Beckmann Tube, see Reimertz 1996; Minna Beckmann-Tube, ex. cat. Staatsgalerie moderner Kunst, Munich 1998.
2 Briefe, Vol. 2., letters 471 and 472 to Minna Beckmann-Tube.
3 See Cat. 21, p. 65.

Walter Benjamin (1892–1940)

The contact between the two Germans in Paris was brief and superficial. Their first meeting was actually not a meeting at all. The fact that Walter Benjamin attended the premiere of *Amphitryon 38* at the Théâtre des Champs-Elysées on 8 November 1929, with Valentine Tessier in the leading role, where Max Beckmann was also present with Mathilde Q. Beckmann and Käthe von Porada, still remains merely an interesting coincidence.[1] (Another guest at the premiere was the young journalist Georges Pompidou).

It was Stephan Lackner who introduced the two men in 1937 or 1938 in his Paris apartment. It seems that Benjamin was very interested in Beckmann's work, although Beckmann himself did not feel particularly drawn to Benjamin,[2] whom he considered to be primarily a follower of Surrealism and an admirer of Paul Klee. The philosopher appeared to identify kindred metaphysical interests in Beckmann's paintings, but the artist did not feel the same way about their conversation. In spite of this, Benjamin was interested in keeping the friendship going, and in his last letter to Stephan Lackner[3] he inquired specifically about Beckmann's whereabouts. Nevertheless a second meeting never took place. TB

1 Cf. Walter Benjamin, Ecrits français, Paris 1991, p. 35.
2 Information from Stephan Lackner, Santa Barbara.
3 Letter from 5 May 1940, in: Neue Deutsche Hefte, No. 161, 26. 1979, issue 1, p. 68.

left: Max Beckmann and Hans Purrmann, 1906.

right: The "Dômiers" in the front room of the Café du Dôme, Paris c. 1905.

La Bohème

"The 'bohème' is the practicum for life as an artist," defined Henri Murger, author of *Scènes de la vie de bohème*, in 1848.[1] The "bohème" was primarily a Paris phenomenon which started in the great boulevards and spread to the "quartier latin," to Montparnasse and Montmartre. In Montparnasse it was more literary, in Montmartre somewhat shady, but at the turn of the century it was the most important place to be. In the midst of the cafés and dance clubs, Cubism found its beginnings. The bohemian way of life did not really develop in a big way in Montparnasse until the period between the two world wars. The representatives of the cosmopolitan scene met at the Café du Dôme or at the Sélect, among them Henry Miller, Hemingway, as well as Léger, Picasso and Jean Cocteau.

In 1903 and 1904 Beckmann also led a bohemian life in Paris, or at least he tried to do so. At 19 or 20 years of age he was still quite young, he was unhappily in love with Minna Tube, who was living in Amsterdam. He was penniless, brilliant and ambitious. He lived in an artist's studio on the Rue Notre-Dame des Champs near the Jardin du Luxembourg. The cafés, cabarets and dance clubs he frequented, such as the Moulin de la Galette or the Concerts Rouges, were very popular among the "bohème" in Paris. He wound up his evenings in the Closerie des Lilas, without any idea of the legendary reputation this establishment would later have: "At precisely 1:00 a. m. I can be found in my café, sometimes drinking absinthe and invariably drinking coffee, sporting a beard and a tall black hat. (...) When I am not in the café or in bed, I am painting 5.50 x 4 m pictures. In short, I am behaving in a manner right and proper for a genius."[2]

The real bohemians mostly went around in loud groups, but Beckmann, on the contrary, gave one the impression of great loneliness. He did not join any of the cliques, especially not those of the other Germans his own age at the Café du Dôme, and there is no mention of any friendships. He sat alone in the bars and cafés. He drank and smoked, thought about Minna and wrote in his diary. Once in a while he read a philosophical book or ruminated about his artistic calling.

In April 1904 he suddenly decided to leave Paris and travel on foot to Italy. The first stop was at Fontainebleau, but after a few days he took a train from Switzerland to Berlin. There he found Minna Tube again and married her a year and a half later. This marked the end of his "practicum for the life of an artist."

"If you scratch a bohemian, you find a bourgeois underneath," were the words of Jerrold Seigel.[3] Beckmann actually started a new chapter in his life. The honeymoon with Minna in 1906 took him back to Paris, but this time they lived on the Rue Lalo in the more respectable 16th arrondissement, where they prepared their journey to the Villa Romana in Florence. BS-A

1 Henri Murger: Scènes de la vie de bohème, Paris 1848.
2 Briefe, Vol. 1, letter 9 to Caesar Kunwald, 86, rue Notre-Dame des Champs, 1 February 1904.
3 Jerrold Seigel, Bohemian, Paris 1986, p. 5.

Georges Braque (1882–1963)

"The thing which has concerned me the most, my whole life long, is painting space."[1] This famous statement of Braque's could easily have come from Beckmann, who also regarded his painting as a constant attempt to come to terms with space, the "infinite deity which surrounds us."[2] Despite the fact that Beckmann occasionally thought of Braque sarcastically as a "French demigod,"[3] he stood out as one of the few artists (together with Rouault) among Beckmann's contemporaries for whom he showed – in his extremely reserved way – any recognition or interest.

At first Braque's work was committed to Fauvism. Between 1907 and 1908 it underwent a radical metamorphosis. Braque's concentration – in keeping with his role model Cézanne – was focused increasingly on the structure of pictorial space. With every painting he laid a further stone for the foundations of Cubism, whose vocabulary he developed and expanded – in part in close collaboration with Picasso – during the period before World War I.

In 1914 Braque enlisted in the war and one year later was badly wounded. After the war he no longer

worked with Kahnweiler, but rather with Leonce Rosenberg, at first, and then from 1912 with the Galerie Rosenberg. His career boomed and in 1922 he was given the "Room of Honor" in the Salon d'Automne. Stylistically speaking, there could be seen a reinstatement of color in his work during this period, and at the same time Braque reduced his motifs almost exclusively to still lifes and interiors. He experimented constantly, trying out a diversity of technical and pictorial possibilities with methodical thoroughness. Braque was fond of using broad, transparent brushstrokes to emphasize contour. The use of black undercoat, the combination of different surface structures, and also the interplay of black surfaces which open up the pictorial space, are formal elements of his technique which all left lasting impressions on Beckmann.

After the war years, which Braque spent partly in the Pyrenees and partly in complete seclusion in Paris, he received international recognition of his work, with important awards (a Venice Biennale prize in 1948) and exhibitions in the major museums of the world (Museum of Modern Art, New York in 1949; Tate Gallery, London in 1956). LB

left: Georges Braque, 1931, Photo by Eli Lotar.

below: French Cancan in the Tabarin, 1937.

Cabarets

LES CONCERTS ROUGES
6, rue de Tournon, 6th arrondissement

Les Concerts Rouges was among the most popular café-concerts at the end of the 19th century. In 1904 Beckmann heard Schubert's *Forellen-Quintett*[1] and *Méphistophélès* by Lalo there.[2] From time to time, there were frivolous dance numbers or the guests danced themselves and found feminine company for the night. The café got its name – as did Le Moulin de la Galette – from its exterior. The facade of the building was painted red in order to unmistakably draw attention to its membership in the world of red lanterns.

The Cabaret was certainly a paradoxical phenomenon during this period in Montmartre. The most extreme vulgarity could be found next to highbrow culture there; the most heinous cynicism went hand in hand with the boldest aesthetics.[3] This may possibly have been just what attracted Beckmann. Most of the time he stayed late into the night at the "Kaffé Rouge" or at the "Kloserie."[4] Although somehow disgusted by it all, he nonetheless enjoyed the infamous goings-on in the smoke-filled cabarets, where he drowned his loneliness in alcohol, made notes in his diary, or wrote letters to his friend Caesar Kunwald and his beloved Minna Tube.

1 Frühe Tagebücher, cited in Buenger, Max Beckmann: Self-Portrait in Words, pp. 64–65.
2 Briefe, Vol. 1, letter 15 to Caesar Kunwald, Berlin, 27 October 1904.
3 Gérard-Georges LeMayre, Les cafés littéraires, Paris 1997.
4 Frühe Tagebücher, cited in Buenger, Max Beckmann: Self-Portrait in Words, pp. 53–71.

1 Jean Leymarie, Braque, les ateliers, Aix-en-Provence 1955.
2 Max Beckmann, On My Painting, p. 5.
3 'Braque and Rouault show his handicraft,' quoted from Fred Neumeyer, Erinnerungen an Max Beckmann, in Bildende Kunst, April 1957, No. 43, p. 71.

BIBLIOGRAPHY:
Nicole S. Manigin (Worms de Romilly), Catalogue raisonné de l'œuvre de Georges Braque, from Jean Leymarie, (ex. cat.) Solomon R. Guggenheim Museum, New York, Munich 1988.
Bernhard Zurcher, Georges Braques, Leben und Werk, Munich 1980.

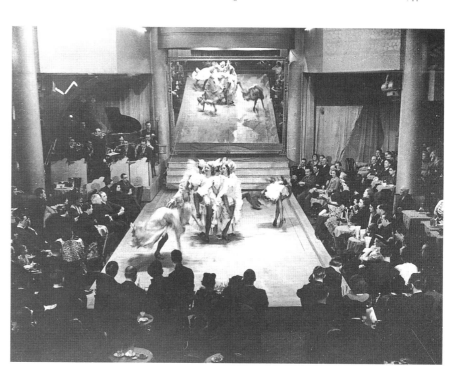

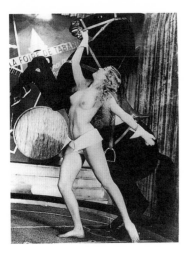

left: Bal Tabarin, Revue c. 1937.

Max Beckmann, *Tabarin*, 1937 (G 485).

below: Bal Tabarin, Revue c. 1937.

below: Max Beckmann, *Woman on Trapeze*, 1936 (G 436).

LE MOULIN DE LA GALETTE
77, rue Lepic,
18th arrondissement

One evening in the winter of 1904, Beckmann visited the bar made popular by Degas and Toulouse-Lautrec: "Very good red wine, danced at the Moulin de Galette with an old cocotte, a maid from the provinces, and a Negro woman, little appreciated by them because I danced badly and spoke French badly ... All with a rather deliberate feeling for a stylish mood, without really possesing any such mood. So now the Closerie [sic]. Here in the thick cigar smoke, Norwegian speaking, appearing to myself and others partly interesting, partly absurd, over the aforesaid red wine. Oh you poor fellow, you can't even be sad over lost beauties."[1]

1 Buenger, Max Beckmann: Self-Portrait in Words, p. 66, 2 February 1904.

LE BAL TABARIN and
LES FOLIES-BERGÈRES
At the corner of rue Pigalle –
rue Victor-Massé and 8, rue Saulnier,
9th arrondissement

After his youthful dreams of a bohemian life in Paris, Beckmann returned to the city on the Seine and several of its cabarets in the 1920s. This time he found the atmosphere bourgeois. It had by then become socially acceptable to go to "artistic

nude dances" in the company of one's wife or even the whole family. The inevitable high point of the evening was provided by the French cancan, a living reminder of the old days. The offerings became more sophisticated, the revues showed choreographic finesse, and the program was changed regularly. More and more fantastic costumes and stage accessories were used. Circus artists performed magic tricks, acrobatics, and even somersault numbers on motorcycles.

Thus, in 1937 Beckmann experienced an evening "revue" in the Bal Tabarin which included trained horses ridden by half-naked women. In the same year in Amsterdam, he painted *Tabarin* (G 485) from memory. However, his version far surpasses what he had really seen.

Beckmann's pictures from the early 1920s show that many of the props in his iconographic stock stem from the cabaret and "varieté:" spectacular acrobatics, masquerades, burlesque, striptease and fetishism, the trivial images of cabaret and "variété" combined with ritual and myths to form a vision in which tragedy and the grotesque collided.

When Beckmann again visited the Bal Tabarin and the Folies-Bergères in 1947, it was as if he was taking a last, discreet glance at this world.[1] The Lackners accompanied him and Quappi on this nostalgic tour. Together they were forced to realize just how much Paris night life had lost its charm. Lackner's recollections, however, make clear that Beckmann –

all sublimation aside – still valued and sought the bluntly erotic atmosphere of the cabarets as before: "Beckmann ... was somewhat disappointed by the thin dancers who appeared to be suffering from malnutrition. 'It doesn't smell quite right,' he said after the cancan."[2] LB

1 Tagebücher 1940–1950, 19 and 21 April 1947, pp. 198–199.
2 Lackner 1967, p. 111.

Cafés and Restaurants

LA CLOSERIE DES LILAS
On the corner of boulevard Montparnasse and Avenue de l'Observatoire, 14th arrondissement

The place is no longer very reminiscent of a "pleasure garden full of lilacs," but in earlier days it was a country inn and watering hole on the way to Fontainebleau. In 1903, thanks to French poet Paul Fort, the Closerie became a café for writers and artists. In that same year, Max Beckmann came to Paris for the first time. He soon became a permanent fixture there. More or less every evening, he got drunk on cheap red wine in the Closerie.[1] One evening in February of 1904, Beckmann recognized Edvard

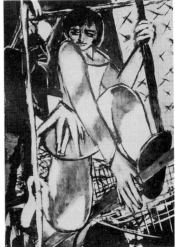

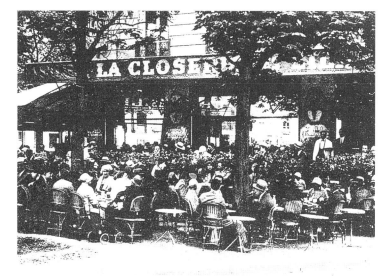

La Closerie des Lilas, Paris c. 1905.

Munch among the guests, but he was afraid to speak to him.[2]

In the following year Paul Fort introduced the literary Tuesdays in the Closerie. Apollinaire came with Pablo Picasso, as well as Herwarth Walden, the publisher of *Der Sturm.* Later on Max Jacob, Raymond Duchamp-Villon, Marcel Duchamp, Fernand Léger, Brancusi, Severini and Marinetti came to take part in the Tuesday meetings. After World War I Hemingway (who made the café famous in *A Moveable Feast*) met Ezra Pound there.

In 1923, as the Paris Dada movement was coming to an end, Tristan Tzara gathered together a group of opponents to André Breton in the Closerie. The café became the boxing ring of the Surrealists. It was a scene of turmoil and scandal, with Max Ernst bellowing "Down with Germany!" and Michel Leiris responding with "Down with France!" and Philippe Soupault swinging from the chandelier and sweeping the dishes from the tables.

1 Briefe, Vol. 1, letter 15 to Caesar Kunwald, Berlin, 27 October 1904.
2 Frühe Tagebücher, cited in Stephan Lackner, Max Beckmann: Memories of a Friendship 1969, p. 104.

CAFÉ RICHE
At the corner of rue Le Peletier and the boulevard des Italiens, 9th arrondissement

The Café Riche was situated close to the opera. In the 19th century the giants of French literature frequented this café. Baudelaire, Balzac, the Goncourt brothers, who had already described the café in their journal in October 1857, Jacques Offenbach, Guy de Maupassant who mentioned it in *Bel Ami,* and Gustave Flaubert, whom Beckmann greatly admired, all came for dinner or held their literary circles here.

During his Paris sojourn in 1903/04, Beckmann occasionally ended his evenings there after a concert at the Salle Erard.[1] His romantic 19th-century outlook probably predisposed him to this café, where he found a slightly melancholic answer to his own inner state of emotions. The "sacred bohemian" way of life had had its demise there, after having been denied by its literary father, Henri Murger.[2]

1 Briefe, Vol. 1, letter 15 to Caesar Kunwald, Paris, 27 October 1904.
2 Henri Murger, Scènes de la vie de bohème, Paris 1848.

CAFÉ DE TOURNON
33, rue de Tournon, 6th arrondissement

Beckmann was fond of visiting this café on the ground floor of the Hotel Foyot, which he liked very much. Austrian writer Joseph Roth was also staying here. At the beginning of the 1930s, he sat in the café downstairs every day to write, and also received visitors here, for example Stefan Zweig, Emil Ludwig, Arthur Koestler or Josef Bornstein, editor-in-chief of the *Pariser Zeitung.*

LE DÔME
On the corner of the boulevard du Montparnasse and boulevard Raspail, 14th arrondissement

In Montparnasse around 1910, the cafés Le Dôme, La Rotonde and La Coupole formed the triangle in which the new "bohème" was developing. The Dôme must be mentioned not because Beckmann was fond of it, but rather the opposite. It is remarkable that he avoided it since the café was the meeting place of the young German artists of his generation. The German students of Matisse, whose art academy was close by, turned the café into the haunt of the German colony. Soon there were not only German artists there, but also art dealers, art experts and collectors. These "dômiers" included, for example, artist Hans Purrmann, art critics Wilhelm Uhde, Julius Meier-Graefe and Harry Graf Kessler as well as art dealers Daniel-Henry Kahnweiler, Alfred Flechtheim and Henry Bing. More or less all of the German moderns born between 1870 and 1880, who wanted a connection to the French tradition and whose great master was Cézanne, met in the Dôme between the turn of the century and the beginning of World War I, except for Max Beckmann.

FOUQUET'S
99, avenue des Champs-Elysées, 8th arrondissement

This restaurant on the Champs-Elysées was the meeting place of several literary juries, but otherwise it had no artistic connections. Its reputation was based on its luxurious furnishings and the prestige of its guests. The restaurant was entirely in keeping with Beckmann's taste; he was seen here occasionally, sometimes in the company of Stephan Lackner or the baron Rudolf von Simolin. A letter from Beckmann to von Simolin in 1931, in which he reminisces about an evening at Fouquet's and at the same time reports on his work on the painting *Paris Society* (G 346), the group portrait of the Paris "haute volée" as he saw them,[1] is very revealing.

1 Briefe, Vol. 2, letter 571 to Rudolf von Simolin, [Frankfurt a. M.], 16 June 1931.

PRUNIER
9, rue Duphot, 1st arrondissement

The Prunier in the Madeleine quarter, famous for its seafood, was Max Beckmann's favorite restaurant. He often spent evenings here with Stephan Lackner. Both men had such fond memories of their evenings in the Prunier that they celebrated their first meeting after the war in 1947 there.

Three years prior to this reunion, Beckmann dedicated a painting to the "établissement" (*Prunier*, 1944, G 667). The painting presents a disturbing scene of the restaurant. After five years of sacrifice at the hands of the war, its elegant clientele underwent a revolting metamorphosis: Two young women behind their facade of elegant clothes and good table manners, abandon themselves to an eating frenzy; with stupid, repulsive expressions they use both hands to gorge their gaping mouths with large, whole fish. LB

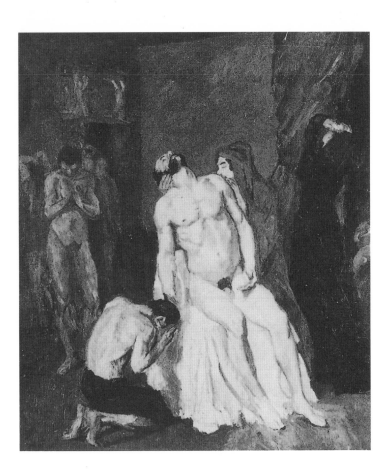

Max Beckmann, *Lamentation*, 1908 (G 89).

Paul Cézanne
(1839–1906)

"As early as 1903 Cézanne was my greatest love and still is when I think of French art."[1] Beckmann never stopped admiring Cézanne as long as he lived. When he first came to Paris in 1903, he paid homage to the work of the master from Aix-en-Provence at the Musée du Luxembourg. In 1913 he no doubt visited the Berlin Secession, where Cézanne's work was present. In the 1920s and 1930s he followed him throughout the Paris galleries Bernheim-Jeune and Paul Rosenberg. In Berlin, Paul Cassier showed work by Cézanne almost every year between 1904 and 1925, and his works could also be seen at the Nationalgalerie. In 1931 the Städel Kunstinstitut in Frankfurt organized a Cézanne retrospective, and Beckmann, who was then giving lessons at the Städel school, most certainly visited the exhibition. After all, the collection of his friend, the baron Rudolf von Simolin, contained important works by Cézanne.

As early as 1906 Cézanne's dealer, Ambroise Vollard, sent illustrations of paintings to Beckmann shortly before his honeymoon in Paris. The couple visited him in Paris, and "Vollard, who shared his enthusiasm for the artist, gave Max a beautiful big photograph of Cézanne."[2] Reinhard Piper also sent Beckmann reproductions of Cézanne and van Gogh[3] in 1912. In 1919 Beckmann read Meier-Graefe's *Cézanne und sein Kreis* and shared the author's enthusiasm for the "greatest painter in the world."

The significance Cézanne had for the young Beckmann was expressed in a letter to Caesar Kunwald, in which he compares the works of Cézanne and van Gogh: "But Cézanne is deeper, more dramatic, more nervous and much more tragic than van Gogh … While Cézanne represents a huge, gloomy and entire personality, in the works of van Gogh there is mainly the presence of a passionate will. … While Cézanne rules nature and is able to express his deepest emotions in an onion and I can remember landscapes he has painted which are like a living drama. In my opinion, he has found

the finest and most discreet way ever to express the soul through painting."[4]

Nevertheless, Beckmann's perception of Cézanne was also ambivalent. An example of this was his controversial reply to Franz Marc's publication *Die neue Malerei* in *PAN* magazine in 1912. Beckmann was very angered that Cézanne was exclusively monopolized, be it by the Cubists, the Fauves or the Expressionists of the Brücke. Beckmann emphasizes the importance of spatial depth in painting and makes a reference to the words of the master: "I never intended the lack of plastic values and tonal modulation, and I shall never reconcile myself to it; it's nonsense." And he continues: "I myself revere Cézanne as a genius. In his paintings he succeeded in finding a new manner in which to express that mysterious perception of the world that had inspired Signorelli, Tintoretto, El Greco, Goya, Géricault, and Delacroix before him. If he succeeded in this, he did so only through his efforts to adapt his coloristic visions to artistic objectivity and to the sense of space, those two basic principles of visual art. Only thus was he

able to preserve his good paintings from a decorative flatness. His weaker things are not much different from a tasteful wallpaper or a tapestry; but his good pictures are magnificent in their greater objectivity and in the resulting spatial depth; they embody eternal human values, yet they are emblematic of the place and time in which he lived."[5] Thus Beckmann disassociated Cézanne from an overly one-sided perception leading to Cubism, abstraction and planar treatment, and adopted him as a role model for his own goals to create a style of painting which was at once modern and a continuation of the Old Masters.

In 1914, in the name of the early Cézanne, Beckmann renewed his attack on the contemporary avantgarde, who worshipped the more mature, "more abstract" Cézanne like a god: "In my opinion there are two tendencies in art. One, which at this moment is in the ascendancy again, is a flat and stylized decorative art. The other is an art with deep spatial effects. It is Byzantine art and Giotto versus Rembrandt, Tintoretto, Goya, Courbet, and the early Cézanne. The former wants the whole effect on the surface and is consequently abstract and decorative, while the latter wants to get as close to life as possible using spatial and sculptural qualities. Sculptural mass and deep space in painting need not by any means be naturalistic in effect. It depends upon vigor of presentation and the personal style. Rembrandt, Goya, and the young Cézanne strove for important sculptural effects without succumbing to the danger of naturalism in the least. It makes me sad to have to emphasize this, but thanks to the current fad for flat paintings, people have reached the point where they condemn a picture a priori as naturalistic simply because it is not flat, thin, and decorative. I certainly don't want to deprive decorative painting of its right to exist as art. That would be absurdly narrowminded. But I am of the opinion that no one of all the French followers of Cézanne has vindicated the principle of two-dimensionality that followed the inspired clumsiness of the late Cézanne, the holy simplicity of Giotto, and the religious folk cultures of Egypt and Byzantium."[6]

Max Beckmann,
Chinese Fireworks, 1927 (G 265).

Marc Chagall,
Paris through a Window, 1913.

Max Beckmann,
Self-Portrait with Champagne Glass, 1919
(G 203).

However, this "brilliant clumsiness" obviously left deep traces. In the 1920s, having come closer to the now somewhat aging Paris avant-garde, Beckmann himself often picked up the same stylistic elements first seen in Cézanne's late works. BS-A

1 Briefe, Vol. 1, letter 173 to Julius Meier-
 Graefe, Frankfurt, 10 May 1919.
2 Minna Beckmann-Tube, Erinnerungen an Max
 Beckmann, in Frühe Tagebücher, p. 172.
3 Briefe, Vol. 1, letter 55 to Reinhard Piper,
 Hermsdorf Berlin, 27 August 1912.
4 Briefe, Vol. 1, letter 18 to Caesar Kunwald,
 Agger, 4 August 1905.
5 "Thoughts on contemporary and uncontem-
 porary art." Response to Franz Marc's essay
 "Die neue Malerei," in Realität der Träume,
 translation included in Buenger, Max Beck-
 mann: Self-Portrait in Words 1997, p. 115.
6 Response to the survey "Das neue Pro-
 gramm," in Kunst and Künstler magazine, in
 Realität der Träume, translation included in
 Buenger, Max Beckmann: Self-Portrait 1997,
 pp. 131–132.

Marc Chagall
(1889–1985)

Marc Chagall, the dreamer from Vitebsk, was an artist who would not normally be associated with Max Beckmann. The usual distinctions for both artists are exactly opposite. Chagall is considered ethereal, feminine, playful and inconsistent, while Beckmann cultivated the image of being solid, masculine, serious and heavy-handed.

Beckmann's connections to Chagall can be found at first in the motifs: both artists shared a love of the circus world and generally for an irrational combination of symbolic pictoral motifs. But also reminiscent of Chagall are the plunging perspectives and interlocking pictorial spaces in Beckmann's works from the early 1920s, as well as their blurred colors. TB

Champagne

Ludwig Feuerbach was no art historian and the history of modern art as the history of individual and period preferences for specific artistic stimuli has yet to be written. Max Beckmann could also offer material for this. Sitting alone in a stylish hotel bar and slowly sipping a bottle of champagne was his preferred method for relaxing, ruminating and meditating his whole life. (A further chapter could also be dedicated to whiskey). There are not only the veritable champagne letters from Beckmann,[1] he also painted (with red eyes and slightly befuddled) a self-portrait holding a champagne glass. Champagne glasses and bottles appear in many of his still lifes. One of these *Still Life with Irroy* (1929, G 311), owes its title to Beckmann's favorite brand of champagne.[2]

Although Beckmann talked mostly of "Sekt," never did he mean the "bad German stuff."[3] At least since the "belle époque," the world has considered champagne to be the symbol of the fashionable and luxurious life style of Paris. The mention of Beckmann's

affinity to the Paris life style, which is reflected in this preference of his, is more than a frivolous "aperçu." Many of his pictures, especially from the Paris period, were the fruit of a champagne mood, an urbane esprit and an elated elegance that counterbalanced the phlegmatic and gruff image the artist carefully cultivated. TB

1 Briefe, Vol. 2, letter 532, 1930,
 to Rudolf von Simolin
2 Self-portraits: Self-Portrait with Champagne
 Glass, 1919, G 203; Self-Portrait with Cham-
 pagne Glass on a Yellow Background, 1925,
 G 246. Still Lifes: G 241, G 250, G 254,
 G 310, G 311, G 343, G 408 (Cat. 31).
3 See above, note 1.

CHAMPAGNE
Carte d'Or
BRUT
TRADE MARK
ERNEST IRROY
Reims.
FRANCE
PRODUCE OF FRANCE..CONT. 1 PT. 10 FL.OZ. ALCOHOL 12% BY VOLUME

left: Champagne label

below: Acrobatic act in front of the
Cirque Médrano, Paris c. 1910.

Cirque Médrano

"Max liked going to the circus and the 'variété'; we went to many performances, in Frankfurt and in most of the other cities where we lived. He was especially impressed by the colorfully costumed circus performers. The dexterity with which they kept their balance during the most difficult stunts transformed the acrobats into a kind of creature moving on a higher level."[1]

The circus was also a favored pursuit of the Beckmanns in Paris. On the left panel of his *Acrobats* triptych from 1939 (G 536) Beckmann captured the arena of the Cirque Médrano; on a program folder lying on the safety net, the letters "Circus Me" can be made out. Emilio Girolamo Médrano, who soon became famous as "Clown Boum Boum,"[2] took over the circus in 1897.[3] During the summer months he went on tour,[4] and in the wintertime his program was one of the most popular forms of entertainment in Paris. Between 1925 and 1939 Beckmann had ample opportunity to visit the circus on the boulevard Rochechouart.

Beckmann's love for this circus was shared by numerous other Paris artists, who also went regularly to the performances. Fernand Léger was a regular there. The painting *Cirque Médrano* from the year 1918 and an oil sketch with the same title (Musée National d'Art Moderne, Paris) show a trained dog, a clown, an equestrian artist and a juggler, as well as the architecture of the circus and its place in the midst of the houses of the city.

Another lover of the world of clowns was Marc Chagall. He often went to the Médrano, and even more frequently to the Cirque d'Hiver near the Bastille. Rouault also loved the Médrano, as I. B. Neumann reports: "Rouault was entirely wrapped up in the world of clowns. He was constantly asking me to accompany him to his favorite circus, the Cirque Médrano."[5]

Picasso went to the circus for the first time in 1905 and found the inspiration for his melancholic compositions of harlequins, jugglers and clowns. As Fernande Olivier remembers: "We all met in the evenings at the Cirque Médrano. Picasso stayed at the bar in the warm, slightly nauseating smells that wafted over from the stalls. He was quite capable of spending the whole evening there with Braque, talking to the clowns. Their accents and their awkwardness amused him just as much as their quick wit, and he had a kind of friendship with them."[6] He could go to the Médrano circus as many as three times a week, where he "enjoyed himself like a child."[7] BS-A

1 Mathilde Q. Beckmann 1983, p. 17.
2 Göpel, Vol. I, p. 335.
3 Pierre Daix, Dictionnaire Picasso, Paris 1996, p. 582.
4 See above, note 2.
5 Israel Ber Neumann, Sorrow and Champagne, Confessions of an Art Dealer, p. 8.
6 Fernande Olivier, 1933, quoted from Pierre Daix, Dictionnaire Picasso, Paris 1996, p. 582.
7 Ibid.

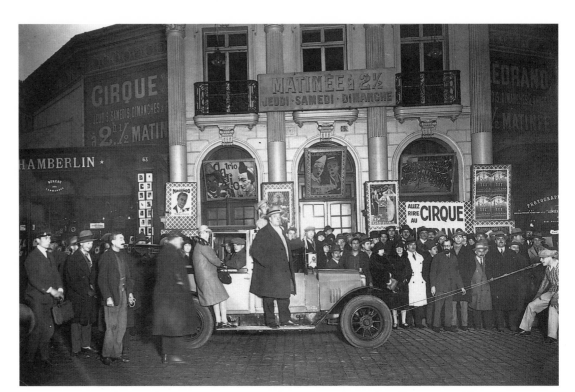

left: Max Beckmann, *View from the Terrasse in Monte Carlo,* 1935 (G 413); beneath it is the postcard used as model.

right: Max and Quappi Beckmann on the Côte d'Azur, film stills c. 1930.

Côte d'Azur

Yet again, Picasso had the honor of playing the role of pioneer when in 1919 he introduced to the Paris artists the fashion of vacationing on the Côte d'Azur in the summer. He went to Saint-Raphaël or to the Hotel du Cap in Antibes, to Juan les Pins or to Cannes; shortly thereafter Matisse even took up residence at the Côte d'Azur.

Beckmann visited various places between the Italian border and Marseilles with his wife. He enjoyed a refreshing break from Paris, found new inspiration and relaxed with friends. He visited the Casino, went swimming or filmed and photographed the landscape: scenes at the beach, his wife and his friends. This was an indication of the extent to which he had adopted the seasonal rites of Parisian society during his Paris period. In March 1930 he stayed for a week in Nice,[1] and from there he explored the nearby area of Cannes, Cap Martin and Monaco. In April 1931 he travelled by train to Marseille and then went on to St.-Cyr-sur-Mer, where art critic Julius Meier-Graefe had a house.[2] From there he also visited La Ciotat, Bandol and Toulon. In 1938 Beckmann went back to the Côte d'Azur with Stephan Lackner. They stayed in Bandol, drove out to Corniche by car, and swam in the sea. According to Lackner: "He could portray himself quite realistically in modern bathing dress, his half-nude body seen not as a classicistic study but as the physique of a metropolitan creature who had left civilization for a short while to relax in the sun. At the beach in Bandol, in the south of France, where we spent some weeks together, one could observe what a strong attraction this mature man had for the opposite sex. His mighty vitality flowed not only into his art but also into his daily living."[3]

During their stay at the Côte d'Azur, Beckmann and his wife made trips to the casino in Nice and to the even more famous one in Monte Carlo. They were fond of playing the tables, especially baccarat and roulette. And for Beckmann as an artist, the casino was the dream image of Monte Carlo,[4] a place where cruel chance affected human destinies in mysterious ways under the influence of devilish croupiers and unholy cocottes.

Beckmann was especially fond of Monaco; while he was there he would visit Käthe von Porada, who had an apartment in the city. The Café de Paris, located in front of the casino and decorated in Art Nouveau style,

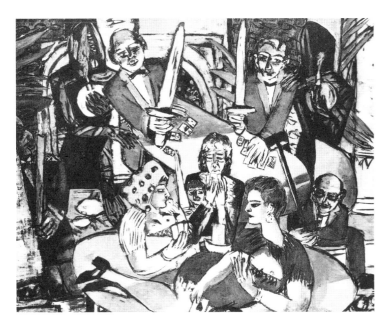

Max Beckmann, *Dream of Monte Carlo* (1939), 1940–43, (G 633).

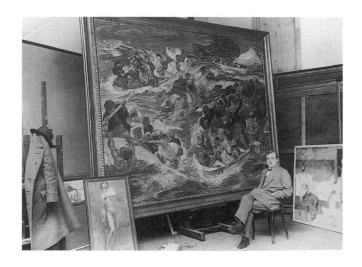

was the meeting place of the chic set, where one went to see and be seen, observe others and be observed. In the spring, one could watch the sailboats start in the annual regattas from there. *View from the Terrace in Monte Carlo* from 1935 (G 413) reflects this atmosphere. Pictures like this one, which the artist did from memory of the south of France, have a rare air of carefree feeling and an acceptance of life. He painted his subjects from the Côte d'Azur later in Paris, Frankfurt and Amsterdam, jogging his memory mostly with postcards. His fascination for the Côte d'Azur was so strong that the Beckmanns returned there on their last trip to France in 1947.[5] BS-A

Eugène Delacroix (1798–1863)

Art critic Julius Meier-Graefe once claimed proudly that he made the "very young beginner" Max Beckmann aware of Delacroix – which Beckmann immediately denied: "In 1904 I was already in Paris, long before I even knew Meier-Graefe."[1] So we can safely assume that Beckmann had already studied Delacroix during his first sojourn in Paris in 1903/04. The echo of these impressions is also strongly evident in the large many-figured works from the early years *(The Battle,* 1907, G 85; *Resurrection,* 1909, G 104; *Scene from the Destruction of Messina,* 1909, G 106; *The Sinking of the Titanic,* 1912, G 159. Already in 1919, Beckmann expressed his great admiration for Delacroix, "even

though I sense a conscious difference between his southern elegance and my own more northern existence."[2]

Delacroix was important for Beckmann in his early work, with respect to composition and also to the problem of how a contemporary history painting is possible. He came back to Delacroix again later on, but for the time being he interested him as one of the brilliant colorists of European painting. Beckmann particularly associated one painting from the great master of French romanticism with the French moderns for this reason: *Women of Algiers* (1834, Louvre) with its revolutionary, striking colors became a guiding star for later developments in French art. Impressionists, Symbolists, Neo-Impressionists and even Matisse and Picasso repeatedly admired the "fabulous brilliance and the flickering magic" (Paul Signac),

"these spicy nuances with all their intensity" (Paul Cézanne) of the painting. Beckmann's odalisque pictures in his later works (Cf. cat. 47, p. 71; cat. 58, p. 81) found their origins here, as did those of Matisse (cat. 82, p. 82; cat. 85, p. 78) and Picasso. TB

1 Briefe, Vol. 1, letter 238 to Reinhard Piper, Frankfurt, 8 April 1923.
2 Briefe, Vol. 1, letter 173 to Julius Meier-Graefe, Frankfurt, 10 May 1919.

1 Briefe, Vol. 2, letter 517 to Rudolf von Simolin, Paris, 21 March 1930.
2 Göpel Vol. 1, p. 22; Briefe, Vol. 2, note p. 379 on letter 522 to Rudolf von Simolin, St. Moritz, 12 January 1930 [1931].
3 Lackner 1969, p. 29.
4 Cf. *Dream of Monte Carlo,* 1939–1943, G 633.
5 From 24 March to 18 April, Beckmann and his wife stayed at the Hotel Westminster in Nice, Promenade des Anglais; cf. Tagebücher 1940–1950, pp. 195–197.

left: the harbor of Bandol, film still c. 1939, see cat. 39, p. 27.

right: Eugène Delacroix, *Women of Algers,* 1834.

below: Max Beckmann in front of the *Sinking of the Titanic,* c. 1913.

Robert Delaunay
(1885–1941)

In 1911 Kandinsky asked Robert Delaunay to participate in the first exhibition of the Blaue Reiter (Blue Rider) in Munich. This was the first of a series of presentations of his work in Germany, for example, in 1913 in the Galerie Der Sturm in Berlin.[1] Thus Beckmann had ample opportunity, even before World War I, to become acquainted with his works. Robert Delaunay was characteristic of his time and, like the Futurists, fascinated by movement and speed. Cars, sporting events, and flying were all significant factors in his art. Very often his works represented recent events so that his pictures often depicted sports reports. He sketched the rough draft for *The Cardiff Team* of 1913 (cat. 70), for example, directly from an illustration in a sports magazine,[2] and then transferred it to canvas.

Delaunay was no purist. Although a trailblazer of abstract art, he saw no contradiction between his abstract, "orphistic" experiments – as his friend Apollinaire once called them – and a representational style of painting. He admired Douanier Rousseau, to whom he felt a strong connection. Delaunay painted many portraits during his artistic career, but was primarily famous as a painter of the Eiffel Tower, which he gave a dominant place in his works after 1909 (the first painter to do so since Rousseau). Like Beckmann, Delaunay often based his sketches on photographs; in the case of the Eiffel Tower he also used postcards.[3] In his portrait of Philippe Soupault, painted in 1922, it is not the Eiffel Tower itself which the observer can see through the window in the background of the picture, but rather one of his own pictures of the structure.[4]

It should be mentioned that Delaunay had an exhibition in the Galerie de la Renaissance two years before Beckmann, in the same year Beckmann painted his *Soccer Players* (cat. 14), which in a way paid homage to Delaunay. BS-A

1 Cf. Peter-Klaus Schuster, Delaunay und Deutschlands, Cologne 1985.

2 Bernard Dorival, Robert Delaunay, Paris 1975, p. 56.

3 Cf. ex. cat. Robert and Sonia Delaunay, Musée d'Art moderne, Paris 1987, p. 18.

4 Michel Hoog, Robert Delaunay in ex. cat. Orangerie des Tuileries, Paris 1976, p. 92.

left: B. F. Dolbin, Carl Einstein, 1926.

below: Robert Delaunay, *Portrait of Philippe Soupault*, 1922.

Carl Einstein
(1885–1940)

After World War I, art critic Carl Einstein played an important role in the Berlin art circles. Through Daniel-Henry Kahnweiler he came into contact with Picasso and Braque early on. From the start Einstein was in favor of Cubism, which remained the foundation of his art preferences until the end of the 1920s. In 1915 he dedicated his trailblazing book to the "spatial integrity" and "cubist attitude towards space and depth" of Black African sculpture. The book, which also carried the name "Negerplastik" was – as Einstein wrote at the beginning of 1923 –"only understood by a few people in France."[1] The first contact between Einstein and Beckmann supposedly took place in 1915 in the "Brussels circle,"[2] initiated by Einstein's partner, the countess Augusta vom Hagen (1872–1949). Beckmann had painted her portrait in 1908 (Göpel 36). We encounter Einstein himself in Beckmann's print *Ideologues* (Hofmayer 144) from 1919.[3]

In the 1920s Einstein and Beckmann met several times in Berlin and in Frankfurt, at the Schwarzer Stern and the Hotel Carlton. At this time Einstein wrote about Beckmann: "For all his robustness he is a delicate boy. Very decent, tortured, very German." Around 1926 the friendship appeared to have cooled off. Nevertheless, Beckmann sent Einstein, who in the meantime was an internationally renowned art critic, photos of his most recent works for his book *Kunst des 20. Jahrhunderts*. He also expressed the hopes "that we will some day still manage to come to an inner and external conformity of our ideas."[4] Einstein dedicated a chapter with five plates to Beckmann in the first edition (1926).

In July 1928 Einstein moved to Paris, where he had close contacts with exponents of Surrealism[5]. In the same year Beckmann tried to win the much-admired author for a catalogue being jointly planned by Günther Franke[6] and Alfred Flechtheim. Einstein refused, whereupon Beckmann responded with the bitter comment: "Einstein will not write the Beckmann book. He has proven himself to be the treacherous dumb 'mime' I knew him to be from the very beginning."[7] The actual reasons for Einstein's refusal were probably more due to his declining interest in art. In fact, in the third edition of *Kunst des 20. Jahrhunderts* (1931) he reserved not less but more space for Beckmann than in the first and second issues, and he explicitly honored Beckmann's development in Paris: "We can see Beckmann's considerable efforts to free himself from everything provincial. The North German came to Paris to measure himself against international painting. Not once did he have anything to do with the cheap appeal of the exotic indulged in by the decorators. His coming to Paris is comparable to the journey of the old Germans to Rome."[8] Einstein emphasized Beck-

mann's efforts to unify modern pictoral elements, such as the cubist overlapping of visual elements, Braque-like color, old and new traditions of representation. "All these formal modern fragments are constantly absorbed by a classicistic pictoral scheme (...) Beckmann is doubtlessly trying to create something like the sum total of the modern artists; which is a tremendous venture of sheer will."[9]

After 1931 Einstein's life in Paris appeared to stagnate: "Money is becoming scarce here, unemployment and financial failures are on the increase, business is slow, there is little demand for books, everyone is saving and the people are very depressed."[10] Einstein felt – in spite of help from his French friends – increasingly reticent and homeless. He had enough of art once and for all. In 1936 he went to Spain to join the fight against Franco. In 1940, fleeing the German invasion in the south of France, he took his life. UH

1 Quoted from: Verschollene und Vergessene, Carl Einstein. Existenz und Ästhetik, Einführung mit einem Anhang unveröffentlichter Nachlasstexte, ed. Sibylle Penkert, Wiesbaden 1970, p. 17.

2 The members of the "Brüsseler Kreis" included Einstein, Carl Sternheim, Gottfried Benn, Alfred Flechtheim, Otto Flake and Wilhelm Hausenstein.

3 Cf: Barbara C. Buenger, Max Beckmann's Ideologues: Some forgotten faces, in The Art Bulletin, Vol. 71, No. 3, Sept. 1989, pp. 453–479.

4 Briefe, Vol. 2, letter 412 to Carl Einstein, Frankfurt, 28 October 1926.

5 Together with Georges Bataille and Michel Leiris in 1929, he founded the interdisciplinary journal Documents. Doctrines. Archéologie. Beaux-Arts. Ethnographie.

6 Briefe, Vol. 2, letter 457 to Günther Franke, Frankfurt, 23 April 1928.

7 Unpublished letter to I.B. Neumann, Paris, 1 March 1930, Estate of Max Beckmann. This resulted in the monograph project, which Waldemar George was to write for the Nouvelle Revue Française's series of art books, under André Malraux's general editorship.

8 Carl Einstein, Max Beckmann, in Die Kunst des 20. Jahrhunderts, 3rd ed, Berlin 1931, p. 184.

9 Ibid.

10 To Ewald Wasmuth, 1928/29, quoted from Sibylle Penkert, Carl Einstein. Beiträge zu einer Monographie, Göttingen 1969, p. 110.

Max Ernst (1891–1976)

That which Max Ernst and Max Beckmann had in common would have been restricted to their Christian names, nationality, profession as painters and their love for Paris, if it had not been for Beckmann's reference to the connection between the *Aerialists* (G 299, cat. 11) and Max Ernst's *Marriage of the Birds*, 1925 (Spies 1030). Beckmann's student Theo Garve (1902–1987) remembered: "Once in a while there was a request to visit him in his atelier on the Schweizer Strasse. (...) One time when I was there I saw, together with several works, the big picture *Aerialists*. Beckmann had disappeared, leaving me alone with my enthusiasm. After a time, he returned with a small exhibition catalogue containing pictures by Max Ernst in his hand. With reference to the *Aerialists,* he showed me the reproduction of the picture *Marriage of the Birds* as a comparable example of differing motifs in the same composition."[1]

A personal meeting, which Stephan Lackner tried to arrange in the fall of 1937 in Paris at Beckmann's request,[2] came to nothing because of Max Ernst: "As I have already told you, I am not particularly interested in Mr. Beckmann's painting ..."[3] So Beckmann's hopes of being introduced to the inner circle of Paris and Surrealism were dashed. His wish to meet his fellow countryman, who had been living in Paris since 1922 and was well-established there, cannot be explained simply by strategic considerations and his plan to move permanently to Paris. Even if Beckmann did not consider Ernst to be a good painter, his affinity for Surrealism was noticeable since the early 1930s – in the combination of the archaic and the modern, the unusual and the ordinary. UH

1 Quoted from Gallwitz 1984, p. 142.

2 "I arranged a meeting in Max Ernst's apartment, primarily to put in a good word for his colleague Beckmann in Paris; I thought that they had something in common." Stephan Lackner, Selbstbildnis mit Feder. Ein Tage- und Lesebuch. Erinnerungen, Berlin 1988, p. 103.

3 Ibid., p. 104.

Max Ernst, *Marriage of the Birds*, 1925.

Exile

Since the beginning of 1938 Beckmann had been trying to leave Amsterdam, the land of exile to which he had fled in the summer of 1937. He was unable to obtain a visa for the USA, so he planned to settle in Paris. From October 1938 to June 1939 Max and Quappi Beckmann lived in the city. On 30 November 1938 they applied for a "carte d'identité." Any foreigner who wished to stay for longer than two months in France was obliged to obtain this identity card, which was valid for a period of two years. The prerequisite for receiving it was having arrived in France with a valid visa. In addition, it was necessary to provide proof that one had a place to live as well as enough money to support oneself.

On 26 April 1939 Beckmann wrote to Stephan Lackner: "I am writing you on a day of good omen, firstly the conscription in England and secondly, almost at the same hour, my 'Carte d'Identité.' At last! So I'll move to Paris and I'll be able to unfold new, intense powers here since la France has taken me into her motherly arms."[1] If the outbreak of war (1 September 1939) had not interfered, Beckmann would probably have spent the rest of his life in Paris.

However, neither of the above-mentioned dates is the same as the only information about Max Beckmann which the "prefecture de police" in Paris still has on record, which states that, although he received an identity card for foreigners, it was only valid until 28 January 1939. It is astonishing that he gave his address on the official application as 91–93, rue Lepic, 18th arrondissement (and not the rue Massenet, where he was in fact living with Quappi). There is otherwise no information available about this address near the Sacré-Cœur church. LB

1 Stephan Lackner 1969, p. 75.

Interview with Alfred Flechtheim in the supplement to the Paris art journal *Cahiers d'Art*, No. 10, 1927.

Exposition des peintres graveurs allemands contemporains

From 10 June to 8 July 1929, the Bibliothèque Nationale (58, rue de Richelieu, 2nd arrondissement) showed the "exposition des peintres graveurs allemands contemporains" which was organized by Curt Glaser. The influential Glaser, first an art critic and later director of the Staatlichen Kunstbibliothek in Berlin, had been interested in Beckmann's work since 1913. In 1929 Beckmann painted his portrait (G 304).

Glaser's Paris exhibition offered a broad and competent overview of the graphic creations of the most important German artists of the 20th century (Lovis Corinth, Otto Dix, George Grosz, Ernst Ludwig Kirchner, Paul Klee, Oskar Kokoschka and Emil Nolde). Seven etchings by Beckmann were also shown: *The Large Bridge*, 1922 (H 243), *Beach*, 1922 (H 239), *Reclining Woman*, 1922 (H 210), *In Front of the Mirror*, 1923 (H 273), *Here Is Spirit*, 1921 (H 208), the lithographic portrait of Reinhard Piper, 1922 (H 240), as well as a print from *City Night*, 1920, the book of poetry by Lili von Braunbehrens, which Beckmann illustrated with lithographs (H 164–170). LB

Alfred Flechtheim (1878–1937)

After his commercial training, Alfred Flechtheim began at a very early age to collect contemporary art.[1] In January 1909 he was one of the founders of the Düsseldorf Sonderbund and served as its treasurer. A major exhibition of the Sonderbund in 1912 in Cologne was considered to be the most important exhibition of the moderns before World War I. In particular, it was a comparison of the German expressionists and the Paris avant-garde; the selection of French art (Picasso, Matisse, Derain, Braque) was made by Flechtheim. In 1917 the remaining paintings from the bankrupt Galerie Flechtheim were auctioned off in Berlin, ironically amounting to the only presentation of the French moderns during the war in Germany. In 1919 Flechtheim opened a new gallery in Düsseldorf, followed by a second branch in Frankfurt, and then in 1921 a further location in Berlin; later he added the Viennese gallery Würthle, managed by Lea Bondi, to his growing network. Flechtheim was in close contact with the Paris art dealers Daniel-Henry Kahnweiler and Ambroise Vollard. Soon he became the single most important dealer of contemporary art in Germany: Picasso, Braque, Derain, Gris, Vlaminck, Léger, Chagall, Klee, Marc, Dix, and Kandinsky were all represented by Flechtheim.

Max Beckmann and Flechtheim began a business relationship in the 1920s. They had known each other since Beckmann's early years in Berlin, but there was never any great love lost between the two men. Flechtheim most probably had not forgotten how Beckmann had taken a stand as a reactionary anti-modernist in a dispute with Flechtheim's protégé Franz Marc before the war. Beckmann was still unable to identify with the abstracts which Flechtheim represented. I. B. Neumann, Beckmann's loyal friend and dealer, brought the two together – something he soon regretted. In May 1924 Flechtheim wrote to Neumann in New York; he made inquiries and could not ind praise enough: "Dix is a great man, today's Stuck. But Beckmann is the really great man ..."[2]

In 1925 Flechtheim showed Beckmann's works for the first time in Berlin. At that time, Beckmann was open to new possibilities. Firstly he was angry at Neumann, who had gone to New York and left his business in Berlin in Nierendorf's hands, from whom Beckmann could expect no support. But most importantly, Flechtheim was the one man, perhaps the only man in Germany, who had a really intimate knowledge of the Paris scene and who cultivated close connections with all the important people in the city. Beckmann dreamed of a big exhibition at Ambroise Vollard or at the Galerie Rosenberg, which represented Picasso. He knew that only Flechtheim could help him

with this. In the summer of 1927 Beckmann began to exert pressure on I. B. Neumann to this end: "Flechtheim is at present a man who likes to sell good paintings without great pretensions, who represents a broad and not very specialized program and who is ready to undertake any endeavor with you at any time ..."[3]

Although Beckmann – who was bound to Neumann by an exclusive contract – merely requested him to agree to a one-off exhibition at Flechtheim's gallery, he actually had other plans in the back of his mind. On 26 July, Neumann learned the whole truth: "I demand of you ... to adapt yourself to the new situation, and that you agree to do this thing together with Flechtheim as of 1 October of this year. If you have not made your decision by 15 September ... I will sign a contract with Flechtheim on 16 September ..."[4] Beckmann's request was fulfilled on 9 September. Flechtheim was taken on as partner in an exclusive contract between Beckmann and Neumann. Immediately after signing the contract, Beckmann wrote the offended Neumann in Berlin and tried to cheer him up: "I. B. Neumann – do not become weak or unwilling because of false pride. You are still with me and I am still with you. Things will really start happening now. – And now do not be angry with F. – if the man is any good, which he will first have to prove to us, we will stay with him. If not, he will fall along the wayside anyway."[5]

left: Residence of A. Flechtheim: Dining Room by Bruno Paul (1912); paintings by Max Beckmann and Karl Hofer, sculptures by Edgar Degas, Ernest de Fiori and Aristide Maillol.

right: Max Beckmann, *The Eiserne Steg (The Bridge)*, 1922 (G 215).

below: Fritz Wichert and Max Beckmann, Hotel Frankfurter Hof, film still c. 1925.

It was the latter which came true. In March 1932 the Galerie Flechtheim in Berlin showed Beckmann for the last time. After the exhibition, Flechtheim terminated the agreement with I. B. Neumann and Max Beckmann. Neither party had fulfilled the expectations of the other. Although Flechtheim had shown Beckmann six times between 1927 and 1932, it was mostly in group exhibitions and invariably in Berlin. It had been Flechtheim's idea to build Beckmann up as the star painter of Berlin, i.e., as a modern Liebermann. Such plans for a local career, however, only offended Beckmann. Flechtheim, for his part, saw no reason to go out of his way and invest money and energy to get Beckmann established in Paris. His decades of experience brought him to a more realistic assessment of Beckmann's career plans in Paris than the artist himself had. TB

1 On Alfred Flechtheim: Alfred Flechtheim. Sammler, Kunsthändler, Verleger, ex. cat. Kunstmuseum, Düsseldorf 1987.
2 Ibid., p. 174.
3 Unpublished letter to I. B. Neumann, Frankfurt, 18 June 1927. Estate of Max Beckmann.
4 Unpublished letter to I. B. Neumann, Rimini, 26 July 1927. Estate of Max Beckmann.
5 Unpublished letter to I. B. Neumann, 9 September 1927. Estate of Max Beckmann.

Frankfurt / Main

Beckmann's Paris years were also his Frankfurt years. During the time he lived and worked in Paris (1929–32), he returned once a month to Frankfurt to carry out his duties as a professor at the Städelschule. But behind this lay a further purpose: without Frankfurt Beckmann would never have been in a position to launch an international career in Paris. This was based on several factors: the art collectors and dealers in Frankfurt and the generous conditions associated with his commitment as teacher of a master class at the Städelschule (1925–33) all combined to provide the necessary material prerequisites. In addition, Frankfurt's educated bourgeois society took Beckmann in after World War I and gave him the final touch of polish he needed for the Paris arena. And finally, the liberal and worldly Jewish intellectual "milieu" within Frankfurt – then situated near the border – opened up Beckmann's intellectual horizons to a culture not exclusively German, but rather European.[1]

Beckmann went to Frankfurt in 1915. Ugi Battenberg, a fellow artist from the early years, and his wife Fridel offered their friend shelter for a few days, or so they thought. Beckmann ended up staying in Frankfurt for 17 years. He did not give up his apartment until 1932 when the more anonymous metropolitan city of Berlin appeared to offer him better protection from the Nazis. A kind of art clique in Frankfurt considerably con-

tributed to Beckmann's rising star in the 1920s. The Städelsche Kunstinstitut, under the direction of Georg Swarzenski, bought their first painting by Beckmann in 1917; later thirteen of his paintings could be found in the museum's collection. Swarzenski also stirred up enthusiasm for Beckmann among many Frankfurt collectors. Fritz Wichert, who was assigned to the reorganization of the Städtische Kunstgewerbeschule in 1923, brought Beckmann to the Städelschule, to teach a master class that was created for him. Benno Reifenberg, the arts editor of the *Frankfurter Zeitung*, often generated good publicity for Beckmann. Heinrich Simon, its editor-in-chief, regularly invited Beckmann to his Friday "rendezvous," where the intellectual elite of the city were in the habit of

meeting. Irma Simon, his wife, introduced Beckmann to the von Motesiczky family, who lived in Vienna and whose daughter, Marie-Louise von Motesiczky, later became his student. It was at the house of this family that Beckmann met his second wife, Mathilde Kaulbach. In Frankfurt Beckmann also became acquainted with the two women who not only collected his paintings, but who were also to offer such massive support to his Paris projects: Käthe von Porada and Lilly von Schnitzler. TB

1 Gallwitz 1984 and ex. cat. Frankfurt 1984. Both provide a full picture of Beckmann's Frankfurt years.

Die Eröffnung der Beckmann-Ausstellung in Paris

Vorige Woche wurde in der Galerie de la Renaissance in Paris eine Sonderausstellung der Werke des großen Frankfurter Malers Max Beckmann eröffnet. Unser Bild zeigt einige prominente Ehrengäste bei der Besichtigung der Ausstellung; von links nach rechts: den deutschen Botschafter Herrn von Hoesch, den französischen Unterrichtsminister Mario Roustan mit seiner Gattin, Mlle. Laval und Madame Pomaret, die sich um das Zustandekommen der Ausstellung besonders bemüht hat.

THE MAX BECKMANN EXHIBITION
ORGANISED BY THE EUROPAISCHER KULTURBUND

AT THE
GALLERY
A LA
RENAISSANCE
II, RUE ROYALE, II
PARIS
FROM I5ᵀᴴ MARCH TO
Iˢᵀ APRIL

WORKS BY BECKMANN
ARE EXHIBITED BY

THE J.-B NEUMANN GALLERIES J.-B. NEUMANN & G. FRANKE
NEW-YORK MUNICH

Galerie de la Renaissance

11, rue Royale, 8th arrondissement

The Galerie de la Renaissance was founded on 28 October 1926 by Marie-Paule Lapauze, Gabriel Saget and Louis Harmansen. Marie-Paule Lapauze, the later Madame Pomaret, initially took over its direction. The gallery could not and would not compete with the big Paris art dealers Simon, Rosenberg and Bernheim-Jeune. It was distinguished by its literary commitment. The gallery published a magazine for art and literature of the same name, and a jury with prominent members regularly met there to select and review new works. Among the members of this jury were Paul Valéry, Philippe Soupault, Paul Claudel and Georges Duhamel. A comprehensive collection of correspondence with authors and journalists from the 1930s shows that the literary world in Paris had great respect for the magazine and for the deliberations of the jury of the Renaissance. The gallery closed on 18 April 1940.

In 1930 Beckmann announced his exhibition at the Galerie de la Renaissance in a letter to I. B. Neumann. He believed that he was "extraordinarily lucky" as he considered the gallery to be just as important as the Galerie Rosenberg, which represented Picasso. In particular, the social connections of the director made him euphoric:

"Madame Pomaret is considered to be very influential here, – (Madame Rockfeller has also visited her). But especially in the truly French circles of society. Her husband is a Member of Parliament."[1]

Beckmann, in a letter to Neumann, boldly reinterpreted his unsuccessful attempts to do business with Rosenberg into a victory: "– My energetic and clear behavior in relation to the Rosenberg clique is just beginning to bear fruit (...) Only through them will we be able to find friends, and that will also have an effect in America. – The Rosenberg clique trembles in fear of the first real blow to its entire edifice. Because it is hollow." Beckmann now tried to persuade his dealer to give his full support to his Paris project and to set his own plans aside, as he wanted to show only his very best paintings: "– Would it not be best if you put off your Beckmann exhibition until May or Oct. or Nov. of next year (31). – I will most certainly need the few pictures I have here to show to a few important people before the exhibition."

The exhibition was opened on 15 March 1931; it was supposed to continue until 15 April, but was extended by a further ten days. It was Beckmann's first major solo exhibition in Paris, and it was was the only one he would have during his lifetime. For him – he had fought for it for years – it was enormously important. It was his chance to present himself to the Paris public, and therefore to the international art world, and to be compared to the Paris artists, most importantly to Picasso, the foundation of the "Rosenberg building," as well as to Braque, Léger, Matisse and Rouault.

Waldemar George contributed a text to the exhibition catalogue, and Philippe Soupault wrote a long article on the exhibition for the *Renaissance* magazine. The event was financed partly by Käthe von Porada and partly by the Deutsche Kulturbund under the direction of Lilly von Schnitzler. The Deutsche Kulturbund was the German regional group of the Internationaler Verband für kulturelle Zusammenarbeit (International Association for Cultural Cooperation), which was also known as the Europäische Kulturbund and was directed by the Austrian journalist and writer Prince Karl Anton von Rohan. In 1926, at a convention in Vienna, Beckmann came into closer contact with these aristocratic-fascist pan-European circles, who were striving for an "anti-Bolshevist" unification of Europe. In 1927, he published his essay "Der Künstler im Staat" in the *Europäische Revue*, which was published by the cultural arts association.

The German Ambassador and the French secretary of state for education and art, Mario Roustan, were present at the opening, which led Beckmann to conclude that this would "guarantee a considerable fuss about Max Beckmann in Paris."[2] This assumption was confirmed by Fritz Neuriges in the *Weltkunst* of 29 March 1931: "The most important personalities of the German colony and the most highly renowned critics from the French art journals met at the 'vernissage'." Wilhelm Uhde, a man who knew the Paris scene intimately, took a more realistic view of the situation. In Paris, the exhibition was not perceived as an artistic event, but rather as a mundane occasion, at best a cultural manifestation of the German-French reconciliation. Nevertheless, art dealer Ambroise Vollard visited it together with Pablo Picasso. As Günther Franke reported, Picasso reputedly said afterwards to Vollard: "Il est très fort" (He is very strong). The reception in the French daily newspapers and magazines was reserved, more disapproving than not, and even in Germany a controversy was set off.[3] Only a single painting was sold, the *Forest Landscape with Woodcutter* of 1927 (Göpel 273), to the French government for the Musée des Ecoles Etrangères du Jeu de Paume. It was the first work of Beckmann's in a public collection in France.

Marc Vaux prepared three photographs of the exhibition room for the Galerie de la Renaissance; he also photographed a number of paintings which were not shown, as there were many more pictures in Paris than could be shown at the exhibition. The photos give an insight into the state of the paintings at that time – for example, *Feet in the Bath, Studio (Night)* or *Claridge I* – which Beckmann later reworked. From the catalogue, conclusions about the original concept of the exhibition could then be drawn, as it included pictures which were not

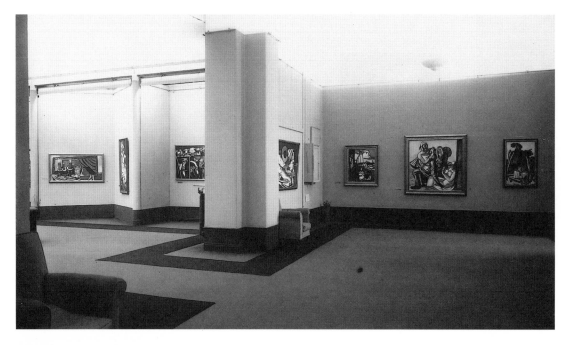

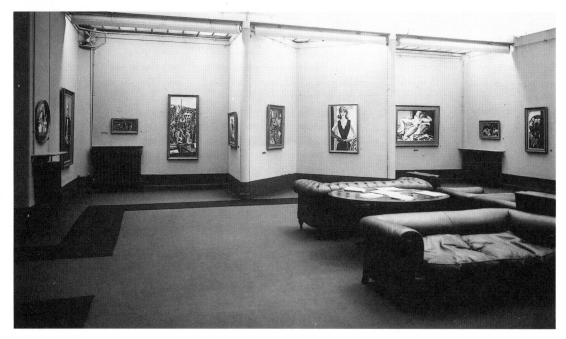

shown in the end. And finally, thanks to a sketch by <u>Mathilde Q. Beckmann,</u> the actual paintings included in the exhibition can be ascertained, and we have been able to complete the somewhat summary checklist of the catalogue. LB

THE ARRANGEMENT OF THE
PAINTINGS AT THE GALERIE
DE LA RENAISSANCE
(CLOCKWISE):
(Catalogue number and title / M. Q. Beckmann title / Engl. title)

12 Le Vésuve, 1926 (*Der Vesuf / Landscape with Vesuvius*, 1926, G 251)

17 Sur la plage 1927 (*Großes Badebild / The Beach*, 1927, G 267)

3 Le Pont, 1922 (*Der eiserne Steg / The Eiserne Steg*, 1922, G 215)

10 Deux masques, 1925 (*Pierrette und Clown / Carnival*, 1925, G 236)

13 Instruments de musique, 1926 (*Saxophone / Large Still Life with Musical Instruments*, 1926, G 257) [41 à 45 Divers] (*Karneval / Double Portrait Carnival, Max Beckmann and Quappi*, 1925, G 240)

4 Trapèze, 1923 (*Das Trapez / The Trapeze*, 1923, G 219)

[41 à 45 "Divers"] (*neu: Traum Paris / Rêve de Paris, Colette, Eiffel Tower*, 1931, G 341)

29 Portrait d'un Argentin, 1929 (*Portrait Argentinier / Portrait of an Argentinean*, 1929, G 305)

28 Pommes et Poires, 1929 (*gr. Apfel / Still Life with Pears*, 1926, G 260)

[41 à 45 "Divers"] (*Neubau / Neubau / Building under Construction* 1928, G 288)

[41 à 45 "Divers"] (*Sonnenaufgang / Sunrise*, 1929, G 303)

16 Fleurs, 1927 (*Blumen Schnitzler / Flower Still Life with Mirror*, 1927, G 271)

39 Portrait de Quappi, 1931 (*neu Portrait Quappi / Portrait of Quappi on Pink and Violet*, 1931, G 339)

22 Plage de Scheveningen, 1928 (*Strand Sch. / Grauer Strand / Gray Beach, Scheveningen*, 1928, G 298)

27 Nu couché, 1929 (*Simolin liegender Akt / Reclining Nude*, 1929, G 308)

36 Verres et chat 1930 (*Rotwein / Still Life with Wineglasses and Cat*, 1929, G 310)

38 Tulipes, 1930 (*Tulpen / Still Life with Tulips*, 1930, G 316)

34 Le joueur de saxophone, 1930 (*Saxophonspieler / Self-Portrait with Saxopohone*, 1930, G 320)

18 Télescope, 1927 (*Interieur m. Fernrohr / Large Still Life with Telescope*, 1927, G 275)

37 Valentine Tessier dans le rôle d'Alcmène, 1931 (*Tessier / Portrait of Valentine Tessier*, 1930, G 314)

20 Lys noirs, 1928 (*Schwarze Lilien / Black Irises*, 1928, G 285)

30 Nocturne, 1929 (*Nächtliche Straße / Street at Night*, 1928, G 292)

26 Deux dames à la fenêtre, 1928 (*2 Damen am Fenster / Two Women by the Window*, 1928, G 281)

23 Scheveningen à quatre heures du matin, 1928 (*Sch. 5 h früh / Scheveningen, Five o'clock in the Morning*, 1928, G 293)

33 Bougies et miroir, 1930 (*Kerzen m. Spiegel / Large Still Life with Candles and Mirror*, 1930, G 315)

19 Tziganes, 1928 (*Zigeunerin / Gypsy [I]*, 1928, G 289)

15 Port de Gênes, 1927 (*Hafen von Genua / The Harbor of Genoa*, 1927, G 269)

[41 à 45 "Divers"] (*Herzogin / Portrait of the Duchessa di Malvedi*, 1926, G 259)

35 Le champagne, 1930 (*Champagner / Still Life with Irroy*, 1929, G 311)

14 Notre-Dame, 1926 (*Notre Dame / Notre-Dame*, 1926, G 261)

[41 à 45 "Divers"] (*Stilleben / Still Life with Mexican Figure*, 1931, G 342)

31 Les Poissons, 1930 (*Fisch Stilleben / Large Still Life with Fish*, 1927, G 276)

24 Promenade à Scheveningen, 1928 (*Sch. Promenade / Strandpromenade bei Scheveningen / Beach Promenade in Scheveningen*, 1928, G 295)

31 Le Poisson, 1930 (*Der Wels / The Catfish*, 1929, G 312)

21 Bûcherons, 1928 (*Holzfäller / Forest Landscape with Woodcutter*, 1927, G 273)

IN THE CATALOGUE ARE THE FOLLOW-
ING WORKS WHICH WERE NOT
INCLUDED IN THE EXHIBITION:

THE FOLLOWING PICTURES WERE
MENTIONED NEITHER IN THE CAT-
ALOGUE NOR IN THE EXHIBITION
PLAN, BUT WERE PHOTOGRAPHED
BY MARC VAUX IN PARIS:

1 All quotes in this paragraph are from Briefe, Vol. 2, letter 550 to I. B. Neumann, Paris, 4 December 1930.

2 Beckmann was mistaken when claiming in his letter to Neumann (Briefe, Vol. 2, 552), that the minister "de Moncie" (sic) was present. De Monzie was only Minister of Education for a few months in 1925.

3 Cf. the essay by Tobia Bezzola, p. 141ff.

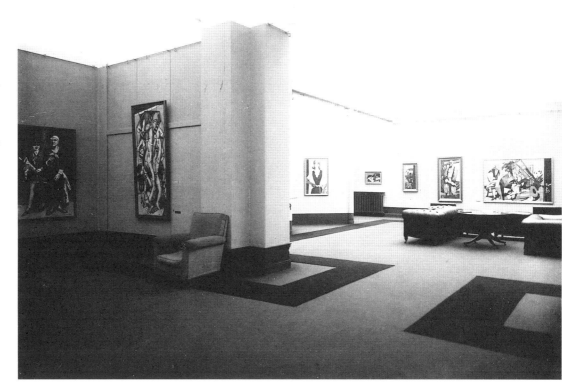

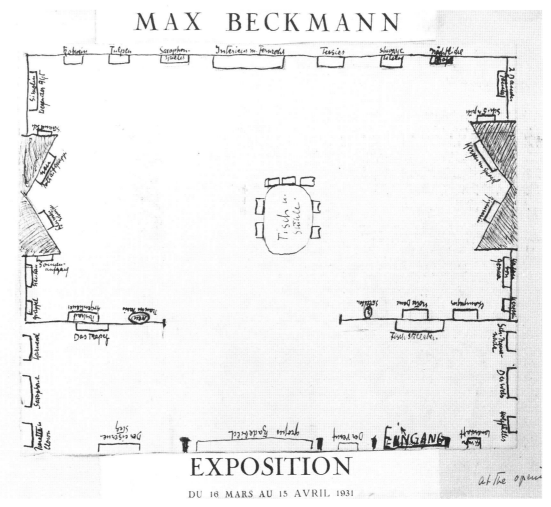

MAX BECKMANN

EXPOSITION

DU 16 MARS AU 15 AVRIL 1931

Galleries

GALERIE BERNHEIM-JEUNE
27, avenue Matignon –
83, rue du Faubourg Saint-Honoré,
8th arrondissement

Alexandre Bernheim opened his gallery in 1863. A friend of Delacroix, Corot and Courbet, he organized an Impressionist exhibition in 1874 and, in 1901 an important exhibition of van Gogh.

Under the management of his two sons, Josse and Gaston Bernheim-Jeune, the gallery bore the double name from 1906 on. The art critic Félix Fénéon lent his advisory support for the renamed gallery's inaugural showing of Bonnard and Vuillard. This was followed in 1907 by an exhibition of work by Cézanne and subsequently exhibitions of Seurat, Matisse, the Italian Futurists, Douanier Rousseau and Dufy or Vlaminck.

From 3 to 14 January, 1927, an exhibition was on view at Bernheim-Jeune with the appellation Multi-Nationale. This touring exhibition was first hosted in Berlin and Bern, and then in Paris, London and New York. It was dedicated to one political, philanthropic "leitmotif" which writer Paul Reboux articulated in his introduction to the exhibition catalogue for Paris: "Thanks to this spiritual and artistic exchange, it will be possible to solve all the problems in international life bit by bit." With the exhibition still at the preparatory stage, Beckmann wrote to I.B. Neumann, "Just think an American millionaire Mrs. Harrimann and her representative and advisor Mr de Zayas are organizing at their own expense at the National Gallery a 4-nation exhibition and this with 40–50 pictures from America, England, France and Germany. That is to say, 40–50 pictures from each single country. – I have been sent the list of German artists with Beckmann at the top, albeit in alphabetical order. The selection is good and for the first time includes only young artists – i.e. not Liebermann Slevogt etc."[1] Beckmann was represented with his *Self-Portrait in Front of a Red Curtain* from 1923 (G 218). Among the nations represented were Switzerland and Mexico, and among the 151 artists, Barlach, Dix, Feininger, Grosz, Heckel, Klee, Nolde, Pechstein, Schmidt-Rottluff, Bonnard, Derain, Denis, Gris, Masson, Matisse, Picabia, Rouault, Augusto Giacometti, Hopper and Max Weber.

It was likely to have been this meeting that prompted Beckmann to intensify his acquaintance with the Bernheim-Jeunes. In 1930, he made mention of his "next year's big exhibition at Bernheim-Jeune."[2] But this was never realized. LB

1 Briefe, Vol. 2, letter 382 to I.B. Neumann, Frankfurt, 26 June 1926.
2 Briefe, Vol. 2, letter to Günther Franke, Paris, 25 January 1930.

GALERIE ETIENNE BIGNOU
8, rue La Boétie,
8th arrondissement

Around 1930, Beckmann met Etienne Bignou, probably on Flechtheim's introduction. His gallery shared the prestigious location of the rue La Boétie with the Rosenberg, Bing and Georges Petit galleries. This contact was promising from the beginning, and Beckmann was persuaded to urge I.B. Neumann, his dealer in New York, not to delay in contacting Bignou to explore the possibilities of future collaboration.[1]

To his dealer in Munich, Günther Franke, Beckmann reported in more detail about an exhibition project at Bignou's: "Meanwhile Flechtheim has been here and has agreed on an exhibition for May 31 with Bignou who is opening a big brand new affair here in October. Nothing more was to be done, as much as I should have liked to have shown something here before then. But Bignou will already be showing individual pieces of mine from October on. So things are as good as they can be at this stage, if I.B. [Neumann] does not find something better in the summer."[2]

However, there was no Beckmann exhibition at Bignou's. The reason may have been that the opening of a new gallery planned by Bignou and Paul Guillaume (which seems to be what Beckmann was alluding to) never came about. When Beckmann made the acquaintance of Marie-Paule Pomaret, the director of the Galerie de la Renaissance, he noted to his satisfaction that she was "on very friendly terms with George[s] Petit and Bignou."[3] Through her, Beckmann would be able to realize the aspiration with which he had unsuccessfully approached Bignou. However, he overlooked the fact that Georges Petit had died in 1920 and the name now represented only a business address. But Etienne Bignou, on behalf of the Bernheim-Jeune brothers, was co-director of the Galerie Georges Petit, and as such was to organize the large Picasso retrospective exhibition there in 1932. Some years later, he would open his gallery in New York, where he would again feature Picasso in particular. LB

1 Unpublished letter to I.B. Neumann, Frankfurt, 15 March 1930, Max Beckmann estate.
2 Ibid.
3 Briefe, Vol. 2, letter 550 to I.B. Neumann, Paris, 4 December 1930.

GALERIE BING & CIE
20, rue La Boétie,
8th arrondissement

Prior to setting himself up as an art dealer, Henry Bing-Bodmer was a painter – his grandfather was the Swiss artist Karl Bodmer. Initially, he lived at the Bateau Lavoir in Montmartre, where his "atelier du pendu," "hanged man's studio," was directly opposite Picasso's. Bing worked as a draftsman for the satirical paper, *L'Assiette au beurre*, in Paris, and its counterpart in Munich, *Simplicissimus*.[1] He maintained numerous contacts amongst the German artist colony at the Café du Dôme. After World War I, he established a gallery on the Rue du Faubourg Saint-Honoré, and a little later on the exclusive Rue de La Boétie. The artists he represented, often without success, were Soutine, Modigliani and Rouault, but he also gave his support to the naive painters Bombois and Vivin.

Beckmann's association with Bing began at the time of his exhibition at the Galerie de la Renaissance in 1931. He wrote to Neumann on the show's success and its evident appeal to Bing, "… as a provisional repository 'Bing' a most charming and likeable person, who, so long as you yourself are not doing anything here, will represent our interests very well."[2] Beckmann at this stage was still looking for a reputable dealer to be his permanent agent in Paris. Galerie Bing appeared to suit him, for "by the way, Bing also told me today that he is friends with

Demotte.[3] Moreover, he organized the first Ro[u]ault exhibitions here – in spite of Vollard – and still has some very fine ones too. Besides, he also has Bombois and Vivin, who are both quite good and whom you can incorporate to great benefit. – You know that if I say such a thing, it is so."[4]

Both Bombois and Vivin painted in the manner of Douanier Rousseau and, like him, enjoyed the support of Wilhelm Uhde.[5] One can question Beckmann's sincerity in his remark concerning them, since he would, of course, have wanted Bing and Neumann to have a business relationship, at any cost, perhaps by Neumann's introducing the two naive painters in New York in an exchange deal with Bing. While Neumann was not interested in taking such a step, Bing did take on some works of Beckmann's. "Bing has hung our pictures at his gallery now, and does that look wonderful! – We have to sell very cheaply here to begin with and I have promised Bing 30–40%, so that we get a foot in the door. He is all enthusiasm."[6] Beckmann also attempted to persuade Günther Franke in Germany to move in this direction: "… and if you were to hold an exhibition of Bombois and Vivin as well, that would be very good. – I beg you not to be put off by petty worries about the percentages. After all, it is only for the time being and nothing agreed in contract form. But it is so important to have a representative here, that one would have to give the pictures away just to assure a start!"[7]

A few days later, he was urging I. B. Neumann again that he, Beckmann, "would just find it very good if you could enter into warmer business relations with Bing who is a very pleasant chap (and speaks excellent German & English)." Although he pointed out that "Bombois & Vivin are certainly no monumental geniuses, but the only positive thing that is still to be had and which in any way goes together with our concerns and Ro[u]ault whom Bing also holds in high esteem. – So it would be most laudable if you could exhibit these people at your gallery at some time, so that Bing gains greater business interest in our cause."[8]

No contractual agreement between Bing and Beckmann ensued, but the

friendliness remained, and Beckmann was convinced that he had found his Paris art dealer at last. As Bing's private apartment at Rue Ernest Cresson in the 14th arrondissement was in the immediate vicinity of Beckmann's studio,[9] he was a frequent visitor there and would take one or the other work along for the gallery. "For this he gets = provisionally = 2 small, more recent pictures = La corniche[10] = and a still life with oysters.[11] = Bing has gone to great efforts on our behalf – The paintings are on constant display and even in the window (…) it is the biggest success we have attained to date. I could tell by the incredible surprise of all the Germans when they saw my pictures at Bing's in the window."[12]

With such a presence in a front window on the Rue La Boétie, Beckmann at last saw himself put on a par with the leading protagonists of modern art in Paris: Picasso, Matisse, Braque, Léger and Derain.

From 20 May to 10 June 1932, Bing devoted all the rooms in his gallery to Beckmann's latest output.[13] No list of works in that exhibition has survived. All we know is that they included three works dating from 1931, *Portrait of Quappi on Pink and Violet* (G 339, cat. 22), the *Church in Marseille* (G 345) and *Woman Reading* (G 350).[14] The response to the exhibition was modest, and only the first painting of the three named above was sold. Nevertheless, Beckmann still reported to I. B. Neumann that the exhibition had been "a great success in terms of morale. Uhde, Bing and Waldemar George are now my close friends."[15] But his collaboration with Bing was soon to end. Even he was not immune to the economic crisis, and had to close the gallery at the end of that year. LB

1 Francis Carco, "Une nouvelle galerie d'art," press article undated and without naming the publishing journal; preserved in the Documentation du Centre Georges Pompidou (Réservé, Galerie Bing).

2 *Briefe*, Vol. 2, letter 562 to I. B. Neumann, Paris, 20 April 1931.

3 Demotte was the proprietor of the bookshop and publishing house Les Quatre Chemins. The journal FORMES was one of its publications.

4 Cf. note 2.

5 Wilhelm Uhde, *Fünf primitive Meister: Rousseau, Vivin, Bombois, Bauchant, Séraphine* (Zürich, 1947).

6 *Briefe*, Vol. 2, letter 565 to Günther Franke, Paris, 6 May 1931.

7 Ibid.

8 *Briefe*, Vol. 2, letter 567 to I. B. Neumann, Paris, 25 May 1931.

9 Conversation between this author and Bernard Bing, Henry Bing's nephew, in February of 1998.

10 *La Corniche*, 1931 (G 344).

11 *Still Life with Oysters*, 1931 (G 343).

12 *Briefe*, Vol. 2, letter 568 to Günther Franke, Paris, 30 May 1931.

13 *Briefe*, Vol. 2, letter 593 to Rudolf von Simolin (and note), Frankfurt-on-Main, 26 April 1932.

14 Göpel I, pp. 240, 243, 246.

15 Unpublished letter to I. B. Neumann, 25 July 1932, Estate of Max Beckmann.

GALERIE JEANNE BUCHER
9, boulevard du Montparnasse,
6th arrondissement

In 1925, Jeanne Bucher (1872–1946) established a publishing house and art dealership.[1] It was a combination she would maintain for the rest of her life. One of the first printed works she issued was Max Ernst's *Histoire naturelle*. Bucher's friendship with Marie-Paule Pomaret enabled her, in 1930, to show sculptures by Lipchitz at the Galerie de la Renaissance. In 1932, the crisis in the art market forced her to give up her activities temporarily. Three years later, she resumed them on the boulevard du Montparnasse. Bucher had a very diverse stable of artists, ranging from the naive painter André Bauchant to Jean Lurçat, Max Ernst or Jacques Lipchitz and Picasso, Braque, Léger, Miró, de Chirico, Mondrian, Kandinsky, Arp, Picabia, Vieira da Silva and Nicolas de Staël. Her modest premises became a meeting place for the international avant-garde of the pre-war years.

Jeanne Bucher's gallery was one of those by which Beckmann kept in touch with his contemporaries' developments. His signature appears, for example, in the visitors' book for the Torrès-Garcia exhibition from 30 January to 14 February 1931, along with those of Käthe von Porada, Georges

Vantongerloo and Piet Mondrian. Beckmann's visits may have ranged beyond merely the exhibitions, for in 1948 it was from Jeanne Bucher's gallery that the Museum of Modern Art purchased for its collection his drypoint, *The Dream II* (1923; H 303).[2] LB

1 Christian Derouet among others, Jeanne Bucher Une galerie d'avant-garde 1925–1946. De Max Ernst à de Staël, Geneva 1994.
2 James Hofmaier, Max Beckmann: Catalogue Raisonné of His Prints, 303.

GALERIE DURAND-RUEL ET CIE
39, avenue de Friedland,
8th arrondissement

On 15 September 1903, before departing for Paris, Max Beckmann wrote himself a memo. The diary entry reads, "Paris: Durand-Ruel et Fils, art dealers. Owner of Manet, Renoir, Cézanne, Sisley, etc."[1] At this time, the gallery was located at 16, rue Laffitte, in the 9th arrondissement and was regarded as the stronghold of Impressionism. Paul Durand-Ruel (1831–1922) had begun by exhibiting artists like Corot, Millet, Courbet and Daubigny. Having met Monet in London in 1870, he soon discovered Pissarro, Sisley, Degas and Renoir, all of whom he represented with commitment from 1871 onwards. In 1886 he organized an Impressionist exhibition in New York. It was such an obvious success that he also opened a gallery at 12 East 57th Street. This continued in business until 1950.

Apart from the artists mentioned by Beckmann – Manet, Renoir, Monet and Sisley – Durand-Ruel also showed Post-Impressionists at his Paris gallery. It is to him that Odilon Redon (1894), Bonnard and Gauguin (1896) and Toulouse-Lautrec (1902) owed their first one-man exhibitions. In Berlin, the art dealer had good relationships with Hugo von Tschudi, the "Konservator" at the Nationalgalerie, and with the Cassirer brothers. After his death, first his sons and later his grandsons took over the business. In December 1924, the gallery took up new premises in the 8th arrondissement, where it is still in business to the present day.

Page from the Guestbook of the Galerie Jeanne Bucher, 1931.
below: Pablo Picasso exhibition in the Galerie Georges Petit, 1932.

From the 1930s, Durand-Ruel occasionally exhibited works by Beckmann, albeit not in Paris (another fluke of the artist's Paris fate) but rather in the New York gallery. Beckmann took part in the group exhibition, *Paintings of Flowers and Still Life*, showing there from 12 to 24 December of 1932. His painting *Flowers at Window* [?] hung among still lifes by Derain, Hofer, Kisling, Nolde, Pechstein, Vlaminck and others.[2] He was again represented at the New York Durand-Ruel from 9 January to 2 February 1946, in the *Modern Religious Paintings* exhibition, this time in the company of Avery, Chagall, Dalí, Picasso, Rouault, Tobey, Weber and others. LB

1 Frühe Tagebücher, included in Buenger, Max Beckmann: Self Portrait in Words, 1997, p. 47.
2 Durand-Ruel archives, Paris.

GALERIE METTLER
174, rue du Faubourg Saint-Honoré,
8th arrondissement

From 15 January to 8 February 1930, the Galerie Mettler mounted an exhibition about which Beckmann wrote to Günther Franke, "On the 5th or 6th, the first exhibition at Mettler's will close. It is a portrait exhibition from Ingres to Picasso. There is also a portrait by me in this exhibition, 'le jeune Espagnol[e]'."[1] "Le jeune Espagnol" is now listed in the catalogue raisonné as *Portrait of an Argentinian*, 1929 (G 305).

For Beckmann, his participation in this exhibition was only a step on the way to greater things. "This gives you a good link to Mettler," he wrote in the same letter to Franke, "the point being that I have the idea of possibly showing the Paris pictures at Mettler's for a short time before they go to Germany. This would be quite a good preliminary to next year's big exhibition at Bernheim-Jeune. Mettler does not know anything about this yet. I will keep quiet altogether, but it might in your hands to get the ball rolling."[2]

Events did not work out, and no further relations were built up with the Galerie Mettler, nor did the "big exhibition" materialize at the prestigious Galerie Bernheim-Jeune, but rather at the Galerie de la Renaissance. LB

1 Briefe, Vol. 2, letter 512 to Günther Franke, Paris, 25 January 1930.
2 Ibid.

GALERIE GEORGES PETIT
8, rue de Sèze,
9th arrondissement

Following the death of his father, Georges Petit took over his gallery. He soon opened its doors to Impressionism and so became one of the most significant art dealers in Paris. When he died in 1920, his gallery enjoyed such an unequalled reputation that it continued as a business under the same name, but was used especially for important auctions and events.[1] In 1930, the Bernheim-Jeune brothers acquired the gallery premises as well as the name of Georges Petit. However, the second Galerie Georges Petit, in which Etienne Bignou also had a hand, survived for only three years.

This was not for lack of trying; on 18 March 1931, under the auspices of the Bernheim-Jeunes, they opened a large exhibition of Oskar Kokoschka's work. Many critics compared it to Beckmann's concurrent exhibition at the Galerie de la Renaissance. The most significant event during those three years, however, was the first comprehensive retrospective given to Pablo Picasso, which showed at the Georges Petit from 16 June to 30 July 1932 before travelling to the Kunsthaus Zürich. It is likely that Beckmann saw the exhibition in Paris; in any event, he possessed the complete catalogue.

The Bernheim-Jeunes, too, succumbed to the crisis afflicting the art trade in the early 1930s, and were compelled to close the Galérie Georges Petit in 1933. LB

1 Pierre Daix, Dictionnaire Picasso, Paris 1995, p. 317 f.

Pablo Picasso exhibition in the Galerie Georges Petit, 1932.

GALERIE ALFRED POYET
Rue La Boétie, 8th arrondissement

Eight years after the exhibition at the Galerie de la Renaissance, another exhibition of Beckmann's work in Paris was finally planned, this time in the Galerie Alfred Poyet.[1] The project was doubly important to Beckmann, since he and his wife had just decided to settle in France. "I intend to stay here in Paris for the time being, for one thing there will be an exhibition at Poyet's from [28] April to 15 May. Though a small one only, more of a business card, because we don't want to startle the Parisians too much right at the beginning."[2] Stephan Lackner took charge of the organizing and finances with Käthe von Porada; both put numerous paintings from their private collections at the exhibition's disposal. But on 1 May 1939 Beckmann wrote to I. B. Neumann, "My exhibition at Poyet's (at the former premises of Paul Guillaume, who has already gone to Paradise), has unfortunately had to be postponed, because my 'friends' in Germany are misbehaving once again – but it doesn't matter, because P. continues to take care of things."[3] With the political situation coming to a head internationally, it was considered unwise to show a German artist in Paris.

Early in April 1939, Stephan Lackner emigrated to the United States with his parents and took with him part of his collection of paintings. This included several by Beckmann that had been intended for the Poyet exhibition. Lackner was no longer able to attend to the project, but the show materialized nonetheless, underground, so to speak. "The Poyet exhibition has been postponed, but no damage done, as the things are staying at Poyet's (except for what Morgenroth [Lackner] has taken with him) and they can be viewed there, privately as it were."[4] Shortly after Lackner, the Beckmanns also left Paris. Käthe von Porada showed his works at her private premises, but in the face of an increasingly ominous situation, she placed the Beckmann paintings in the care of Marcelle Bernadette Ratier, a friend of Lackner's. Beckmann wrote to Lackner: "So at Poyet's there are a good many pictures under Kati's care. You had best have a list sent you, or better still, have them photographed by Marc Vaux Rue Vaurigard so that you can choose. Likewise with the pictures which are still at Marcell's. But at Marcell's

amongst other things there are 2 unfinished ones – a very dark "Children of the Night" and a sketched portrait of a young girl. I am sure the pictures that you choose from the photographs can be sent rolled up."[5]

We do not know whether Marc Vaux ever produced the photographs; all that is certain is that Marcelle sent no paintings to Lackner in the States. She joined the French Resistance and hid Beckmann's works in the attic of a restaurant in the Rue d'Anjou in the 8th arrondissement, where they survived the war unscathed.[6]

Once the war ended, it was important to get the paintings back, and in 1946 Beckmann sent a list of the pictures stored at Mademoiselle Ratier's to Stephan Lackner.[7] It comprised *Woman at Her Toilette with Red and White Lilies*, 1938 (G 493), *Park Bagatelle in Paris*, 1938 (G 496), *Warrior and Bird Woman*, 1939 (G 522), *Children of Twilight*, 1939 (G 526) and *Cap Martin*, 1939 (G 527). But Beckmann would have to wait another year before he obtained a travel permit to Paris. There he met his friend Lackner again at last, on 19 April 1947, and two days later they visited the restaurant on Rue d'Anjou together. "At 3 Stephan picked us up, and we drove

to an enormous old house with an elevator, where right at the top stood many of my working pictures. Most belonging to Stephan, but Self-Portrait in Tails 1937 and Woman with Tambourine popped up again and said 'Hello Herr Beckmann'."[8] Only a few days later, the Beckmanns returned to Amsterdam with the pair of newfound pictures, and Lackner went back to the States with his. The turmoil of war had claimed at least one of the Beckmann paintings in Paris, however. As irony would have it, it was the portrait of his foremost Parisian patron, Madame Pomaret (1939, G 515). LB

1 Briefe, Vol. 3, letter 692 to Curt Valentin, Paris, 31 March 1939.

2 Briefe, Vol. 3, letter 691 to Valentin, Paris, 17 March 1939.

3 Briefe, Vol. 3, letter 694 to Israel Ber Neumann, Paris, 1 May 1939.

4 Briefe, Vol. 3, letter 695 to Valentin, Paris, 1 May 1939.

5 Briefe, Vol. 3, letter 710 to Stephan Lackner, Amsterdam 20 November 1939.

6 As Stephan Lackner kindly informs Barbara Stehlé-Akhtar and Laurent Bruel.

7 Briefe, Vol. 3, letter 774 to Lackner, Amsterdam, 26 May 1946.

8 Tagebücher 1940–1950, p. 199.

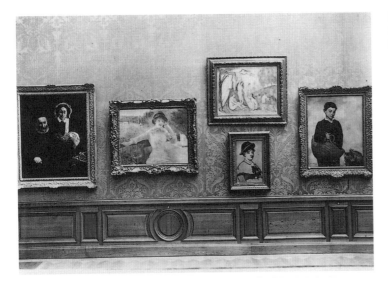

left: Exhibition in the Galerie Paul Rosenberg, with works by Manet, Renoir, Cézanne and Corot, 1931.

below: Exhibition in the Galerie Paul Rosenberg, with works by Braque, Matisse, Picasso, Laurencin and Léger, 1931.

GALERIE PAUL ROSENBERG
21, rue La Boétie,
8th arrondissement

It was through their father Alexander that the brothers Léonce and Paul Rosenberg entered the art trade. From 1901, they co-managed a gallery with him at 38, avenue de l'Opéra and organized exhibitions of the Old Masters and the Impressionists.

In 1906, Alexander Rosenberg retired, leaving his sons to continue the art dealership until 1910, at which point they went their separate ways.[1] Henceforth, Léonce headed the Galerie de l'Effort moderne in Paris. Its significance was far eclipsed by that of the Galerie Paul Rosenberg. This was where the best artists sought to show and where the prices set standards; and it was also where the clientèle came from the best circles. The Paul Rosenberg gallery was so renowned that it received up to 700 visitors a day.[2] A branch was opened in London under the management of Rosenberg's brother-in-law, Jacques Heft; in New York, Paul Rosenberg was associated with the Wildenstein Gallery, and in Germany, he collaborated with the Galerie Paul Cassirer in Berlin.[3] There can be no doubt that Rosenberg dominated the Paris art market between the two world wars.

In Paris, Beckmann regularly called at the Rue La Boétie galleries, and he is sure to have been highly impressed by Paul Rosenberg, in whose range were united the most important protagonists of French painting – on the ground floor, the classics – Ingres, Delacroix, Douanier Rousseau, van Gogh, Gauguin, Manet, Renoir, Degas, Courbet and Corot; on the floor above, Cézanne, Braque, Léger, Matisse, Laurencin, Vuillard and Bonnard; but most significant of all, Pablo Picasso.

From this time on, Beckmann considered the name of Rosenberg to be synonymous with the Parisian art establishment. In his mind, the two brothers merged into a single great power on both the Paris and the world art scene. From the "bastion" of Paris, he thought, the "Rosenberg clique" "directed the taste and philosophy of the art of the whole world … with a fantastic foolishness."[4]

He would have had nothing against Paul Rosenberg if he had taken an interest in Beckmann's work. In 1926, knowledge of the connections of his new patron, the Prince Karl Anton von Rohan (see Stratégie Parisienne p. 224), had the artist dreaming of an international exhibition at Rosenberg's, in which the artistic achievement of Europe was to be shown.

"… only four artists an Italian, a German, Frenchman and Spaniard (collective exhibition) I thought: Severini, Beckmann, Braque and Picasso."[5] Gino Severini was at this time showing at Léonce Rosenberg's Galerie de l'Effort moderne, whereas Picasso and Braque were among Paul Rosenberg's artists. Beckmann already had visions of himself crossing the threshold into the Paris art scene and of counting his adversaries as his allies. In 1928, he was still writing to I. B. Neumann about the "world power" that he envisaged he would attain via an axis of "Rosenberg in Paris, Franke in Munich, Flechtheim in Berlin and you in New York."[6]

Beckmann's attitude towards the Rosenberg brothers changed according to his changing expectations of them as aides or opponents in his endeavors to gain a foothold in Paris. Ultimately, however, the Rosenbergs, like Kahnweiler, remained an elusive goal that was never achieved. From the 1930s, with all the conceivable plans for collaborating with them crumbling, Beckmann began to regard the Rosenbergs as his greatest foes. He believed that with his exhibition at the Galerie de la Renaissance, he would shake the "Rosenberg edifice," and, exhibiting at Bing's on the Rue La Boétie just a few steps away from Galerie Paul Rosenberg in 1931, Beckmann writes triumphantly to Günther Franke, "The paintings are on constant display and even in the window – … to annoy Rosenberg."[7]

Léonce Rosenberg died in Paris in 1947; Paul found his way to the USA in 1940, and in 1941 set up a gallery on 15 East 57th Street, very near to the galleries of Curt Valentin and I. B. Neumann. We cannot be sure whether Beckmann ever went there between 1947 and 1950, or indeed whether Rosenberg ever made his way to Valentin's to look at the German's work. Neither of the two art dealers' visitors' books have survived. BS-A

1 Our gratitude goes to Mrs Elaine Rosenberg for her friendly cooperation and the documents she allowed us to peruse.
2 Hector Feliciano, The Lost Museum, New York, 1997, p. 57.
3 Information from Elaine Rosenberg, February 1998.
4 Unpublished letter from Beckmann to I. B. Neumann, 2 June 1926, Estate of Max Beckmann.
5 Unpublished letter from Beckmann to I. B. Neumann, 15 December 1926, Estate of Max Beckmann.
6 Unpublished letter from Beckmann to I. B. Neumann, 24 November 1928, Estate of Max Beckmann.
7 Briefe, Vol. 2, letter 568 to Günther Franke, [Paris], 30 May 1931.

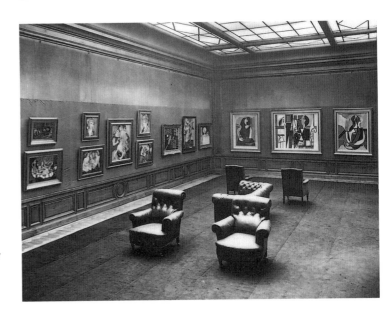

HOTEL D'ARCADE
7, rue d'Arcade,
8th arrondissement

The Arcade was a humble hotel in which Jean Genet lodged for an extended period of time during the 1950s. The Beckmanns stayed here from 18 to 21 April 1947 after his return from the Côte d'Azur. Here Beckmann was near to the Rue Vignon, where Daniel-Henry Kahnweiler lived. Kahnweiler was acting as an agent for Beckmann.

HOTEL CALIFORNIA
16, rue de Berri,
8th arrondissement

It was here that Beckmann stayed in 1925 during his first stay in Paris after World War I. The luxury hotel was situated near the famous Rue La Boétie, where Picasso lived and where the most significant galleries were located. Beckmann and I.B. Neumann held their meetings in the Hotel California from 27 to 31 July of that year. The painter was impressed: "Neumann picked me up and dragged me to one of the most fantastic hotels 'California' where only the American millionaires stay. (…) I have such a wonderful apartment in the California with such a big bed and separate washroom and bathroom and anteroom."[3]

HOTEL CLARIDGE
74, avenue des Champs-Elysées,
8th arrondissement

The hotel was opened on the Champs-Elysées in 1914 as one of the greatest hotels in Paris.[4] In the 1930s, Marlene Dietrich was among the guests, and Colette put on grand receptions in the salons. In 1928 when Beckmann was planning their meeting in Paris from 9 to 10 September, he suggested to Minna Beckmann-Tube that she meet him in the tearoom at the Claridge,[5] if they should happen to miss each other at the train station. Beckmann stayed at the Claridge until he returned to Frankfurt on 14 or 16 September. From then on, the Claridge was his hotel. Later, when he had an apartment in Paris, the Claridge assumed the same role as that of the Frankfurter Hof in Frankfurt: a salon for business and private appointments.

The comings and goings of elegant women is reflected in *Claridge I* of 1930 (G 335). *Claridge II*, which was also created in November 1930 (G 336), represents a waiter who roams through the hotel as if he had come from a dream world. In 1938 Beckmann asked Käthe von Porada to reserve a room for him at the Claridge, where he stayed from 24 to 28 March. He wrote to Quappi: "Thinking of you in the Claridge, where I am just having a quiet hour of meditation."[6] In April 1939 he composed a letter on the stationery of the Claridge for the last time.

HOTEL DE CRILLON
10, place de la Concorde,
8th arrondissement

The Crillon, built by Jacques-Ange Gabriel at the end of the 18th century, was one of the most elegant hotels in Paris. Thanks to its excellent location in the Place de la Concorde, it offered a fantastic panoramic view of the "tuileries" and the gardens of the Champs-Elysées. Proust and Hemingway could not resist the magic of this hotel. The hotel had found its place in Beckmann's work, as the painting *Place de la Concorde at Night* (1939, G 523) shows the view from the balcony of the "piano nobile." Beckmann himself had never stayed at the Crillon, but his friend Rudolf von Simolin was in the habit of staying there: "Well I caught up with Rudo, but not at the Chattam, but rather at the Crillon … "[7]

HOTEL EDOUARD VII
39, avenue de l'Opéra,
2nd arrondissement

This luxury hotel was situated between the Opera and the place Vendôme and was the last Paris hotel in which Beckmann was to stay. Together with his wife, Beckmann stayed at the Edouard VII from 25 to 27 March 1947,[8] before taking the train to Lyon where they stayed at the Hotel Nouvelle. On 29 March 1947 Max and Quappi Beckmann arrived in Nice, where they stayed at the

right: Max Beckmann, *Place de la Concorde at Night,* 1939, (G 523).

Hotel Westminster on the Promenade des Anglais.

HOTEL DES ETATS-UNIS
16, rue d'Antin,
9th arrondissement

This renowned hotel is situated near the Opera. In June 1927 I.B. Neumann stayed here and met with Georges Rouault.[9] It remains unclear whether Beckmann visited the hotel one year later, in August 1928, when he had arranged a meeting with I.B. Neumann. In any case, he used the stationery of the Etats-Unis on 25 June 1931, to give Neumann his new private address on the Rue des Marronniers.[10]

HOTEL FOYOT
33, rue de Tournon,
6th arrondissement

This hotel, which no longer exists, was situated on the northern fringes of the Jardin du Luxembourg, very close to the "quartier" Latin and not very far from the Rue Notre-Dame-des-Champs where Beckmann had his studio in 1903/4. The Foyot was the meeting place for numerous artists. Due to a planned meeting with I.B. Neumann, Beckmann took a room here from 11 to 15 August 1926.[11] In the following year he again stayed here for a few days from 10 July, in order to look for an apartment and a studio in Paris. It was to be a short stay, as Käthe von Porada had already made arrangements for him.[12]

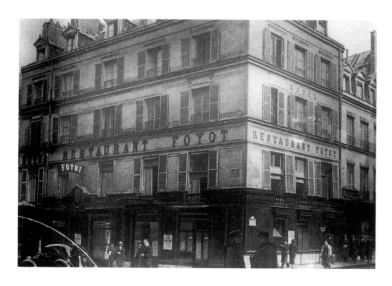

Impressionism

In 1919 Beckmann noted that he had remained "to this day a pupil of Liebermann and Leibl."[1] With that assertion, he placed himself in the tradition of German Realism and Impressionism. Both the artists he cited had spent considerable time in Paris and had high regard for Courbet and Corot. During his training at Weimar between 1900 and 1903 Beckmann studied Liebermann, Slevogt and Corinth – painters who might be regarded, as Bernard Denvir has done, as the "triumvirate of German Impressionism."[2] There is a photograph taken in 1907 which shows the young Beckmann painting "en plein air."

In 1903, before he left for Paris for the first time, Beckmann noted the address of the leading Impressionist dealer, Durand-Ruel. This was where Monet, Manet, Renoir, Cézanne and Sisley were shown.[3] On the Salon des Indépendants of 1904, Beckmann wrote to Caesar Kunwald, "Les Indépendants, who persuaded me to put Impressionism down to sweet memory and away in the junk room."[4] The exhibition included works by Bonnard, Matisse, van Dongen, Delaunay, Vuillard, Vallotton, Denis, Sirusier and Signac – in other words, alongside the Post-Impressionists, also the future Nabis and the Fauves.[5] But far from implying that he was about to join this new generation of painters, Beckmann's renunciation of Impressionism identified them all as latter-day proponents, and he did not want to be associated with them. In 1912 his response to the so-called "new painting,"[6] was scathing, and some years later he wrote to Meier-Graefe. "From my first sojourn in Paris in 1903, when I worked alone, I derived only a very intense distaste towards the tide of imitations of Impressionists prevalent there."[7]

This attitude was quite distinct from his great and enduring respect for the Impressionists proper. In Berlin, too, he would turn to their work again and again; there at the Nationalgalerie, he could see the collection of Impressionist painting that had been assembled from 1896 by Hugo von Tschudi, prompted by Liebermann, with purchases of works by Manet, Monet, Pissarro and

HOTEL GEORGES V
31 avenue Georges V,
8th arrondissement

The imposing Georges V was in the 1930s one of the newest luxury hotels in Paris. Beckmann often met Stephan Lackner here, and then they would go for walks together in the "quartier".[13]

HOTEL RITZ
15, place Vendôme,
8th arrondissement

Towards the end of the nineteenth century the Hotel Ritz opened in what had formerly been the private palace of the Duc de Lauzun at the Place Vendôme; from the very beginning it was a prestigious address in one of the most beautiful squares in Paris. It was here that Beckmann dined for the first time with his sister-in-law Hedda and her husband, the sculptor Toni Stadler, towards the end of his Paris sojourn in July 1925.[14] At the beginning of the 1930s, the Ritz was among the hotels in whose salon or bar Beckmann was fond of doing his correspondence. In April 1947, when he came to Paris for the last time, he visited the bar of the Ritz with Quappi Beckmann and Stephan Lackner.[15]

HOTEL ROYAL MONCEAU
37, avenue Hoche,
8th arrondissement

This hotel was situated in a particularly elegant residential area of Paris between the Place de l'Etoile and the Park Monceau. It was here that Stephan Lackner stayed in April 1947 with his wife Margaret and their baby. They had a date with the Beckmanns, and on 20 April 1947 their reunion took place in this hotel.[16]

HOTEL SCRIBE
1, rue Scribe,
9th arrondissement

Beckmann stayed in this first-class hotel next to the Opéra during a brief business trip to Paris from 10 to 12 October 1927,[17] during which time he met Alfred Flechtheim. BS-A

1 Das Hotel, 2nd Act in Buenger 1997, p. 240.
2 "Sometimes fate appears in the form of a lift boy," Max Beckmann, from a conversation with his son Peter on the Temptation triptych of 1936–1937 (G 439), presumably 1937, in Realität der Träume, p. 47.
3 Briefe, Vol. 1, letter 324 to Mathilde Kaulbach, Paris, 27 July 1925.
4 The Baedeker Paris listed 550 rooms with bath from 50 francs, with double rooms from 90 francs.
5 Briefe, Vol. 2, letter 472 to Minna Beckmann-Tube, Frankfurt, 1 September 1928.
6 Briefe, Vol. 3, letter 677 to Mathilde Beckmann, Paris, 25 March 1938.
7 Briefe, Vol. 2, note p. 339 on letter 439 to Marie-Louise von Motesiczky, Frankfurt, end of Sept. 1927.
8 Tagebücher 1940–1950, p. 198.
9 Israel Ber Neumann, Sorrow and Champagne, Confessions of an Art Dealer, p. 3.
10 Briefe, Vol. 2, letter 573 to Israel Ber Neumann, Paris, 25 June 1931.
11 Briefe, Vol. 2, letter 401 to Mathilde Kaulbach, Paris, 11 August 1926 and letter 404 to Mathilde Kaulbach, Paris, 14 August 1926.
12 Briefe, Vol. 1, note p. 459 on letter 210 to Israel Ber Neumann [undated].
13 Lackner 1969, p. 104.
14 Briefe, Vol. 1, letter 326 to Mathilde Kaulbach, Frankfurt, 1 August 1925.
15 Tagebücher 1940–1950, p. 199.
16 Tagebücher 1940–1950, pp. 194–195.
17 Lackner 1969, p. 104.

Renoir. Also in Berlin, the art dealer Paul Cassirer worked in association with the Galerie Durand-Ruel, and in October of 1904 was able to present Claude Monet's paintings of London. Beckmann was moved to rhapsodies. "Recently at Cassierer [sic] I saw a brand new exhibition of Monet: Theme avec variations: A bridge in London, in eleven times a different lighting. All this lighting that you now also know from the Paris bridges. Only heavier in atmosphere. A lot of fog, you know. What an incredibly beautiful thing to see. The most subtle nuances of air and light seen with temperament. Classic. I wished you had seen them."[8]

In spite of all his effusive enthusiasm for Monet, it was Edouard Manet whom Beckmann truly regarded as the artistic paragon. In this he was in agreement with prevalent critical opinion, although Monet had been the real driving force of Impressionism in an orthodox sense.[9]

In 1906 Beckmann made the acquaintance of Harry Graf Kessler, the owner of a significant collection of Impressionists and Post-Impressionists. A letter to Kessler is Beckmann's fullest statement on his view of Impressionism. "As you will recall, I have always mentioned Cézanne as one of the artists closest to me (not that I compare myself to him, I mean only in my goals) and have found him in contradiction to Impressionism. – The label Impressionism is in any case a term which does not come anywhere near covering all the endeavors of the great French masters speaking for myself at least I definitely feel impres-

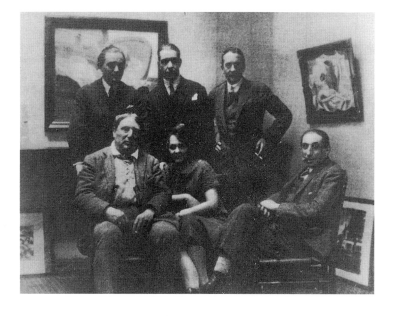

seated from left to right, Vlaminck, Louise Leiris and Alfred Flechtheim; standing: Kahnweiler, Gris, Otto Waetjan; c. 1925.

below: Max Beckmann at the Baltic Sea, 1907.

sions of the spirit, although they are of a more ingenious or lyrical nature chiefly in Manet, Monet and Renoir. After all, the spirit has a hand in everything and the difference is just in how we sense the world to be. One person will sense on a more cosmic and dramatic plane, another more microscopically and lyrically. Both are equally valid, if they will only derive from an inner unity. Those so-called Impressionists fit together their world out of a host of little impressions kaleidoscope-fashion."[10] BS-A

1 Reinhard Piper, Mein Leben als Verleger, Munich 1964, p. 324.
2 Bernard Denvir, Encyclopaedia of Impressionism, 1990, p. 97.
3 Frühe Tagebücher, p. 45.
4 Briefe, Vol. 1, letter 15 to Caesar Kunwald, Berlin, 27 October 1904.
5 Letter 15 to Kunwald, note, p. 402.
6 Gedanken über zeitgemäße und unzeitgemäße Kunst. A response to Franz Marc's essay, "Die neue Malerei", in Realität der Träume, cited in Buenger, Max Beckmann: Self-Portrait in Words, 1997, p. 113.
7 Briefe, Vol. 1, letter 173 to Julius Meier-Graefe, 10 May 1919.
8 Briefe, Vol. 1, letter 15 to Caesar Kunwald, Berlin, 27 October 1904.
9 Daniel Wildenstein, Monet. Catalogue raisonné, Cologne 1997, pp. 165, 177.
10 Briefe, Vol. 1, letter 50 to Harry Graf Kessler, Berlin 18 April, 1911.

Edmond Jaloux (1878–1949)

Edmond Jaloux published his first poems when he was eighteen, and his first novel at the age of twenty-one. During the course of his career he wrote over fifty novels and, in 1909 was awarded the "Prix Femina" and in 1920 the "Grand prix de littérature de L'Académie Française." From 1922 to 1940 he made a name for himself as a brilliant serial writer of "nouvelles littératures." He was closely allied with Surrealism and wrote articles about art even more often than did his friend and colleague at the *Revue Européene*, Philippe Soupault.

In June of 1939, when Käthe von Porada organized a Beckmann exhibition in her apartment, she requested Jaloux to contribute a text. This text was never published,[1] although the typescript was distributed among those who were present at the showing, who also received Stephan Lackner's "Max Beckmann's Mystical Pageant of the World," the essay "Max Beckmann" by Heinrich Simon and Helen Appleton Read's article entitled "Max Beckmann's Latest." BS-A

1 Edmond Jaloux, Max Beckmann, Typescript, Library of the Museum of Modern Art, New York.

Daniel-Henry Kahnweiler (1884–1979)

Kahnweiler arrived in Paris from Stuttgart in 1902. Young painters such as Derain, Vlaminck, van Dongen, Signac and Braque gained his enthusiasm. In 1907, he established a gallery at 287 rue Vignon in the 9th arrondissement, and soon after he was showing Picasso, whom he had met through Wilhelm Uhde. Kahnweiler was the first to represent the Catalan artist in Paris and bound him to an exclusive contract, as he was soon to do also with Vlaminck, Braque, Léger and Juan Gris. Later he also served as agent for Paul Klee and André Masson.

In 1909 Uhde introduced Kahnweiler to another personality who would prove vital, namely Alfred Flechtheim. In 1923, acting on his encouragement, Flechtheim entered into the art trade. Later, he would reflect, "… to him I owe the fact that I became a propagandist for contemporary French art in Germany …"[1] It was not long before Kahnweiler had assumed for the young Paris avantgarde the significance that Durand-Ruel and Vollard, Kahnweiler's models, had had for the preceding generation. He now also became active as a publisher and essayist.

In the wake of World War I, Kahnweiler's career came to a brutal end. The fact that he, like his friend Uhde, was a German national prompted the French government to confiscate his collection of paintings and to put it up for public auction as part of the program of "Reparations" imposed on Germany by the Allies. But far from abandoning the art business altogether, Kahnweiler continued in it by changing his approach and, from 1920 was directing the Galerie Simon² at 29, rue d'Astorg, in the 8th arrondissement. The premises were a stone's throw from the Rue La Boétie. The era saw the gallery develop into a notable meeting place for artists from both France and Germany.

Its position, however, was by no means guaranteed: Léonce presented Rosenberg a competitor to be reckoned with. Artists who had been contracted to the pre-war Kahnweiler gallery were now with Rosenberg, and if that were not enough, it was also he who took charge of the liquidation of the other man's entire possessions in the name of the French government. Kahnweiler's professional ethics, his patient, unswerving and untiring commitment impressed Beckmann in the high demands he placed on any dealer. He made no effort to exhibit at Kahnweiler's, even though this "art dealer of all art dealers" would have been the ideal agent between Beckmann and the Parisian public. We can be certain that the artist attended Kahnweiler's exhibitions, and was aware of the role that Kahnweiler was increasingly taking on as the skies over Germany grew decidedly darker. Thus Flechtheim, when he left Germany in 1933, placed the sole representation for Paul Klee in Kahnweiler's hands. The flow of German intellectuals and artists calling to seek his help in their exile steadily rose at the Galerie Simon.

Across the Atlantic, Kahnweiler strengthened his business relations with Curt Valentin, whom he knew from his time with Flechtheim.³ A friendship formed by mutual regard developed between the two men. Whenever Valentin – Beckmann's agent in New York – visited Paris, he would have his mail forwarded to Kahnweiler's gallery.

The outbreak of World War II once again plunged Kahnweiler into troubled circumstances: it threatened to become even worse than the confiscation of his paintings which were now considered "Jewish property." He faced his own arrest and deportation. Consequently he went underground in the country, with his wife, his daughter Louise and her husband, Michel Leiris. Louise successfully passed herself off as Kahnweiler's daugher-in-law, so that in 1941 she was able to take over her father's gallery in Paris in her own name and save it from being closed. After the end of the war the name Galerie Louise Leiris was retained, with Daniel-Henry Kahnweiler more active than ever in its operation.

At that point he and Beckmann did meet. The occasion was Beckmann's efforts to procure from Amsterdam an entry permit to France for himself and his wife. On 2 February 1947 he submitted a visa application accordingly, while Curt Valentin wrote to Galerie Leiris with recommendations on his behalf. On 10 February Beckmann received a letter from Louise Leiris,⁴ which caused him to write to Valentin, "Ja, thank you [sic], there, Galerie Le[i]ris Paris has sent me an invitation. – But as this is not enough to speed up the processing of my visa application (which first has to go to Paris only to lie there indefinitely), I have written to Louise asking whether she does not know a more or less important person in Paris who could accelerate the matter a little in the relevant department (...). – I would like to go to Cannes & Monte Carlo in early April but without some personal assistance it will not be possible – and it would be so exceptionally important for me and everything it would imply."⁵

Beckmann obtained his visa, but still needed Valentin's financial support for the trip. Again, the Galerie Leiris intervened. "I travel on 25 March. Perhaps it would be possible to transfer the money to the Galerie Leiris, so that I could pick it up on the 26th. I can buy ticket at this end. – Can I actually count on the Galerie Louise and Mr. Kahnweiler's being friendly enough towards me, or is there any antipathy against me from somewhere or some time. – I hope not."⁶ Beckmann's unaccustomed and ultimately inexplicable coyness at this point suggests that he probably did not expect their meeting to be plain sailing. Since his trip to Paris went well, we can assume that he

Max Beckmann, *Portrait of Stephan Lackner,* 1939 (G 519).

right: Fernand Léger in his (and Max Beckmann's former) studio, 86, rue Notre Dame des Champs, 1931.

did visit Kahnweiler at his gallery and was given the money. But not a single entry in Beckmann's diary and no reference in his correspondence says anything about the details or about the meeting face to face of a painter by then renowned, and an art dealer who had become legendary. LB

1 Christian Zervos, Entretien avec Alfred Flechtheim, in Les Feuilles Volantes 10, 1927, supplement to Cahiers d'Art.

2 The name was inherited from André Simon, Kahnweiler's associate in the pre-war period.

3 Letters from Daniel-Henry Kahnweiler to Bores, 31 July 1939 and 29 November 1939. The Kahnweiler Archives, Galerie Louise Leiris, in Pierre Assouline, L'Homme de l'art, D. H. Kahnweiler 1884–1979, Paris 1988.

4 Tagebücher 1940–1950, p. 190.

5 Briefe, Vol. 3, letter 796 to Curt Valentin, Amsterdam, 19 February 1947.

6 Briefe, Vol. 3, letter 797 to Curt Valentin, Amsterdam, 19 February 1947.

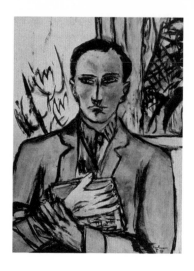

Stephan Lackner (Born in 1910)

Stephan Lackner met Beckmann one evening at a party during his last year of school in Frankfurt. After finishing his studies, Lackner devoted himself to his literary career. In 1933 he bought his first painting by Beckmann, which marked the beginning of a lifelong friendship. The two men met regularly in Berlin or Paris, where Lackner's parents lived in nearby Le Chesnay from 1933 onwards. Lackner himself left Berlin in 1937 and moved into an apartment on the Rue Gaston-de-Saint-Paul, in order to further pursue his literary and journalistic career. From then on, he gave Beckmann his carefully directed support – sometimes with his father's help as well: "When Beckmann went into exile in 1937, for a long time I was the only one who provided the enthusiasm – and fortunately also the money – to continue promoting Beckmann's creativity. That this was often associated with the greatest material difficulties, need hardly be emphasized!"¹

In Paris, Lackner wrote, among others, for the German-language newspaper *Das Neue Tagebuch,* "an influential paper, a reservoir for the voices of international anti-Fascism, from Churchill to Trotsky, with a few moderate immigrants in the center."² At the end of 1936 Lackner asked Beckmann to create several illustrations for his new play "Der Mensch ist kein Haustier" (Man is Not a

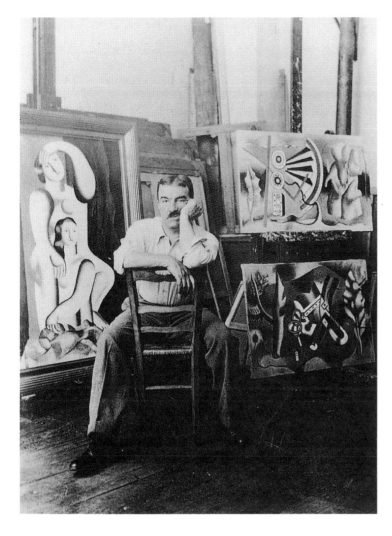

Domesticated Animal). Beckmann agreed to do this for his friend, before returning to Berlin. It was Käthe von Porada who secured the connection between Lackner and Beckmann, who was soon to receive seven sketches on which to base the lithographs for "Der Mensch ist kein Haustier" (H323–329). The staff of the literary and political magazine *Das Neue Tagebuch*, which was published by Lackner and several German refugees, prepared the book edition. Editions Cosmopolites, situated at 92, rue des Boulets in the 11th arrondissement, who took care of French and foreign literature, were responsible for the publishing. At the beginning of September in 1937, Beckmann arrived in Paris and, together with Lackner, visited the famous Desjobert graphics studio where the 140 lithographs on Japanese vellum were to be made for the special edition. Beckmann checked and signed the prints.

Stephan Lackner and Käthe von Porada both worked tirelessly for Beckmann, and in 1939 they rented the Galerie Poyet for him. They also made sure that he was represented at the anti-Fascist Twentieth Century German Art exhibition in London in 1938, as well as at a similar show in Paris, the "Freien Künstlerbund 38."

When the war broke out, Stephan Lackner emigrated with his family to the United States on board the Paris, while Beckmann spent the war years with his wife in Holland. In spite of the distance between them, Lackner did his best to give the artist his continued support. The two men did not see each other for eight years, until they finally met again after the war in 1947 in Paris, where the Lackners and Beckmanns spent several days together. Even after Beckmann emigrated to the United States at the end of August in 1947, the friendship persisted. Stephan Lackner continued to buy Beckmann's

paintings and organize exhibitions for the artist. After Beckmann's death, he dedicated several monographs to his old friend, wrote numerous articles, and in 1967 he published his memoirs of Max Beckmann. BS-A and LB

1 Stephan Lackner, Die Entstehung meiner Sammlung, in ex. cat. Kunstmuseum Luzern, Lucerne 1967, p. 9.
2 Stephan Lackner, Reflections on Exile in France and the United States in Exiles & Emigrés. The Flight of European Artists from Hitler, New York 1996, p. 363.

Fernand Léger (1881–1955)

Fernand Léger came from Normandy and, like Max Beckmann, was the son of a simple rural family. He lost his father early and, to the horror of his family, decided to become a painter. He did not pass the entrance examination for the Ecole des Beaux Arts in Paris, but enrolled at the Ecole des Arts Décoratifs in that city in 1903. At the Salon d'Automne of 1907, he discovered Cézanne, who was to be a lasting influence on his painting. The dominant feature of his pictures was an increasingly geometrical analysis of form. But, like the Futurist painters at that time, he also was interested in translating movement into pictorial terms. At the Salon des Indépendants in 1911, art critic Louis Vauxcelles called his work 'tubist'. From 1913 on Léger was elaborating a new pictorial language by means of deliberate effects of contrast within shapes, lines and colors. In the same year, he set himself up in the studio on Rue Notre Dame des Champs where Beckmann had worked in 1903. Apart from coincidences of this kind, it is likely that Léger first came to Beckmann's notice during the period from 20 September to November 1913. At the Erste Deutsche Herbstsalon, or German Autumn Show, in Berlin, Léger exhibited ten works, among them *Woman in Blue* of 1912.

In August 1914, he was conscripted into the military and was in action until 1917. One consequence of this profound experience was that Léger

turned increasingly to a penetrating questioning of the nature of machines. The mechanical now acquired a sculptural potential for expression, while in terms of painting technique, Léger set pure tones down in flat areas next to subtly nuanced grays. The work of the 1920s is characterized by a detached, objective treatment of the pictorial subject: human beings are also set down with industrial objectivity and the human figure becomes a jointed marionette. At the same time, several of the works from this phase in his career emanate the classicism of an Ingres or the naivete of a Douanier Rousseau.

During his time in Paris in the 1920s and 1930s, Beckmann had many opportunities to see Fernand Léger's works in galleries and at the Salons. Perhaps he visited the retrospective exhibition that their dealer in common, Alfred Flechtheim, organized in Berlin; it ran from 6 February to 2 March 1928. Beckmann and Léger were not only attended by the same dealer, but supported in part by the same critics, among them Carl Einstein, Waldemar George and Wilhelm Uhde.

Léger and Beckmann both fled in exile from the Fascists, the former to the United States, from where he returned to France in 1945.

In New York, Léger and Beckmann were to cross paths again. Full of pride, Beckmann wrote to his first wife about a visit to the Museum of Modern Art, "... in the Modern Art museum they have hung my big still life next to Picas[s]o and Leger. What more can you desire ... "[1]
BS-A

1 Briefe, Vol. 3, letter 1005 to Minna Beckmann-Tube, New York, 29 August 1950.

BIBLIOGRAPHY
Fernand Léger, Catalogue raisonné, ed. Georges Bauquier, Paris 1 990f.
Fernand Léger, ed. Isabelle Monod-Fontaine and Claude Laugier, (ex. cat.) Centre Georges Pompidou, Paris 1997.
Fernand Léger, Meine Berliner Ausstellung, Der Querschnitt, No.20, s1928.

André Pieyre
de Mandiargues
(1908–1991)

André Pieyre de Mandiargues spent
years writing poetry before he sought
publication. During World War II he
fled to Monaco and, towards the end
of the war, published his first book
under the title of "Les années sor-
dides." This was followed by the
poetic work "Hedera ou la persistance
de l'amour pendant une rêverie,"
which had such an intensely surrealist
tone that its author received an invita-
tion from André Breton to participate
at the Surrealist group's meeting in
1947.

During the war years, Pieyre de
Mandiargues met Käthe von Porada in
Monte Carlo. She needed money and
was trying to sell several Beckmann
works from her own collection, but
finding no takers. She turned to Pieyre
de Mandiargues.[1] He took up the mat-
ter of the paintings, anticipating that
he could effect a sale among his circle
of friends. However, the magic of the
Beckmann paintings seemed to have
temporarily diminished, and his
numerous attempts to find a buyer,
though motivated by a genuine enthu-
siasm for Beckmann, failed. LB

1 Correspondance Käthe von Porada – André
 Pieyre de Mandiargues, 16 December
 1943–25 March 1981, manuscript collection,
 Bibliotheque Nationale Paris (naf 18 899),
 letter from Paris, May-June 1945.

Max Beckmann, *Carnival Paris*, 1930
(G 322).

Edouard Manet, *Masked Ball at the
Opera*, 1873 (detail).

Edouard Manet
(1832–1883)

"Manet purifies the air. Purging.
Manet, Manet et encore une fois … I
will sing this tune 1–10 times over on
request for anyone."[1] With Delacroix
and Cézanne, Edouard Manet occu-
pied a place of honor in Max Beck-
mann's personal pantheon. At the
beginning of his career, this adulation
was expressed more in his writings
and theories than in practice. It was
only from 1926 on that he freed him-
self completely from an earth-colored
palette inherited from his artistic back-
ground in Berlin. After a phase of
clearly separated local colors inspired
by Henri Rousseau, it was with his
Quappi in Blue (cat. 3; 1926) that he
crossed the threshold of a new style.
The pure colorist modelling from out
of a black picture ground and the
masterly drawing straight from the
brush would have been inconceivable
without Manet's example. Velázquez,
Goya and Manet, the great "painters
in black," remained guiding stars in
Beckmann's work to the end of his
life. His great awe of Manet linked
Beckmann directly to Matisse and
Picasso who, each in his own way,
also drew extensively on this inheri-
tance. In Matisse's case it was more in
a formal sense. The interlocking of
space and surface, the striving to
attain pictorial depth independently of
single-point perspective or indeed, of
cubist disintegration, is owed to a very
great extent to Manet, in both Matisse
and Beckmann.

In Picasso's case, content is the
more important factor. His efforts to
redefine the concept of history painting
for the twentieth century (*Les Demoi-
selles d'Avignon, Guernica*), would seem
only idiosyncratic were it not for
Manet's radical example. TB

1 Briefe, Vol. 1, letter 15 to Caesar Kunwald,
 Berlin, 27 October 1904.

Henri Matisse
(1869–1954)

As early as 1905, Henri Matisse was
considered the leader of new art in
Paris, first and foremost of the group
that went down in art history as the
Fauves. Even Picasso unconditionally
accepted the privileged position which
Matisse was to retain during his entire
lifetime of devotion to artistic creation.

Matisse was a great loner. Although
he gave lessons (in the early days his
students also included the young Ger-
man painters who met at the Café du
Dôme), for the most part he stubbornly
went his own way; once he had left his
youth behind he did not allow himself
to be classified by any school or style.
To him, the contact to his contempo-
raries was much less important than his
dialogue with tradition; he further
developed the rudiments of Ingres,
Delacroix, and Manet in his own per-
sonal way.

Beckmann encountered Matisse's
pictures for the first time during a visit
to the Salon des Indépendants in 1904.
In the winter of 1908–1909, Paul Cas-
sirer showed Matisse in Berlin. Beck-
mann's reaction was vehement: "I dis-
liked the Matisse paintings intensely.
One piece of brazen impudence after
another. Why don't these people just
design cigarette posters (…). Curious
that these Frenchmen – otherwise so
intelligent – can't say to themselves
that after the simplification practiced
by van Gogh and Gauguin it's time to
go back to multiplicity."[1]

During the time just before World
War I, there were many such contro-
versial comments made. Beckmann saw
in Matisse an over-estimated "epigon
talent"[2] for decorative art with an
exotic flair: "Matisse is an even more
deplorable representative of this eth-
nology museum art: the Asian depart-
ment. Even this he gets at secondhand,
from Gauguin and Munch."[3]

From the mid-1920s onwards, Beck-
mann thoroughly revised these opin-
ions, albeit never aloud: Matisse was
always the only one among the French
colleagues who was observed in
absolute silence. All the more to
approach the master in his own artistic
practice. The fresh colors of the pic-
tures, the addition of brightly colored
upholstery fabrics and wallpapers, the

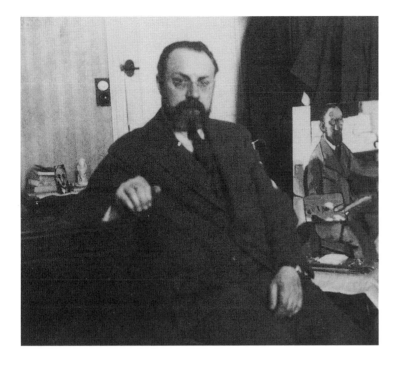

new soft lines in which the erotic and the exotic flow together – all this was unthinkable without the example of Matisse. At the Côte d'Azur Beckmann took walks in the hilly area around Cimiez, where Matisse lived. The abundant light of the region is captured in landscape paintings, which also follow in Matisse's footsteps. BS-A

1 Diary entry 7 January 1909, quoted from Realität der Träume, cited in Buenger, Max Beckmann: Self-Portrait, 1997, p. 96.

2 Briefe, Vol. 1, letter 51 to Reinhard Piper, Berlin, end of April/May 1911.

3 Gedanken über zeitgemäße und unzeitgemäße Kunst. Erwiderung auf Franz Marcs Aufsatz "Die neue Malerei" in Realität der Träume, cited in Buenger, 1997, p. 117.

BIBLIOGRAPHY:

Pierre Schneider, Matisse, Munich 1984.

Jack Flam, Matisse. The Man and His Art 1869–1918, London 1986.

Henri Matisse, A Retrospective, from John Elderfield, ex. cat. Museum of Modern Art, New York 1992.

Marie-Louise von Motesiczky (1906–1996)

Beckmann first met Marie-Louise von Motesiczky, also called "Pizchen" and "Piz," in 1920, through Irma and Heinrich Simon, the publisher of the *Frankfurter Zeitung.* When Beckmann first encountered her, at Hinterbühl in the aristocratic family's country house, Marie-Louise was fourteen years old. At their Vienna address, No. 7 Brahmsplatz, the Motesiczkys would be hosts to famous musicians, and to artists such as Kokoschka. Although Marie-Louise von Motesiczky virtually "grew up with painting," she found Beckmann's work outlandish. "My grandparents had been portrayed by Lenbach. One did collect postcards of Klimt, Schiele and Kokoschka, but among all my mother's acquaintances, admirers of von Hofmannsthal, it certainly would have been difficult to find anyone who would not have been shocked by Beckmann's early prints and drawings, and no one who would not have found his paintings simply awfully ugly. A winged creature from Mars could not have made a deeper impression on me."[1]

In this hospitable house in 1924, Beckmann also met his future second wife, Mathilde von Kaulbach. At the time she was in Vienna to study singing, and lived at the Motesiczkys' house. Mathilde and Marie-Louise were almost the same age and became good friends. Käthe von Porada, later also among Beckmann's intimate friends, was another close friend of the Motesiczkys. At nineteen, Marie-Louise accompanied her mother to Paris in order to take painting lessons. From Paris in 1926, she invited Beckmann to pay her a visit and go with her to the museums and art galleries; but Beckmann had to decline. "My dear

Pizchen," he wrote, "Unfortunately it is not to be for the time being. No money. Too bad. Should have liked to stroll with you through Paris spring should have liked to see the pictures you speak of and to have drunk some 'Irroy' with you as it happens to be excellent. (…) Do please write me whether the various Spring Exhibitions have opened yet. Should have liked to look into the standard in Paris again. (…)"[2]

Later that year, Beckmann did, in fact, travel to Paris, where he visited the Louvre with Marie-Louise von Motesiczky.

In the winter of 1927–28, von Motesiczky took up Beckmann's invitation to come to Frankfurt and studied in his master class at the Städelschen Kunstinstitut. Over this period, student and master were frequent museum visitors; she also posed for him. Thus we encounter her in several of Beckmann's paintings and drawings, sometimes beside his wife. Marie-Louise and Quappi are the *Two Women at the Window* of 1928 (G 281), and they reappear on the right panel of the *Actors* triptych of 1941–42 (G 604).

After Austria joined forces with Germany, Marie-Louise von Motesiczky and her mother emigrated to Holland, where Marie-Louise's sister, Ilse Leembruggen, lived. All too soon she would be supporting Beckmann in his exile in Amsterdam. In 1939, the von Motesiczky family moved to England for good. Marie-

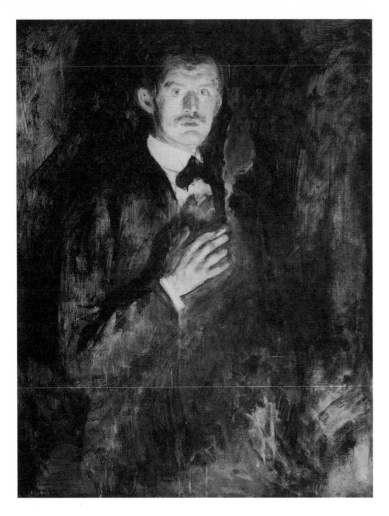

Louise remained Beckmann's friend for the rest of his life. She recorded her memories of the painter and her teacher in 1964.[3] BS-A

1 Marie-Louise von Motesiczky, Max Beck-
 mann als Lehrer Erinnerung einer Schülerin
 des Malers, 1964, p. 7; the typescript is pre-
 served in the Library of the Museum of
 Modern Art, New York.
2 Briefe, Vol. I, letter 362 to Marie-Louise von
 Motesiczky, Frankfurt, 12 February 1926.
3 Marie-Louise von Motesiczky, 'Max Beck-
 mann als Lehrer. Erinnerung einer Schülerin
 des Malers', 1964; abridged version in
 "Frankfurter Allgemeine Zeitung", issue of
 11 January 1964; quoted in turn in Max
 Beckmann, Galerie Franke, Munich 1964. See
 also Ernst H. Gombrich: Marie-Louise von
 Motesiczky in ex. cat. Marie-Louise von
 Motesiczky, Österreichische Galerie, Vienna
 1994, pp. 7–8.

Edvard Munch
(1863–1944)

Like Edvard Munch years before, Beckmann, having finished art school at Weimar in 1903, continued his training at the Académie Colarossi in Paris. He spent his evenings at the Closerie des Lilas (in the immediate vicinity of his "enormous studio" at 86, rue de Nôtre-Dame-des-Champs) alone in the midst of others ("ensembles mit autres," as he put it), making entries in his blue journal, swathed in tobacco smoke.[1] On one such long evening of red wine, on 5 February 1904, he found himself sitting across from the "noble Munch," whom he was eager to get to know, for "my heart longs for human beings, human beings who also suffer as I do."[2] In situ, he did not dare address the older colleague-in-arms. When at last Beckmann was introduced to Munch, in Berlin in 1906, the elder artist com-

mented, "Oh, I know you, don't I, you'd always be sitting at the Closerie des Lilas in the evenings and drinking all that red wine."[3]

From his first studies in May of 1885 until 1904, Munch regularly spent several months a year in Paris. But he never acquired the notoriety there that he had in Berlin ever since the scandalous exhibition at the Association of Artists in Berlin (Verein Berliner Künstler) in November of 1892.[4] With his participation at the Salon des Indepen-dants in 1986 and a solo exhibition at Galerie L'Art Nouveau the following year, Munch's name spread. Both exhibitions drew a series of reviews. The French critics were shocked by the "too direct, because too material procedure" (Yvanhoé Rambosson, 1887)[5] They said Munch showed people and objects in a simplified ugliness and with aggressive coloring; they claimed his formal qualities were "modern, occasionally somewhat morbid;" that his work belonged as much in the "realm of the hospital as into the realm of Art."[6] These characterizations anticipated the reception Beckmann's work would be accorded in Paris a quarter of a century later.

Many of the paintings Beckmann completed in the early years in Berlin betray his stylistic kinship with Munch.[7] How much the younger artist regarded him as a fellow-traveler in his own later years is evident in a diary entry for 24 January 1944: "Munch has died – when is it my turn?! – He held out pretty long!!"[8] UH

1 Frühe Tagebücher, p. 80.
2 Buenger, Max Beckmann, p. 67, diary entry 2
 Feb. 1904.
3 Minna Beckmann-Tube, Erinnerungen an Max
 Beckmann, in Frühe Tagebucher, p. 165.
4 Lovis Corinth, Das Leben Walter Leistikows,
 Berlin 1910, p. 48 f. See also Peter Paret, Die
 Berliner Secession, Frankfurt/M. and Berlin
 1983, p. 79 ff.
5 Quoted after Rodolphe Rapeti, Munch und
 die französische Kritik: 1893–1905, in ex. cat.
 Munch in Frankreich, Sabine Schulze (ed.),
 Stuttgart 1992, p. 27 f.
6 William Ritter, Correspondance de Bohe me,
 in Gazette des Beaux-Arts, 111/34, 1905,
 336–46, p. 346.
7 Briefe, Vol. 1, letter 25 to C. Kunwald, Berlin,
 9 June 1906; Briefe, Vol. 1, letter 34 to Minna
 Beckmann-Tube, Marienfelde, 13 May 1907.
8 Tagebücher 1940/1950, p. 80.

left: Edvard Munch, *Self-Portrait with Cigarette*, 1895.

Museums

MUSÉE DE L'HOMME
Place du Trocadéro, 16th arrondisse-ment

"What particularly interests me at the moment (apart from women), besides my vocation as a painter, is geology and astronomy. Love digging around the time around 4000 BC – that's the most interesting time really if you consider that it has been proven without a doubt that there were people living around 200 000 BC, but that the animate world is probably around one million years old. Probably much more happened at that time than we assume. I consider the empires of the Sumerians and Egyptians to be the remains of very magnificent cultures – oh and so on."[1] Beckmann's great interest in earlier and non-European cultures was due to his extensive reading. Mythology and the world of images from alien civilizations preoccupied him again and again and traces of these are to be found in his works. A sculpture from Africa given to him by Heinrich Simon can be seen in *Still Life with African Sculpture* of 1924 (G 225) and again later in *Studio with Table and Glasses* of 1931 (G 340, cat. 23). In *Still Life with Foxglove* (G 636) he includes a toad from the Ming Dynasty and a blue vase of Chinese origin.

This is why he liked to visit the Musée de l'Homme in Paris where Gauguin, Matisse, Alberto Giacometti, Picasso and Brancusi also took a look around. This is where the anthropolog-

ical and ethnological collections, which were begun in the sixteenth century, are all to be found under one roof and which comprise extensive collections from all five continents. The Musée de l'Homme offers an insight into the history of humanity and the manifold forms of expression in human life. Early history, paleoanthropology, anthropology and archeology constitute the main themes.

While Stephan Lackner was living on the Rue Gaston-de-Saint-Paul next door to the Musée de l'Homme in 1937, they once visited the department of Oceania together: "One day we strolled through the Musée de l'homme, the Paris ethnological museum, and he inspected a huge stone idol from Easter Island whose profile bore a striking resemblance to Beckmann's lapidary features. In walking on, he nodded to the rocky head and remarked casually: 'This is what I also was, long ago.'"[2] BS-A

left: Stone sculpture in the Musée de l'Homme.

below: Musée des Ecoles Etrangères Contemporaines, 1932.

MUSÉE DU JEU DE PAUME
1, place de la Concorde, 8th arrondissement

In 1909 exhibition rooms were erected on the former royal tennis courts at the end of the Tuilerie Gardens. Over a period of fourteen years, a wide range of exhibitions was organized here. In the spring of 1922, part of a collection of modern art in the

Musée du Luxembourg was transferred to the Jeu de Paume, which was placed under the administration of the Musée du Louvre. It was called a "Museum of Contemporary Painting of Foreign Countries" and was administered by the Ministry of the Exterior and the National Directorate of the Museums of France. Exhibition topics were chosen less according to aesthetic aspects than political considerations. This was the case, for example, with the Max Liebermann Retrospective scheduled in 1927, but which caused such great indignation among French veterans of the "Great War" that the Minister of Culture called off the exhibition at their insistence.

On 23 December 1932, the museum was reopened after renovations. At the time of its inauguration, it was given the official title Musée des Ecoles Etrangères Contemporaines. Paintings were hung according to schools. For example, in the room dedicated to the Ecole de Paris, works were shown by artists who had either acquired French nationality, had been living in France for a long time or had painted in France.[1]

This is where you will also find

Beckmann's *Forest Landscape with Woodcutter* of 1927 (G 273).[2] This painting was added to the collection of the Jeu de Paume in 1931, after Beckmann's exhibition in the Galerie de la Renaissance. In an ecstatic mood, Beckmann writes to I. B. Neumann: "Here we have achieved all that we could. The painting Woodcutter is being sold to Luxenburg. Very serious success with the press ..."[3] In his excitement, he mixed up the Musée du Luxembourg with the Musée des Ecoles Etrangères du Jeu de Paume. Käthe von Porada states for the record that it was "the first work of a German artist to be purchased by this museum for a long time. For Beckmann, it represented a great success."[4]

Although the Director of the Jeu de Paume, André Dézarrois, was interested in Beckmann, the purchase was not organized directly by the Museum, nor did it seem to have been organized by the management of the umbrella association, the Musées Nationaux.[5] The initiative was due to a higher instance, to Mario Roustan,[6] Minister of Education and Culture, who was a friend of Charles Pomaret

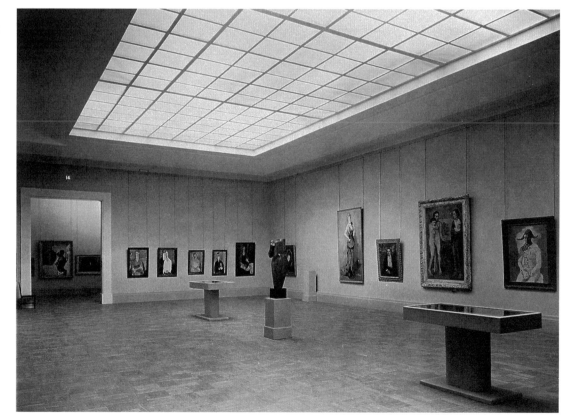

1 Briefe, Vol. 2, letter 624 to Reinhard Piper, 22 February 1934.
2 Lackner 1969, p. 34; see also Stephan Lackner, Exile in Amsterdam and Paris in Retrospective 1984, p. 151.

Letter from the minister of culture to the director of the Musée du Jeu de Paume.

and his wife, Marie-Paule Pomaret. Charles Pomaret arranged the transaction between the Galerie and the Ministry and was responsible for the pur chase of Beckmann's painting.

One source of bitterness was the low sum of payment: "The Luxembourg only paid FF 2500 for the Woodcutter,"writes Beckmann to Neumann, and continues: "But in view of the publicity, I had to do it of course."[7] His Berlin dealer, Alfred Flechtheim, saw things a little differently. He reproached Beckmann for having accepted such a low price; this weakened his position, could even make a fool of him. First and foremost Beckmann had to compensate him: "Unfortunately I have to give Flechtheim another painting to make up for it, which I am not very happy about. – But for the sake of business for God's sake. – He is horribly jealous because of all these things in Paris and because of Franke and is making life difficult for me with all his demands. – But I'll manage to get him where we want him."[8]

André Dézarrois continued to think highly of Beckmann, so that when he was offered *The Small Fish* (1933, G 373) for the Museum in 1933, he took great pleasure in informing the Director of the Musées Nationaux "Dear Mr. Director, Please find enclosed the invoice which is to be paid by the Musées Nationaux: for the greatest German painter, Beckmann (who exhibited at Madame Pomaret's 3 years ago), from whom Mr. Mario Roustan the Minister spon-

taneously purchased a small painting on our behalf, a painting which caused our friend C. Mauclair[9] in E. to cry out loud, and who would be prepared to give us a second, large painting with 3 persons (Format 100) – a 'unique opportunity'. I – that is to say, you – need only pay the costs of transport and packaging, as per the attached memo, namely 18 reuten [sic] Mark. The picture is on its way."[10]

At this time, Roustan had ceased to be Minister 15 months earlier. It is not clear what his position was at the time of handing over the painting or when he had actually acquired it. On the other hand, the manner in which it was purchased is the same as that of *Forest Landscape with Woodcutter*, also this time it concerned a small favor. It is impossible to ascertain whether *The Small Fish* was ever hung in the rooms of the Jeu de Paume and accessible to the public of Paris.

During the years of occupation, the Musée du Jeu de Paume became the central point for the confiscation of Jewish-owned art treasures, which were then forwarded from here to Germany. Excluded from this were those works of art declared as degenerate, of which around 600 pieces, including works by Ernst, Klee, Léger, Masson, Miró, Picabia and Picasso were publicly burned on the patio of the Tuileries.[11]

Both of Beckmann's works were kept out of Nazi hands. They were put into storage in a depot of the Musées Nationaux, probably in the cellar of the former Musée National d'Art

Moderne. After the war, they became part of its collection (in the Palais du Trocadéro). Today, both paintings belong to the collection of the Musée National d'Art Moderne, Centre Georges Pompidou. There too, they are almost never put on view. LB

1 *Jeu de Paume History*, Paris 1991.
2 "La fin de l'"Ecole de Paris' ou le retour des enfants prodigues", in *L'Intransigeant*, 15 March 1932 in Adam Biro, *Ecrits sur l'art*, Paris 1996, p. 393.
3 *Briefe*, Vol. 2, letter 562 to Israel Ber Neumann, Paris, 20 April 1931.
4 Käthe von Porada, Max Beckmann, der Titan, in Gallwitz 1984, p. 139.
5 There is not one reference to such a purchase in the minutes of the committee for acquisitions of the Musées Nationaux; Archives of the Palais du Louvre, Paris.
6 Roustan was Minister of Education and Culture from 27 January 1931 to 10 May 1932.
7 *Briefe*, Vol. 2, letter 567 to Israel Ber Neumann, Paris, 25 May 1931.
8 Ibid.
9 André Dézarrois refers to the article "Ebats germaniques" in the newspaper *Eclaireur de Nice*, March 1931; cf. essay from Tobia Bezzola, p. 141.
10 The letter to Henri Verne, Director of the Musées Nationaux, is dated 7 August 1933; Archives of the Musées Nationaux (Section U2), Palais du Louvre, Paris.
11 Rose Valland, *Le front de l'art, défense des collections françaises 1939–1945*, Paris 1961.

MUSÉE DU LOUVRE

An entry is made in Beckmann's diary about his last visit to Paris in 1947: "Then to the Louvre. – magnificent Louvre. – Walk along La Concorde with Q. and Butshy."[1] For Beckmann, this museum was a place he always loved to visit, from his first stay in Paris in 1903. For him, the Louvre represented a treasure chest and history book. Some of the Old Masters whom he admired were on view there: Tintoretto, Botticelli, Watteau, Ingres, Simon Vouet, Jean Fouquet, Goya, Vermeer. But he also enjoyed visiting the departments of Antiquity, of the Etruscans, Greeks and Egyptians. For decades, traces of his preference for certain works can be found in his correspondence.

When Caesar Kunwald was in Paris in 1904, Beckmann wrote to him: "The obligatory visits to the Louvre are now over. Not true. What I like to see are the Country Wedding or Fair by Rubens, the Titians presque tous, especially the entombement."[2] He was particulary receptive to Velázquez, especially the two pictures of the *Infanta Maria Margarita* and the *Infanta Maria Teresa*, having been prepared by Manet: "And through him [Manet] to the great V ...quez. Although it's in bad taste, really, running with the herd, because at the moment, everyone is talking about the two of them, especially the great -quez. (...) V-quez with his apple-blossom-cheeked (nice adjective) princesses until – jus'qu'a l'extase."[3]

On his honeymoon with Minna Tube the two of them visited the Louvre in September and October 1906 where they discovered the *Avignon Pietà* (c. 1455): "It is beautiful. In the Louvre, we discovered a Lamentation of Christ, School of Avignon, mid-15th century among the French primitives. This is simply incredible."[4] The principle of the synthesis of Southern and Nordic styles, which he discovered, was always to play a major part in Beckmann's work.

Also to the mature painter the Louvre continued to be of interest: "He did not mingle with the artistic crowd on the *rive gauche*, but occasionally he visited exhibitions of new works. He did not find much to his liking. Abstract art evoked his violent antipathy; experiments in this field he called *Krawattenkunst*, necktie art. – He preferred by far to stroll through the Louvre and the Musée Cluny, 'avant-garding' for himself and always discovering art which was new to him."[5]

In 1925 Beckmann headed straight for the Louvre when he arrived in Paris, and wrote to Quappi as if she had accompanied him: 'You were in the Louvre with me and you looked at the beautiful Rembrands [sic] with me and a beautiful Greco.'[6]

Beckmann had a special relationship to Rembrandt:[7] he considered him to be "the greatest of all artists ever."[8] It gave him very great pleasure

then, when Rudolf von Simolin at the time of his visit to Paris in 1928 compared his latest purchase, the *Gypsy (Nude with Mirror)* (G 289, cat. 10), with Rembrandt's *Bathsheba* from 1654: "As regards your parallels between the Bat[h]seba in the Louvre and my gypsy woman, I think that what you are saying is certainly correct. – I myself have not thought about it, but it may interest you to know that Benno Reifenberg (the critic from the *Frankfurter Zeitung*) made the same comparison when he saw the picture for the first time in my studio about 3 months ago. – This is quite all right with me, because I love this painting by Rembrandt in particular and can only feel honored by such a comparison."[9]

Beckmann's attention also fell on works by El Greco, like the *St. Louis of France with His Page*, – a favorite subject of Beckmann, who painted many pictures of kings. In August 1926, during his fourth visit to Paris, he saw this El Greco while in the company of Marie-Louise von Motesiczky. She remembers: "A remark about a king by Greco in Paris, no more than 'wonderful,' or his delight in something by Le Nain, were capable of encouraging him to add quite different elements."[10] BS-A

1 Butshy is the small Pekinese to which Beckmann was very attached; cf. Tagebücher 1940/50, p. 198.

2 Briefe, Vol. 1, letter 15 to Caesar Kunwald, Berlin 27 October 1904.

3 Ibid.

4 Briefe, Vol. 1, letter 32 to Caesar Kunwald, Paris 30 September 1906.

5 Lackner 1969, pp. 70–71.

6 Briefe, Vol. 1, letter 325 to Mathilde Kaulbach, Paris 28 July 1925.

7 Peter Eikemeir, Beckmann and Rembrandt in *Retrospective* 1984, p. 121.

8 Mathilde Q. Beckmann 1983, p. 150.

9 Briefe, Vol. 2, letter 478 to Rudolf von Simolin, Frankfurt 17 October 1928.

10 Marie-Louise von Motesiczky, Max Beckmann als Lehrer, New York 1964, p. 5.

I. B. Neumann, c. 1955.

Israel Ber Neumann (1887–1961)

In 1911 I. B. Neumanni founded a gallery in Berlin, on Grolmannstrasse.[1] His inaugural exhibition showed work by Munch, Melzer and Schmidt-Rottluff. He specialized in Expressionism and actively promoted Rouault, Klee and Feininger. The first meeting with Beckmann was in 1912, at a time when Paul Cassirer, then the most influential art dealer in Germany, was already aware of this young talent. Cassirer saw to it that several large-scale paintings by Beckmann were included at the Berlin Secession show of 1912. Even so, the young and ambitious Beckmann was not able to dismiss the impression that Cassirer had positioned him behind Liebermann, Slevogt and Corinth, the three Secession giants, and, to his chagrin, even behind Picasso and Matisse, whose agent Cassirer was likewise.

Therefore Beckmann had no objection when I. B. Neumann took an interest in him, and no objection at all that he should be seeking brazenly to cut a figure in Berlin as an anti-Cassirer, albeit with sparse means. His commitment was full-blooded, but was currently devoted to the young painters of the Brucke, which meant in turn that he could give only insufficient time to Beckmann, a rather more difficult case. Thus, several years passed before a genuine personal and professional friendship developed between them. In 1917 Neumann orga-

Max Beckmann, *Double Portrait of I. B. Neumann and Martha Stern*, 1922, Lithograph (H 209).

nized the first solo exhibition of Beckmann's work. In 1919 he published the lithograph portfolio, *Hell* (Hofmaier 139–149), and in 1920 they concluded a first contract on the sale of paintings. This contract was to be renewed regularly from then on. Their collaboration lasted another fifteen years, surviving some periods of high tension on the way.

Beckmann was only three years Neumann's senior, but his strong personality largely determined the course of the relationship. Neumann's unpublished memoirs, "Sorrow and Champagne, Confessions of an Art Dealer," are eloquent of his visits to Beckmann's studio, the artist's fits of rage and his refractory deviations from their exclusive contract, but equally so of many times spent in mutual cordiality. In turn, Beckmann's letters to the dealer sometimes express delight at his professional commitment, sometimes deliver a critical note regarding Neumann's rather haphazard management of details or his somewhat irregular private life. For Beckmann, nothing Neumann undertook was enough: he would plead and flatter, sulk and threaten, and would stress how their relationship was ultimately not a commercial one but a common service to an idea. It was a turbulent, extraordinary friendship, and Beckmann did not hesitate to reflect it in his paintings.[2]

As Günther Franke was Neumann's associate in Munich, Beckmann followed suit and contacted him so as to be able to exhibit in several cities at the same time. Neumann was one of the first German art dealers to go to the United States. Although he did not settle permanently there until 1932, he established the New Art Circle Gallery at 19 East 57th Street, in the heart of New York's art district, in February of 1924. One of the beneficiaries of this measure was Beckmann, for the New Art Circle was a turntable and forum for an amicable German-American exchange between artists. At his departure from Berlin, Neumann put his art dealer's premises into the care of Carl Nierendorf, whose efforts focused on promoting Dix and Kandinsky. The two artists were also his friends, whereas he and Beckmann were not. That is one reason why Beckmann had Alfred Flechtheim represent him in Berlin; another was that Flechtheim

was in touch with the people who mattered in Paris.

When Beckmann set his sights on entering the Paris art scene, Neumann and Günther Franke were harnessed to his endeavor. Beckmann evidently soon found Neumann's backing for his Paris plans half-hearted, however, for from 1927 he put the dealer under increasing pressure, and in September that year, coerced him to take Flechtheim into the exclusive agreement as a more promising third partner. "Not Flechtheim – Rosenberg is your real competitor..."[3] he assuaged the somewhat dumbfounded Neumann. But the success Beckmann was hoping for came no closer in the wake of this new liaison with Flechtheim either. In the summer of 1930, Beckmann again concluded a contract making Neumann his sole agent, and spent the two subsequent years plying him relentlessly to persuade him to move to Paris instead of investing in an uncertain future in America. On the occasion of his exhibition at the Galerie de la Renaissance in 1931, Beckmann wrote enthusiastically to Neumann, "In my opinion you have to come here soon. – Because now the field is open for you and your situation, by virtue of my exhibition here, has become an entirely different one. – I have now gotten my feet very firmly planted on the ground here and you must take advantage of that commercially now!!!!"[4]

Neumann did not move to Paris, however. The artist went to some effort to forge a business connection

between Neumann and a Parisian dealer, and introduced to Neumann the gallery director, Henry Bing, whom he had befriended in Paris. But the political events and the crisis in the art market foiled all such plans. From 1933, there is a distinct ebb in the correspondence between Neumann and Beckmann. In view of the increasingly dangerous political situation in Europe, Neumann made his home in the United States his permanent one where Beckmann met him after his own immigration from Holland. He found his dealer in financial straits, having to move several times and finally, in the 1950s, compelled to give up his gallery. BS-A

1 After arriving in the United States, Neumann altered the initial of his first name to "J"; Beckmann would still write "I. B."

2 He immortalized the man with his small stature and dark hair in 1919 in the etching, *Portrait of I. B. Neumann* (Hofmaier 154), and again in 1920, for example, in the painting, *Carnival* (G 206) at Fridel Battenberg's side. In the drypoint engraving of *The Large Man* (Hofmaier 196) in the *Jahrmarkt* cycle of 1921, we encounter I. B. amongst the staffage figures. In 1922, Beckmann completed the lithograph *Double Portrait of I. B. Neumann and Martha Stern* (Hofmaier 209), and finally, in 1923, Beckmann set his relationship to his friend and dealer in the scenery of *In the Hotel (the Dollar)*, another etching (Hofmaier 260).

3 Unpublished letter to I. B. Neumann, 10 October 1927, Estate of Max Beckmann.

4 *Briefe*, Vol. 2, letter 562 to I. B. Neumann, Paris, 20 April 1931.

The *PARIS*

At the beginning of 1939 Stephan Lackner decided to emigrate from France to the United States with his family. They booked passage on the passenger steamer *Paris*, which was to set out from Le Havre to New York on 20 April. A few hours before the Lackners were to catch the train to Normandy, they learned from a radio report that a fire had broken out on the ship as it lay anchored in the harbor. The fire had spread from the bakery to other rooms of the ship, and finally to the upper deck. On the morning of 20 April the steamer drifted in the harbor with its stern completely destroyed. Only two injuries were reported. However, Lackner was devastated by the news: his large collection of paintings from Max Beckmann, which had already been stowed on board the ship with the rest of the luggage, appeared to be lost. But a few days later he learned that, due to carelessness on the part of the loading crew, they had neglected to bring his things on board, and his collection was intact: "This initiated a chain of adventures through which these masterworks were to survive the cataclysms of World War II."[1] LB

1 Lackner 1969, p. 75.

The *Paris* in the harbor of Le Havre, 1939

left: Moret-sur-Loing

right: Fontainebleau

below: Saint-Cloud

Paris et ses environs

Beckmann's curiosity and love of adventure caused him to frequently explore the area around Paris. It is not difficult to follow his tracks, as he obviously made his choices for his day trips based on the Baedeker issue of *Paris et ses environs*. He especially liked citadels, castles and Gothic churches. At the same time, he developed a weakness for palaces and their grounds and gardens. Beckmann was particularly impressed by the architectural creations from the time of Ludwig XIV, such as can be found in Versailles and Saint-Cloud.

VERSAILLES

"I would like to walk once with you, now, tomorrow through the old paths of the park at Versailles. It is wonderful there when it rains so softly and the shiny raindrops hang from all the branches of the old chestnut trees and from all the old sweet and yet so stylistically fitting figures and the expansive views over the fantastic, wonderfully styled park dripping with delicate veils and the gossipy Parisians are sitting comfortably in their cafés."[1] After this early visit, Versailles remained in Beckmann's memory, and he returned there often, the next time in July of 1925 with his sister-in-law Hedda and her husband Toni Stadler,[2] and in the 1930s again with Stephan Lackner.[3]

SAINT-CLOUD

The very first time Beckmann stayed a while in Paris he visited Saint-Cloud: "Have you already been in St. Cloud. It has almost more character and is almost more melancholic than Versailles."[4] The park lay southwest of Paris on the way to Versailles. The lands were the property of the brothers of Louis XIV, the castle had been the royal residence under Louis XVI, and the imperial residence under Napoleon Bonaparte and again in the second French empire. The big waterfalls with the water fountains from the seventeenth century give an insight into the grand atmosphere of the castle grounds where splendid festivities were once held. One of the park entrances at Saint-Cloud leads to the tiny wood called Fausses Reposes and the Ville d'Avray, a small town which was made famous by Corot, Courbet, Renoir and Monet, who went there to paint.

FONTAINEBLEAU AND ENVIRONS

"Fontainebleau the castle and the castle park in the spring, when the arrow-straight black trees are covered with fire-red, identically shaped young buds, the an[n]emones in the same park (…)."[5] It is not known whether Beckmann also visited the castle chambers and galleries; the creations of the school of Fontainebleau with the Italians Primaticcio, Rosso Fiorentino and Nicolò dell'Abate had made the castle just as famous as its architecture. The forested area around the castle grounds attracted the Barbizon school painters as well as Cézanne and the Impressionists. Beckmann reports on his visit to one of the localities in the former royal environs of Fontainebleau: "… and the church in Moret, (in the region of Fontainebleau.) An old dream of a Got[h]ic Romantic – wonderful."[6]

Barbizon, well-known through the school of painters, was situated in the northwest part of the region. Not far from Moret, southeast of the forest of Fontainebleau, lies Marlotte, where the painter friends Renoir and Monet regularly met in the "Cabaret de la Mère Antony." Corot also lived for some time in Marlotte, and Cézanne came here many times from 1890 onwards.

left: Max Beckmann at the racetrack at Longchamp, film still c. 1930.

below: Pablo Picasso, 1921.

BOIS DE BOULOGNE

With his mention of "le bois"[7] in 1904, Beckmann adopted the usual Parisian term for the parks on the western boundary of the 16th arrondissement, which, with their artificial lakes, reached almost as far as Neuilly. The luxurious residences of the aristocracy, the Longchamp horse racetrack and the lovely avenues which invited one to leisurely strolls, all combined to make the Bois de Boulogne the ideal meeting place for the high society of Auteuil, Passy, La Muette and Neuilly in the afternoons.

Here Beckmann took many walks during the 1920s and 1930s when he had an apartment in the 16th arrondissement. He was first enchanted by "le bois" on his honeymoon with Minna Beckmann-Tube in 1906, when the couple purposely rented an apartment on the nearby Rue Lalo. In her memoirs, Minna Beckmann-Tube writes: "The sun always shone, the roses and chestnuts bloomed all over. We sat in the parks when we'd had enough of the Louvre, and Max read 'Education sentimentale' from Flaubert to me. We had looked for a place to live near to the Bois de Boulogne."[8]

This description is reminiscent of the Jardin de Bagatelle with its uniquely beautiful rose gardens, which a gardener by the name of Forestier had planted in the Bois de Boulogne. He was a friend of Monet and for this reason that part of the park was also referred to as the "Impressionist gar-

den." Beckmann enjoyed the interplay of rose gardens, French gardens and palace aura and came back again and again with every visit to Paris. In 1938 he painted *Park Bagatelle in Paris* (G 496, cat. 37).

CHARTRES

Together with Rudolf von Simolin, Beckmann undertook a further trip in 1937, and proved himself this time a lover of Gothic architecture: "Tomorrow we want to take his car and drive to Chart[r]es (…)."[9] The cathedral of Notre-Dame from the thirteenth century with its huge, magnificent rosettes and the 160 wonderfully fashioned church windows was their destination. BS-A

1 Briefe, Vol. 1, letter 15 to Caesar Kunwald, Berlin, 27 October 1904.
2 Briefe, Vol. 1, letter 326 to Mathilde Kaulbach, Frankfurt, 1 August 1925.
3 Lackner 1969, p. 68.
4 See note 1.
5 Ibid.
6 Ibid.
7 Ibid.
8 Minna Beckmann-Tube, *Erinnerungen an Max Beckmann* in *Frühe Tagebücher*, p. 172.
9 Briefe, Vol. 3, letter 665 to Mathilde Beckmann, Paris, 16 or 17 September 1937.

Pablo Picasso (1881–1973)

When Beckmann came to Paris in the mid-1920s, Pablo Picasso had long left the bohème behind him. He was now living his "chic" phase, enjoying his status as uncontested leader of modern painting and demonstrating this with a flamboyant lifestyle. At this time Paris began the idolization of Picasso as a person which would later, in the 1950s, turn him into the first media star of modern art.

Beckmann's comments on Picasso were less directed at his work than at his success, his fame and his prestige. These comments reveal an irritated observer who is trying to hide his admiration behind a facade of aggression. There was never an open dialogue, as Picasso cultivated with Braque and Matisse; Beckmann and Picasso never met. Nevertheless, Beckmann's library provides proof of the ongoing attention he paid the Catalan.

A piece of somewhat condescending criticism of Cubism in 1912 tells of the occasion when Picasso first came to Beckmann's attention: "As if there were no structural idea embodied in every good painting, old and new – including, if you like, those calculated to achieve cubist effects."[1] It was in this context that Beckmann referred to Picasso's little chessboards ("Picassoschachbrettchen"). After World War I, cubist elements could soon be seen in Beckmann's own concept of space,

for example in *The Night* of 1918–1919 (G 200). A Cubist vocabulary, which in the end can be traced back to Cézanne, can also be read clearly in Beckmann's still lifes from the 1920s and 1930s.[2]

With *Olga Picasso Seated in a Chair* of 1917 (Z III, 83) Picasso uses a classicistic portrait form that can also be found in Beckmann's work from the 1920s (*Portrait of Minna Beckmann-Tube*, 1924, cat. 1, G 233). Numerous other parallels with respect to form and content exist between Picasso's works from the period between the wars and Beckmann's pictures.

In 1925 Beckmann visited the exhibition *25 Peintres contemporains* at Druet's on the Rue Royale in Paris and reported to Quappi: "This morn-

ing I was also at an exhibition of the prominent French painters Bonnard Picasso Matisse etc. and was able to confirm with satisfaction that I do everything better. Quite a pleasant feeling (…)."[3] Through other Paris exhibitions between 1926 and 1939, Beckmann was able to follow Picasso's artistic career, and he made several different attempts to organize a shared presentation in Paris. But this was not to come about until, at an exhibition in 1930 at Flechtheim's in Germany, the press suspected an influence of Beckmann on Picasso: "His loyal followers say that he has learned from every sigificant artist of the times – his last picture at this exhibition is in fact from Max Beckmann – but that his is such a huge personality that this

learned matter only acquires its ultimate creative portent through his action."[4]

Beckmann read this article; it is among the newspaper clippings that his wife Quappi collected. However, the flattering relationship between his and Picasso's work, which is under consideration here, was not very probable at this point in time. The only exhibition that could have made an impression on Picasso was the one in the Galerie de la Renaissance in 1931, which Picasso visited together with Vollard; when leaving the gallery, Picasso is to have said: "Il est très fort" (He is very strong).

This comment was supplied by Günther Franke, and Picasso's biographer John Richardson has confirmed that Picasso, when he wanted to express his praise for a work, used the adjective "fort" equally when referring to his own work or to that of other painters.[5]

It is not known whether Beckmann was present at the major Picasso retrospective in the Galerie Georges Petit from 16 June through 17 July 1932. In any event, the extensive catalogue on the exhibition can be found in his library and the copy shows signs of intensive study.

The recognition of his work as being on a par with that of Picasso, which Beckmann so yearned for, was not to be received in Paris, but would be fulfilled very soon in the USA. His triptych *Departure* (1932–1935, G 412) and Picasso's *Guernica* of 1937 (Z IX, 65) were hung side-by-side in the Museum of Modern Art during the war years. The critics commented: "Only Picasso, with his exciting works inspired by the bombing of Guernica, comes anywhere near to the aesthetic energy of Beckmann …"[6] In 1947, a slim catalogue from the Museum of Modern Art on *Guernica* found its way into Beckmann's library. But he continued to denounce or criticize the painting of the Spaniard, while at the same time constantly comparing himself to him as a way of evaluating his own career. It is not likely that Picasso was ever aware of his role as Beckmann's omnipresent but ever absent competitor; in 1964 he praised him again "Ah, a great painter."[7]

For Beckmann, the Catalan remained his greatest rival until he

died, as a late letter to Minna Beckmann-Tube shows: "The French moderns are still standing as steady as a rock, but it cannot be denied that the solid work of Valentin and my own – perhaps not completely untalented – painting have succeeded in chipping away not inconsiderable gaps from this citadel. – But the struggle is damned hard. Big money and years of aggressive propaganda have made the position of these people quite impenetrable and it is really something that I am beginning to stand on a (business) level with them. For example Pulitzer has approx. 10 Picasso 8 Rouault 5 big Braques etc. etc. – Mister Golschman the conductor of the symphony concerts here has about 40 Picassos. – Mary Calorie a rich sculptress in New York and a friend of mine has about 50 Pic. etc. – In spite of this, Aline Lochhem critic for the New York Times (most important paper in U.S.A.) bought a big picture of mine last week and all of New York is running to see it. Had a nice coc[k]tail party at her place, where for the first time Mister Barr (Director of modern Art Museum New York) owns the museum 20 Picassos including the huge picture 'Guerzina'. 'Bombardement' world-renowned. Mr. Sooby his co-director who recently wrote quite a good piece about me etc. They both greeted me as a "great artist." You have to understand that this is all about art politics and the modern Art Museum is in America the equivalent of the Nationalgalerie under Justi; before the Nazis and is the absolute trend-setter here. The party Aline arranged was also for me alone, she will also arrange an official Beckmann party. By the way, Barr has already bought the 'Departure' from me 8 years before – and then there was a big new wave of Picasso propaganda and I was sitting in Holland — and so on. – I could tell you a lot more segments from this circle but that would be going too far. We have achieved quite some 'glory' already, but the sales are still few and far between and unfortunately when this wonderful moment arrives I have to give Valentin his 'half' and my prices are still a lot lower than those of the French artists. – A picture of mine that costs 1000 $ is for something by Picasso or Braque 3–4000 $$. And

these prices are really being paid. – But let us hope that all of this will improve with time. – By the way, please handle this with discretion."[8] BS-A

1 Gedanken über zeitgemäße und unzeitgemäße Kunst. Erwiderung auf Franz Marcs Aufsatz "Die neue Malerei" in Realität der Träume, cited in Buenger, Max Beckmann: Self-Portrait in Words, 1997, p. 116.

2 E.g., Max Beckmann, *Still Life with Gramophone and Irises*, 1924 (G 231), and Picasso: *Still Life with Small Table in front of an Open Window*, watercolor painting, 1919 (Z XXIX, 454).

3 Briefe, Vol. 1, letter 325 to Mathilde Kaulbach, Paris, 28 July 1925.

4 Lothar Brieger: Meister oder Epigonen?, Oct. 1930. ex. cat. Matisse Picasso Braque at Alfred Flechtheim, Berlin.

5 We would like to thank John Richardson for this information from 3 February 1998.

6 Alice Bradley Davey: Two Extreme Styles of Modern Art Top Week's Exhibitions. Max Beckmann's Paintings Contrasted with Exhibition of Purism in The Chicago Sun from 10 January 1942.

7 St. Louis Post Dispatch from 2 October 1964: Beckmann Display Opens World Tour (without mention of author); Picasso's comment was supplied by Hanns Swarzenski.

8 Briefe, Vol. 3, letter 884 to Minna Beckmann-Tube, 18 September or 18 October 1948.

BIBLIOGRAPHY:

Pablo Picasso. A Retrospective, ed. William Rubin, ex. cat. Museum of Modern Art, New York 1980.

John Richardson, Pablo Picasso, Leben und Werk, Munich 1995, 1997.

Pierre Daix, Dictionnaire Picasso, Paris 1995.

Paul Poiret
(1879–1944)

Paul Poiret got his start in the fashion
world with "couturier" and art collector
Jacques Doucet, who also instructed
him in the art of stage setting. In 1904
Poiret opened a studio of his own. He
was among the revolutionary fashion
designers who freed women from the
corset and other such restrictive acces-
sories during this period. He had his
artist friends design fabrics or decora-
tions for elegant receptions in his
house.[1]

At the Paris "Exposition interna-
tionale des arts décoratifs et industriels
modernes" of 1925, Poiret created a
sensation with his fantastic decoration
of three houseboats which were to
serve as restaurants and dancing clubs.
It may be significant that Marie-Paule
Pomaret was general secretary of the
exposition. But is also possible that
Poiret met Max Beckmann through
Käthe von Porada. Or perhaps at the
reception at the German Embassy,
some of whose guests can be identified
in Beckmann's *Paris Society* (G 346, cat.
26). The worldly, affable Poiret appears
on the very left in the picture. But
even if Poiret and Beckmann did not
come into closer contact, with this por-
trait of the "couturier," the painter did
want to express the fact that he himself
was now moving in the most stylish
Paris circles – albeit at a considerable,
ironic distance. LB

1 Göpel, Vol. I, p. 243.

Marie-Paule Pomaret

Marie-Paule Fontenelle was born on
16 June 1889 in Maubeuge and her
first marriage was to Henry Lapauze,
literary critic and curator of the
Musée du Petit Palais in Paris. He
managed the Revue de la Renais-
sance, which published contributions
from the art world "recto" under a
white title page, and literary and eco-
political information "verso" under a
green title page. After the death of
Lapauze, Marie-Paule continued on
with the magazine and founded the
Galerie de la Renaissance, which
became a platform for the Revue. In
1928 she married Charles Pomaret
(1897–1984), a lawyer originally from
Montpellier who was also active politi-
cally and as a journalist. As a member
for the department of Lozère, he
became undersecretary for the Min-
istry of Education in 1931. From
August 1938 to July 1940 he was Sec-
retary of State for Employment, and
for a period of ten days in June 1940
he was Secretary of the Interior.

Marie-Paule Pomaret was friends
with another, remarkable woman,
Käthe von Porada, who introduced
her to Max Beckmann. During this
time, Pomaret gave her support to
Rouault, in Beckmann's eyes one of
the few French painters with any
sophistication. At the same time, she
cultivated friendships with Marc
Chagall, Maurice Denis, Paul Bel-
mondo – whose work she collected –
as well as the curator Jean Cassou,
critics Waldemar George and Louis
Vauxcelles and art dealers Ambroise
Vollard, Paul Guillaume, Louise Weiss
and Jeanne Bucher. Last but not least,
her circle included publisher Gaston
Gallimard, film director René Clair,
and writers Max Jacob, Blaise Cen-
drars, Paul Claudel, Colette, Paul Fort,
Paul Nizan and Georges Duhamel.

Pomaret was interested in support-
ing Beckmann's work; through her
influence he was finally able to fulfill
his dream of a major Paris exhibition:
"In Paris everything is going well.
Madame Pomaret, who is doing my
exhibition in the Renaissance gallery,
has become an enthusiastic party
member and is even buying pictures."[1]
Pomaret never bought any paintings
in the end, although she remained a
benevolent supporter during his Paris
period. Thus, in 1938 he wrote to
Rudolf von Simolin: " … at the
moment I am painting Madame
Pomaret who are [sic] just been made
Secretary. A very entertaining

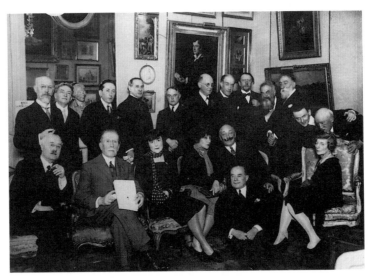

The Jury of the Prix de la Renaissance,
1928. Mme Pomaret in the center with
dotted scarf, on the right the writer
Colette.

woman."[2] However, as a result of the turbulence surrounding the Beckmann exhibition which was planned in the Galerie Poyet in 1939, this portrait was lost. During the time around 1938/39, when the Beckmanns were planning to settle permanently in Paris, they received valuable support from Pomaret, with her vast network of political connections. Beckmann was successful in having his "carte d'identité" extended, but the outbreak of war prevented him from settling permanently in Paris. Before leaving Paris, he gave Marie-Paule Pomaret the painting *Place de la Concorde at Night*, 1939 (G 523). They were not to see each other again.

After the occupation in July 1940 the Pomarets retired from public life, moving first to Ciotat, and in 1942 to Pey Blanc near Aix-en-Provence. Charles Pomaret again opened a law office after the war, but withdrew completely from politics. The couple lived in Tholonet near Aix, in Nice, Monaco and Saint-Paul-de-Vence. Marie-Paule Pomaret always kept up her friendly relations with Käthe von Porada. LB

1 Briefe, Vol. 2, letter 552 to Rudolf von Simolin, St. Moritz, 12 January 1930 [1931].
2 Briefe, Vol. 3, letter 688 to Rudolf von Simolin, Paris, 21 December 1938.

Käthe Rapoport von Porada (1891–1985)

Käthe von Porada was one of the most important women in Beckmann's life. This is also made clear by the fact that he immortalized her in his key work, the *Large Painting of Women* (*Five Women*) (1935, G 415). Beckmann met her in 1922 at the home of the Motecisczky family in Vienna. The young aristocrat – she was considered the most beautiful girl from Berlin[1] – was fascinated by the painter. They met again in Frankfurt, where, in 1924, the *Portrait of Käthe von Porada* (G 226) as well as a portrait of her daughter, Hilda, were painted. Porada became a loyal friend and gave Beckmann the utmost support and encouragement.

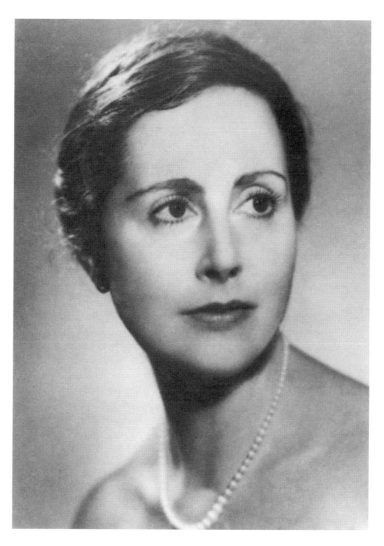

On the occasion of his wedding to Mathilde Kaulbach in September 1925 she did not hesitate to sell a diamond tiara from her own wedding in order to buy a car as a wedding gift to the young couple.[2] It is possible that this was a symbolic gesture: her passion for art – in particular that of Max Beckmann – caused her to sacrifice one after the other her marriage, her family, and all her worldly goods until, in 1926, she was free to move to Paris.

There, "K," "Rapoport," "Die Rappo" or "Kati," as Beckmann was wont to refer to her in his letters, worked as a fashion correspondent for the *Frankfurter Zeitung* and several of the magazines under the Ullstein Verlag imprint. She also worked for designer Molyneux, and later for Paul Poiret. In 1932 her book *Mode in Paris* was published by the Societäts-Verlag.

Käthe von Porada found Beckmann his first Paris apartment on the Rue d'Artois and his atelier on the Boulevard Brune.[3] She acted as chauffeur, helped with the correspondence,[4] accompanied him to galleries and generally planned his Paris career. She even took over the function of banker for the purchase of *Forest Landscape with Woodcutter*.[5] Her role as a collector of Beckmann's works is not to be underestimated; both she and Lilly von Schnitzler promoted his career in this way. Together, they financed the exhibition of 1931 in the Galerie de la Renaissance. Thanks to her initiative, in the summer of 1938 in London Beckmann featured prominently at the 20th Century German Art exhibition, which was a counteraction to the "Entartete Kunst" exhibition. In 1938 Porada and Stephan Lackner assumed the costs for a touring exhibition of Max Beckmann's works in Switzerland.

Käthe von Porada, c. 1925.

The canary yellow Opel that Käthe von Porada gave Max and Quappi as a wedding gift.

When Beckmann's life in Germany became increasingly difficult, Käthe von Porada tried to arrange his permanent move to Paris. At the beginning of 1939, together with Lackner, she tried to arrange a showing for him at the Galerie Poyet. When this failed due to political reasons, she persuaded the gallery to give a private showing.[6] In addition, in June of that year, she organized a private exhibition in her apartment in the 16th arrondissement. This showing included watercolors, pastels and her own paintings by Max Beckmann.[7] She gave visitors the catalogue which had originally been planned for the Galerie Poyet, which contained the passage which Edmond Jaloux had written for the exhibition.

With the outbreak of the war, Porada remained in France. She moved to Nice, and later to Monte Carlo. One of her neighbors there was André Pieyre de Mandiargues, through whom she made the acquaintance of writers Adrien de Meeüs and Albert Paraz. During the years of the occupation, her pictures were kept safely in the house of Paraz in Neuilly sur Seine.[8] When the war ended, Porada became active once again. In 1945, Beckmann learned that "... the Bird Hell and numerous others by me, together with Grommayre Chagall Rouolt [sic] and also some others, were being shown in Paris under the title of 'Expressionists.'"[9] Käthe von Porada had obviously lent her Beckmann pictures to Waldemar George for an exhibition. Where exactly this showing took place is not known. The

only existing information about it came from Pieyre de Mandiargues: "I have been to see the exhibition of the Expressionists. The big picture by Beckman [sic] is the only interesting piece there. All the others are deplorable. A very poor Rouault ... "[10]

In spite of this fresh new start, the collaboration which Käthe von Porada and Max Beckmann had previously enjoyed was not be reinstated. On 16 April 1947 they saw each other again in Monte Carlo, where Beckmann gave her two watercolors. It was to be a farewell present, as they never saw each other again. She was now living with Albert Paraz in Vence and worked for the Galerie Alphonse Chave. In 1953 the shed in which her pictures were stored caught fire. Numerous pictures were destroyed, including the *Portrait of Hilda* of 1924. The upper third of *Negro Poilu* from 1931 (G 347) was also damaged.[11]

In her estate there are unpublished memoirs, with a chapter dedicated to Beckmann entitled "Le Titan." LB

1 Briefe, Vol. 2, note p. 295–362 to Marie-Louise von Moteciszcky, Frankfurt, 12 February 1926.
2 According to information kindly supplied by Pierre Chave, summer of 1997.
3 Briefe, Vol. 1, note p. 459 on letter 210 to Israel Ber Neumann [undated].
4 Briefe, Vol. 3, letter 676 (and note), to Käthe von Porada, Amsterdam, 21 March 1938.
5 Acquisition file at Archives Nationales CARAN, Paris, Serie F21.
6 Briefe, Vol. 3, letter 695 to Curt Valentin, Paris 1 May 1939.
7 *Harbor of Genoa*, 1927 (G 269), *Negro Poilu*, 1931 (G 347), *Woodcutters in the Forest*, 1931 (G 349), *Small Still Life*, 1932 (G 362), *Fountain in Baden-Baden*, 1936 (G 442), *Quappi with Green Parasol*, 1938 (G 491), *Small Bandol Landscape*, 1938 (G 503), *Birds' Hell*, 1938 (G 506).
8 Correspondence between Käthe von Porada – André Pieyre de Mandiargues, 16 December 1943–25 March 1981; Manuscript department, Bibliothèque Nationale, Paris (naf 18 899); letter from André Pieyre de Mandiargues from Paris, May-June 1945.
9 Briefe, Vol. 3, letter 756 to Curt Valentin, Amsterdam, 7 December 1945.
10 Cf. note 8 above.
11 Göpel, Vol. 1, pp. 244–245.

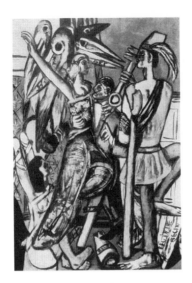

Max Beckmann, *Begin the Beguine*, 1947 (G 727).

below: June Knight and Charles Waters dancing *Begin the Beguine* in *Jubilee*, 1935.

right: G. F. Reber with Olga and Pablo Picasso, Lausanne 1931.

Cole Porter (1891–1964)

Such conflicting questions ride / all round in my brain / should I order cyanide / or order champagne ...[1] There was a surprising affinity between Beckmann and Cole Porter. His whole life long, Beckmann took the lyrics of popular songs very seriously as a kind of modern wisdom. "Begin the Beguine," a song Cole Porter wrote in 1934 for the musical *Jubilee*, lent its title to an important painting of the post-war years (G 727).

The musical *Paris* (1928) the actual breakthrough for the New York composer and "I love Paris" one of his biggest hits. It is likely that the jazz fan Beckmann often heard Porter's melodious, smooth swing in the Paris bars and cabarets. Porter's weakness for bitter, erotic intrigue and his underlying tone of self-irony explain Beckmann's liking for his music. The imaginary stage of Paris through which the heroes of Porter's musicals danced could easily be transformed into the background for Max Beckmann's more sardonic interpretations of the city (cf. *Paris Society*, 1925/31/47, G 346, cat. 26 or *Carnival Paris*, 1930, G 322). TB

1 Cole Porter, "I Am in Love"

Gottlieb Friedrich Reber (1880–1959)

Gottlieb Friedrich Reber had a successful career in the dry goods business in Wuppertal. His wealth made it possible for him to retire early and devote himself exclusively to art. In the 1910s he accumulated a significant collection of nineteenth century French art (Corot, Courbet, Manet, Renoir, Degas, Gauguin, Cézanne and van Gogh). Then in the early 1920s he sold these works and turned to Picasso and other Cubists. In just a few years Reber had one of the most important Picasso collections of all time.

The major Picasso retrospectives in Paris and Zurich in 1932 revealed the immense scope of Reber's collection (for the exhibition in the Kunsthaus Zürich the collector, who had been living in Switzerland since 1919, contributed 18 paintings and 22 sketches and watercolors). Soon after, however, Reber experienced considerable financial difficulties because of the economic crisis. He had to sell many of his pictures. During the war his German citizenship was revoked, and returning home from a trip to Italy, the authorities refused to allow him to cross the border into Switzerland. His wife was forced to sell more pictures in the following years; by the time Reber died, his collection was scattered to the four corners of the earth.[1]

It was Alfred Flechtheim who introduced Beckmann to Reber in 1928 in Berlin. The collector was skeptical

about Beckmann's work. Although he knew and liked Quappi Beckmann, he only agreed to meet the painter himself under one condition: that he would not be urged to buy any pictures. To everyone's surprise, the result of the meeting was an order for a portrait. The first sketches for it were done soon afterwards at the Hotel Adlon (or at the Hotel Esplanade). Beckmann painted the portrait (G 306, cat. 13) in the summer of 1929 in Frankfurt, but it was not handed over to the collector until Beckmann had returned to Paris. Reber's secretary in Paris picked it up and sent it to Reber in Lausanne. He was not very happy with the portrait and his family made fun of it, saying that he looked "like a pink piglet" or "like a floor manager of a department store." The picture was stored in the cellar.[2]

This reaction was significant: Although Beckmann had temporarily impressed the collector of French moderns to the extent that he was prepared to have him do his portrait, the heavy red tones turned out to be too intense and unsophisticated to be included in a collection otherwise dominated by Parisian taste. It is possible that Reber had only ordered the portrait as a favor to Flechtheim; the portrait was quite inexpensive: 2500 RM.

Beckmann was not able to achieve a direct link to Pablo Picasso through his acquaintance with Reber. The Beckmann literature[3] tells us that, in the spring of 1929, Beckmann did further studies for Reber's portrait in Lugano (or Ascona[4]) whereby he had the opportunity to study Reber's Picasso

Max Beckmann sketching for the Portrait of G. F. Reber (cat. 13), Berlin 1928.

Pablo Picasso, *Madame Eugenia Errazuriz*, 1921, Private collection.

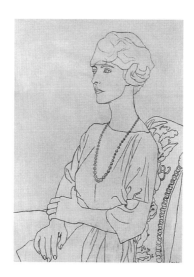

collection. But a photograph from the winter of 1930/31 shows several of the Picassos which Beckmann could have seen – but presumably never did see. Because in 1929, Reber was already living in Lausanne, and the meticulously kept guest book of the 1920s shows no visit from Max Beckmann, either in Lugano, Ascona or in Lausanne.[5] TB

1 Cf. Geelhaar 1993, p. 157 ff.
2 I would like to thank Christoph Pudelko, Bonn, for the information about his grandfather, G. F. Reber.
3 Headed by Göpel, Vol. 1, p. 221.
4 From information from Mathilde Q. Beckmann, Erratum list in ex. cat. Karlsruhe 1963.
5 Information from Christoph Pudelko.

Retour à l'ordre

The phrase "return to order" dominated the French art scene in the 1920s. It was an aesthetic debate combined with a political one, and with respect to Max Beckmann's efforts to make a name for himself in Paris, the thrust of this slogan – at times very chauvinistic – is of particular significance. The debate was set off when Picasso and André Derain turned away from Cubism towards a more classically inspired form of art. Many circles were in favor of the rebirth of the specifically French art form which they saw in this development. In the nationalistic and reactionary atmosphere after World War I, these themes were well received. Painters André Lhote and Roger Bissière developed and propagated the theories for a

national French tradition, characterized by clear lines from Fouquet, Poussin, Ingres to Braque. The main idea was to stress the superiority of French art over Italian, Spanish and specifically German art. The prejudices which Beckmann had to grapple with, as a German living in Paris between the wars, were many and, in sublimated, theoretical form at least, reached far into artistic and intellectual "milieus."

Only in this connection can the core concept in Beckmann's Stratégie Parisienne truly be understood: to imagine and promote oneself, not as a German but rather as a European painter. Similarly, Waldemar George entitled one of his essays programatically: "Beckmann l'Européen,"[1] and named his catalogue text for Beckmann's showing at the Galerie de la Renaissance accordingly: "Beckmann et le problème de l'Art Européen."[2] TB

1 FORMES, revue internationale des arts plastiques, No. 13, March 1931, p. 50.
2 ex. cat. Max Beckmann, Galerie de la Renaissance, Paris 1931.

Reber's study in Lausanne, 1930/31.

Georges Rouault in his studio in Saint-Malo, 1932.

Max Beckmann, *Lake with Fishermen*, 1924 (G 232).

Georges Rouault (1871–1958)

Beckmann often mentions Georges Rouault in his letters from the Paris period, and invariably in a positive, accepting manner. In a certain way, Beckmann saw in the other man his French *alter ego*; they shared similar views on all kinds of topics, from the circus to the "demi-monde" to religious themes. As early as 1930 Will Grohmann compared the spiritual tendencies of the two painters: "The Catholic Rouault remained at the source of Christianity, the Protestant Beckmann was searching for it."[1] After that, they both had a common style which worked with the contrast between black borders and luminous colors (in the case of Rouault this was reminiscent of his earlier apprenticeship in glass painting).

While staying for a few days in Paris in the summer of 1925, Beckmann visited the exhibition "25 Peintres contemporains" in the Galerie Druet at 20, rue Royale. Here he noticed the work of Rouault, whose name he made a note of, along with several others.[2] There was soon an indirect connection between the two artists through I. B. Neumann, who showed their work alternatively, and sometimes even together, in New York and Munich. Between Neumann and Rouault there existed a friendship; they wrote often to one another, and towards the end of the 1920s, they met regularly in Paris.

Neumann realized that Rouault's expressive style was quite possibly the connecting element between the German and the Parisian developments in art. "But we, who were struggling for recognition of modern German art, could never overlook the fact that Paris was officially the international center for modern art. Therefore, an artist like Rouault, who spoke our language with a Parisian accent, was inestimably valuable to us."[3] Nevertheless, his attempts to promote Beckmann's Paris career through shared presentations and through reciprocal business within the framework of his representation of Rouault, were without great success.

Although Rouault played a remarkable role for Beckmann, the two artists never actually met. As far as we know, the lone wolf Rouault never particu-

larly noticed Beckmann's work.[4] Beckmann, on the contrary, kept an eye on Rouault his whole life long. In his library there are not one but two copies of an issue of *Artlover* magazine which had been dedicated to Rouault. And when in 1945 a significant Rouault retrospective took place in the Museum of Modern Art, Beckmann, who was still living in Holland at the time, made a point of obtaining the catalogue, presumably through Curt Valentin. BS-A

1 *Artlover*, Vol. 4, Georges Rouault, Munich Exhibition 1930, I. B. Neumann Galerie.
2 *Briefe*, Vol. 1, letter 325 to Mathilde Kaulbach, Paris, 28 July 1925.
3 Israel Ber Neumann, Sorrow and Champagne, Confessions of an Art Dealer, p. 1.
4 Verbal information from Mme Isabelle Rouault, Paris, 1998.

BIBLIOGRAPHY:

Georges Rouault, L'Œuvre peint, ed. Bernard Dorival and Isabelle Rouault, 2 Vols., Monaco 1988.

Fabrice Hergott, Georges Rouault, Barcelona 1991.

Henri (Le Douanier) Rousseau (1844–1910)

As with Marc Chagall, one is surprised to find Henri Rousseau among Max Beckmann's perceived kindred spirits in art. The eccentric customs officer left behind works of a disarming, fantastically dreamy amiability and childish charm; one would never use such terms to describe Max Beckmann.

In his London speech "On My Painting" (1938), Beckmann declared his admiration for Rousseau in a remarkable way. In the literary form of describing a dream, he reviewed his artistic motivation and mentioned at the end of his talk his "… my grand old friend Henri Rousseau, that Homer in the porter's lodge whose pre-historic dreams have sometimes brought me near the gods …"[1] And Mathilde Q. Beckmann reported: "He was simply fascinated by the fantasy and the pictorial structure of Henri Rousseau … and by his way of painting. Every time he visited the Museum of Modern Art in New York he would stand a while before the *Sleeping Gypsy*; it was one of his favorite pictures …"[2]

Henri Rousseau, *Portrait of Pierre Loti,* c. 1910.

Max Beckmann, *Bitterness,* etching, 1920, (H 167).

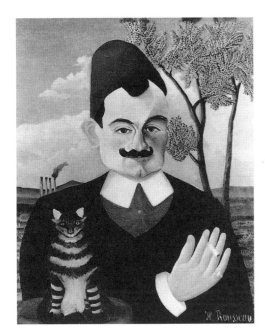

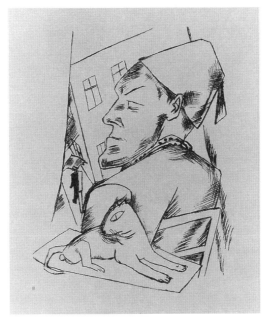

Collector and art critic Wilhelm Uhde organized the first showing of Rousseau in 1908 in Paris and also brought attention to him later in Germany. The result was an actual outbreak of Rousseau fever at the beginning of the 1920s. Beckmann's admiration for Rousseau also intensified between 1917 and 1924. There were few pictures, almost all landscapes, and the homage was restricted to the attention to fine details and the tranquil, somewhat melancholic "poésie" of Rousseau's scenes of everyday life; a certain borrowing can also be found in the portraits. In the realm of fantasy, Beckmann followed his own path through the primeval forests of the twentieth century.

It should also be mentioned that Max Beckmann's interest in Rousseau was shared by his French peers: Pablo Picasso was the most famous collector of the customs officer, and Robert Delaunay was a good friend of his. TB

1 Max Beckmann, On My Painting. Reprint of Curt Valentin's translation of Meine Theorie der Malerei. Beverly Hills, California 1950, p. 13.

2 Mathilde Q. Beckmann 1983, p. 152.

Rues, Boulevards, Places

RUE NOTRE-DAME-DES-CHAMPS
6th arrondissement

86, rue Notre-Dame-des-Champs was Beckmann's very first address in Paris. He rented a large atelier there in October of 1903, in which he also lived.

Since April 1892 James Whistler had also had a studio in this house. At the time the whole street was dominated by artists, and most of the houses from the early nineteenth century contained artists' ateliers. Renowned salon painters like Bouguereau, Jean Paul Laurens and Carolus-Duran worked in this somewhat humble quarter, where the two academies Colarossi and Julian, as well as numerous shops for painting supplies, were located. In 1913 Fernand Léger took over Beckmann's former studio from Henri le Fauconnier and kept it until the end of his life.

RUE LALO
16th arrondissement

This short street led to the Bois de Boulogne in the vicinity of the Arc de Triomphe. Max and Minna Beckmann-Tube stayed at number 8 on this street during their honeymoon in September and October 1906.

RUE D'ARTOIS
8th arrondissement

In the fall of 1929, Beckmann rented a furnished apartment at 24, rue d'Artois, very close to the Champs-Elysées. A few months later, he moved to the Rue des Marronniers.

BOULEVARD BRUNE
14th arrondissement

In July 1929 Beckmann found a studio at 23, boulevard Brune, on the outskirts of the city. Presumably it was located on the top floor of the big whitewashed house, as the top windows were the largest. It was here that his Paris works between October 1929 and April 1939 were created.

Paris street scene, c. 1935.

26, rue des Marronniers.

23 bis, boulevard Brune.

86, rue Notre Dame des Champs.

RUE DES MARRONNIERS
16th arrondissement

At the beginning of 1930 Beckmann and Quappi moved to the "quartier" Passy, to 26, rue des Marronniers. According to the official registry from 1931 they lived in apartment No. 3 as subtenants of Augustine Charlotte Leblond.[1] She was the "Madame Jolli," whom Beckmann mentions in one of his letters (her ex-husband was Antonin Léon Joly).[2] It is here that the painting *View at Night onto the Rue des Marronniers* from 1931 (G 351, cat. 27) was painted.

1 Archives Départementales, Paris.
2 Briefe, Vol. 3, letter 700 to Mathilde Beckmann, Abano Terme, 31 May 1939.

RUE MASSENET
16th arrondissement

This address, where the Beckmanns lived from October 1938 to June 1939, was only a few streets away from the Rue des Marronniers and was very close to Käthe von Porada's apartment on the Rue de la Pompe.

RUE LEPIC
18th arrondissement

In 1937 or 1938, the Beckmanns gave their address as 91–93, rue Lepic in Montmartre, near Sacré Cœur when filing for a "carte d'identité" for foreigners and also a residency permit.[1] It is possible that this was a temporary address or the address of a friend.

1 Archives of the Paris Police Headquarters

RUE LA BOÉTIE
8th arrondissement

Between the two world wars, the "quartier" Madeleine formed the cultural core of the "rive droite." On the Rue La Boétie were located the major art dealerships Paul Rosenberg, Paul Guillaume, Alfred Poyet, Bonjean, the Galerie La Boétie, and also Bignou and Bing & Cie. In 1918 Picasso also took an apartment at 23, rue La Boétie, next door to the Galerie Rosenberg.

RUE ROYALE
8th arrondissement

Only a few steps from the Place Vendôme and the Hotel Ritz, the elegant Rue Royale winds down from the "quartier" Madeleine to the Place de la Concorde. The Galerie de la Renaissance was at number 11, which was an excellent location. Anyone who was among the elite in Paris between the two world wars was seen in the tea rooms and posh restaurants on the Rue Royale: in Maxim's, in the Café Weber or at X, the headquarters of writer and billionaire Raymond Roussel.

RUE DE LA POMPE
16th arrondissement

The Paris apartment of Käthe von Porada was located on this distinguished street (No. 29). It was here that she organized a private showing of Beckmann's works in June 1939.

RUE GASTON-DE-SAINT-PAUL
16th arrondissement

In October 1937 Stephan Lackner left Berlin for good and moved to Paris. From the windows of his apartment at 4, rue Gaston-de-Saint-Paul, one had an excellent view of the Seine and the Eiffel tower; this view comprises the background for Beckmann's *Portrait of Stephan Lackner* (1939, G 519). In early 1938 Lackner gave a house-warming party here, which came close to being a Beckmann exhibition. "Morgenroth [Stephan Lackner] is opening next week with the II Tryptichon [sic] and the other pictures in his new studio."[1]

1 Briefe, Vol. 3, letter 675 to Curt Valentin, Amsterdam (?), 11 February 1938.

Max Beckmann, *View from the Window (Eiffel Tower)*, 1930, Pastel.

Max Beckmann, *Notre-Dame*, 1926 (G 261).

PLACE DE LA CONCORDE,
8th arrondissement

The Place de la Concorde formed the center of Beckmann's Paris life in the 1930s. It was surrounded by the Rue La Boétie, the Rue Royale, the Restaurant Prunier, the Hotel Crillon, and the Musée du Jeu de Paume. In 1939 Beckmann painted two scenes of the square: *Place de la Concorde at Night* (G 523) and *Place de la Concorde by Day* (G 524). The scene at night shows the view from the terrace of the Crillon, where Beckmann often met Rudolf von Simolin. The second picture shows the view from the terrace in front of the Musée du Jeu de Paume – in which two paintings of Beckmann's were on view at that time. It is no coincidence that Beckmann gave the picture to Marie-Paule Pomaret, to whom he owed this showing at the museum. LB

left: Maurice Utrillo, *Rue du Chevalier-de-la-Barre,* c. 1918.

right: Max Beckmann, *Sacré-Cœur in the Snow,* 1939 (G 513).

Sacré-Cœur

This famous structure in neo-Byzantine-romanesque style symbolizes the eclecticism of the nineteenth century. It is an unusual building – not very well-liked by the Parisians but highly popular among the tourists – which dominates the city from high upon the Montmartre. This basilica is a very frequent motif in the work of Maurice Utrillo; together with the Moulin de la Galette, it became the symbol of the "bohème" of Montmartre.

Sacré-Cœur in the Snow (1939, G 513), one of the last paintings which Beckmann completed in Paris, is an actual exercise in the stylistic idiom of the Ecole de Paris. Its precise counterpart in the work of Utrillo was painted in c. 1918 and is called *Rue du Chevalier-de-la-Barre. Montmartre.* Both pictures show the basilica from the same angle, and the compositions are almost identical.

Although Beckmann painted "à la Utrillo," it is not likely that he decided to create a paraphrase after having visited an Utrillo exhibition. There is no sketch for this painting in existence, and Stephan Lackner has confirmed that Beckmann never made sketches during his walks through Paris and certainly never set up his easel on the street.[1] This leads to the conclusion that Beckmann did not paint from nature but rather used models or patterns.

Similarly, from 1909 Utrillo hardly painted outdoors, but rather mainly from postcards.[2] Beckmann also liked using photographs, not only for portraits, but also for landscapes; postcards were mostly used as the basis for his landscape pictures of the Côte d'Azur. When the Sacré Cœur paintings of both artists are compared to reproductions of the basilica on postcards, there are astonishing similarities. The typical angle can be found on a postcard from 1904 and is still

Rue Royale, c. 1938.

Sacré-Cœur, Postcard, c. 1940.

Salon des Indépendants and Salon d'Automne

The independent Paris Salons at the turn of the century were important events for artists, critics, collectors and dealers, and achieved recognition throughout Europe. Shortly after Beckmann's arrival in Paris in 1903, the first Salon d'Automne exhibition took place from 31 October to 6 December in the Petit Palais. Eight pictures by Gauguin, who had just died, were shown in his honor. There were also works by Cézanne, Bonnard, Matisse, Rouault, Valloton, and Vuillard.[1] A few months later, Beckmann visited the Salon des Indépendants which was held in the Grandes Serres,[2] from 21 February until 24 March 1904.

By the second Salon d'Automne 1909 in the Grand Palais, from 1 October to 8 November, Beckmann was no longer just a visitor. Several of his paintings were included in a contribution by the "Deutsche Gruppe." It was his first public appearance on the Paris art scene. The works selected conformed to conservative academic tradition. Submitting his skills to full scrutiny, his exhibits embraced the leading genres: the history paintings of religious subject matter, the *Lamentation* of 1908 (G 89) and *Crucifixion* of 1909 (G 119); mythological history painting, *Mars and Venus*, 1908 (G 91); *Double Portrait of Max Beckmann and Minna Beckmann-Tube* of 1909 (G 109);[3] and a still life and a landscape.

Not until 1927 did Beckmann exhibit again in the Salon d'Automne, 5 November–18 December, and this was the last time. He was represented at the Berlin Secession with a single work. This sparse representation did not worry him. Visiting Paris briefly in 1925 he had disparaged the Salons … "where just the same mediocre 'kitsch' was shown as in the glass palaces of Berlin and Munich."[4] LB

the same fifty years later. Beckmann followed Utrillo not only with respect to style and subject, but also with respect to working methods. He allowed himself little freedom in the creation of the view, but rather respected and reproduced a reality which the public was familiar with and which had already been frozen into a cliché.

Perhaps Max Beckmann was simply showing his sardonic sense of humor when he again reproduced a "kitsch" reproduction of the Sacré Cœur: it was exactly at the same time the picture was created that he filed for his residency permit in Paris (cf. Exile), giving his address as the rue Lepic in Montmartre. Was it his intention to use the picture to prove his successful assimilation as a German painter in the "milieu" of the Ecole de Paris to the French authorities?[*] BS-A

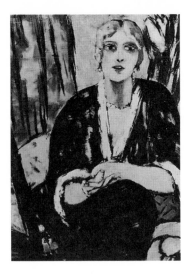

Lilly von Schnitzler-Mallinckrodt (1893–1983)

Beckmann made the acquaintance in Frankfurt of the wife of George von Schnitzler, director of IG. Farben. Lilly was an important figure in Frankfurt society. In 1924, she bought a painting; seventeen more were to follow. She continued to support Beckmann, in spite of her husband's close connection to the Nazis, visiting him in exile in Amsterdam, even in dangerous phases of the war. After the war she tirelessly promoted Beckmann and his work. At her house in Murnau on 8 February 1953, the Max Beckmann Society was founded. Ten of the works in this collection were made a legacy to the city of Cologne for the opening of the Wallraf-Richartz Museum in 1957.[1]

Von Schnitzler published a number of texts on Beckmann.[2] Despite the somewhat mocking tone of some of Beckmann's written remarks about Lilly von Schnitzler ("Schnitzlerin"), the importance of this friendship must not be underrated. In the Paris period, too, she played an essential role, being a close friend of Prince Karl Anton von Rohan, the leader of the European Cultural Union. She was the secretary of the German contingent,[3] which helped to organize the major Beckmann exhibition in 1931 in the Galerie de la Renaissance.[4] The director of the gallery, Marie-Paule

Pomaret was a friend of Lilly von Schnitzler.[5] Even if she was not the main promoter, she and Käthe von Porada were vital accomplices in the realization of Beckmann's Paris strategies. Both women supported the exhibition financially as well.[6] TB

1 Verbal information from Stephan Lackner, March 1997.

2 Alfred Werner, Sabine Rewald, Maurice Utrillo, New York 1981, p. 20.

1 Donald E. Gordon, Modern Art Exhibitions, 1900–1916 Munich, 1974.

2 Frühe Tagebücher, p. 87 Beckmann's diary note, Artistes indépendants 20 Februar – Grandes Serres de la Cour de la Reine.

3 Göpel 1976, Vol. 1, pp 81–82, 92, 96.

4 Briefe, Vol. 1; letter 324 to Mathilde Kaulbach, Paris 27 July 1925.

1 Klaus Gallwitz, Max Beckmann in der Sammlung Lilly von Schnitzler-Mallinckrodt in Die Expressionisten (ex. cat.), Museum Ludwig, Cologne 1996, pp. 250–255.

2 Max Beckmann, "Der Querschnitt", ed. 4, 1928, p. 28, "Bunte Blätter," Kölner Stadt Anzeiger, 8 February 1958; "Das Enstehen einer Beckmann-Sammlung," Blick auf Beckmann, 1962 pp. 175 f.

3 Cf. Briefe, Vol. 2, pp. 286– 321.

4 Cf. articles on Waldemar George (p. 197) and article on "Stratégie Parisienne" (p. 224).

5 Cf. the letter from Pomaret to von Schnitzler, in ex. cat. Frankfurt 1984, p. 289.

6 Briefe, Vol. 2, letter 583 to Günther Franke, Frankfurt, 19 February 1932.

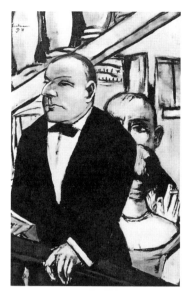

Max Beckmann, *Portrait of Rudolf Baron von Simolin*, 1931 (G 348).

Baron Rudolph von Simolin (1884–1945)

The rather formal Baron von Simolin, a tireless traveller, was one of Beckmann's closest friends. They kept in regular contact in the 1920s and 1930s. Beckmann's letters to Simolin are among the few which discuss private and personal matters. Mathilde Q. Beckmann recalls "a well educated, cultured man; a great connoisseur of art with a magnificent collection of impressionist paintings, and also sculpture. He added to it in the late 1920s with works by Beckmann. Simolin was a distant cousin of mine. He occasionally visited my parents and was a witness at our wedding. He often visited us to see Max's new pictures."[1] In his collection were works by Delacroix, Cézanne, van Gogh, and fifteen paintings by Beckmann. Von Simolin once remarked, "I have two kinds of visitors, those who come to see my Beckmanns, and those who come to see me in spite of them."[2] The bulk of the collection was in a hall at the baron's castle on Lake Starnberg. The rest was housed in his apartments in Munich, Stuttgart and Berlin. Rudolph von Simolin also helped Beckmann to get useful connections. In his role as a patron of the friends of the Nationalgalerie in Berlin, he exerted personal influence to make sure Beckmann was favorably presented, obliging him to deposit

there his *Large Still Life with Fish*, 1927 (G 276, cat. 6). He renewed his efforts on Beckmann's behalf in 1933 when the Nationalgalerie decided to purchase a work by Beckmann, and to devote a room to him in the Kronprinzenpalais.

The baron was a great enthusiast of French literature, especially of Baudelaire and Gustave Flaubert. He possessed a manuscript and writing desk[3] which had belonged to Flaubert. In 1935 he presented a translation of the "Tentation de St. Antoine" to Beckmann, who was inspired to paint the tryptich, *Temptation*, 1936–1937 (G 439).

A Francophile, Simolin travelled frequently to Paris, meeting Beckmann regularly between 1929 and 1931. In Fouquet's Restaurant, the Hotel Crillon, or in a Champs Elyseés café, he would tell of his travels over champagne, and take a deep interest in Beckmann's career. During Simolin's travels in India Beckmann continued to keep him informed, "I have worked very intensively and well and look forward especially to looking at the new works with you. Here a lot is happening in cultural politics. The Beckmann 'thing' continues to develop, gaining ever more in dimension."[4] Soon he was able to inform the Baron about the Galerie de la Renaissance opening, "The exhibition is to be opened on 15 March by de Moncie. The Schnitzlerin will come to Paris ten days before to get it all going so that a lot of noise in Paris about Beckmann is practically guaranteed."[5] Von

Simolin lent eight works from his collection for the exhibition.[6] In 1928 Beckmann had completed two etched portraits, *Baron Simolin* I and II (H 314, H 315). In 1931 the *Portrait of Rudolph Baron von Simolin* (G 348) was painted in Paris. Beckmann appears in the background. He mentions a "double portrait" in a letter to the Baron.[7]

In 1938, when Beckmann had already been regarded as "degenerate," von Simolin travelled to an exhibition in Zurich organized by Stephan Lackner and Käthe von Porada. Again, the Baron showed friendly generosity, as Lackner noted in his memoirs, "As an agreeable surprise, one of his former collectors, Baron Simolin, came straight from Germany, bought the *Self-Portrait with Crystal Ball* (G 434), and bravely took it back into Naziland."[8]

This must have made the pain all the more bitter for Beckmann when he heard of von Simolin's suicide in 1945, as American troops were preparing to occupy his castle. He soon began work on a Simolin triptych, but this never reached fruition. Only one sketch, made in 1946, survives. BS-A

1 Mathilde Q. Beckmann 1983, p. 19–20.
2 Reinhard Piper, Nachmittag, Munich 1950, p. 48.
3 Briefe Vol. 2, letter 564 to Rudolph von Simolin, Frankfurt, 4 May 1931.
4 Briefe, Vol. 2, letter 517 to Rudolph von Simolin, Paris, 21 March 1930.
5 Briefe, Vol. 2, letter 552 to Rudolph von Simolin, St. Moritz, 12 January 1930 [1931].
6 See note 3 above.
7 *The Trapeze*, 1923 (G219), *Large Still Life with Fish*, 1927 (G 276, cat. 6), *Gypsy*, 1928 (G289, cat. 10), *Reclining Nude*, 1929, (G 308 cat. 15), *The Catfish*, 1929, (G 312), *Large Still Life with Candles and Mirror*, 1930 (G 315), *Marine, Côte d'Azure*, 1930 (G 318).
8 Lackner 1969, p. 41.

left: Man Ray, Parisian Dadaists, c. 1922.

left to right: Paul Chadourne, Tristan Tzara, Philippe Soupault, Serge Charchoune; seated: Man Ray, Paul Eluard, Jacques Rugaut, Mick Soupault, Georges Ribemont-Dessaignes.

facing page: Max and Quappi Beckmann with I.B. Neumann and his wife in Paris, film still, c. 1930.

Philippe Soupault (1897–1990)

Beckmann's letters mention first Soupault in 1927. "At last, unexpected good news has arrived for the proliferation of our name, from Uhde, Waldemar George, Supault [sic] and 3 or 4 other French people."[1] It is likely at this point that Lilly von Schnitzler approached those mentioned in order to launch Beckmann onto the Paris art scene. Käthe von Porada knew Philippe Soupault from the circle round Adrienne Monnier and Sylvia Beach. It is not clear whether Beckmann knew these literary figures personally by 1927, or whether this occurred in 1929 or even 1930, with the exhibition preparations in the Galérie de la Renaissance. Soupault's book, *Paolo Uccello*, 1929, was in Beckmann's library with a dedication from the author, but it was not dated.[2] We know that Soupault agreed in 1931 to write an article for Beckmann's first Paris exhibition. This appeared a few days before the preview, in the March edition of the gallery periodical, *La Renaissance.*

The former Dadaist and then committed Surrealist produced the "Champs Magnetiques" together with André Breton, but soon went his own way. Soupault then devoted himself exclusively to the *Revue Européenne*, which he had been directing since 1923. It created a stage for contemporary poets and writers of various directions, including German ones.

The paper's publishing department produced works by Thomas and Heinrich Mann, and also Klaus and Erika Mann, Stefan Zweig, Rainer Maria Rilke and Carl Einstein, whom he also knew personally.[3]

During the exhibition, March – April 1931, Beckmann befriended Soupault, nursing the hope that he might enlist the writer's support. In May he wrote to I.B. Neumann in New York, "a few days ago Soupault, Waldemar George, Bing and Reifenberg visited with their wives. (...) Around 20 July Soupault will visit you. He is a very intelligent Frenchman. He wrote the article on me for the "Renaissance" magazine. – He will give lectures in New York and other American states on French literature and painting. He wants to talk about me, too. It would be good if you'd concern yourself a little for him, as he could prove to become a very important man."[4]

It was questionable how much weight an article by a former Surrealist could exert on the Paris art scene of 1931. Yet Beckmann nurtured high hopes. "Soupault is completely beside himself and wants to turn Paris upside down,"[5] Beckmann writes to Günther Franke. There was however no great response. Philippe Soupault was able to offer less help than, say, Waldemar George. Soupault's article in "La Renaissance" covered four pages, with six illustrations. Significantly, the author excluded it from the complete edition of his art criticism,[6] yet Beckmann's name was included in his con-

versation with Serge Fauchereau.[7] The essay was basically a charming, self-conscious deference to the German painter and his admirers von Schnitzler and Porada as well as to Marie-Paule Pomaret, the gallerist. There were a few digs against Surrealism, but to assume that "the writer had in fact construed with Beckmann a form of anti-Surrealism"[8] would be rather far-fetched. BS-A

1 Unpublished letter to Israel Ber Neumann, Frankfurt, 18 June 1927; Max Beckmann Estate.

2 Briefe, Vol. 2, observation p. 402.

3 Loc cit., p. 165.

4 Briefe, Vol. 2 letter 567 to Israel Ber Neumann, Paris, 25 May 1931.

5 Briefe, Vol. 2, letter 558 to Günther Franke, Paris, 26 February 1931.

6 Philippe Soupault, Ecrits sur la peinture Paris, 1980.

7 Philippe Soupault, Vingt mille et un jours, especially Entretiens avec Serge Fauchereau, Paris, 1980.

8 V. Schwarz 1996, p. 68.

Stratégie Parisienne

In Paris for the first time, Beckmann said of his new, romantic bohemian life, "In short, I am behaving in a manner right and proper for a genius."[1] A quarter century later, Beckmann the established artist observed Paris with a cool detachment. What artistic or sentimental affairs occasioned his presence were no longer a subject for discussion. The decision was a practical one. Paris was a doorway to international success. Taste was formed there, and it was from here that the international art trade operated. After his first taste of Paris, Beckmann swaggered to I.B. Neumann, his dealer, "The chairs in Paris have weak occupants. – I was just recently there. – In me you have a formidable weapon."[2]

In a war-like tone, Beckmann promised to conquer art's capital city. By the mid-1920s he felt himself powerful enough to cross the borders of the German provinces. The art world had to be conquered. Over the years, however, his rhetoric changes. The second key metaphor is that of the stage, and the painter takes the hero's role. Paris was the stage, and the plot consisted of battles for aesthetic, journalistic and economic victory. The German painter was a lone knight, sometimes reminiscent in his zeal of Don Quixote (the romantic irony of the early years has caught up with him once again).

As the correspondence shows, Beckmann made vassals of his dealers, Günther Franke and especially I.B. Neumann. He never tired of admonishing them, of goading them to action, of setting his objectives before them. In 1926 he commanded Neumann to set up a strategic base in Paris. "A small shop," for "there we must attack.(...) ... literally steer public taste, this unfortunately still needs to be done from Paris." He openly names the usurpers whose property should be seized. "This bastion is securely locked and without exception effortlessly and cheaply occupied by Rosenberg, Flechtheim, Picasso, Braque."[3]

Beckmann advocated the formation of alliances. First, he considered enlisting Ambroise Vollard as the most prestigious of Paris dealers and forging

an alliance between him and Neumann. "If we succeeded in having an exhibition at Vollard's, the whole business would be off the ground and you'd be able to add the praises of Vollard to your merits and achievements."[4] Considering the practical problems of communication, he added, "Can you speak French?" Yet it would all be in vain. Vollard proved a completely unsuitable ally. He was no longer active, limiting himself to keeping and guarding the investment value of his considerable assets.

Within a few months there arose the possibility of a very promising alliance: "Now the fight has really begun. A few things have really been happening here, and I am getting a group of people ready for you in which Prince Rohan and Mrs. v. Schnitzler play an important role."[5] In Paris, now imbued by the atmosphere of retour à l'ordre a special strategy was required. With the support of the European Cultural Union, the protégé of Prince Rohan, Beckmann intended to change his image of provincial painter from Germany now so despised. "The people here, like you do, regard me as the painter of Europe."[6] Beckman saw to it from then on that he should no longer be the German knight campaigning to seize his share of the kingdom. Instead painters would be brought together under the shield of a politico-cultural alliance, and under the banner of European culture. "They want to form an international exhibition in Paris in 2 years. Only four artists –

one Italian, one German, French and Spanish (collective exhibition)." Beckmann knew who should take part. "I thought: Severini, Beckmann, Braque and Picasso."[7] The project was never realized, but in 1931 all the publicity surrounding the exhibition in the Galerie de la Renaissance presented Beckmann as representing a common European tradition.

At this time Galerie Bernheim-Jeune had already encouraged Beckmann by exhibiting some of his etchings. He soon pursued other plans. He introduced Neumann to the allies he had found through Lilly von Schnitzler. They were the critics Wilhelm Uhde and Waldemar George. An influential Frankfurt friend, Heinrich Simon, the editor of the *Frankfurter Zeitung*, appears to have helped here, too. For, as Beckmann describes, he travelled "by chance" to Paris. "... and had various fruitful discussions with Uhde, George and others. George is willing to write a foreword to the exhibition and Uhde and George will do their best to find a suitable gallery in which the drama is to unfold."[8]

Much to Beckmann's annoyance, I. B. Neumann was very reserved about the Parisian conquest. It is probable that he reminded Beckmann of their contract. This made any exhibition in Paris impossible without his prior agreement. Beckmann raged that he'd be made a fool of before his protectors, Rohan and Simon, but gritting his teeth, he stepped down and decided to wait for Neumann. "In 1928 you will make the first large

exhibition in Paris. I shall do all I can to help, and I'll keep all the machinery rolling until then, and move to Paris completely in January, February, March to prepare the ground for you."[9]

But Neumann stayed in New York. As Günther Franke prepared a Beckmann catalogue a year later in Munich, the possibility of gaining allies among the Paris critics arose; "... some poet, or dilettante instead of Apollinaire. Or just a Frenchman – perhaps Christian Ze[r]vos the editor of *Cahier-D'Art* 40 Rue Bonapart(r) or Waldemar George(...)"[10] But Beckmann could not win the influential Zervos, who was a confidant of Picasso. However, throughout the project he retained contact with Waldemar George, who took on a Beckmann monograph. The *Frankfurter Zeitung* published a preview of this; however, it never appeared.

These setbacks only spurred Beckmann on. He suggested to Neumann – somewhat naively – a pact with the adversary. "I do not actually know if it will work but it appears to me that becoming a world power in the future is only possible with Rosenberg in Paris, Franke in Munich, Flechtheim in Berlin and you in New York."[11] In fact (and Neumann was now to grit his teeth) Beckmann would soon be flanked by the dealer Alfred Flechtheim as, somewhat deceptively, he projected all the setbacks sustained in the Paris scene, 'this neglected, Kingless Kingdom.'[12], onto Picasso's dealer, Paul Rosenberg.

Beckmann had by now recognized that the only way to get on in Paris was always to be there. He concluded that his noble patrons, Käthe von Porada and Lilly von Schnitzler lacked the driving power to promote him in Paris. At last, in 1929, after several long stays, he settled with a home and studio in Paris for a greater part of the year. He shrewdly combined his appearances with a display of social ritual. For his strongholds, he chose luxury hotels like the Ritz, and from here he dispatched his strategic bulletins. He wrote to I. B. Neumann on notepaper from the Claridge, "At last, after six months I am certain that Paris will work."[13]

Beckmann actually did succeed in quickly making a number of promising contacts, for example with the Galerie Mettler, the Galerie Billiet[14] and the Galerie Etienne Bignou. He pursued two goals. On the one hand he aimed to become well-known in Paris through his one man exhibitions; on the other, he sought business contacts which would strengthen the Paris position of his dealers (who worked only in Germany and the USA). Flechtheim had been able to promote Beckmann in Paris, but he was unwilling to risk the time and money required to realize Beckmann's vast project.

The exhibition in the Galerie de la Renaissance in 1931 was the crown of four years' hard work for Beckmann. Yet he gravely misjudged its significance. "It seems almost like the center of opposition party to Rosenberg."[15]

This, the gallery was not. It was more a platform for high society, with little artistic profile or prestige. In a way, the gallery put the painter at a disadvantage among insiders. Beckmann overlooked the fact that success always comes from the heart of the art scene, the artists, critics, curators, collectors – and not from the periphery of journalists and society followers. He bargained on the assumption that the gallery director, Marie-Paule Pomaret, would use her connections as a politician's wife to guarantee the exhibition's success in chic society circles. "The whole of Paris will be turned upside-down by Mrs. v. Schnitzler and Pomaret."[16]

At the same time, Beckmann did not shy away from painting pictures suited to his strategic goals. Society portraits like the *Portrait of an Argentinian*, 1929 (G 305), the *Portrait of Rudolph Baron von Simolin*, 1931 (G 348), or the self-portrait as a member of high society, the *Self-Portrait in Tuxedo* of 1927 (G 274, cat. 5) are examples. The effect of the portrait of the popular actress Valentine Tessier was also calculated; and the fact that he painted more still lifes than previously was not without good reason – a direct provocation to the masters of the École de Paris. A series of views of the Côte d'Azur followed in the same vein. At a respectful distance, he followed the influential in their summer resorts, enticing them with artistic postcards.

After the exhibition at the Galerie de la Renaissance, Beckmann was able to make further contacts. One of these was the Galerie Bing & Cie, where he achieved one of his last Paris successes. By the beginning of the 1930s, the art world was hard hit by the recession, and the gallery, like countless others, had to close. Time was running out, and Beckmann's field of operation on the Paris terrain continued to shrink.

At the same time, the political situation was breaking Germany apart at the seams. It was hardly possible now to claim to be a Germanic ambassador of a new Europe. Beckmann's tone rapidly altered, losing its compulsive authoritarianism. He continued to live and work in Paris, intending to settle here permanently, despite his lack of success and his failure to secure a gallery. Now it was less a case of occupying Paris, than of fleeing Germany. In 1939 Beckmann had a very important one-man show in the Galerie Poyet, upon which he expressed himself with greater modesty: "It is only small, more a calling card than anything, as we don't want to alarm the Parisians."[17] Yet the war – the real war – forced Beckmann to retreat and put an end to his plans of conquest. LB

1 Briefe, Vol. 1, letter 9 to Caesar Kunwald, Paris, 1 February 1904.
2 Unpublished letter to Israel Ber Neumann, Frankfurt, 2 June 1926, Estate of Max Beckmann.
3 Ibid.
4 Briefe, Vol. 2, letter 382 to Israel Ber Neumann, Frankfurt, 26 June 1926.
5 Unpublished letter to Israel Ber Neumann, 15 December 1926, Estate of Max Beckmann.
6 Loc cit.
7 Ibid.
8 Unpublished letter to Israel Ber Neumann, Frankfurt, 22 May 1927, Estate of Max Beckmann.
9 Unpublished letter to Israel Ber Neumann, Frankfurt, 18 June 1927, Estate of Max Beckmann.
10 Briefe, Vol. 2, letter 457 to Günther Franke, Frankfurt, 23 April 1928.
11 Unpublished letter to Israel Ber Neumann, Frankfurt, 24 November 1928, Estate of Max Beckmann.
12 Unpublished letter to Israel Ber Neumann, Frankfurt, 2 June 1926, Estate of Max Beckmann.
13 Unpublished letter to Israel Ber Neumann, Paris, 1 March 1930, Estate of Max Beckmann.
14 Galerie Billiet, Rue de la Boétie 30, 8th arrondissement (cf. "Rue la Boétie").
15 Briefe, Vol. 2, letter 550 to Israel Ber Neumann, Paris, 4 December 1930.
16 Briefe, Vol. 2, letter 556 to Israel Ber Neumann, Paris, 22 February 1931.
17 Briefe, Vol. 3, letter 691 to Curt Valentin, Paris, 17 March 1939.

La Révolution Surréaliste, Paris 1924.

Collecting of ingredients for the soup kitchen, Montmartre, 20 January 1935.

"Die Welt-Kunst" Berlin May 1931

Moderne Deutsche in Paris
Von Dr. Fritz Neugass (Paris)

Surrealism

In the strict sense, of course, Max Beckmann was not a Surrealist. His contact with members of that Paris group was confined to its apostates, Philippe Soupault and a failed approach to Max Ernst. André Breton's Surrealist doctrine did not interest Beckmann much. Yet if Surrealism is understood as a general creative principle, Beckmann wih his predelection for "metaphor, oracle, mystery,"[1] his love of Bosch and Goya, his dream pictures, and interest in the collective unconcious, was to a certain extent surrealist.

The roots for Beckmann's surrealist tendency are to be found in his symbolist beginnings. The apocalyptic period after the first war resulted in the artist creating such works. In the

early 1920s Beckmann produced dream pictures vaguely reminiscent of Chagall. With the first *Departure* triptych (1932–1935, G 412) Beckmann's personal mythology of images saw the light of day. He was to develop this all his life. It cannot be denied that some of the paintings of the 1930s are directly reminiscent of the surrealistic painting of Salvador Dali, André Masson, Yves Tangy, Max Ernst, Pablo Picasso. TB

1 V. Schwarz, 1996.

Valentine Tessier
(1892–1981)

Valentine Tessier started her career under Jacques Copeau at the Theatre Le Vieux-Colombier. Her partner was Louis Jouvet whom she followed to the Comédie des Champs-Elysées when he was appointed its director. In the late 1920s and early 1930s she performed in all premieres of Jean Giraudoux's works: *Siegfried, Amphitryon 38, Intermezzo.* She triumphed with Michel Simon in Marcel Achard's *Jean de la Lune.* She was celebrated by public and critics alike. Her tall, slim frame and her natural ways inspired Colette to call her the "toute femme" (the complete woman.) She was compared to Sarah Bernhardt, and was quickly regarded as the premiere

actress of the French theater. She took on film roles as well, working under the leading directors Yves Allégret, Alexandre Cayatte, Julien Duvivier, René Clair (*Un chapeau de paille d'Italie*, 1927), but above all, Pierre Renoir (*Madame Bovary*, 1934; *French Cancan*, 1955).

On 8 November 1929 Valentine Tessier played the role of Alcmene for the first time in Giraudoux's comedy, *Amphitryon 38*. She played opposite Pierre Renoir, in a production

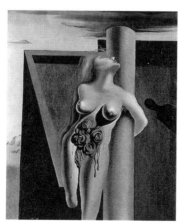

Max Beckmann, *Adam and Eve*, 1932 (G 363).

Salvador Dalí, *Les roses sanglantes*, 1930.

Wilhelm Uhde
(1874–1947)

The middle-class Prussian boy Wilhelm Uhde arrived in Paris at the turn of the century. He was soon to play an important role amongst the artists who gathered at the Café du Dome. In 1905, defying the ridicule of his friends, he bought his first Picasso and soon added works by the Fauves, Dufy, Derain and Vlaminck. He also became one of the first collectors of Georges Braque. In 1911 he published the first monograph on Douanier Rousseau. With Alfred Flechtheim and Daniel-Henry Kahnweiler he immediately belonged among the first supporters of the Cubists. Uhde had to leave France in the first world war. In 1921 his collection, like Kahnweiler's, was seized by the state as enemy property and auctioned. Nevertheless Uhde settled again in Paris in 1924. Like Kahnweiler, he was Jewish. He succeeded in disappearing in southern France during World War II, thereby protecting his collection from the Nazis.

In 1928, when Wilhelm Uhde published the book, *Picasso et la tradition française*, he was attacked as being a hopeless Francophile and a traitor to German art. He continuously bore the brunt of the old nationalistic rivalry. In the "Weltbühne" of February 1929 he defended himself against his attackers, and emphasized his promotion of German artists in Paris. "Herr Schmidt accuses me of repeatedly applying my influence to prevent the exhibitions of living German artists in Paris. The truth is, that a small gallery here was going to exhibit two German artists. The sight of their work would have reawakened here an embarrassing impression of German art. I advised the gallery to show instead a third artist, Paul Klee. And I have helped and advised other German artists as much as I could. I was asked by friends to arrange a show for Beckmann in Paris; and despite my distaste for his art, I spent days searching for a gallery, and trying to overcome their resistance. I was happy when I finally found one – regarded highly for its courage, and it was ready to take the exhibition on. I also found a significant critic to write a serious foreword to the exhibition."

In spite of, or maybe even because of his negative attitude towards Beckmann, Uhde composed the most astute critique on the 1931 exhibition in the Galerie de la Renaissance.[1] Uhde was a connoisseur of the Paris art world. His doubts about Beckmann's Stratégie Parisienne were confirmed by events. "Opening an exhibition of this nature should be avoided. Such exhibitions are held in Paris only for great dead Frenchmen or for living "kitsch" painters from South America ..."[2] TB

directed by Louis Jouvet. Käthe von Porada, a friend of the actress, invited Max and Quappi Beckmann to the premiere. The production was a resounding success. Playwright, producer and, above all, the bewitching main actress were celebrated. The elegantly transparent costumes designed for the female roles by Jeanne Lanvin created a sensation. Beckmann enjoyed the performance so much that he saw it three or four more times, making sketches of Valentine Tessier, as he had just begun a painting of her (G 314, cat. 16). The portrait was finished on 10 February 1930. Käthe von Porada arranged a meeting with the actress. Valentine Tessier appeared surprised and delighted. She liked the picture very much, the only fault she found was in the fact that Beckmann had made certain moderations to the famous transparent dress. LB

1 Cf. Tobia Bezzola, "German Follies," pp. 141f.
2 The dispute over the Beckmann exhibition in Paris, Das Tagebuch, book 12, 1931, pp. 745f.

Valentine Tessier, c. 1930.

Valentine Tessier as Alcmene and Pierre Renoir in *Amphitryon 38*, Comédie des Champs-Elysées, Paris 1929.

Wilhelm Uhde, Walter Bondy, Rudolf Levy and Jules Pascin in the Café du Dôme, c. 1910.

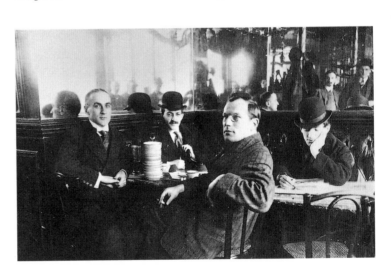

Curt Valentin, c. 1950,
Photo by Mathilde Q. Beckmann.

Max Beckmann, *Portrait of Curt Valentin
and Hanns Swarzenski*, 1946 (G 731),
(Valentin on the right).

Marc Vaux in his studio, c. 1925

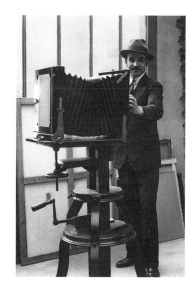

Curt Valentin
(1902–1954)

Mathilde Q. Beckmann wrote in her memoirs of the first encounter with the art dealer Curt Valentin, "We got to know Curt Valentin through Alfred Flechtheim on a short visit to a gallery in the late 1920s in Berlin. Valentin worked for Flechtheim in those days. He appeared for a short moment and quickly disappeared again into his office. I remember how Flechtheim said to Max that Curt managed to make most of the sales because of his great talent as a salesman – something that Flechtheim could not say of himself, and that Curt was indispensable to the gallery. Soon after we moved to Berlin in 1933 Flechtheim had closed his gallery and emigrated to London. We heard from Hanns Swarzenski that Curt Valentin now worked in a room at the back of the "von Bucholz" bookstore where he sold paintings, among them, some Beckmanns which he had taken over from the 'Galérie Flechtheim'. Max would occasionally meet up with Curt and Hanns Swarzenski for supper in the Stoeck-ler, a famous Berlin restaurant before the second world war. This was when the lifelong friendship between Curt and Hanns began. A few years later Curt Valentin became Beckmann's dealer, and remained so until his death in 1950."[1]

In January 1937 Valentin went to New York and opened the Bucholz Gallery. Its final address in 1939

became 32 East 57th Street. Valentin presented artists of various nationalities, with an emphasis on German art. French artists on view were Picasso, Matisse, Léger, Juan Gris, Bonnard, Jacques Lipchitz and Hans Arp. Between 1947 and 1950 he organized many shows of French art. Beckmann certainly saw some of these during the periods he stayed or lived in New York. Valentin dedicated his first one-man show to Beckmann in 1938. It opened in New York and travelled to seven other American states. In 1948 Beckmann completed the *Double Portrait of Curt Valentin und Hanns Swarzenski* (G 731),[2] which he started after visiting the two separately in Holland.

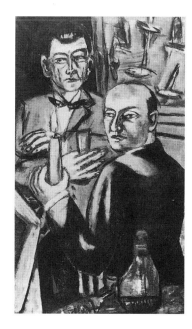

Among those close to Valentin was Picasso's dealer, Daniel-Henry Kahnweiler. Valentin had learned his trade from him, and the friendship continued as Valentin worked for Alfred Flechtheim in the late 1920s. When Valentin stayed in Paris in 1937, he gave Kahnweiler's gallery as his contact address.[3] They remained in close business contact following the war, and each would represent the other in the respective countries in which they worked.

Valentin made a network of significant contacts in the international art world and enjoyed an excellent reputation. Beckmann owed his career in the United States to him. Valentin showed much understanding of Beckmann's needs and wishes. He supported Beckmann's emigration to America. He had achieved much for the representation of European modern art throughout the United States, particularly in the case of Beckmann. Although Beckmann had not succeeded in being recognized in Paris as an equal modern master to the French "stars," who were his contemporaries, he did achieve this in the USA, largely thanks to the efforts of Curt Valentin. BS-A

Marc Vaux
(1895–1971)

Marc Vaux worked as a carpenter until World War I. On his release from military service he became a photographer, settling in the Rue Vaugirard Paris in 1920. He specialized in reproductions of works of art, and quickly made a name for himself as a photographer for Matisse, Juan Gris, Pascin and Kisling to name a few. He was soon working for all the great artists and important galleries in Paris. Over the years, he built up a collection of more than 250,000 glass plates which his widow later bequeathed to the Musée National d'Art Moderne in Paris.

On the occasion of Beckmann's exhibition in the Galerie de la Renaissance in 1931, Marie-Paule Pomaret commissioned Marc Vaux to photograph all the paintings in the gallery. He also took three general shots of the gallery hall. In 1939 Beckmann recommended Marc Vaux to Stephan Lackner[1] to photograph his works, stored in the Galerie Poyet. It remains unclear whether the photographs were ever made. They would have been the only documentary evidence of an exhibition which had to be organized "underground" and was only accessible by private appointment. LB

1 Mathilde Q. Beckmann 1983, pp. 18–19.
2 Cf. Göpel, Vol. 2, pp. 438.
3 Letter from Valentin to Ernst Ludwig Kirchner, 21 May, 1937; Museum of Modern Art Archive, New York.

1 Cf. Briefe, Vol. 3, letter 710.

Catalogue

Max Beckmann

Georges Braque

64 page 129
Fruit Bowl and Tobacco Pouch
1920
Oil on canvas
31.5 x 65 cm
Musée national d'art moderne, Centre
de création industrielle, Centre
Georges Pompidou, Paris

65 page 122
The Fireplace
1923
Oil on canvas
130 x 74 cm
Kunsthaus Zürich

66 page 121
*Still Life with Fruit Bowl, Bottle and
Mandolin*
1930
Oil on canvas
114 x 89 cm
Kunstsammlung Nordrhein-Westfalen,
Düsseldorf

67 page 130
Carafe and Fish
1941
Oil on canvas
33.5 x 55.5 cm
Musée national d'art moderne, Centre
de création industrielle, Centre
Georges Pompidou, Paris

68 page 127
Dressing Table in front of the Window
1942
Oil on canvas
130 x 97 cm
Musée national d'art moderne, Centre
de création industrielle, Centre
Georges Pompidou, Paris

69 page 124
The Salon
1944
Oil on canvas
120.5 x 150.5 cm
Musée national d'art moderne, Centre
de création industrielle, Centre
Georges Pompidou, Paris

Robert Delaunay

70 page 34
The Cardiff Team
1912/13
Oil on canvas
324 x 208 cm
Musée d'Art Moderne de la Ville
de Paris

Fernand Léger

71 page 119
The Typographer
1919
Oil on canvas
54 x 46 cm
Kröller-Müller Museum, Otterlo

72 page 88
The Staircase
1919/20
Oil on canvas
74.6 x 60 cm
Private Collection

73 page 94
The Lunch
1921
Oil on canvas
92 x 65 cm
Musée national d'art moderne, Centre
de création industrielle, Centre
Georges Pompidou, Paris

74 page 74
Woman with a Cat
1921
Oil on canvas
130 x 89 cm
The Metropolitan Museum of Art,
New York

75 page 105
Still Life
1922
Oil on canvas
65 x 50 cm
Kunstmuseum Bern
Hermann-und-Margrit-Rupf-Stiftung

76 page 83
The Red Bodice
1922
Oil on canvas
60 x 92 cm
Ursula and R. Stanley Johnson Family
Collection

77 page 123
Still Life with Arm
1927
Oil on canvas
55 x 46 cm
Museum Folkwang, Essen

Fig. 5 page 33
Acrobats at the Circus
1918
Oil on canvas
97 x 117 cm
Öffentliche Kunstsammlung Basel,
Kunstmuseum
Gift of Dr. h. c. Raoul La Roche

Henri Matisse

78 page 16
Algerian Woman
1909
Oil on canvas
81 x 65 cm
Musée national d'art moderne, Centre
de création industrielle, Centre
Georges Pompidou, Paris

79 page 82
Sleeping Nude on a Red Background
c. 1916
Oil on canvas
94.5 x 195 cm
Private Collection

80 page 72
Laurette with Coffee Cup
1917
Oil on canvas
65 x 53 cm
Kunstmuseum Solothurn
Dübi-Müller Foundation

81 page 86
Large Landscape, Mont Alban
1918
Oil on canvas
73.5 x 93 cm
Private Collection

82 page 82
Odalisque with Red Trousers
1921
Oil on canvas
67 x 84 cm
Musée national d'art moderne, Centre
de création industrielle, Centre
Georges Pompidou, Paris

83 page 103
Woman Before a Fish Bowl
1921/ 23
Oil on canvas
81.3 x 100.3 cm
The Art Institute of Chicago
Helen Birch Bartlett Memorial
Collection

84 page 69

Decorative Figure on an Ornamental
Background
1925/ 26
Oil on canvas
130 x 98 cm
Musée national d'art moderne, Centre
de création industrielle, Centre
Georges Pompidou, Paris

85 page 78

Odalisque with Tambourine
1926
Oil on canvas
74.3 x 55.7 cm
The Museum of Modern Art,
New York
The William S. Paley Collection

86 page 101

Odalisque
1926
Oil on canvas
73 x 60 cm
The Metropolitan Museum of Art,
New York
Gift of Adele R. Levy Fund, Inc.

87 page 97

Still Life with Green Sideboard
1928
Oil on canvas
81.5 x 100 cm
Musée national d'art moderne, Centre
de création industrielle, Centre
Georges Pompidou, Paris

88 page 80

Reclining Nude
1936
Oil on canvas
38 x 61 cm
Private Collection, Courtesy Daniel
Varenne

89 page 36

Still Life with Magnolia
1941
Oil on canvas
74 x 101 cm
Musée national d'art moderne, Centre
de création industrielle, Centre
Georges Pompidou, Paris

Fig. 6 page 91

Still Life with Oranges
1912/13
Oil on canvas
94 x 83 cm
Musée Picasso, Paris

Pablo Picasso

90 page 53

Harlequin
1918
Oil on canvas
147.3 x 67.3 cm
Private Collection

91 page 67

The Reader
1920
Oil on canvas
166 x 102 cm
Musée national d'art moderne, Centre
de création industrielle, Centre
Georges Pompidou, Paris

92 page 66

Woman Reading
1920
Oil on canvas
100 x 81.2 cm
Musée de Grenoble
Gift of the Artist

93 page 64

Woman with Blue Veil
1923
Oil on canvas
110 x 81 cm
Los Angeles County Museum of Art
Purchased with De Sylva Funds

94 page 44

Guitar, Glass and Fruit Bowl
1924
Oil on canvas
97.5 x 130.5 cm
Kunsthaus Zürich

95 page 51

Studio with Plaster Head
1925
Oil on canvas
97.9 x 131.1 cm
The Museum of Modern Art,
New York

96 page 50

The Bottle of Wine
1925/26
Oil on canvas
98.5 x 131 cm
Foundation Beyeler,
Riehen/Basel

97 page 60

Reclining Woman
1932
Oil on cardboard
10.5 x 19 cm
Musée national d'art moderne, Centre
de création industrielle, Centre
Georges Pompidou, Paris

98 page 70

Nude in a Red Armchair
1932
Oil on canvas
130 x 97 cm
Tate Gallery, London.
Purchased 1953

99 page 44

Still Life with Lemon and Oranges
1936
Oil on canvas
54 x 65 cm
Musée national d'art moderne, Centre
de création industrielle, Centre
Georges Pompidou, Paris

100 page 38

Still Life with Fish
1940
Oil on canvas
73 x 92 cm
Museo Nacional Centro de Arte Reina
Sofia, Madrid

101 page 46

Still Life with Cherries
1943
Oil on canvas
54 x 81 cm
Musée national d'art moderne, Centre
de création industrielle, Centre
Georges Pompidou, Paris

102 page 47

Still Life with Lamp
1944
Oil on canvas
73 x 92 cm
Musée national d'art moderne, Centre
de création industrielle, Centre
Georges Pompidou, Paris

103 page 48

Tomato Plant
1944
Oil on canvas
92 x 73 cm
Private Collection

Fig. 7 page 63

Portrait of Olga
1923
Oil on canvas
130 x 97 cm
Private Collection

Fig. 8 page 47
Still Life with Candlestick
1937
Oil on canvas
64.8 x 53.3 cm
Private Collection

Fig. 9 page 42
Yo, Picasso
1901
Oil on canvas
73.5 x 60.5 cm
Private Collection

Fig. 10 page 58
At the Lapin Agile
1905
Oil on canvas
99 x 100.3 cm
The Metropolitan Museum of Art,
New York, The Walter H. and
Leonore Annenberg Collection, Partial
Gift of Walter H. and
Leonore Annenberg

Georges Rouault

104 page 108
Head of a Tragic Clown
1904
Watercolor, pastel and gouache
on paper
37 x 26.5 cm
Kunsthaus Zürich
Gift of Dr. Max Bangerter

105 page 115
The Fugitives (The Exodus)
1911
Gouache and pastel
45 x 61 cm
Kunsthaus Zürich

106 page 109
The Old Clown
1917–20
Oil on canvas
102 x 75.5 cm
Private Collection

107 page 111
Three Clowns
1917–20
Oil on canvas
105 x 75 cm
Private Collection

108 page 117
The Dancer
1932
Oil on paper on canvas
216 x 116.5 cm
Fondation Georges Rouault

109 page 19
The Loge
1940
Oil on canvas
81 x 64 cm
Private Collection

110 page 112
The Dreamer
1946
Oil on paper on canvas
34.3 x 26.7 cm
Musée national d'art moderne, Centre
de création industrielle, Centre
Georges Pompidou, Paris

Bibliography

WRITINGS BY MAX BECKMANN

Max Beckmann. *On My Painting*. Reprint of Curt Valentin's translation of *Meine Theorie der Malerei*. Beverly Hills, California 1950

Max Beckmann, ed. by Curt Valentin, includes English translation of Address to the Friends and Faculty of Washington University 1950, (ex. cat.) Bucholz Gallery, New York 1954

Max Beckmann. Sichtbares und Unsichtbares, ed. by Peter Beckmann, Stuttgart 1965

Max Beckmann. *Briefe im Kriege*, collected by Minna Tube, Munich 1984

Max Beckmann. Tagebücher 1940/50, compiled by Mathilde Q. Beckmann, ed. by Erhard Göpel, Munich 1984

Frühe Tagebücher 1903/4, 1912/13, ed. by Doris Schmidt, Munich 1985

Leben in Berlin. Tagebuch 1908/9, ed. by Hans Kinkel, Munich 1985

Max Beckmann. *Die Realität der Träume in den Bildern. Schriften und Gespräche 1911 bis 1950*, ed. by Rudolf Pillep, Munich 1990 [Realität der Träume]

Max Beckmann. *Briefe*, ed. by Klaus Gallwitz, Uwe M. Schneede and Stephan von Wiese, 3 vol., Munich/Zurich 1993–1996

Max Beckmann. Self-Portrait in Words. Collected Writings and Statements, 1903–1950, ed. by Barbara Copeland Buenger and Reinhold Heller and assistance from David Britt, Chicago 1997

CONTEMPORARY SOURCES

Erhard Göpel, *Max Beckmann in seinen späten Jahren*, Munich 1955

Israel Ber Neumann, Sorrow and Champagne, Confessions of an Art Dealer, unpublished manuscript, 1958, Museum of Modern Art, New York

Lilly von Schnitzler, Erinnerungen an Max Beckmann, in: *Kölner Stadt-Anzeiger*, 8.2.1958

Marie-Louise von Motesiczky, Max Beckmann als Lehrer. Erinnerungen einer Schülerin des Malers, in: *Frankfurter Allgemeine Zeitung*, 11.1.1964; reprinted in: *Max Beckmann*, Katalog Galerie Franke, Munich 1964

Reinhard Piper, *Mein Leben als Verleger. Vormittag-Nachmittag*, Munich 1964

Stephan Lackner, *Ich erinnere mich gut an Max Beckmann*, Mainz 1967

Stephan Lackner, *Max Beckmann: Memories of a Friendship*, Coral Gables, Florida 1969

Doris Schmidt (ed.), *Briefe an Günther Franke. Portrait eines deutschen Kunsthändlers*, Cologne 1970

Reinhard Piper, *Briefwechsel mit Autoren und Künstlern 1903–1953*, Munich 1979

Mathilde Q. Beckmann, *Mein Leben mit Max Beckmann*, Munich 1983

Stephan Lackner, *Max Beckmann*, New York 1983

Stephan Lackner, Exile in Amsterdam and Paris, in: *Retrospective* 1984, pp. 147–158

Erhard Göpel, *Max Beckmann. Berichte eines Augenzeugen*, Frankfurt a. M. 1984

Minna Beckmann-Tube, Erinnerungen an Max Beckmann, in: *Frühe Tagebücher* [Minna Beckmann-Tube 1985]

SELECTED MONOGRAPHS AND EXHIBITION CATALOGUES

Kurt Glaser, Julius Meier-Graefe, Wilhelm Fraenger and Wilhelm Hausenstein, *Max Beckmann*, Munich 1924

Max Beckmann. Das gesammelte Werk, (ex. cat.) Städtische Kunsthalle, Mannheim 1928

Max Beckmann 1948, (ex. cat.) City Art Museum of St. Louis, St. Louis 1948

Benno Reifenberg und Wilhelm Hausenstein, *Max Beckmann*, Munich 1949

Peter Beckmann, *Max Beckmann*, Nürnberg 1955

Hans Martin Frhr. von Erffa / Erhard Göpel (Ed.), *Blick auf Beckmann. Dokumente und Vorträge*, Munich 1962

Max Beckmann, *Das Porträt*, (ex. cat.) Badischer Kunstverein, Karlsruhe 1963

Peter Selz, *Max Beckmann*, New York 1964

Friedhelm Wilhelm Fischer, *Max Beckmann*. Translated by P. S. Falla. London 1972

Erhard und Barbara Göpel, *Max Beckmann. Katalog der Gemälde*, 2 vol., Berlin 1976

Stephan von Wiese, *Max Beckmanns zeichnerisches Werk 1903–1925*, Düsseldorf 1978

Max Beckmann: The Triptychs, (ex. cat.) Whitechapel Art Gallery, London 1980

Max Beckmann. Seine Themen – seine Zeit, (ex. cat.) Kunsthalle, Bremen 1984

Max Beckmann. Frankfurt 1915–1933, (ex. cat.) Städtische Galerie im Städelschen Kunstinstitut Frankfurt a. M. 1984

Max Beckmann in Frankfurt, ed. by Klaus Gallwitz, Frankfurt a. M. 1984

Max Beckmann Retrospective, ed. by Carla Schulz-Hoffmann and Judith C. Weiss, (ex. cat.) Haus der Kunst, Munich; Nationalgalerie Berlin; The Saint Louis Art Museum; Los Angeles County Museum of Art 1984/85; Munich/St. Louis 1984 [Retrospective 1984/85]

Max Beckmann. Bibliographie, ed. by Felix Billeter, Alina Dobrzeckei and Christian Lenz, Bayerische Staatsgemäldesammlungen, Max Beckmann-Archiv, Munich 1984

Max Beckmann: Work on Paper, (ex. cat.) Eva-Maria Worthington Gallery, Chicago 1987.

Peter Beckmann, *Max Beckmann. Leben und Werk*, Stuttgart/Zurich 1989

Max Beckmann. Gemälde 1905–1950, (ex. cat.) Museum der Bildenden Künste, Leipzig 1990

James Hofmaier, *Max Beckmann. Catalogue raisonné of His Prints*, 2 vol., Bern 1990

Stephan Lackner, *Max Beckmann*, Cologne 1991

Carla Schulz-Hoffmann, *Max Beckmann. Der Maler*, Munich 1991

Peter Beckmann and Joachim Schaffer (Ed.), *Die Bibliothek Max Beckmanns. Unterstreichungen, Kommentare, Notizen und Skizzen zu seinen Büchern*, Worms 1992

Max Beckmann. Selbstbildnisse, (ex. cat.) Hamburger Kunsthalle; Staatsgalerie Moderner Kunst Munich, Stuttgart 1993

Max Beckmann. Meisterwerke, ed. by Karin von Maur, (ex. cat.) Staatsgalerie Stuttgart, Stuttgart 1994

Peter Selz, *Max Beckmann*, New York 1996

Christian Lenz, "Max Beckmann in seinem Verhältnis zu Picasso", in: *Niederdeutsche Beiträge zur Kunstgeschichte* 16 (1977), pp. 236–250

Martin R. Deppner and Christoph Krämer, "Vom Gewöhnlichen zum Fremdartigen, vom Exotischen zum Alltäglichen. Ein Blick auf Beckmann und Léger," in: *Tendenzen* 19 (1978), H. 122, pp. 30–33

Barbara C. Buenger, *Max Beckmann's artistic sources. The artist's relation to older and modern traditions*, Ph. D. Columbia University, NewYork 1979

Dietrich Schubert, Die Beckmann-Marc-Kontroverse von 1912: "Sachlichkeit versus innerer Klang," in: *Max Beckmann. Die frühen Bilder*, (ex. cat.) Kunsthalle, Bielefeld 1982, pp.175–188

Hans Belting, *Max Beckmann. Tradition as a Problem in Modern Art*. Translated by Peter Wortsmann. New York 1989

Hans Belting, *Das Ende der Kunstgeschichte?*, Munich 1984

Manfred Brunner, "Beckmann und der Kubismus. Ursachen des großen Stilumbruchs oder der Anteil von Kunsterfahrung am Werden einer modernen Malerei," in: *Max Beckmann*, (ex. cat.) Josef-Haubrich-Kunsthalle, Cologne 1984, pp. 11–40

Günter Metken, Somnambulismus und Bewußtseinshelle. Beckmanns Umgang mit der Tradition, in: (ex. cat.) *Max Beckmann. Frankfurt 1915–1933*, Frankfurt 1984, pp. 43–50

Susanne Rother, *Max Beckmann – der Maler im Urteil seiner Zeitgenossen 1917–1933*. Magisterarbeit Cologne 1985

Siegfried Gohr, Max Beckmann und Frankreich, in: *Wallraf-Richartz-Jahrbuch*, 47, Cologne 1986, pp. 45–62

Max Beckmann. *Die Frankfurter Jahre*, ed. by W. A. Nagel, text by Ewald Rathke, Hanau 1991

Hans Belting, *Die Deutschen und ihre Kunst. Ein schwieriges Erbe*, Munich 1992

Siegfried Gohr, Beckmann and Picasso or Two Ways to Abolish Gravity, in: *Max Beckmann*, (ex. cat.) Galerie Michael Werner, New York 1994

Ortrud Westheider, *Die Farbe Schwarz in der Malerei Max Beckmanns*, Berlin 1995

Michael V. Schwarz, *Philippe Soupault über Max Beckmann. Beckmann und der Surrealismus*, Freiburg im Breisgau 1996

Birgit Schwarz/Michael V. Schwarz, *Dix und Beckmann. Stil als Option und Schicksal*, Mainz 1996

Index of Names

Photo and Copyright Credits